Encyclopedia of Artists

Painters of the NINETEENTH-CENTURY

Exclusive publishing rights for all Spanish-speaking countries are held by

Editorial Libsa
San Rafael, 4
28108, Alconbendas
Madrid, Spain
Tel: (34) 91 657 25 80
Fax: (34) 91 657 25 83
E-mail: libsa@libsa.es
Website: www.libsa.es

Text by The Editorial Team

This edition published by

TODTRI Book Publishers
254 West 31st Street
New York, NY 10001-2813
Fax: (212) 695-6984
E-mail: info@todtri.com

Visit us on the web!
www.todtri.com

ISBN: 1-57717-198-5

Printed and bound in Spain

Encyclopedia
of Artists

Painters of the
NINETEENTH-CENTURY

TODTRI

INTRODUCTION

The nineteenth century was without a doubt one of the most prolific times in the history of art as far as artists, works, and art movements are concerned.

For this reason the publishers have decided to put this very important cultural period within the reach of the general public with this volume, *Encylopedia of Artists*. Our research treatise on nineteenth-century painting presents these works to the reader in a analytical fashion, in a context in which the author and his work are considered in light of the artist's evolution. In producing this work, a broad range of criteria was used, both in choosing the artists represented and in determining their different creative periods. Thus, artists such as Goya, who worked both the eighteenth and nineteenth centuries, or Bernard, who painted well into the twentieth, are included. Nevertheless, the main body of the book is made up of those artists whose works were produced in the century that gives the book its title.

In this book, which is aranged in encyclopedic order, brief biographies are provided for the most influential artists of the era, along with a list of their most representative works. Special mention is also made of the different schools of art and the various movements that developed during this period: Neoclassicism, Realism, Romanticism, the Nazarene movement, and Impressionism.

The arrangement of the artists in alphabetical order and the clarity of the text greatly facilitates access to information. In addition, the summaries provided for the artists are extensive enough to locate them in their periods, explain which artists most influenced their styles, and indicate whether or not they created or helped to form a new movement. In many cases, the different works are analyzed along with information about which museums house them today. Cross references to other artists or movements, set in bold face type, provide additional information, since by following them it is possible to recreate an entire movement or period. In selecting the illustrations for this volume, the editors have chosen the best-known images or those that are most representative of the artist in question. The entries for major artists are accompanied by more illustrations than those for lesser-known painters.We invite readers to tour this imaginary museum in book format, where works of extraordinary beauty are displayed, and where a great deal of information can be obtained about one of the richest and most important art periods of all time.

ABBATI, GIUSEPPI

(Naples, 1836–Florence, 1868)

Italian painter. The son of a painter of interiors, Abbati moved to Venice in 1846, and studied at its academy. There he met D'Ancona and Signorini and produced some of his earliest works. In 1852, he went to Naples, and six years later to Florence. In principle, he was fundamentally a painter of interiors until, after fighting under Garibaldi, whom he would once again join in other campaigns in 1862 and 1866, he began to frequent the Café Michelangelo, where he adopted the painting techniques of the Macchiaioli movement. His paintings at that time showed great plasticity, due to the enormous simplicity of their composition and their marked contrasts of light and color, achieved through patches of color, especially shades of white, such as in the stone blocks seen in *The Cloister*. His realist landscapes of Piagenta and Castiglioncello, in which he depicted the banks of the Arno, the beaches of Livorno, and so forth, are from a somewhat later period and are the result of his observations of nature and its luminous effects. His later paintings are completely Macchiaioli in style, with darker forms standing out from a luminous background. Other important works are *The Arno Through Casaccia, Woman in Gray,* and *Painter Pointeau.*

AGASSE, JACQUES-LAURENT

(Geneva, 1767–1849)

Swiss painter. Agasse received his artistic training in Paris under David and Carle Vernet and in 1800 settled in London. There, due to the success of

Castiglioncello Landscape.
GIUSEPPE ABBATI.

his elegant paintings of landscapes with animals, especially dogs and horses, he became a successor to George Stubbs. His work was well received by the English, including King George IV (*Landing at Westminster Bridge,* 1818). His style is characterized by its realism, demonstrating his extensive knowledge of animal anatomy—a result of his veterinary studies—and his great sense of modeling. He also painted portraits, such as that of *John Gubbins Newton and His Sister Mary*.

The Flower Seller.
JACQUES-LAURENT AGASSE.

AGRICOLA, FILIPPO

(Urbino, 1795–Rome, 1857)

Italian painter. A pupil of his father, who was a drawing teacher, and of Vicenzo **Camuccini** and Gaspare Landi, he was one of the most noteworthy Italian painters of the first third of the nineteenth century who followed the movement led by David. Apart from this painter's influence, shown by a certain coldness in his work, and that of Camuccini, evident in his use of chiaroscuro, his style also includes elements from the great masters of the sixteenth century, especially Raphael, whose work he studied. He produced paintings on

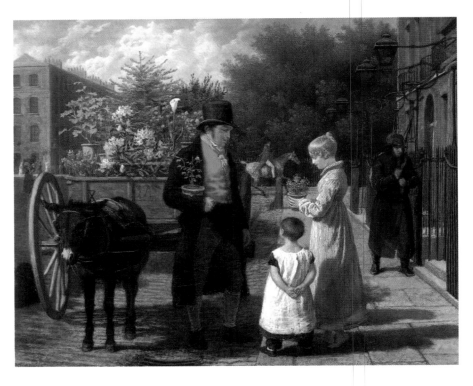

historical, religious, and mythological subjects—the latter area being the most important in his work—as well as portraits. He was so successful that he joined the Academy of St. Luke at the age of twenty-six and was its director from 1854 to 1855. Among his best works are *Marius Meditating Amidst the Ruins of Carthage*—with which he won the Napoleonic Exhibition at the age of seventeen—*Titian's Ladies, The Countess of Cortari's Daughter, Tasso at the Monastery of Saint Onofrio, Poet Monti, The Prince of Denmark,* and *Constanza Perticari.*

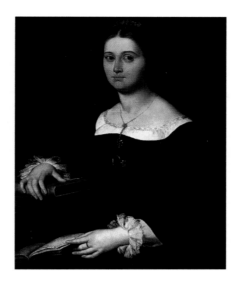

Portrait of Constanza Monti Perticari.
FILIPPO AGRICOLA.

ALENZA NIETO, LEONARDO

(Madrid, 1807–1845)

Spanish Romantic painter, one of the few followers of **Goya**. Despite the solid training he received at the San Fernando Fine Arts Academy as a pupil of Juan Antonio de Ribera and **José de Madrazo**, he soon departed from the dominant historicist style and content, as well as from official commissions from court circles of King Ferdinand VII. He was fascinated by subjects dealing with customs and manners and took his inspiration from everyday life and from scenes involving people, which he captured using the purist line and the style of Goya's drawings. Works such as *The Beating* and *The Drunkard* are indicative of the spontaneous, colorististic, and popular nature of his work, but above all of his profound knowledge of Goya's art. In his famous *Suicide*, he demonstrates that he is one of the best representatives of Spanish **Romanticism**. In addition to his numerous portraits of people from a humble social station, his work as an illustrator and his sketchs

of ordinary people must also be mentioned. One of his most ambitious and personal works—now lost, and known only through a sketch—is *The Levant Café*, considered to be the epitome of the Romanticism of Madrid. His early death and the limited amount of work he produced allow him to be justly considered a very talented painter who died before having produced his best work.

ALLSTON, WASHINGTON

(Waccamaw, 1779–Cambridge, Massachusetts, 1843)

An American painter, Allston was a pioneer in and one of the most important exponents of American Romantic painting. His work as a whole, compositions primarily dealing with historical and Biblical subjects, had a decisive impact on the later development of American painting. He studied at Newport and later at Harvard, with his artistic training beginning in Charlestown and continuing at the Royal Academy in London, starting in 1801. A stay in Paris from 1803 to 1804 gave him the opportunity to become familiar with the masterpieces in the Louvre and to make contact with important artists. One of his first known works, *Jacob's Dream* (1804), is from a trip he made to Rome during this period

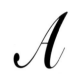

The Deluge.
WASHINGTON ALLSTON.

The Pyrrhic Dance.
SIR LAWRENCE ALMA-TADEMA.

A

and indicates the influences that flowed from his discovery of the Venetian paintings of Titian, Tintoretto, and Veronese. Also noteworthy in the development of his painting style is the admiration he felt for classical art, probably "rediscovered" through his friendship with the Neoclassical sculptor Thor-

Promise of Spring.
SIR LAWRENCE ALMA-TADEMA.

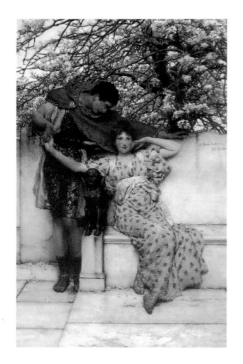

valdsen. After returning to the United States in 1809, he produced extensive work on subjects from the Old Testament. Following a further trip to Europe, he settled in Boston, where he spent most of his life. Among his works, which are full of dramatic effects and surprising colors, some of the most noteworthy are *The Prophet Jeremiah*, *Saul and the Witch of Endor*, *Dante and Beatrice*, and above all, *Belshazzar's Feast*, a grandiose composition that he began in 1817 and left unfinished when he died. The portraits he made of some of his friends, such as the one of the poet Samuel Taylor Coleridge, are of great interest.

ALMA-TADEMA, SIR LAWRENCE

(Drontyp, 1836–Wiesbaden, 1912)

Painter of Dutch origin who obtained British citizenship and lived in London from 1870 onward. He first studied with **Wappers** at the Academy of Painting in Antwerp and was later a pupil of **Leys**, with whom he produced frescoes to deco-

rate the Antwerp City Hall (1859). Due to his vast knowledge of ancient times, he began in 1863 to concentrate on an "archaeological" genre, painting numerous scenes of classical Greek and Roman times. His style was academic, within the style of bourgeois realism, with impeccable technical skill and highly meticulous detail in his treatment of fabrics, furniture, bronzes, and the like. His use of pastel hues and uniformly distributed light is reminiscent of the Old Dutch Masters, whose work was characterized by theatricality, at times striving excessively for effect. He also produced high-quality, small-format genre paintings, such as *The Attendant of the Baths* and *Reading from Homer*, in which he maintained his skilled draftsmanship and rich and brilliant coloring. In addition, he created some fine watercolors. His chosen subject matter and style brought him great fame, but it did not survive him, although the recognition he received from his contemporaries

was reflected by the fact that he was knighted and received the British Order of Merit. His paintings were so successful that they brought very high prices and were reproduced as prints and etchings. Among his most noteworthy works are *The Ten Plagues of Egypt* (1836), *The Pyrrhic Dance* (1869), *Attendant Slave of the Women's Baths in Rome, The Roses of Heliogabalus,* and *Gallo-Roman Women.*

AMERLING, FRIEDRICH VON

(Vienna, 1803–1887)

An Austrian painter, Amerling's style and subject matter place him in the school known as "Biedermeier." He began his studies at the Vienna Academy and continued in Prague. On a trip to London, where he worked with the painter **Thomas Lawrence**, he discovered the elegance of English portrait

Countess Nákó.
FRIEDRICH VON AMERLING.

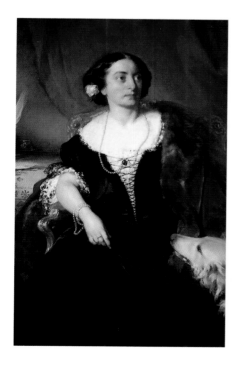

painting, which he would apply to his own creations. He continued his travels through Paris and Munich before returning to Vienna. In that city, he presented two works, *Dido on the Pyre* and *Moses in the Desert,* paintings that received awards from the Viennese Academy. However, Amerling's main contribution was his portrait work rather than his historical and religious paintings. He began working in this area as a result of a commission from Emperor Franz Joseph, and the portrait that he painted of the monarch made his name in Viennese society. *Count Breunner-Enkrevoirth's Family* (1834) and *Mr. Rudolf Arthaber and His Children* (1837) are two good examples of his pictorial work, which was based on the conventional, elegant portraiture of the upper-middle class and their comfortable bourgeois dwellings. He made two trips to Italy, the first in 1831 and the last in 1841. After the latter trip, Amerling mainly worked on genre scenes and those showing customs and manners, as seen in some of his last paintings, such as *The Beggar* and *The Fishing Boy.*

ANGLADA CAMARASA, HERMENEGILDO

(Barcelona, 1871–Pollença, Majorca, 1959)

The chief representative of Catalan Post-Modernism, he achieved great success in the first third of the twentieth century. His training began at the Fine Arts School in Barcelona under the teaching of Modesto Urgell, a painter who led him towards landscapes as subject matter, as reflected by his work *Formentor Pine Tree.* Receiving a stipend from a relative, he

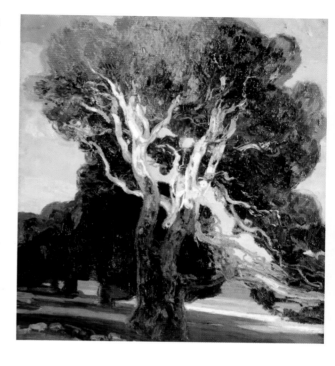

Formentor Pine Tree.
HERMENEGILDO ANGLADA CAMARASA.

moved to Paris to pursue training at the Julien Academy, with the painters Jean-Paul Laurens and Benjamin Constant, and at the Calarossi Academy with René Prinet and L.A.

Mr. Arthaber and His Children.
FRIEDRICH VON AMERLING.

A

Famine of Madrid.
JOSÉ APARICIO INGLADA.

Girardot. These studies radically changed his painting, and he began to recreate urban scenes featuring the nooks and crannies of the French capital with a style linked to Symbolism. He returned to Spain in 1895, and two years later went back to Paris. There the nightlife and the cabarets served as inspiration for his canvases and for his great pictorial objective: studies of artificial light, an interest he resolved with brilliant colors and sinuous brush strokes. An example of this is *Lamp Effect*, a work he exhibited in 1898 at the Salon of Independent Artists, which was very favorably received by the critics. His depictions of Paris brought him great success when he exhibited them at the Parés Gallery in Barcelona in 1900. *Paris Café, Paris Garden, Horse and Rooster,* and *The White Turkey,* works from the first few years of the twentieth century, are clear exponents of the traits that characterize his work: an emotive glorification of color and light, and a rebellious and non-conforming aesthetic attitude. His special style, a departure from most traditional and commercial art, amazed not only the Catalan public but also the middle-class internationally, through his participation in the most prestigious European and American competitions, such as those in Berlin in 1907 and in Lon-

don in 1909. To a certain extent, he also painted subjects relating to customs and manners, such as peasants, gypsies, and nudes, to which he gave his own avant-garde, modernistic stamp. The First World War put an end to his constant visits to Paris, and he settled in Majorca, in the small town of Pollença, the place where he died and which inspired his last works: colorful, refined landscape paintings, of which *Almond Trees in Bloom*, from 1917, is a clear example. In 1954, the Academy of San Fernando in Madrid named him an honorary member.

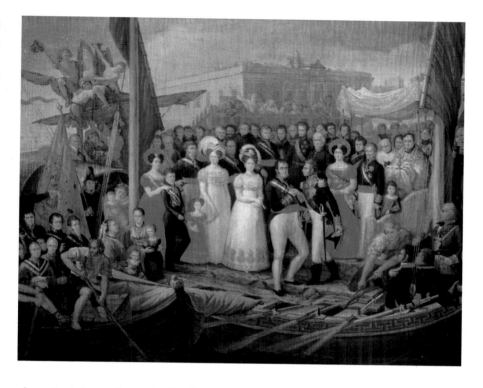

APARICIO INGLADA, José

(Alicante, 1773–Madrid, 1838)

A Neoclassical painter trained in Valencia, Aparicio Inglada continued his studies at the Academy of San Fernando in Madrid and at **David's** atelier in Paris from 1799 onward, at the same time as Juan Antonio de Ribera and **José de Madrazo**. Upon his return to Spain, he disseminated

Portrait of General Dasaix.
ANDREA APPIANI.

the principles and standards of **Neoclassicism** in Madrid through a painting style that, nevertheless, fits within the academic tradition—cold and carefully drawn. He was appointed court painter by King Ferdinand VII, and in 1815 became director of the Academy of San Fernando. Historical and patriotic themes dominate his most important paintings. *Famine of Madrid* (1818) and *Ferdinand VII Disembarking at the Island of León* (1827) are examples of works that are somewhat outdated, with a painting style that is sycophantic and clearly striving for effect.

APPIANI, Andrea

(Milan, 1754–1817)

An Italian painter, the most important representative of that country's Romantic Neoclassicism. His work can be divided into two phases. In the first, which lasted until 1796, his painting is idyllic, showing the influence of Raphael and Correggio,

Ferdinand VII Disembarking at the Island of León.
JOSÉ APARICIO INGLADA.

whom he discovered on a study trip through several Italian cities. His first works were the ones he painted for Archduke Ferdinand of Austria, including the mythological frescoes for the Monza Palace (1789), in which he portrayed the theme of *Love and Psyche* with a harmonious and light technique. Another large decorative scheme from this first phase was the one at Santa María presso San Celso (1792–1795). The second phase began when he was appointed court painter to Napoleon I, the first Italian to hold this position. He did several portraits of Napoleon, in which he glorified the figure of the emperor and which are of a higher quality than his frescoes. In 1801, he traveled to Paris, where he painted his *Chariot of Fire* using a style classified as Romantic Neoclassicism, now very pictorial and clearly reminiscent of Mannerism. Nevertheless, he nearly always worked in Milan, where he

Eugène de Beaubarnais.
ANDREA APPIANI.

White Birds.
JOHN JAMES AUDUBON.

decorated the Royal Palace (1808), in which he exalted the figure of the emperor and his military successes through mythological and Christian references, very carefully drawn though lacking strength and a sense of movement. He also produced numerous paintings with mythological themes (*Pluto and Proserpina; Ganymede at the Feet of Jupiter and Juno; Cephalus and Aurora; Achilles' Fury*) and other portraits (*Carolina Angiolini; Mariana Waldstein*). In some of these, despite their energy, the excessive perfection characteristic of Neoclassicism made them too cold: a quality not found in his sketches, which are strongly expressive and spontaneous.

AUDUBON, JOHN JAMES

(Haiti, 1785–New York, 1851)

French-American painter. From 1796 to 1797, he was a pupil of **David**. In 1803, he moved to the United States to avoid joining Napoleon's army; there he made a living from the portraits that he painted and from his work as a drawing teacher. From 1827 until 1838, he produced 435 color illustrations in aquatint for a large book that he himself wrote about American birds, which was published in London and which became a key work on ornithology. He began a second volume on viviparous quadrupeds, which his children continued when he lost his sight. Despite the realism

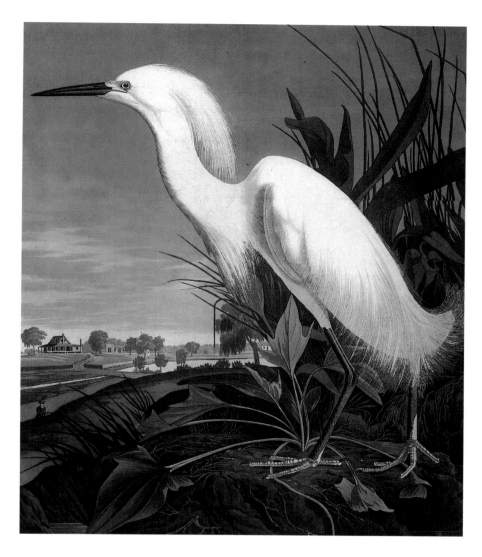

Snowy Egret.
JOHN JAMES AUDUBON.

inherent in his painting because of its scientific nature, a certain romantic touch can be seen.

AVENDAÑO MARTÍNEZ, SERAFÍN

(Vigo, 1838–Valladolid, 1916)

Spanish painter specializing in landscapes. This artist's development started with a Romantic tradition that finally connected with the regionalism in painting that was characteristic of the first third of the twentieth century. He studied in Madrid with **Genaro Pérez Villaamil** at the San Fernando Fine Arts School. In 1863, he received a scholarship to the Spanish Academy in Rome, where he specialized in painting landscapes. In Italy, where he stayed for more than twenty-five years, he exhibited his work in several cities, establishing himself as a painter and engraver, and producing landscapes in a naturalistic style that had great luminosity. From 1859 to 1861, he traveled around the United States and later visited Switzerland, France, and England. In 1891, the year he returned to Spain, he was fully accepted as a painter. For a time, he took refuge in his native Vigo. Having dedicated himself to capturing the nature of his land, he began a more realistic interpretation of that setting, such as in *Winter Landscape* (1891) and *Autumn Landscape* (1910). At the same time, he recreated scenes of customs and manners, such as the well-known *Village Procession* (1895).

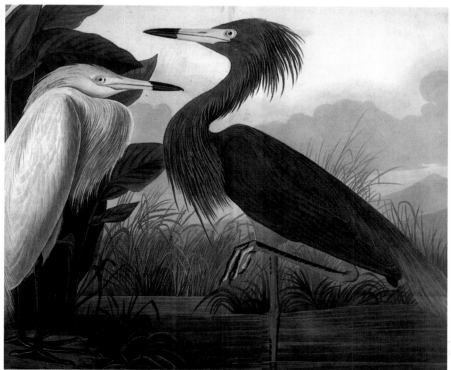

Egrets.
JOHN JAMES AUDUBON.

BARABÁS, MIKLÓS

*(Markusfafva, Siebenbürgen,
1810–Budapest, 1898)*

Hungarian painter and draftsman. A prolific and popular artist, Barabàs was attracted to painting from a very early age. In 1829, he began his studies at the Vienna Fine Arts School along with Johann Ender and continued them in Budapest from 1836 to 1838, where he produced an abundance of work. After a trip through Italy, where he studied the paintings of the Old Masters, he settled permanently in Vienna and became highly esteemed as a portraitist. His style is harsh, with skillful execution and great expressive strength, although with some technical mistakes. Some critics consider him better at sketching than painting, since his pencil portraits are exceptional. Among these is one he did of Franz Liszt which is noteworthy and can be found in the Budapest Historical Museum. Besides portrait sketches, he also did scenes of rural centers (some of which have been reproduced in lithographs), interiors, customs, and the manners and mores of country folk. In honor of the treatment of perspective in one of his paintings, he was named a member of the Budapest Academy of Sciences.

BARBASÁN LAGUERUELA, MARIANO

(Saragossa, 1864–1924)

Spanish landscape painter. The artist studied in Valencia and in 1888, obtained a grant to study in Rome. In

*In the Studio.
MIKLÓS BARABÁS.*

that city, he painted a large historical picture, *Peter III at the Las Panizas Mountain Pass.* However, he abandoned historical subjects to devote himself to painting landscapes and scenes of rural life, using a type of Realism that, through his vibrant and colorful style, shows a certain Impressionistic influence.

*Ville d'Avray.
JEAN-BAPTISTE-CAMILLE COROT*

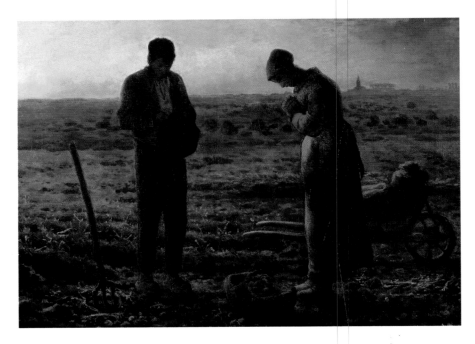

*The Angelus
JEAN-FRANÇOIS MILLET.*

BARBIZON SCHOOL

The term designating a group of painters who, around 1848, settled in and around the French village of Barbizon near the Fontainebleau forest. They were also known as the Fontainebleau School, and their work is considered the strongest French landscape movement of the nineteenth century. They did open-air painting with remarkable precision, minutely observing natural settings, and rejecting academic and Neoclassical composition. Their paintings are mostly landscapes of plains, trees, and forests, all rendered in a fluid style. The most representative painters of this school are **Jean-Baptiste-Camille Corot** and **Théodore Rousseau**, the latter being the organizer and leader of both the group and proponent of its theory. Other noteworthy figures were Jules Dupré, whose work was characterized by the somber use of light, and **Jean-François Millet**, a true innovator because of his unusual subject matter, which glorified the world of peasants and rural workers. **Charles-François Daubigny**, a specialist in landscapes featuring riverbanks, was also an important member of the group, as was the French painter of Spanish origin **Virgilio Narciso Díaz de la Peña**.

BARKER, THOMAS

(Pontypool, Wales, 1769–Bath, 1847)

English painter. Barker learned to paint by studying and copying

The Harvesters.
JULES BASTIEN-LEPAGE.

the great masters of painting. From 1791 to 1794, he was in Italy, where he continued his training in order to perfect his technique. Upon returning to his native land, he settled in Bath, a city in which he did almost all of

Landscape with Trees
THOMAS BARKER.

his work, and where he achieved the renown that would bring him many commissions. It was *The Woodman and His Dog in a Storm*

15

(ca. 1787) that was the first work to bring him success. In his paintings, he developed scenes of customs and manners, romantic landscapes reminiscent of Gainsborough, and portraits. He also worked as a copyist and even did some work with frescoes while decorating his house, *The Massacre of the Inhabitants of Scio by the Turks* (1824–1825). Some of his works were used to decorate Worcester ceramics.

Portrait of Renoir
FRÉDÉRIC BAZILLE.

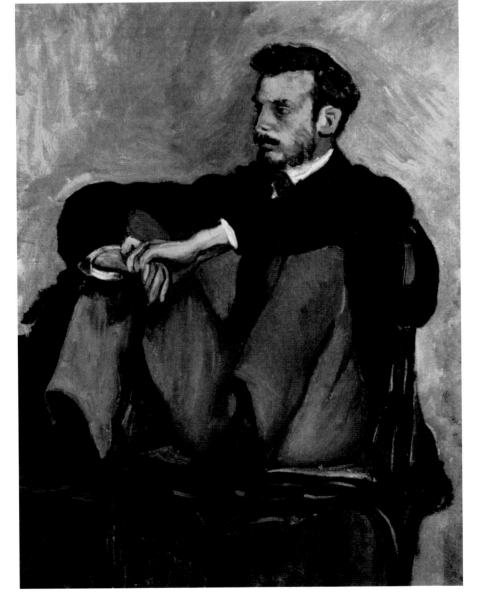

BASTIEN-LEPAGE, JULES

(Damvillers, 1848–Paris, 1884)

French painter. Bastien-Lepage studied with **Cabanel** and was influenced by naturalism, staying within the stylistic lines of **Gustave Courbet** and **Jean-François Millet**. He depicted the fundamentals of rural life in paintings filled with a certain sentimental air which approached French **Impressionism**, especially because of his use of light colors in an attempt to achieve the *plein-air* ("open-air") feeling con-

veyed by the Impressionists, without forsaking draftsmanship, as can be seen in *The Harvesters* (1877) and *The Haymakers* (1877). This manner of treating country life afforded him great fame which went beyond the borders of his country and influenced several painters, primarily in France, England, and Scotland. He also painted portraits; noteworthy examples of this genre are those he did of Joan of Arc, Juliette Drouet, and Sara Bernhardt.

BAZILLE, FRÉDÉRIC

(Montpellier, 1841–Beaune-La Rolande, 1870)

A French painter, he was present at the beginnings of **Impressionism**, but his death at an early age prevented him from witnessing the height of this movement. He was from a well-to-do family from the Protestant middle class and studied medicine in Montpellier. In 1862, when he went to Paris to study for his doctorate, he gave everything up to devote himself passionately to painting. He entered **Gleyre**'s atelier, made contacts in artistic circles, and met **Renoir** and **Monet**. His work focused on landscapes, still lifes, and portraits. However, he primarily investigated the human figure in the open air and its realtion to the natural world and the landscape. Examples of this interest are seen in *The Pink Dress*, from 1864, and the painting that is considered his masterpiece, *Family Reunion*, also known as *The Artist's Family in Montpellier*. He did two versions of this painting and exhibited it at the Salon in 1868. His compositions are very structured, with broad brush strokes, in which

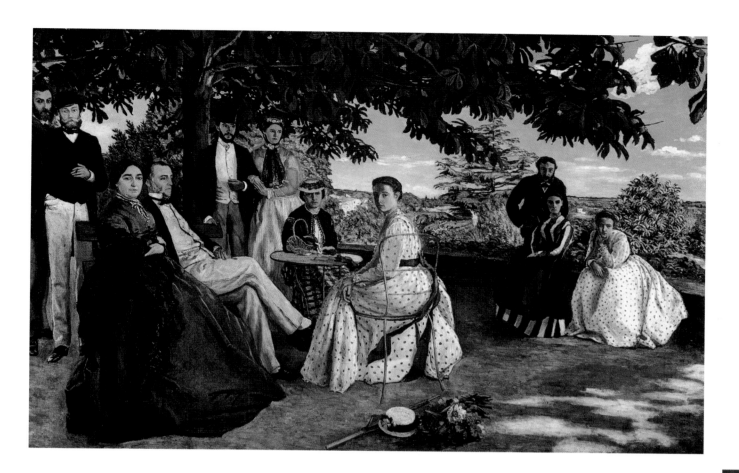

B

Family Reunion
FRÉDÉRIC BAZILLE.

the figures seem to be in front of a photographer's lens. He was also interested in representing nudes in the open air—*Summer Scene* (1869) is an example—a subject shared by nearly all of the Impressionists. Bazille's style departed somewhat from the other Impressionists, since he reconsidered form and volume as elements that were necessary parts of his paintings, an aspect that the Impressionists obviated. His brilliant and well-known painting *The Artist's Studio* reveals the intellectual and artistic context in which Bazille worked. The artist himself appears, being painted by **Monet**, together with the painters **Manet** and **Renoir**, the writer Émile Zola,

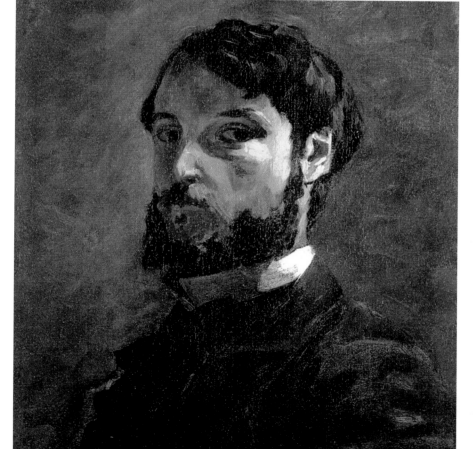

Self-Portrait
FRÉDÉRIC BAZILLE

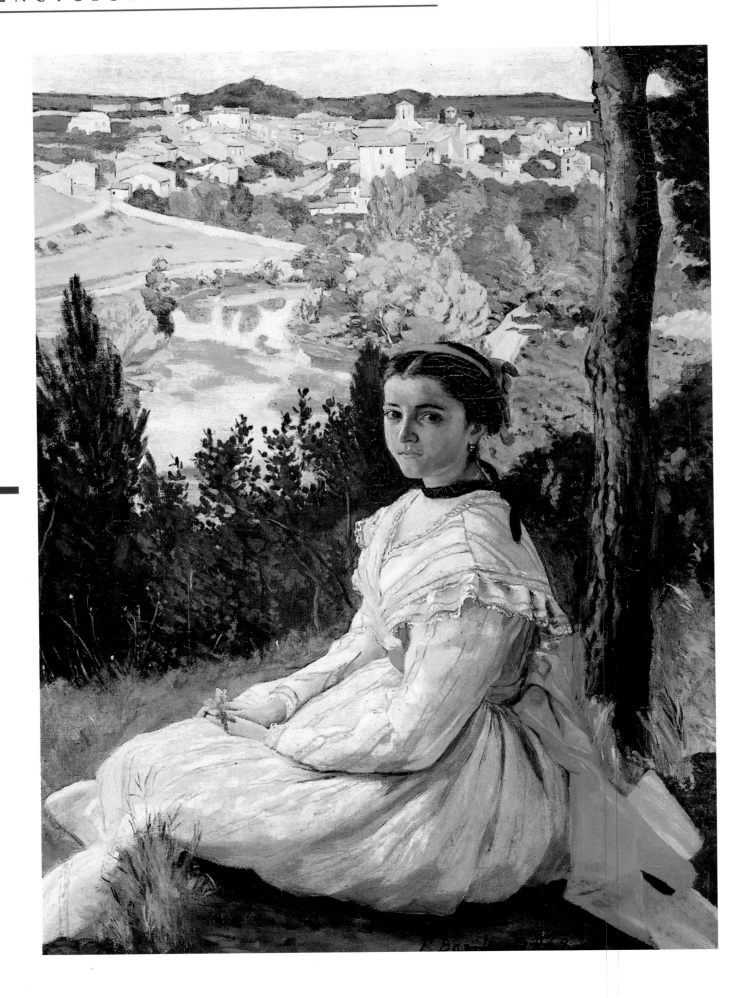

and the musician Edmond Maître. His death as a soldier in the Franco-Prussian War cut short a promising artistic career.

View of the Village
FRÉDÉRIC BAZILLE.

BEARDSLEY, AUBREY VINCENT

(Brighton, 1872–Menton, 1898)

A British illustrator and draftsman, Beardsley was a representative of Symbolist Modernism. He was self-

La Toilette
FRÉDÉRIC BAZILLE.

taught in drawing and perfected it by studying the works of Dürer, Michelangelo, and Botticelli; he was also influenced by the Pre-

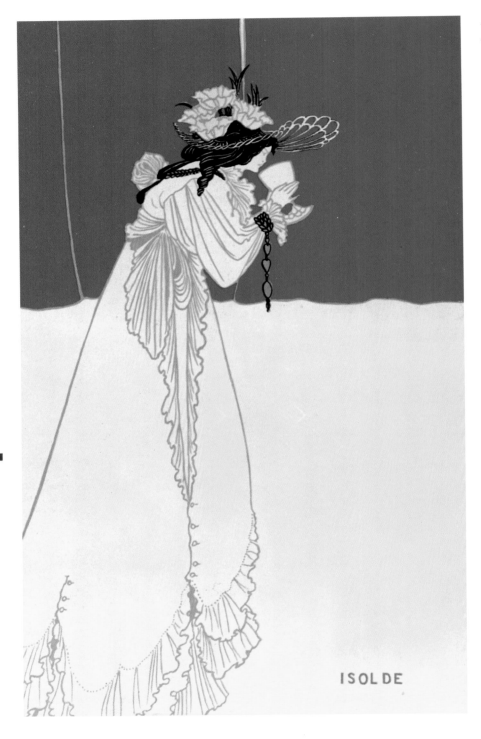

Isolde.
AUBREY VINCENT BEARDSLEY.

ISOLDE

B

Burne-Jones, can be readily observed. Also evident is the influence of Hellenistic ceramics and Japanese woodcuts, especially in his simple and daring compositions (contrasting with the rich ornamentation that he introduces in some details), with their large black and white spaces, curved lines expressing great movement, and strong contrasts between shadow and light. He primarily sought inspiration in the past and totally abandoned the conventional concept of perspective and proportion. His style, which had great impact on graphic design all over the world, places him in the end-of-the-century aestheticism movement in Europe. In addition to illustrating books—which was his most notable area of work—he was also a caricaturist for several publications, he designed posters, and he wrote prose and poetry, illustrating some of his own books himself, such as *The Story of Venus and Tannhäuser*, published in 1907. Another facet of his creative output was his position as art editor for the short-lived but influential magazine, *The Yellow Book*. Beardsley died of tuberculosis at the age of twenty-five, leaving a body of work that was created in only six years. Nonetheless, he has become known as the most important British Symbolist-Modernist illustrator in the history of art.

BENVENUTI, PIETRO

(Arezzo, 1769–Florence, 1844)

Italian Neoclassical painter. Benvenuti studied in Rome with Asmus Jacob Carstens and **Camuccini**

Raphaelites. His first commission as an illustrator, at the age of twenty-one, was to provide five hundred drawings for an edition of Malory's *Le Morte d'Arthur* (1893). The illustrations were highly successful because of their innovative and aesthetic nature. This opened the doors for further commissions: Oscar Wilde's *Salomé* (1894); *The Works of* *Edgar Allan Poe* (1894-1895); Aristophanes' *Lysistrata* (1896); Pope's *Rape of the Lock* (1896); Ben Jonson's *Volpone* (1898); and Wagner's *The Rhine Gold*. His work deals with fantastic and at times erotic subject matter, using a delicate, sensitive, and imaginative style in which the influence of the Pre-Raphaelites, especially that of

and was strongly influenced by **David**. In 1803, he was named director of the Fine Arts Academy in Florence, where he remained for almost forty years until three years before his death. His portraits stand above the rest of his work, which also included religious, historical, and mythological subject. David's influence on his historical paintings can be seen in *Oath of the Saxons*, whose composition is very close to the type used by the French painter. Of his mythological subjects, his frescoes in the Pitti Palace must be mentioned, and in the religious area, his frescoes in the Medici Chapel in Florence. Other impor-

tant works are *Marriage of Hercules and Hebe, Elisa Baciocchi and Her Court, Self-Portrait,* and *Princess Luigina Corsini-Scotto.*

BERNARD, ÉMILE

(Lille, 1868–Paris, 1941)

French painter, engraver, and illustrator, Bernrad was part ofthe Pictorial Symbolist movement and is considered the inventor of Synthesism or Cloisonnism. A friend of **Van Gogh**, he was also a pupil and a rival of **Gauguin**. Until 1886, he painted in a Post-Impressionistic style, following the scientific process

of the divisionists or the Pointillist technique. Convinced that one's technique should be dominated by one's own ideas, he destroyed all of his previous work and left Paris. He settled in Pont-Aven, in the Brittany region, where he worked with Gauguin and began to pursue a pictorial style using strong outlines framing flat color, the formula of Cloisonnism. His painting *Madeleine in the Forest of Love* is one of the most representative of his works. He directed the magazine *La renovation esthétique* and published numerous

Madeleine in the Forest of Love
ÉMILE BERNARD.

The Manzanares River
AURELIANO BERUETE MORET.

writings on Gauguin, **Cézanne,** and Van Gogh.

BERUETE MORET, AURELIANO

(Madrid, 1845–1912)

A critic and landscape painter, This artist's work is key in the evolution of Spanish landscape painting at the end of the nineteenth century. From a well-to-do family, he received his degree in Law and in 1874, began to study painting at the Academy of San Fernando in Madrid. There he was influenced by his teacher and friend, **Carlos de Haes,** who directed him toward landscapes. With this painter, he began his travels around different Spanish regions in search of panoramas and views. The environs of Madrid, the Guadarrama mountains, and the Castilian meseta shaped his works from the 1870s, causing him to create landscapes with great **realism** and with peculiar moral and ideological connotations typical of the Regenerationist movement. In 1878, he was awarded third prize at the National Exhibition for *The Banks of the Manzanares* and was invited to participate in the Universal Exposition in Paris. The Barbizon School and his friendship with **Martín Rico,** who drew him towards **Impressionism,** gave a new twist to his landscapes. Light and color became Beruete's fundamental objectives, and his work gradually received international recognition. As a critic, he displayed admirable acuteness and erudition, and his monographs on Velázquez and **Goya** are worthy of note. From 1902 on, he traveled indefatigably through several European countries, which reaffirmed his Impressionistic technique and his interest in atmospheric values: characteristics that can be observed in works such as *Toledo from the Fruit Gardens on the Outskirts of the City, The Pardo Wall,* and *Madrid from the Pradera de San Isidro.* He took advantage of his numerous trips to build up his famous collection of works of classical art.

BIERSTADT, ALBERT

(Solingen, 1830–New York, 1902)

American painter of German origin. Bierstadte studied at the Düsseldorf Academy, but his training was truly American. After traveling through Italy and Switzerland, he

settled in the United States, where, in 1860, he joined the National Academy in New York. He is considered the chief representative of the landscape painters of the American West through compositions he treated in grandiose fashion and which show great technical skill in their execution, with precise lines and brush strokes using very thinly applied paint. This technique allowed him to produce very meticulous and detailed paintings, such as *The Rocky Mountains* (1863), *The Yosemite Valley* (1866), *The Sierra Nevada in California* (1868), *St. Anthony Falls* (1880), and *On the Merced River*, among others.

BLAKE, WILLIAM

(London, 1757–1827)

English painter, draftsman, engraver, and poet, his varied and ambitious work is the result of a mystical and visionary nature, completely

Four Indians.
ALBERT BIERSTADT.

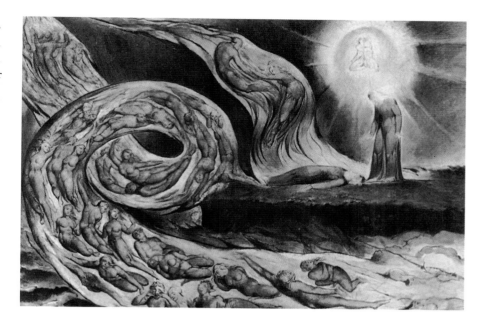

Whirlwind of Lovers.
WILLIAM BLAKE.

at odds with any religious convention. The subject matter of his work has many prophetic elements, and his style combines **Neoclassicism** and **Romanticism** in a very original way. He was from a humble family, and the mystical revelations he experienced as a child compelled his father to steer him towards drawing. Later, at the age of fifteen, he entered the workshop of an engraver, James Basire, as an apprentice and stayed for seven years until becoming a master engraver. During these first

years, he did medievally inspired drawings and illustrations, becoming interested in the Bible and in the works of Shakespeare, Dante, and Milton, as well as the paintings of Michelangelo, whose command of draftsmanship and whose monumental style influenced his later work. In 1778, he joined the Royal Academy, and made his position clear by rejecting oil painting, color, and reality, and proclaiming inspiration, enthusiasm, and draftsmanship as the the bases of art. This attitude put him in opposition to the painter Reynolds, for whom color was the basis of pictorial reality, a conflict that echoed the traditional argument over the supremacy of draftsmanship over color, and vice-versa. Blake's classicism, in this sense, had repercussions for his career, especially when he exhibited *Joseph Making Himself Known to His Brethren* in 1784, since this watercolor was rejected by academicians. Along with his illustrations and commentaries on the Bible and *The Divine Comedy*, among other texts,

B

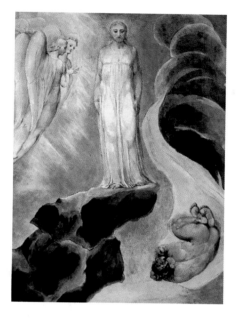

The Stoning of Abraham.
WILLIAM BLAKE.

his written work also stands out, such as *Songs of Innocence* (1789), *Marriage of Heaven and Hell* (1790), and *Songs of Experience* (1798), which are considered by some to be the height of English poetry. The conjunction of text, poems, drawings, and illustrations makes his work an innovative combination of painting and poetry, of the symbolic unity between words and images. His illustrations and watercolors are difficult to interpret because of his irrational rationalism, the symbolic nature of his world view, and because of the symbols and subjects he systematically chooses (religious, satanic, literary, or phantasmagoric). Stylistically, he rejects chiaroscuro, although his colors—he did many color impressions for his engravings—are delicate with a wealth of hues. He was a friend of the artist John Flaxman and of **Füssli**, and many aspects of his work are along the lines of **Goya**'s. Blake was an artist who did not travel, except for occasional stays on the coast, at Haley's house, his poet friend. He only worked for one patron, Thomas Butts. In 1809, he exhibited his work in London. Rejected by both critics and the public, it did not produce sales, and it was, therefore, quite a few years before his work was recognized.

BLANCHARD, PHARAMOND

(Lyon, 1805–Paris, 1873)

French painter and illustrator. Blanchard trained at the Fine Arts School in Paris with **Gros** and Chasselat. His work primarily deals with

The Third Temptation.
WILLIAM BLAKE.

popular scenes and with a few religious and historical subjects. He was a great traveler, who visited Mexico, Russia—where he did many drawings and watercolors—Africa, and Spain. While in Spain, he was entrusted with the task buying artworks for King Louis-Philippe of France. These pieces had come onto the market as the result of the disentailment of ecclesiastical property, and when sent to France, were on view from 1838 onward, providing a great influence on the artistic work of many young French painters of the time. Blanchard was also an illustrator for the "Lithographic Collection," headed by **José de Madrazo** for *La Illustration* of Paris. Of his extensive works, the following are noteworthy: *A Bullfight, The Poor at the San Bernardino Asylum, St. Isidore, Laborer, Patron of Madrid, The Disarming of Veracruz, A Street in Tangier*, and *The Departure of a Squadron of Ships for the Battle of Veracruz.*

BLECHEN, KARL EDUARD

(Cottbus, 1798–Berlin, 1840)

German artist, considered one of the greatest talents of the generation immediately following **Friedrich**'s. Blechen's work fluctu-

Rolling Mill near Eberswalde.
KARL EDUARD BLECHEN.

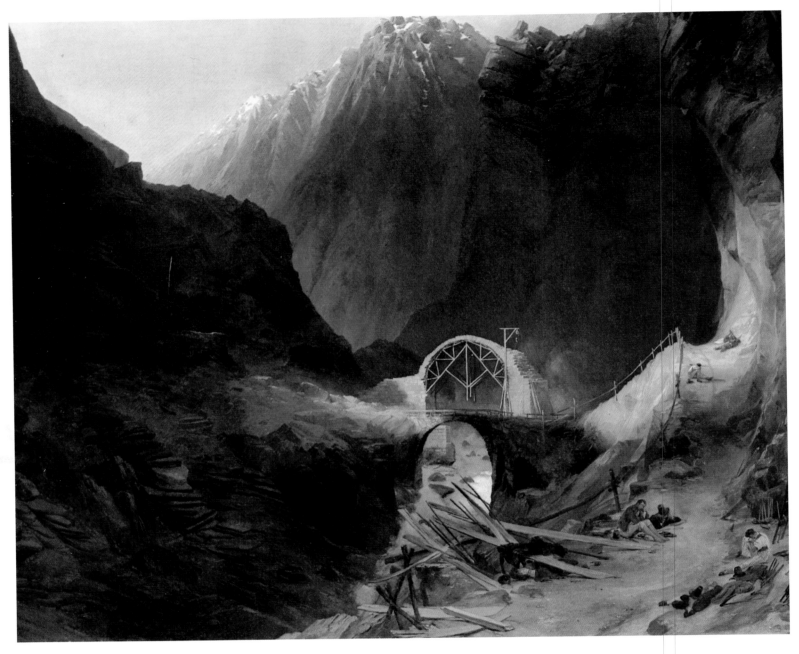

The Building of Devil's Bridge.
KARL EDUARD BLECHEN.

ates between the two opposite poles that characterized the aesthetics of the nineteenth century, **Realism** and **Romanticism**. At the age of twenty-four, he left his job at a bank and went to the Berlin Academy to study landscape painting. On a trip to Dresden in 1823, he met Friedrich, who had a decisive influence on his pictorial concept of nature. However, his work also evolved when he met Dahl, a realist painter who steered him towards "open-air" painting. This tendency was reinforced during a trip to Italy in 1828, especially when he visited Naples and other southern locations. His landscapes then fell within the framework of some aesthetic suppositions that were very close to Realism, with a tendency similar to **Corot**'s. *Monks on the Gulf of Naples* (ca. 1829) and *In the Park of the Villa d'Este* (ca. 1830) are paintings that are indicative of his progressive interest in the direct observation of nature, an objectivity supplemented by attention to the landscape's chromatic and visual phenomena, with light effects that seem to foreshadow **Impressionism**. However, he never gave up the sentiment and exaltation typical of the Romantic era, as one can see in his painting *The Building of Devil's Bridge* (ca. 1830–1833), considered to be one of the first industrial landscapes. A draftsman and excellent watercol-

orist, he was a teacher at the Berlin Academy from 1831 on, but he did not achieve commercial success as an artist. His career ended in 1835, due to depression that degenerated into a state of severe insanity in 1839. He died a year later.

BÖCKLIN, ARNOLD

(Basel, 1827–San Domenico di Fiesole, 1901)

Swiss painter, a pioneer of Symbolism and one of the most criticized and, at the same time, most admired artists, due to the imaginary

The Isle of the Dead.
ARNOLD BÖCKLIN.

and fabulous nature of his paintings. He trained at the Düsseldorf Academy with the painter Schirmer and later in Geneva and Paris. He traveled around Belgium and Holland and lived in Zurich for several years. In 1850, he went to Italy for the first time, where he was impressed by the scenery and the ancient Roman monuments, elements that he incorporated into his work. In around 1857, he went to Munich, where he achieved his first successes, especially after Ludwig I of Bavaria bought one of his paintings. After working as a art teacher in Weimar, he moved permanently to Italy, settling first in Rome and later in Florence, where he lived until his death. His paintings *The Centaur and the Nymph* and *The Elysian*

Fields are from that period and reveal his interest in mythology and allegorical themes. Death is one of his most recurrent symbols, as demonstrated by the five versions that he painted, starting in 1880, of *The Isle of the Dead*, a somber creation set in a seascape with a wealth of complex, dreamlike elements. The unsettling atmosphere that characterizes his work is also prominent in *Ruins by the Sea* (1880), *Vita somnium breve* (1888) and *At the Mercy of the Waves* (1883), paintings that reveal, despite his meticulous, academic style, his liking for a rich colors which even seem strident at times. Works such as *War* (1896) and *The Plague* (1898) are apocalyptic visions from the last period of his life.

B

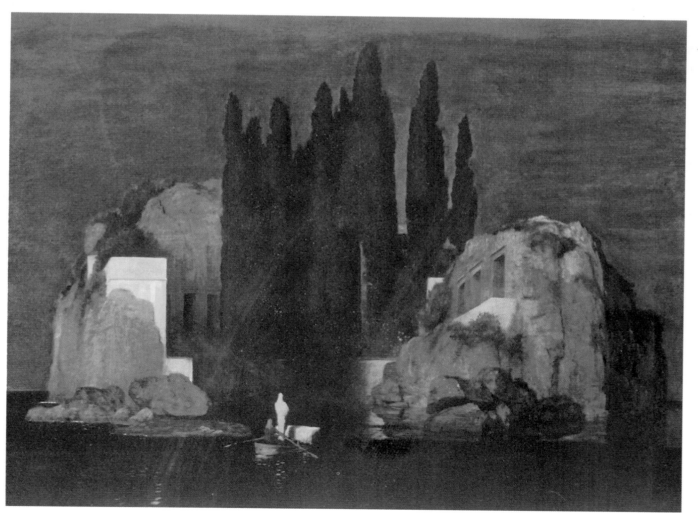

Madame Vicent.
LOUIS-LEOPOLD BOILLY.

BOILLY, LOUIS-LEOPOLD

(La Bassée, 1761–Paris, 1845)

French painter and lithographer. Boilly's work included genre painting and scenes of gallantry, according to the tastes of the period, as well as portraits, including those of Robespierre and Marat. He first painted in Arras and in 1784 moved to Paris, where his work reflected the everyday and social life of the city during the time of the Revolution and the Empire, without avoiding its darkest and most debased aspects; some examples are *Disappointments in Love* (ca. 1789) or *Improvised Concert.* They were paintings that were very successful, characterized by great formal virtuosity and clearly classicist in type, but in which he portrays happy, leisurely, and relaxed environments with objectivity and great meticulousness, the result of his attentive observations. He also achieved great popularity with his colored prints and hu-

Madame Lanthelme.
GIOVANNI BOLDINI.

morous drawings, many of them caricatures. Among his numerous works, made popular through lithographs and engravings, the most noteworthy are *Prize for Harmony* (1790), *The Triumph of Marat* (1796), *A Painter's Studio* (1800), *The Arrival of the Diligence* (1803), *The Galleries of the Palais Royal* (1804), *The March of the Recruits* (1808), *Free Admission to the Buffet* (1819), and *Distribution of Provisions in the Champs-Elysées.*

BOLDINI, GIOVANNI

(Ferrara, 1842–Paris, 1931)

Italian painter. Boldini was trained at the Fine Arts School in Florence with the **Macchiaioli** group, where he showed precocious and brilliant talent. Although some of his compositions were mundane, he specialized in portraits and became the fashionable portraitist of the era in London, the city where he lived until 1872, when he moved to Paris; there he continued to paint portraits of elegant women (such as *Madame Lanthelme*), artists, and intellectuals with great success. He struck up friendships with numerous Impressionist painters but kept free of any influence. The lines of his portraits were very dynamic, with polished composition, causing them to be extraordinarily suggestive, as shown by *Marquise Casati.* Among his most noteworthy portraits are the ones he did of Giuseppe Verdi, **Adolf von Menzel**, and **James A. M. Whistler.**

BONHEUR, ROSA

(Bordeaux, 1822–By, 1899)

French painter and sculptor, Bonheur began training with her father, the

Marquise Casati.
GIOVANNI BOLDINI.

painter Raymond Bonheur. She received public acclaim for works she exhibited at the Paris Salon in 1841. Her favorite subject was animals, although she was also inclined towards depicting rural life, where the influence of **Constant Troyon** can be noted. Of her many works, *The Horse Fair* (1853) is worthy of special mention, since it brought her fame even outside of her country and was widely reproduced in engravings, thereby becoming accessible to the public. Due to her popularity, she received the Grand Cross of the Legion of Honor, an award that until that time had been exclusively reserved for men. Part of her work is in a small museum in Fontainebleau that bears her name.

BONINGTON, RICHARD P.

(Arnold, 1801–London, 1828)

An English landscape painter, his work was a connecting point between English and French landscape

painting, and clearly foreshadowed Naturalism. The son of a drawing master, he settled with his family in the French city of Calais in 1817. There he devoted himself to what would be his great skill, watercolors. In 1818, he went to Paris and met **Eugène Delacroix**, with whom he forged a friendship that would last his entire life. He studied the masterpieces in the Louvre and made watercolor copies of the landscapes in the Flemish and Dutch schools. In 1821 and 1822, he worked with **Gros** at the Fine Arts School, and two years later exhibited at the Paris Salon, winning his first medal. Together with **John Constable**, he was the English artist who awakened the most interest and received the most recognition that year in art circles, and his importance lies in the fact that he brought watercolor landscapes to French art. In 1824, he did a series of lithographs for a port-

B

The Lagoon in Venice.
RICHARD PARKES BONINGTON.

folio on Normandy, *Picturesque and Romantic Tours of Old France* (a collection that was published from 1820 to 1878). As a result of this enterprise, he decided to make several trips, one to England and Scotland in 1825 with his friend Delacroix, and another to the north of France to paint landscapes taken from the coast and ports of Normandy. Some of his most famous works resulted from this pilgrimage, such as *At the English Coast* (1825) and *Normandy Beach Scene* (1826), watercolor and oil respectively, reflecting his interest in the atmospheric effects of light and color. The sky is, thus, an essential and main element in his landscapes, occupy-

ing a great deal of space in his compositions. He was especially interested in color, always brilliant and luminous and with a certain emphasis on chiaroscuro, a palette with fluid and delicate brush strokes that evidently come from his watercolor techniques. An example of this is *The Park at Versailles*, which, like all of his works, was painted directly from nature. In 1826, he moved on to Italy, where he saw the great works of the Venetian masters, and especially the work of Canaletto and the *vedute* painters, whose technique and colors impressed him. *St. Mark's Column in Venice* (ca. 1826–1828), one of the many views of the city that he painted, is a departure from the traditional baroque scheme of the *vedute*, reflecting not only a panorama but also partial areas. His

life was very short, since he died of tuberculosis at the age of twenty-seven. Although he did a few paintings with historical subject matter influence by Delacroix (*Henry IV and the Spanish Ambassador*, 1827), Bonington's importance to the history of painting is his naturalistic concept and technique for landscapes, which was a decisive influence on some painters of the **Barbizon School** and on later **Impressionist** figures.

BONNARD, PIERRE

(Fontenay-aux-Roses, 1867–Le Cannet, 1947)

A French painter, Bonnard was part of the group of Intimist painters known as the **Nabis**, along with

Nude with Lamp.
PIERRE BONNARD.

Paul Serusier, **Maurice Denis**, Édouard Vuillard and the sculptor Aristide Maillol. After studying law for a few years, he attended the Fine Arts School in Paris and the Julien Academy and exhibited his first paintings in 1891. Evident in these paintings was the synthesis of influences from the Impressionists and from the work of **Paul Gauguin** and **Henri de Toulouse-Lautrec**. He met Denis and formed the Nabis, which in Hebrew means "prophets." Denis valued line above all and chose subject matter somewhere between **Impressionism** and Symbolism. Their paintings are Intimist paintings, whose subjects are pleasant and easily recognizable (domestic interiors, nudes—*Nude with Lamp*—, still lifes, and a few landscapes), with flat colors but compositions with a great sense of space. From the 1890s onward, Bonnard also worked as a the-

B

31

ater set designer and book illustrator and designed posters, such as the one he did in 1894 for *Revue Blanche*, a magazine to which the Nabis were frequent contributors. Beginning in 1900, he devoted himself exclusively to painting and was one of the great innovators with color. Some of his noteworthy works are *Woman with Crossed Legs* (1919), *Nude in Bathroom* (1930), and *The Breakfast* (1930).

BONNAT, Léon

(Bayonne, 1833–Monchy-Saint-Éloi, 1922)

French painter with an Academic style within **Realism**. Initially,

Bonnat devoted his paintings to religious subjects and created paintings such as *St. Nicholas of the Country, Christ on the Cross,* and *The Martyrdom of St. Denis.* Later, around 1870, he began to paint naturalistic society portraits. Some of his subjects were outstanding figures in the fields of culture, science, and social life, such as Pasteur, Puvis de Chavannes, Victor Hugo, and others His style is clearly within the Realism of the Academics, but strongly influenced by the tenebrism of the Spanish school of the seventeenth century. He traveled to Spain, which gave him the opportunity to study the great masters of Spanish painting, especially Ribera, with the result that he began to create somber paintings with pronounced

Self-Portrait.
Léon Bonnat.

The Breakfast
Pierre Bonnard.

chiaroscuros, both in religious painting and in portraits. His precise technique in this latter genre produced paintings so realistic they were almost like photographs. He also painted historical and mythological subjects. All of the above work enabled him to amass a great deal of money, which he used to create a collection of works of art that he would bequeath to the city of Bayonne. In his studio, artists as well known and important as **Toulouse-Lautrec** and Jean Beraud were trained, among others.

BORDALO PINHEIRO, COLUMBANO

(Cacilhas, 1857–1929)

Portuguese painter belonging to the Realism movement. Initially This artist showed the influence of his father, who was also a painter, especially in the small genre paintings that he did before adopting the Realist style. This can be seen in works of his that reflect the society of the times, in which caricature is a prominent element, as in *The Dance* and *The Soirée*, both from 1880. In 1881, he made a trip to Paris, where he went to study with **Carolus-Duran**, and was able to study the masters whose work was exhibited in the city's museums. Upon his return home, he brought the new painting methods , so he is considered to be, along with José Malhoa, the artist who introduced the Naturalistic style into Portuguese painting. The Lisbon bar, El León, became a meeting place for artists concerned about the different aspects that made up

Madame Pasca.
LEÓN BONNAT.

Beach-51.
EUGÈNE BOUDIN

the new Realism movement in painting, and thus the "El León Group," whose main leaders were Bordalo and Malhoa, was born, in honor of the aforementioned locale. Bordalho painted an excellent group portrait of these painters in1885, in which each artist was psychologically characterized; this represents a clear example of the new pictorial direction, Naturalism. In his work, in which he used impasto and dull hues that enabled him to harshly express himself in his—at times—aggressive portraits, the influence of the Spanish and

Dutch painters of the seventeenth century can be seen, especially in his genre paintings and in such religious works as *Christ Crucified*, as well as in his still lifes. His importance is demonstrated by the gold medal he received at the Universal Exposition held in Paris in 1900. Other noteworthy works are *Ramal-ho Or ti Gao* (1880), *A Luva Cinzen-ta* (1881), *Invitation to Waltz, Soirée chez Lui* (1882) and *Antero de Quen-tal* (1889). He also painted theater decor, such as the work he did on the walls and ceilings of the María II Theater in 1894.

BOSBOOM, JOHANNES

(The Hague, 1817–1891)

Dutch painter specializing in frescoes who was also an outstanding landscape artist. Bosboom began his training in the atelier of painter Johannes van Hove, where he was accepted as an apprentice. His artistic progress was marked by a deep religiousness, which inspired his masterpieces. In 1836, he received a

gold medal for one of his rural scenes. During these first years, he traveled around Germany and France, recording all types of landscapes and architectural styles in drawings and studies that he used as models for his paintings. From 1851 onward, he lived in The

achieved popularity. He especially devoted himself to historical paintings, in which he exalted the figure of Napoleon, although he also did small mythological works (*Amoroni's Dance*) and portraits, which are perhaps the most interesting of all his paintings, (*Self-Portrait*). In Milan, he

ing began with a modest gallery that exhibited the landscapes of other painters from his town and from the region of Normandy. At the age of twenty-four, he met **Millet**, who inspired his vocation and encouraged him to paint in the open air. He sent his first landscapes to an institute in

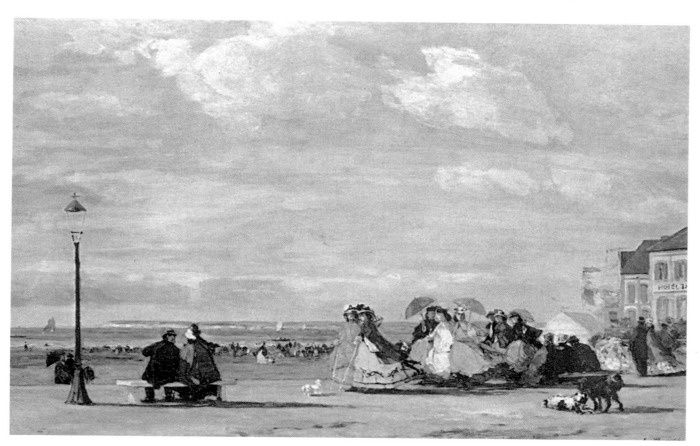

The Empress Eugénie.
Eugène Boudin

Hague, where he primarily devoted himself to painting murals.

participated in the creation of schools devoted to anatomy and ceramics.

BOSSI, Giuseppe

(Busto Arsicio, 1777–Milan, 1815)

Italian painter, poet, engraver, and author of treatises on art. He Bosi trained in Rome with Antonio Canova; at the Milan Academy with Knoller, Travessi and **Appiani**; and later, in Paris. He belonged to the Neoclassical movement, and his work, under **David**'s influence,

BOUDIN, Eugène

(Honfleur, 1824–Deauville, 1898)

A French painter, his landscape work can be considered a link between the **Barbizon School** and the Impressionist movement of which he is clearly a forerunner. The son of a navigation officer, whose ship covered the route between Honfleur and Le Havre, his association with paint-

his native town, whose town council granted him financial assistance to study in Paris. He stayed in that city for three years, where his work was focused on depicting the Seine estuary; he also specialized in seascapes and port scenes. His preferred media were pastels and watercolors, although he also used oils. The subtlety that he achieved in portraying light and skies, the true main elements of his paintings, is noteworthy. In Honfleur, he formed a group

of artists that included **Johan Barthold Jongkind** and **Claude Monet**, a painter who was highly influenced by his technique and compositions. He was praised by critic and writer Charles Baudelaire and participated in the first Impressionist exhibition in 1874. *The Port of Bordeaux, Beach near Trouville*, and *Rocks at Trouville* are representative examples of his work.

The Birth of Venus.
WILLIAM BOUGUEREAU.

BOUGUEREAU, WILLIAM

(La Rochelle, 1825–1905)

French painter belonging to the bourgeois **Realism** movement. Trained at the Fine Arts School in Paris, he was a student of Picot and is one of the most notable representatives of Academicism, a style rooted in France. His works received numerous awards, and he was named to the Academy in 1876. His preferred area of work was in painting

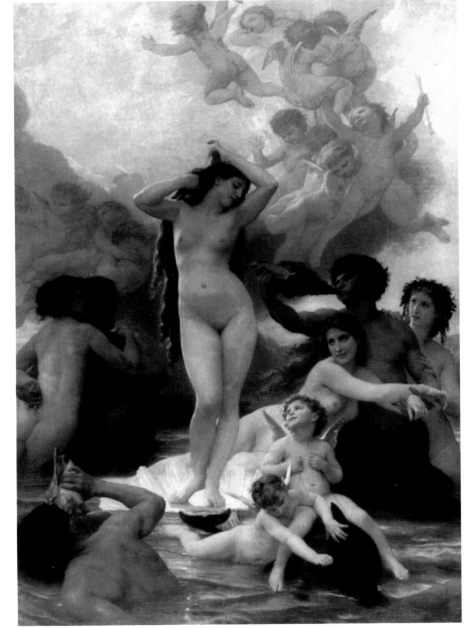

Man Sitting in a Chair.
HENRI DE BRAEKELEER.

pleasant, large-format compositions with mythological/allegorical subjects, populated by female nudes, as shown in *Youth, Love* and *The Birth of Venus*, both of which display an almost hyper-realistic style, bearing no resemblance to any modern movement. Also among the large number of works he painted, which display his brilliant brush skills, are his outstanding *Self-Portrait* and his murals, such as the ones in the St. Agustin Chapel in Paris (1866) or in the Grande Théâtre de Bordeaux. He had many disciples, such as Perrault and Pellicer. Other works that are worthy of mention are *Virgin of Consolation* (1877), *Napoleon III Visiting the Flood Victims of Tarascon, The Return of Tobias, Oreads,* and *Regina Angelorum.*

BRAEKELEER, HENRI DE

(Antwerp, 1840–1888)

Belgian painter, deeply influenced by the Dutch school of the seventeenth century, who worked in a very personal Realistic style. The son of Ferdinand de Braekeleer—a painter of portraits and historical subjects—he trained with his father and his uncle **Henri Leys** from a very early age. A trip to Holland and Germany exposed him to the German and Flemish primitive masterpieces and to the Dutch painters of the seventeenth century. His first exhibit was in the city of his birth in 1861, where he showed works such as *The Laundress*, a composition that reflects meticulous **Realism** in an Intimist atmosphere. Other examples are *Catechism Lesson*

The Mother.
GEORGE-HENDRIK BREITNER.

(1872) and *The Schoolmaster*. He received awards at international exhibitions, and in the latter years of his life was influenced by **Manet** and by the Impressionists. He died at the age of forty-eight, while committed to a psychiatric hospital.

BREITNER, GEORGE-HENDRIK

(Rotterdam, 1857–Amsterdam, 1923)

Dutch painter, whose work is included in the Realist painting style that evolved towards **Impressionism**. After studying at the Academy in The Hague, and later at the one in Delft, he saw **Maris'** work. He went to Paris in the 1880s, where upon discovering the style of **Manet**, he became an unconditional admirer. However, he devoted himself to painting urban scenes, capturing their own unique personality. His style reflects aspects that are typical of the painting of the Dutch school of the seventeenth century, especially that of Hals and Rembrandt. A great many of his paintings are city scenes, views of Amsterdam, such as *Amsterdam Canal*, and subjects with a certain amount of social content, such as *Workers Leaving*.

BRETT, JOHN

(Bletchingley, 1830–Putney, 1902)

An English painter, he was one of the first and most notable followers of the **Pre-Raphaelites**. His first

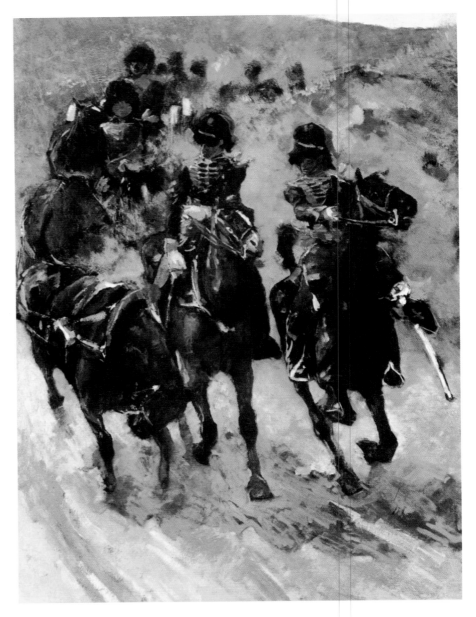

Mounted Artillery.
GEORGE-HENDRIK BREITNER.

works were also influenced by **John Ruskin**, and some were of very high quality and done in a realistic style with great virtuosity and meticulous detail. They were also very poetic, but that aspect disappeared in his later work, which while still showing meticulous **Realism** was somewhat prosaic. From 1870 onward, his favorite subject for landscapes was the southern coast of England, where he painted works with great luminosity and an agile style. He participated in the Pre-Raphaelite exhibition of 1856. Among his noteworthy works are *The Stonebreaker* (1857–1858), a subject also painted by **Abbati** and

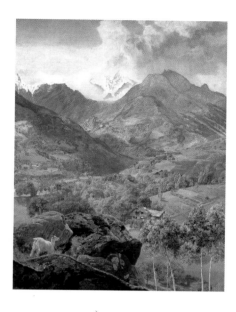

Val d'Aosta.
JOHN BRETT.

Courbet, whose realism is so pronounced as to be hyper-realistic; *Val d'Aosta* and *Britannia's Realm* (1880).

BRIULLOV, KARL PAVLOVICH

(St. Petersburg, 1799–Rome, 1852)

Russian painter belonging to the Romantic **Neoclassical** movement. Briullov is one of the most outstanding Russian painters, and throughout his life, he was elected to different academies in recognition of

The Last Day of Pompeii.
KARL P. BRIULLOV.

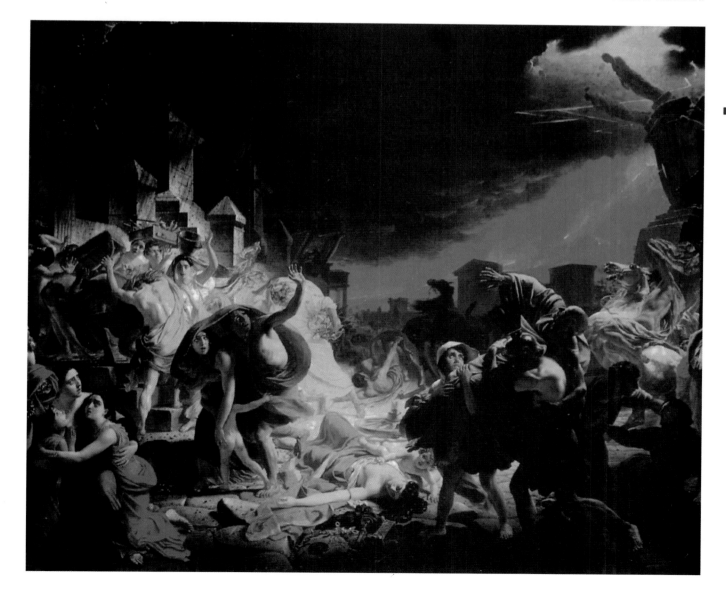

B

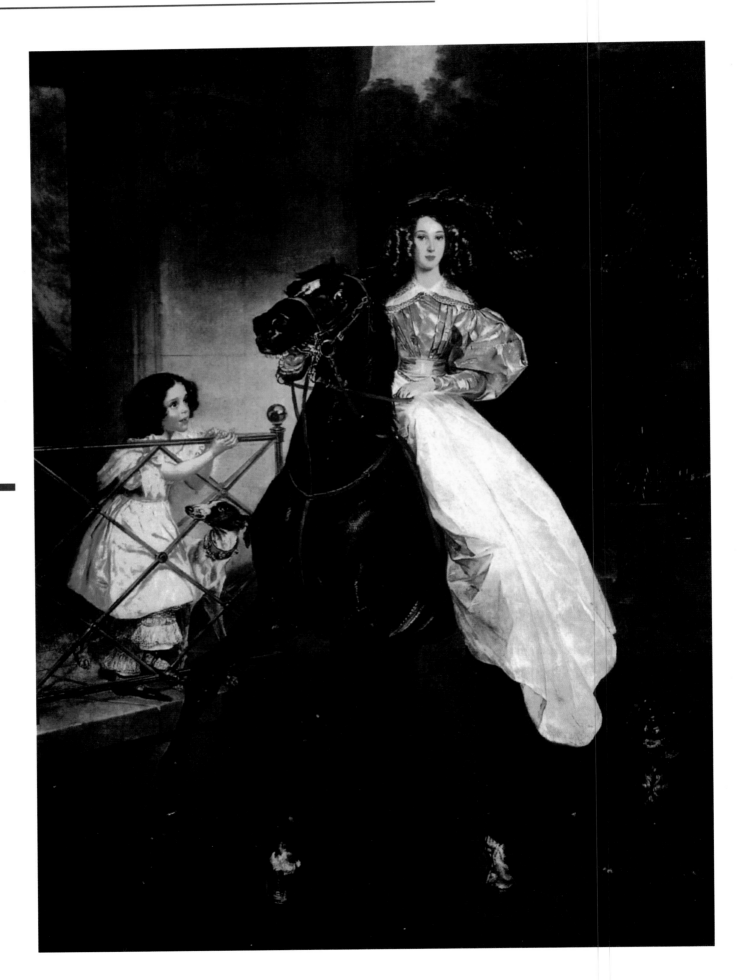

Self-Portrait.
KARL P. BRIULLOV.

Portrait of Nikolai Kukolnik.
KARL P. BRIULLOV.

his work. He did his apprenticeship at the St. Petersburg Academy with **Andrei Ivanov** and **Alexei Egorov** and continued his training in Rome and Naples under scholarship. There he painted his most important work in the historical genre, *The Last Day of Pompeii* (1830–1833). This painting is completely **Romantic** and one of the most representative of that movement, both because of its subject matter—nature unleashed and man at its mercy, bound by des-tiny—and its composition, which reflects the very instant of the city's collapse and its tragedy, giving the painting that dramatic and violent sensation typical of Romantic scenes. Likewise, the light in this painting is very theatrical and strives for effect, making it indisputably Romantic. Briullov also painted murals, such as those in the St. Isaac Cathedral, as well as genre paintings and noteworthy, elegant portraits of aristocrats and intellectuals, such as *Countess Samoilova, The Horseman,* and *Princess Saltikova,* and others of a more Intimist nature in which soli-

The Rider.
KARL P. BRIULLOV.

Italian Midday.
KARL P. BRIULLOV.

tude and a dreamy air are the main elements, such as *A. N. Strugovchikov* (1840) and his *Self-Portrait* (1848). He was also an excellent watercolorist, as was his brother Alexander Briullov.

BRODOWSKI, ANTONI

(Warsaw, 1784–1832)

Polish painter. Brodowski studied in Paris beginning in 1809, under the tutelage of **François Gerard**,

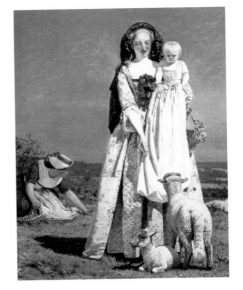

The Pretty Baa-Lambs.
FORD MADOX BROWN.

and upon returning to his own country, was named a professor and subsequently introduced the Classicism he had learned in France. He devoted himself to portraits and to historical paintings. In 1819, he put on an exhibition which made his work known. He is considered the most important Polish artist of his time.

BROWN, FORD MADOX

(Calais, 1821–London, 1893)

Eminent English painter of the second half of the nineteenth century; although he never became fully integrated into the Pre-Raphaelite group, he is linked to them. He was born in France, in the city of Calais, and at the age of fourteen, wsa taken by his father to the Bruges Academy to study art. Later, he completed his artistic training at the Antwerp Academy. In 1840, he settled in Paris, where he studied drawing and copied the Old Masters in the Louvre. In 1845, he traveled to Rome, stopping in Basel on the way, where he discovered the painter Hans Holbein, whose brilliant colors influenced his work. In the Italian capital, he came into contact with the German **Nazarenes**, especially with **Johann Friedrich Overbeck** and **Peter von Cornelius**, whose spiritual ideals regarding art had an impact on Brown's aesthetic thinking. One year later, in 1846, he went to England and settled in London. There he painted two of his most im-

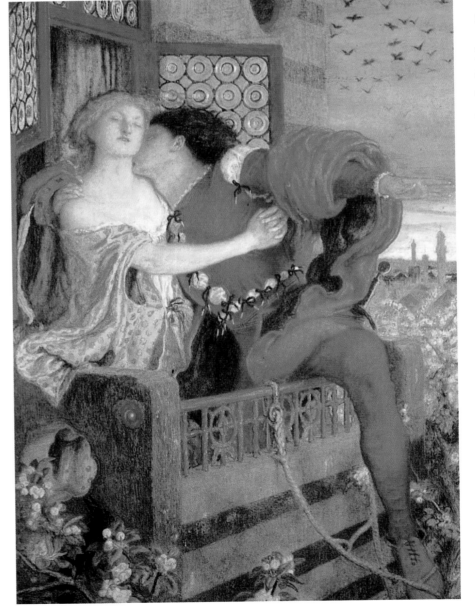

Romeo and Juliet.
FORD MADOX BROWN.

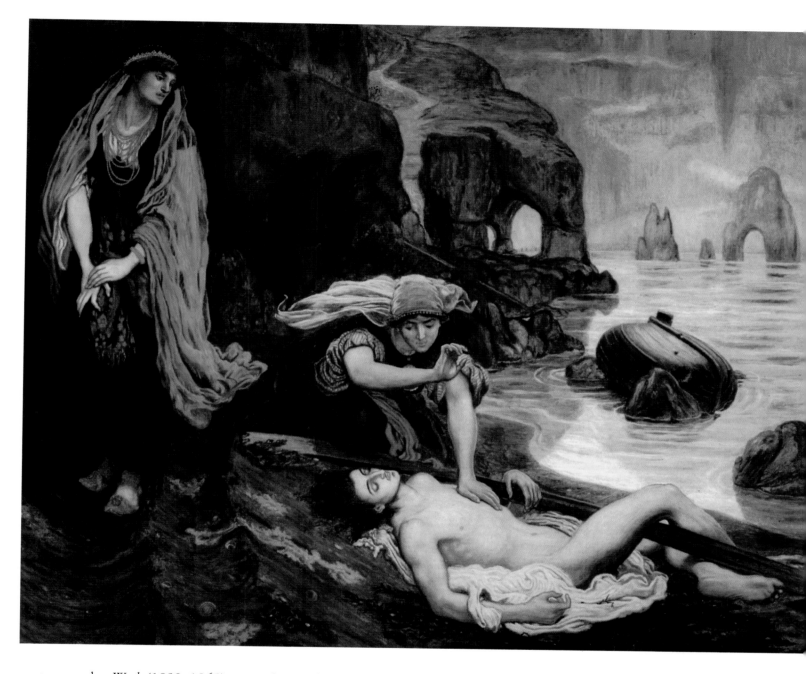

The Finding of Don Juan by Haidee.
FORD MADOX BROWN.

portant works: *Work* (1852–1865), an acidic and critical allusion to Victorian society, and *The Last of England* (1852–1856), calling attention to the unemployment and massive emigration that took place in England in the second half of the nineteenth century. His pictorial denunciation of harsh social injustice and his anti-academic attitude earned him a poor reputation, and he, therefore, received scant recognition and was held in so little regard by his contemporaries, that he never showed his work

at the London Academy. Nevertheless, he was closely related to such Pre-Raphaelites as **Hunt**, **Burne-Jones**, and **Rossetti**. The latter influenced him at the beginning of the 1860s, by giving him a new direction in his style and subject matter. As a result, he preferred to devote himself to romantic, historical, medieval, and sentimental subjects taken from the literature that was in vogue at the time, particularly the works of Sir Walter Scott and Lord Byron. He alternated painting with

book illustrations and designs for furniture and stained glass windows. In 1881, he received a commission to produce twelve large frescoes for the Manchester Town Hall, a work he finished in 1887 and which illustrated some of the city's historic events. Among his works, mention should be made of *Chaucer at the Court of Edward III* (1845–1851) and *An English Autumn Afternoon* (1852–1854).

BRUNI, FEDOR A.

(Milan, 1799–St. Petersburg, 1875)

A Russian painter of Italian origin, Bruni was trained at the St. Petersburg Academy, where he was influenced by **Egorov** and **Ivanov**. In 1818, he went to Italy to study and remained there for a long time. In his work, he preferred historical subjects dealing with Biblical and mythological themes with a clearly Romantic slant, full of mystery and mysticism. He portrayed action as unpredictable and full of impulsiveness, distancing himself from the Neoclassical ideal in which balanced composition and action understandable to everyone prevailed; this is evident in *The Death of Camille, Horace's Sister* (1824) and *The Bronze Serpent* (1841). He also did decorative work for cathedrals in St. Petersburg and Moscow.

The Death of Camille, Horace's Sister (detail).
FEDOR A. BRUNI.

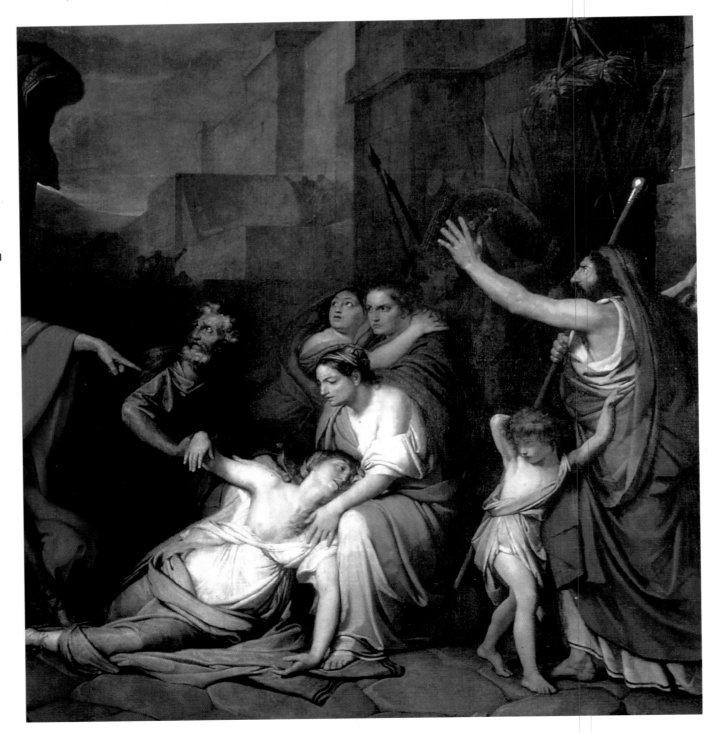

B

BURNE-JONES, Edward Coley

(Birmingham, 1833–London, 1898)

Pre-Raphaelite English painter, whose work was inspired by mythological/allegorical themes and historical legends. The son of a gilder and wood carver, he began to study theology under scholarship to Oxford University. There he met **William Morris**, who became a lifelong friend and whose ideas filled him with enthusiasm and inclined him towards art, causing him to leave his university studies. In 1855, he entered the studio of an artist he admired, **Dante Gabriel Rossetti**, with whom he founded the Pre-Raphaelite Brotherhood along with Morris and **Hunt**. Burne-Jones' extensive and varied work was born of this association: work that investigates the possibilities of craftsmanship, an activity he knew very well because of his father's profession and which he would master in sketches, drawings, illustrations, and above all, designs for interior decoration, carpets, tapestries, wallpaper, ceramic tiles, and furniture. His work with stained glass was outstanding, and in 1857, he created a series of stained-glass windows with classical themes for St. Andrew's School in Bradfield. The high quality of his work brought a new commission for stained-glass windows that he worked on with William Morris. In 1859, he traveled to Italy and lived for a time in Milan and Venice with the English painter **John Ruskin**, his devoted friend, studying the Renaissance painters he venerated. The influence of Italian art is evident in his pictorial work, such as *The Mirror of Venus* and *The Golden Stairs*. His interest in mythological subjects can be seen in the series of tempera paintings about the mythical Perseus for which he received a commission in 1875 from a British prime minister. *King Cophetua and the Beggar Maid,* from 1884, is one of his masterpieces. Inspired by a ballad by the contemporary poet, Alfred Tennyson, it is set in a medieval interior, a setting that was very popular at the time. The painting was taken to the Paris Exposition of 1889, where it achieved great success and made him famous in official circles. In 1890, he was elected to the Royal Academy, and four years later was made a baronet. For some historians, his craftsmanship was the forerunner of Modernism, and his pictorial series captured Richard Wagner's musical dramas in visual form.

Atlas Turned to Stone.
Edward Coley Burne-Jones.

B

CABANEL, ALEXANDRE

(Montpellier, 1823–Paris, 1899)

French painter. Cabanel studied at the Fine Arts School in Paris and is the most representative of the French academic painters of the time. He was an exponent of the *pompier* ("conventional") style, along with **Bourguereau**, with whom he also directed the annual Salons which excluded the Impressionist painters. He was Napoleon III's favorite painter, and his fame brought him membership in most academies. His work was centered mainly on portraits, abiding by the principles of Academicism that were so beloved by Parisian society, and was especially adept at painting portraits of women, such as *Countess Keller* (1889). However, allegory was also an important subject for him, leading to such works as *Allegory of the Five Senses* (1858) and *Allegory of the Hours* (1864), as was historical painting (*Phaedra*, 1880). His style is characterized by its technical perfection, careful draftsmanship and finishing, coloring—which is brilliant at times—and by the sentimentality and tenderness that are evident in his paintings. His best-known piece is *The Birth of Venus* (1863) which is reminiscent of **Ingres** in its perfection and careful draftsmanship, Morover, it shows his skill in posing female nudes in a suggestive and seductive manner. It was very highly praised at that year's Salon and was immediately acquired by Napoleon III.

CAILLEBOTTE, GUSTAVE

(Paris, 1848–Gennevilliers, 1894)

French painter, grounded in **Realism**. Caillebotte's work gradually adopted impressionistic subjects, and he became one of the most important collectors of Impressionist paintings. After the Franco-Prussian War, he left his law studies, which his father had forced him to begin, in order to devote himself to painting. He entered the atelier of the Academic painter **Léon Bonnat**, where he achieved a virtuoso technique, using a great deal of color while striving for **Corot**'s realism. When his paintings were rejected at the 1875 Salon, he decided to exhibit with the Impressionists in 1876. As he was interested in the work of these painters, he became one of their great patrons, buying numerous paintings until he had accumulat-

The Orange Trees.
GUSTAVE CAILLEBOTTE.

The Birth of Venus.
ALEXANDRE CABANEL.

C

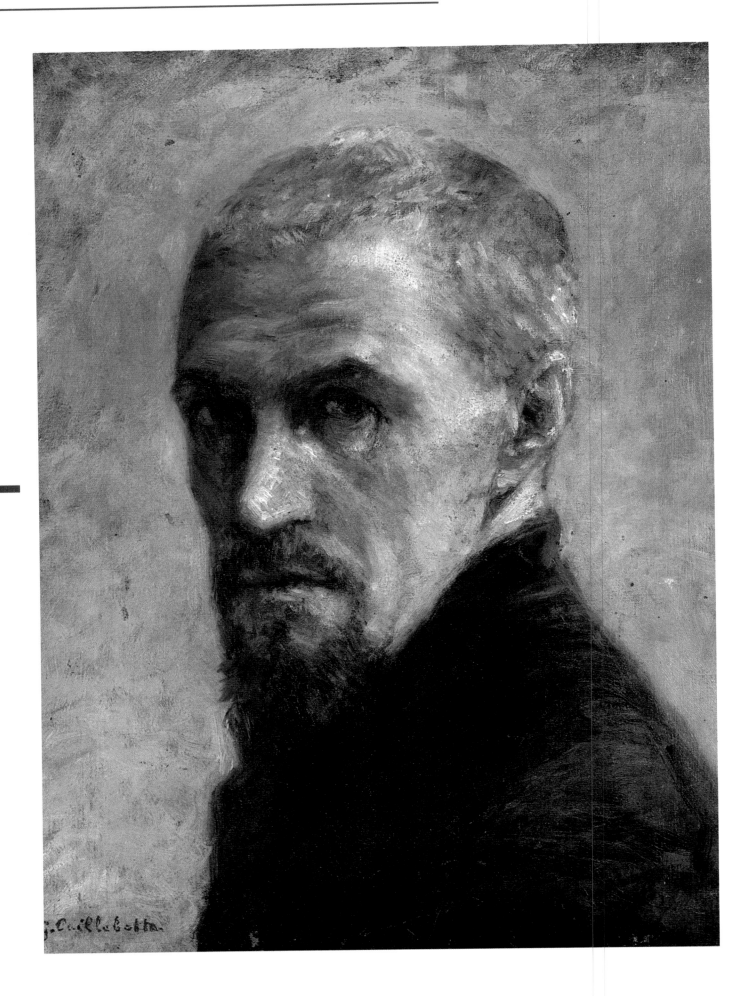

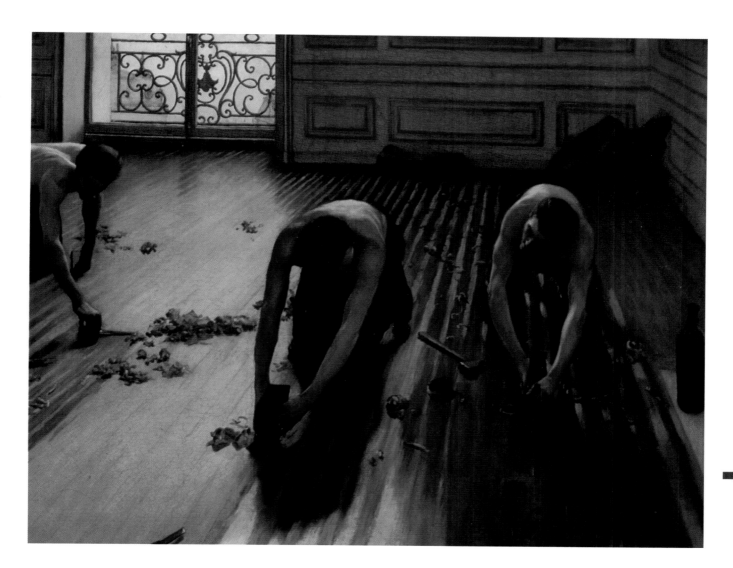

The Floor-Scrapers.
GUSTAVE CAILLEBOTTE.

ed a major collection, which he bequeathed to the French government in 1883. Landscapes, seascapes, and regattas are prominent in his work, but even more so are the scenes of the urban life of Paris, such as *Le pont de l'Europe* (1877), *Paris Street: Rainy Day* (1877), and *In a Café* (1880).

CALLCOTT, SIR AUGUSTUS WALL

(Kensington, 1779–1844)

English painter. After studying music, Calcott decided to devote

Self-Portrait.
GUSTAVE CAILLEBOTTE.

himself to painting and began lessons with John Hoppner. He soon proved to be a great landscape artist, whose works, depicting natural settings in Holland, Spain, and Belgium, were greatly acclaimed and made him England's best-known landscape artist of the time. His style gradually lost the spontaneity and freshness of his early works and finally became Italianized and slightly reminiscent of **Turner**. He has sometimes been called the "English Claude," because his style evokes that of Claude Lorrain and **Richard Parkes Bonington**. In 1806, he was elected associate of the Royal Academy in London, and because of his fame, was knighted in 1837;

in 1844, he succeeded Segnier as Keeper of the Royal Collection. Among his works, *Raphael and His Fornarina* (1837) should be mentioned as noteworthy.

CAMUCCINI, VINCENZO

(Rome, 1771–1844)

Italian painter, chief official representative of Roman **Neoclassicism**, in the spirit of Mengs, which is evident above all in his portraits. Camuccini initially studied painting with Domenico Corvi and Pompeio

Batoni, and later, with **David**. Portraits were his specialty (*Portrait of Pope Pius VII*), along with his historical paintings (*Archelaos Giving Paris Custody of Hecuba*, 1790). The choice of colors is somewhat poor, and the paintings themselves are extremely cold, perhaps due to his excessive perfectionism which causes them to lose freshness. However, the best feature of his artistic work is his powerful draftsmanship which is combined with marked contrasts in shading. In 1797, he painted *Caesar's Death*, which was well received by critics and which helped him to obtain the posts of Inspector-General of the Papal Museums and Director of the Academia Napolitana in Rome.

C

CARNOVALI, GIOVANNI

(Montegrino, 1804–Cremona, 1873)

Italian painter, also known as Il Piccio ("The Little One"), a nickname he received as a child from his patron, Count Spini. Carnovali's work can be classified as part of the first Italian Romantic Classicist movement. From an early age, he showed a great talent for painting, with a style and an innovative sketching technique that he applied to the small paintings he did on Biblical and mythological themes. Some of his works, especially the nudes, such as *The Bather* and *Young Ladies Bathing* (1868), show *sfumato* ("shading") and a highly luminous transparency. Some of his landscapes are treated in a Romantic fashion, with patches of color and thick brush strokes. In contrast to

Lady with a Glove.
CAROLUS-DURAND (DURAND, CHARLES-AUGUSTE-ÉMILE).

this, his work contains elements that evoke the Baroque painting of the Bolognese school of the seventeenth century and the Venetians of the eighteenth. His portraits are considered his best work, including *Gina Caccia* and *Benedetta Carminati*.

The Bather.
GIOVANNI CARNOVALI.

CAROLUS-DURAND
(DURAND, CHARLES- AUGUSTE- ÉMILE)

(Lille, 1837–Paris, 1917)

French painter. Carolus-Durand studied at the Swiss Academy in Paris and traveled to Spain to continue his training, where he was able to study the works of the great Spanish masters. He also traveled to Italy, visiting Venice and Rome. Following his studies, he achieved great fame in portraiture, an area of art which he pursued from 1869 onward and in which he showed great skill and elegance. In his portraits, the influence he received from the Spanish painters of the seventeenth century—Velázquez in particular—can clearly been seen, with figures that are outlined to stand out from neutral backgrounds, such as in *Lady with a Glove* (1869), which, was one the first to bring him fame. An academic painter, he was one of the chief representatives of the Realist style. He was greatly influenced by **Courbet**, especially in his early works, employing a meticulous technique that takes realism to an extreme. Some of his notable works include *The Assassination* (1866) and *The Triumph of Marie de Medici* (1878). He is best known as the teacher of many famous painters. In 1905, he assumed the position of director of the Académie de France in Rome.

CARRIÈRE, EUGÈNE

(Gournay, 1849–Paris, 1906)

French painter and engraver, whose gentle, sweet portraits and family scenes show great sensitivity and are enshrouded in an ethereal and shad-

Lady Leaning Her Elbows on a Table.
EUGÈNE CARRIÈRE.

owy atmosphere which is very characteristic of his style. He began his artistic training at the Fine Arts School in Paris, and first saw **Turner**'s work during a trip to London. He was taken prisoner during the Franco-Prussian war of 1870 and was sent to Germany, where he devoted himself to studying the works of Rubens, from whom he learned the exaltation of color. Among his works, the most noteworthy ones are *Maternity* (1879) and *The Family*, which is one of the paintings that best reflects his evanescent and visionary style with figures in half-light. He painted some of the most interesting members of the Parisian intellectual scene of the times, such as Verlaine and **Gauguin**. He was also involoved in painting decorative pieces for the interiors of the Sorbonne and the Paris Town Hall.

CASADO DEL ALISAL, José

(Villada, Palencia, 1832–Madrid, 1886)

Trained at the San Fernando Fine Arts Academy in Madrid and a pupil of **Federico de Madrazo**, he was one of the most prominent nineteenth-century Spanish specialists in historical painting. In 1855, a fellowship allowed him to pursue his studies in Rome, training which he completed in Paris beginning in 1861 when his financial assistance was extended. Thus, he belonged to the first generation of Spanish painters trained in Paris. Casado del Alisal received several medals in national exhibitions: in 1860, for his painting *The Last Moments of Ferdinand IV, "El Emplazado,"* and in 1864, for *The Surrender of Bailén*, his best-known work, inspired by Velázquez' *The Lances*. It is also the one that is most representative of his cold and calculating technique which sought to reconcile Academic and Romantic ideals. Aware of **Meissonier**'s commercial success, he also practiced genre and portrait painting, especially high-society

6

Surrender of Bailén.
JOSÉ CASADO DEL ALISAL.

C

portraits (Isabella II, Alphonso XII, Espartero, Castelar, and the well-known *Portrait of a French Lady*). His participation in different European exhibitions earned him several awards, such as the medal of honor in Munich in 1883 for *The Monk King*. In addition to receiving international recognition and critical acclaim, his prestige grew in the offi-

cial circles of Madrid. He held a professorship at the Academy of San Fernando in Madrid; from 1873 to 1881, he held the position of director of the Spanish Academy in Rome; and in 1885, was named a member of the Academy of San Fernando. Other important historical paintings are *The Bell at Huesca* and *Taking the Oath in the Cortes of Cádiz*.

CASAS I CARBÓ, Ramón

(Barcelona, 1866–1932)

An illustrator, poster artist, and draftsman, he is one of the most representative painters of Catalan **Modernism**. His artistic training began in 1877, when at the age of eleven, he entered the Lonja Fine Arts School in

In the Open Air.
RAMÓN CASAS I CARBÓ.

Self-Portrait Dressed as a Bullfighter. He returned to Spain in 1884 and settled in Madrid so that he could copy the great masters in the Prado Museum. From 1889 onward, he was known as an innovative painter with modernist tendencies. However, his exhibition at the Parés Gallery in Barcelona did not win critical praise, and his work was accused of being trivial. He returned to the French capital in January 1890, and there joined **Santiago Rusiñol** and Maurice Utrillo, with whom he participated intensely in the Bohemian life of the times. His new friendships with French artists led him to emulate the dominant artistic trend: paintings of urban scenes, such as *In the Open Air* or *Dance at the Moulin de la Galette*. These scenes which were also disseminated through posters, illustrations, and drawings which he executed with confident and convincing lines. In 1894, he established his residence in Barcelona and became part of one of the most active Bohemian groups in the city. This group was centered around the Quatre Gats bar, whose name would also be given to the magazine in which Casas participated as an advertising artist. One of

Barcelona. At fifteen, he moved to Paris, where he encountered other Catalan artists but never became a part of French artistic circles. However, he attended **Carolus-Duran**'s atelier, and two years later, was admitted to the Paris Salon with his

his best-known works, *The Vile Garrote*, is a result of the social upheaval that was violently disturbing the city. Another example of socially conscious art is *The Charge*, a work that received first prize at the National Exhibition in 1904. From that time on, he made frequent trips to Paris and sporadically to Madrid, where he painted the equestrian portrait of Alphonso XIII. In the field of portrait painting, he showed good aptitude and an innovative style, departing from the genre's traditional conventions, as ssen in *Portrait of Eric Satie*. This painting served as a vehicle for making his work known in the United States, a country he visited from time to time, beginning in 1908, to undertake

commissions to paint portraits of important figures.

CASSATT, MARY

(Pittsburgh, 1845–Beaufresne, 1926)

American painter living in France. A friend and artistic colleague of

6

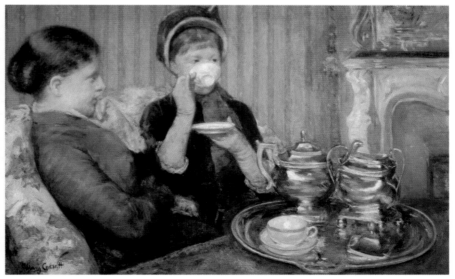

Tea.
MARY CASSAT.

Mother Bathing Her Child.
MARY CASSAT.

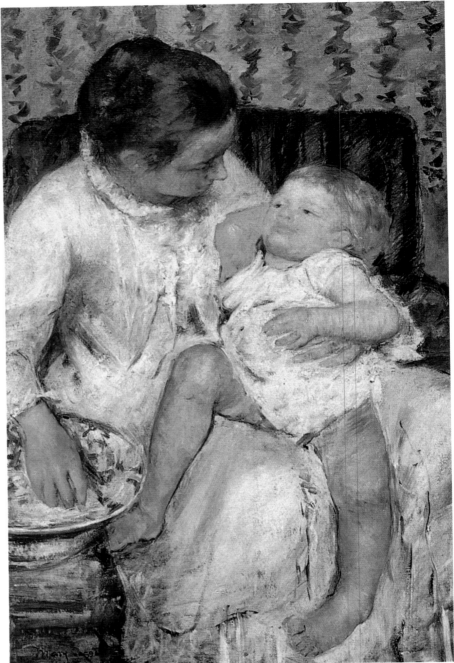

Berthe Morissot, Cassatt's work was an important factor in making **Impressionism** known in the United States. A tireless traveler, she went all over Europe, including Spain, studying the work of great masters like Rubens. However, it was the discovery of **Corot**'s work, and especially his painting *Burial at Ornans*, which was then at the Louvre, that caused her awakening to Naturalism and her zeal for *plein air* (open air) painting. She studied with **Edgar Degas** and with **Edouard Manet** which led her to Impressionism in 1877; she exhibited with Impressionist artists between 1879 and 1886. Her work showed great delicacy and encompassed all techniques, demonstrating similar levels of mastery in pastels, engravings, and oils. Her favorite subjects concerned maternity, family scenes, and children. Prominent among her paintings are *Mother Bathing Her Child* (1880), *Tea* (1880), and *Girl Arranging Her Hair* (1886).

Buffalo Bull.
GEORGE CATLIN.

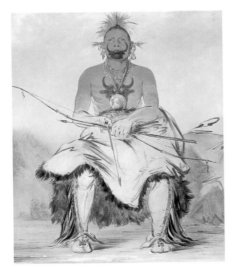

CATLIN, GEORGE

(Wilkes-Barre, 1796–Jersey City, 1872)

American painter. Catlin started out as a portraitist, although his fame is based on the drawings, watercolors, and designs he did of Native American culture. From 1824 onward, he was a member of the Pennsylvania Academy of Fine Arts in Philadelphia, the city in which he lived. In 1837, he organized an expedition to the western territories of North America to visit the native tribes. There he lived for nearly ten years and did more than three hundred portraits and two hundred paintings documenting Indian life, manners, and customs. His work is a clear testimony to this society and has been

Girl Arranging Her Hair.
MARY CASSAT.

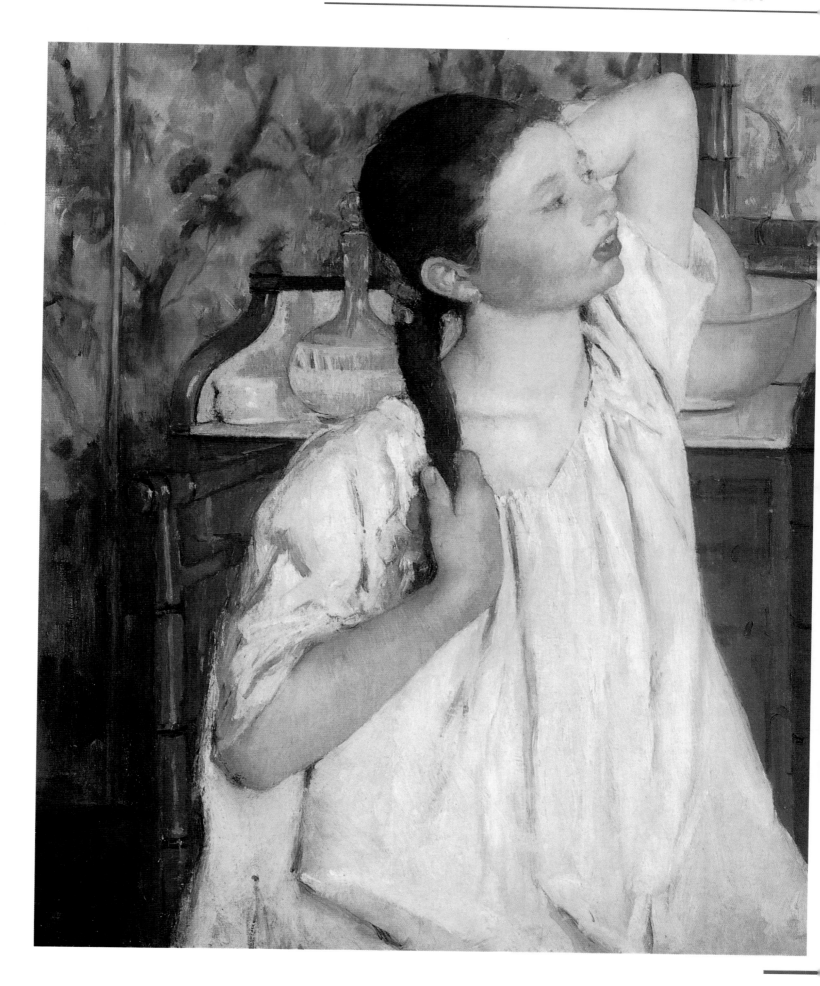

C

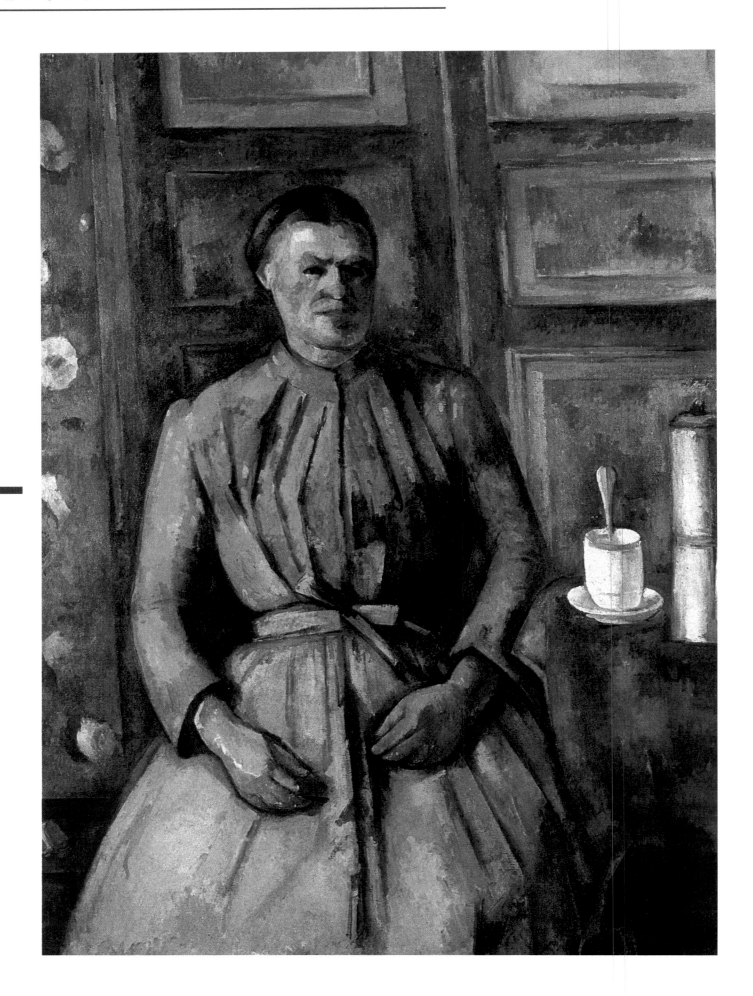

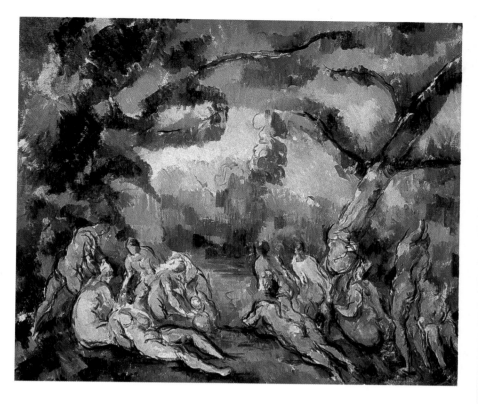

Bathers.
PAUL CÉZANNE.

compared to the writings of the author James Fenimore Cooper, although Catlin shunned literary fantasies to offer accurate and exceptional documentation for ethnographic study.

CLAVÉ I ROQUER, PELEGRÍN

(Barcelona, 1811–1880)

Spanish painter. Trained at the Fine Arts School in Barcelona, his work was spiritual and medieval in appearance, representative of the **Nazarene** style which was typical of several Catalan painters who were influenced by the German Nazarenes based in Rome. Clavé moved to that city in 1834 with a scholarship from the Barcelona Board of Trade and met **Johann Friedrich Overbeck**, the leader of the Nazarene circle. He freed himself from Neoclassical strictness after becoming interested in the Italian primitives and the work of Raphael, as reflected in his paintings, *The Parable of the Good Samaritan* and *Elias' Dream*. In 1845, he traveled to Mexico to reorganize his painting studies and while there, became director of the San Carlos Fine Arts Academy. His work branched out to include portraits of the Mexican ruling class, local landscapes, and some paintings on historical subjects. In 1868, after being dismissed from his position, he returned to Barcelona, where he lived until his death.

CÉZANNE, PAUL

(Aix-en-Provence, 1839–1906)

French painter. Paul Cézanne belonged to the same generation as the

Woman with Coffee Pot.
PAUL CÉZANNE.

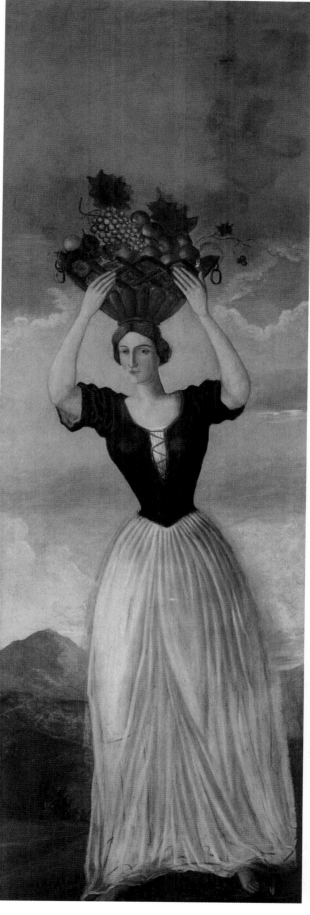

The Four Seasons.
PAUL CÉZANNE.

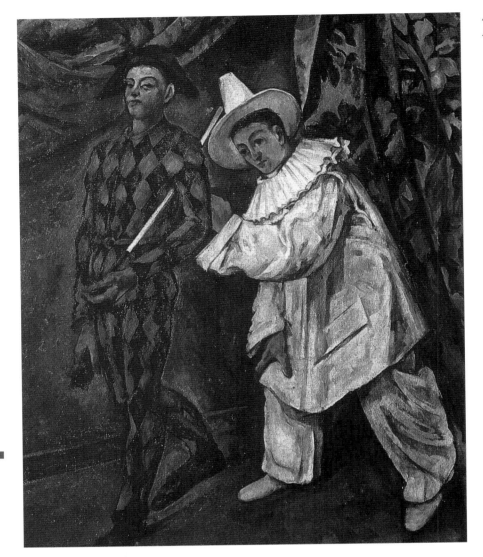

Mardi Gras.
PAUL CÉZANNE.

Impressionists, but his work showed different concerns and a type of experimentation that made him the immediate forerunner of the "-isms" and vanguards of the twentieth century, especially Cubism. The son of an affluent banker of Italian origin, he received solid academic training at Bourbon College in the city of his birth. He was a classmate of Émile Zola, and he and the famous writer would be close friends until they definitively broke off their relationship in 1886. He managed to convince his father of his vocation as a painter and left his law studies in 1860, moving to Paris to study at the Swiss Academy, from which he was later expelled. He was not successful in being accepted at the Fine Arts School and returned to Aix to take a position at his father's bank, a job he quit in 1862. His return to Paris allowed him to form good friendships with Impressionist painters like **Bazille**, **Renoir**, **Sisley**, and **Monet**, as well as to have the opportunity to admire the masters in the Louvre. In the mid 1860s, his paintings already reflected his spirituality and his esthetic interests: more than painting, he sculpted his work, using a palette knife and heavy impasto. His technique was not understood, and in 1866 he was rejected at the Paris Salon, a unanimous and systematic rejection that prevented him from exhibiting and making his work known. The Franco-Prussian War led him to settle in the French Midi, first near Marseilles and, between 1873 and 1874, in Au-

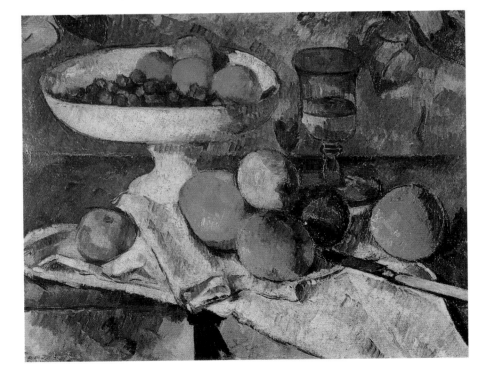

Still Life with Compote.
PAUL CÉZANNE.

In the Park at Château-Noir.
PAUL CÉZANNE.

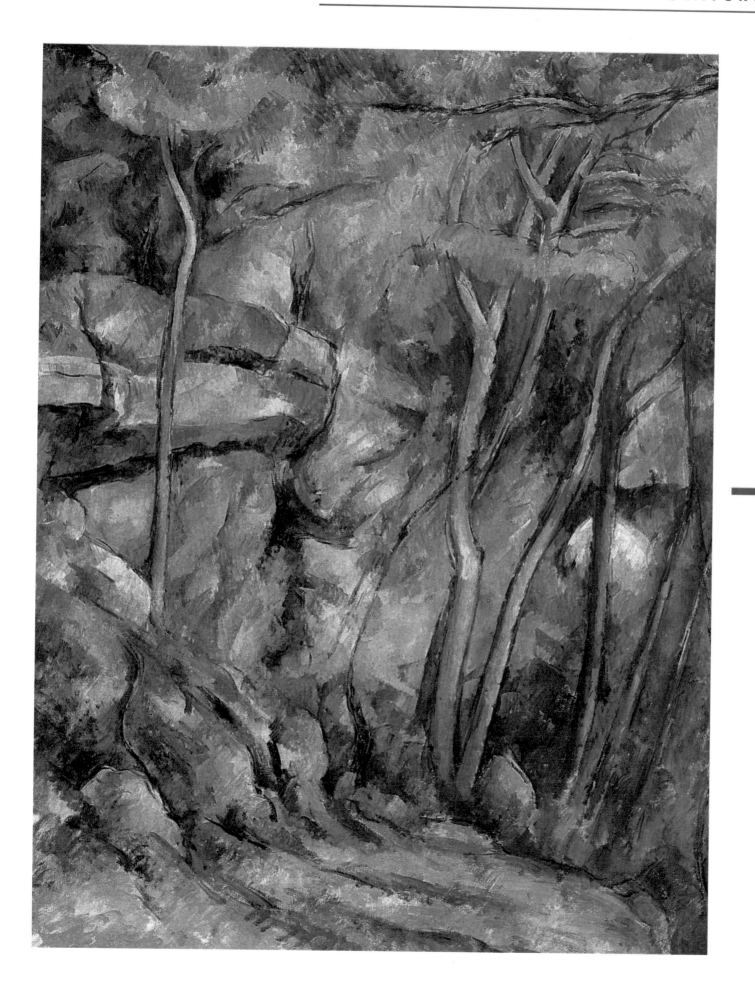

6

C

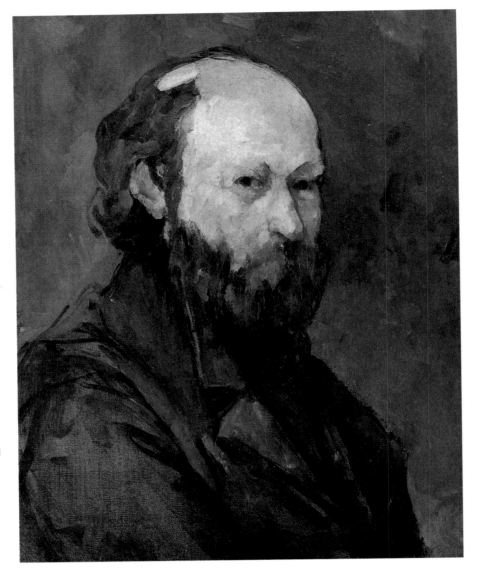

Self-Portrait.
PAUL CÉZANNE.

The Blue Vase.
PAUL CÉZANNE.

up committing suicide, was the deathblow to their warm friendship. This would turn his artistic life around. Cézanne went into seclusion at a country house near his hometown to devote himself to painting. The scenery in these surroundings (*Mountains in Provence*, 1886) and above all, *Mont Sainte-Victoire* (of which he painted more than sixty versions) were his favorite subjects, although his famous still lifes of bottles, fruit, and baskets (*Still Life*,

vers. Two paintings from this period took inspiration from **Manet**, whose talent had an impact on Cézanne from the time he was first able to admire his paintings at the Salon des Refusés ("Salon of the Rejected") in 1863. These paintings were *Le Déjeuner sur l'Herbe* (1870) and *A Modern Olympia* (1873). His friendship with the Impressionists gave him the opportunity to exhibit his paintings at the group's first exhibition in 1874, held at the studio of the photographer Nadar. However, Cézanne soon separated from the group, as he was

not so interested in capturing the moment or fleeting images, nor in light or atmosphere, but rather everything that he considered essential, material, and permanent: things that man can see and touch, the representation of which, he believed, required a harmoniously conceived and executed construction and a structural synthesis of light. This was the origin of his tendency toward the use of geometric forms and the ochre hues that dominate his limited colors, as well as of the importance his paintings would have for later artists. The publication of *L'Oeuvre* by his friend Zola, a novel in which the protagonist is a failed painter who ends

1878), as well as female nudes, were also noteworthy. Several of his paintings deserve special mention, such as *Leda and the Swan* (1886) and, above all, *Bathers* (1898-1905), as well as the portraits he did from life, such as *Madame Cézanne* (1890-1892). In 1902, he achieved his first great success, when the National Gallery in Berlin bought one of his paintings, one of the few he managed to sell under optimum conditions. Fame would come two years before his death, when the Autumn Salon in Paris devoted a whole room to his

compositions. His work opened up unsuspected horizons for contemporary painting, and at the same time, it summarized the heritage from the past, a heritage that began in the Classicism of the seventeenth century and extended to the **Realism** of **Courbet** and Manet.

CHASSÉRIAU, THÉODORE

(Samaná, 1819–Paris, 1856)

French painter. Chassériau was considered one of the most important French figurative painters of the nineteenth century, with his style forming a bridge between the **Neoclassicism** of **Ingres** and the **Romanticism** of **Delacroix**. The son of a French consul, born in the Dominican Republic while his father filled a post there, he began his training at the age of ten with Ingres, who markedly influenced him; he stayed in Ingres' atelier for twelve years. Chassériau exhibited at the 1836 Salon and soon proved to be an excellent portrait painter, a specialty he demonstrated in the painting of his sister, *Adele Chassériau* (1836). In 1840, he traveled to Rome and there he painted the portrait *Père Lacordaire*, using the clarity of composition that characterized Neoclassical painting, with accentuated contours, heavily drawn outlines, and strong chiaroscuro. The severity of his work is softened, however, by the psychological traits it depicts, which are more typical of Romanticism, and by the gradual influence of Delacroix, whom he admired for the richness of his colors. This characteristic began to appear in Chassériau's paintings, particularly in one he did of the Spanish dancer Petra Cámara. Interested in

Arabs Watering Their Horses Outside Constantinople.
THÉODORE CHASSÉRIAU.

female nudes, he moderated the severity of Neoclassicism to create his own style, which is obvious in *The Chaste Susanna* (1839) and in the renowned *La toilette d'Esther* (1842). Between 1843 and 1845, his activity was focused on the murals he painted in several churches in Paris, and later, between 1844 and 1848, in the Palais d'Orsay, where he created a series of great fresco compositions devoted to subjects relating to war and peace. The trip he made to Algiers in 1846 accentuated his Romantic traits and reinforced Delacroix's influence on him, while at the same time allowing him to

develop certain Oriental motifs, as seen in his painting *Harem Interior*. He was also interested in prints, creating a series of etchings for an edition of Shakespeare's *Othello*.

CHINNERY, GEORGE

(Tipperary, 1748–Macao, 1847)

British painter. A pupil of **West**, Chinnery set off for the Near East,

6

Blacksmith at Macao.
GEORGE CHINNERY.

C

India, and China, after living a few years in Dublin. He took advantage of the fact that these were places with which Britain had trade and political relations, allowing him the security to indulge his interest in exotic things which were in vogue at the time in Europe. He was to spend a large part of his life in the East, where he created nearly all of his artworks, becoming, as his own name indicates, an expert in Chinese sub-

The Falls at Tequendama.
FREDERICK EDWIN CHURCH.

Falls of Kaaterskill.
THOMAS COLE.

jects. He did several portraits, among them his *Self-Portrait*, but his fame is based on the landscapes he painted of these mysterious lands, as well as the numerous scenes depicting life in places such as Madras, Canton, Calcutta, and Macao. His work, which included oils as well as watercolors and drawings, was exhibited at the Royal Academy in London on several occasions.

CHURCH, FREDERICK EDWIN

(Hartford, Connecticut, 1826–New York, 1900)

American landscape painter. Church's travels around the Americas, Ja-

maica, Europe, and Palestine contributed to a large extent to the shaping of his pictorial style. In fact, many of his most representative canvases have as their subject the various countrysides he visited during those trips, which he treats with his own brand of "effectism;" his work *Heart of the Andes* (1859) is a good example of this. He was a pupil of **Thomas Cole**, from whom he would distance himself in his treatment of landscapes, making them more naturalistic and using almost scientific detail to represent nature. This has caused him to be compared to **William Turner**, because of his

treatment of light and because he fills his paintings with a certain mysticism,which is evident in his painting *Morning in the Tropics* (1877). Among his most noteworthy works, which were very successful both in America and in Europe, is a series of paintings entitled *The Heart of America*, representing American lands, many of them virgin or recently settled, and *Niagara* (1857), a powerful painting that presents the viewer with a monumental and overwhelming concept of reality.

COLE, THOMAS

(Bolton-le-Moors, 1801–Catskill, New York, 1848)

American painter and landscape specialist. Cole was the founder and a prominent member of the Hudson River School, one of the few and one of the most interesting nineteenth-century associations of American painters, whose desire to paint the untamed scenery of their region was based on academic suppositions. Of English origin, Cole began his artistic studies at an early age in his native land. In 1818, at the age of seventeen, he moved to North America and settled in Ohio. He studied drawing and the technique of wood engraving and for a time was enrolled in an academy in Philadelphia. However, he was primarily self-taught. The trips he made to New York and to the nation's different states in 1826 served both as an exercise and as the basis for his later compositions, which he painted in Catskill, a town on the banks of the Hudson River. This river would give its name to the school of landscape artists he founded, along with other painters, that would disseminate landscape painting throughout America. The success of his work and that of all of the Hudson group was probably a result of the novelty of capturing on canvas the immensity of the American countryside: a spectacular natural setting, untouched, wild, and unknown to most people. Cole enjoyed profitable sales in New York, which allowed him to visit Europe in 1829. He traveled through England, Switzerland, and Italy. In the latter country, he studied the masters of classical landscapes: Poussin, Claude Lorrain, and Salvatore Rosa

The Oxbow.
THOMAS COLE.

6

St. Isabel of Hungary.
JAMES COLLINSON.

C

while, at the same time, encountering aspects of the Romantic movement of the times. Upon his return to America, he brought with him aesthetic knowledge that radically transformed his painting. He introduced a new genre, the allegorical or symbolic-moral landscape, which made him a Romantic painter but diminished the freshness and quality that his work had had before. *The Giant's Chalice* (1839), *The Architect's Dream* (1840), and *Voyage of Life* (1842) are examples of his new method of depicting landscapes, based on a synthesis of the Romantic ideas that he had encountered in Europe.

COLLINS, WILLIAM

(London, 1788–1847)

English painter. He began his art training with George Morlans, and later completed it by traveling through Europe to France, Holland, Germany, and Belgium. He painted rural landscapes and scenes of country life that were filled with sentimentality, leading him to discover the road to success with scenes involving children. He used watercolors and oils with great skill and

Weymouth Bay.
JOHN CONSTABLE.

achieved great fame in his time. His creative capacity suffered because of an excessive repetition of subjects. He was also the father of an artist: Charles Allston Collins (1828–1873) who painted in the Pre-Raphaelite style. Though somewhat excessive in its detail, *Convent Thoughts* (1851) is his outstanding work. Charles eventually left painting to become a writer.

COLLINSON, JAMES

(Mansfield, 1825–London, 1881)

English painter. In 1848, together with **John Everett Millais, Dante Gabriel Rossetti, William Holman Hunt**, and others, he became a founding member of the Pre-Raphaelite Brotherhood. This was a group of English painters who sought to return to artistic forms that had existed prior to Raphael and to break with Academicism. Two years later, in 1850, Collinson left the Brotherhood because of a major personal crisis that led him to enter a Catholic seminary. However, after four years, he returned to painting and produced genre works filled with feeling, as well as religious scenes, such as *St. Isabel of Hungary*. His style evolved from its beginnings within the Pre-Raphaelie movement to his later style in which **Wilkie**'s influence is noticeable, such as in *The Empty Purse* (1857).

CONSTABLE, JOHN

(East Bergholt, 1776–London, 1837)

An English painter, Constable was one of the most important landscape artists of the nineteenth cen-

The Hay Wain.
JOHN CONSTABLE.

tury and the most influential in France, admired by **Delacroix** and **Gericault**, and later, by the landscape artists of the **Barbizon School**, to such an extent that he has been considered to be their true founder. The son of a Suffolk miller, he followed his father's profession for several years, while he worked at his painting in his free time. He attended painting classes near his home, and in 1795 went to London to work as a topographical draftsman; his family helped him enter the Royal Academy as a student in 1799. At first, he painted portraits and religious paintings, but he soon excelled as an outstanding landscape artist. However, it can be said that his greatest source of creativity was derived from self-training through which he developed a keen ability to observe nature and which became the fundamental basis of his work. The studies he made of the work of Jacob von Ruisdael—whose influence on him was noticeable—as well as of Sir JoshuaReynolds, the Dutch school, and his viewing and first-hand study of rustic sites and

natural settings in Suffolk, Essex, and Brighton, helped his work slowly to evolve and mature. Among his most noteworthy works are *Weymouth Bay* from 1816, and *The White Horse* from 1819, two paintings that give evidence of his interest in the environmental effects of light on nature. In 1819, he traveled to Italy and visited Venice and Rome, where he had the chance to become familiar with Claude Lorrain's classical landscapes and Poussin's pastoral and Arcadian representations. His style, as one can see in *The Hay Wain* (1821) or *Salisbury Cathedral from the Bishop's Grounds* (1828), shows a treatment of color that was revolutionary for the time: ochres and yellows for the hay and straw, greens for the grass, and blues for the sky. His technique of using small patches of color and superimposed lines was also innovative. He achieved charm and feeling in his compositions, but the English critics did not approve of

6

comes from the influence of **Courbet**, **Millet**, and the **Impressionists**. In his artistic training, which began at the Munich Academy, his trip to Paris in 1884 played a key role. There he became familiar with contemporary artists and painters and discovered the painting of the Flemish and French schools. He worked in all genres, and his large compositions and portraits are noteworthy. In his *Self-Portrait with Skeleton* from 1896, the Expressionistic background inherent to German artists of the time is evident. He became part of the Berlin *sezession* ("secession") group.

Self-Portrait.
LOUIS CORINTH.

Lake Walchensee.
LOUIS CORINTH.

his free style and considered his works to be "unfinished." However, his participation at the 1824 Autumn Salon in Paris—where he won a gold medal—brought him success in France, the admiration of the Romantic artists, and as an immediate result, recognition in his own country, where he was made a full academician in 1829.

CORINTH, LOUIS

(Tapiau, 1858–Berlin, 1925)

A German painter and etcher, Corinth was born in an East Prussian town. His work has a personal style that

CORMON, FERNAND

(Paris, 1845–1924)

French painter. Cormon is the pseudonym of Ferdinand Annie Piestre whose work is representative of academic Realism. Trained in Brussels

Sigfried's Farewell.
PETER VON CORNELIUS.

6

and Paris, he received numerous awards at different international exhibitions. **Van Gogh** and **Toulouse-Lautrec** were among the disciples who studied with him. He applied his style, which was similar to **Courbet**'s and to **Gérôme**'s and **Meissonier**'s, to historical compositions and religious subjects which were highly literary in character. However, his subject matter is highly varied, as it encompasses portraits, floral themes, animals, and genre painting. Among his most outstanding works are the decorations he did for the National Museum of History in Paris, with a fa-

mous series on the origins of man which tells the story of the human race starting in the Quaternary age. He also decorated the old Saint-Germain-en-Laye château, now a museum, and the Petit Palais Museum in Paris.

CORNELIUS, PETER VON

(Düsseldorf, 1783–Berlin, 1867)

German painter. An artist specializing in murals, Cornelius was a prominent figure in the Roman group, the **Nazarenes**, a proponent

Last Judgment.
PETER VON CORNELIUS.

of their aesthetics, and fully imbued with German idealism. Trained at the academy in the city of his birth, he continued his studies in Frankfurt from 1809 to 1811, and then moved to Rome where he met the founder of the Nazarene Brotherhood, **Overbeck**. He began to do fresco painting, directly inspired by medieval models, although always clearly in combination with Academicism. In 1816, he received his first commissions in Rome: the decoration of the Consul of Prussia's house and the frescoes in the Palazzo Zuccaro. In these compositions, based on subjects from the Old Testament, such as *Joseph Recognized by His Brothers* (1816–1817), he demonstrated the simplicity of the Nazarene style and ideals, which was a populist and somewhat patriotic aesthetic mixture. The success he achieved with the Roman frescoes brought him recognition in Germany, where he was appointed to a professor's chair at Düsseldorf, and later named director of the Academy in Munich to which he moved in 1824. In Munich, he painted the frescoes at the Glyptothek (ca. 1820–1825), which no longer exist. Later, in 1840, he moved to Berlin where he lived for the rest of his life.

COROT, JEAN-BAPTISTE-CAMILLE

(Paris, 1796–1875)

A French painter, Corot was one of the creators of the Romantic landscape, and his work, which belongs

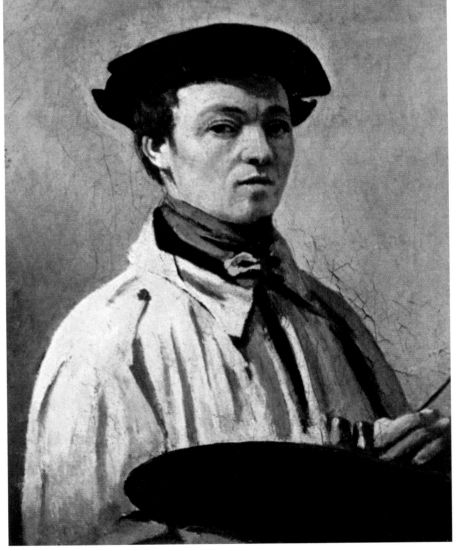

Self-Portrait.
JEAN-BAPTISTE-CAMILLE COROT.

6

to the **Barbizon School**, was a forerunner of Impressionist painting. In 1822, he quit his job in his father's cloth business to study with a Neoclassical landscape painter, Victor Bertin, and also took time to copy the classical masters of the Dutch school. Soon deciding to study on his own, he set out for Italy in 1825. There he made sketches from life: highly fresh and innovative sketches of landscapes that detailed the ruins and the environs of Rome. These preliminary studies would become high-quality compositions in his studio; one example of this is *View of the Coliseum* (1826). In contrast, the paintings he exhibited at the Paris Salon in 1827 were of an Academic and Neoclassical nature, as seen in *View of Namie* (1827). This, however, was a manner he soon abandoned after returning to France, where he traveled around many provinces trying to capture the widest variety of scenery. At the end of the 1840s, he came into contact with the painters **Millet** and **Rousseau** of the Barbizon School and adopted their aesthetic principles. Later trips to Italy (1834 and 1843), to Holland (1854), and to England (1862) reinforced his preference for using luminous hues and his interest in light and atmosphere, that were always combined within intimate and somewhat ethereal compositions. From the 1850s onward, he went through a "mysterious and poetic" period, which produced enchanted landscapes filled with magic, such as *Morning, the Dance of the Nymphs* (1850), *The Lake* (1861), and *The Gust of Wind* (1865). He achieved continuous success at exhibitions, especially at

Woman with a Pearl.
JEAN-BAPTISTE-CAMILLE COROT.

the 1855 Universal Exposition in Paris, where Napoleon III bought one of his works, which was a decisive factor in producing explosive sales of his paintings internationally. In his final period, he was interested in representing female figures that evoked the tranquility and style of Dutch masters such as Vermeer,

although some of these works seem akin to Impressionism. Examples of these paintings are *The Gypsy* (1865) and *Woman with a Pearl* (1870). In 1874, he was invited to participate in the first Impressionist exhibition.

COTMAN, JOHN SELL

(Norwich, 1782–London, 1842)

English landscape painter and expert watercolorist. Cotman was a member of the association of artists in Norwich devoted to landscape painting (Norwich Society of Artists) who, along with their art, created a solid tradition of watercolor landscapes: a technique that is executed quickly, spontaneous by nature, and innovative compared to the traditional oil process and to academic conventions. He had no art training or studies, as he was self-taught. Cotman went to London in 1798, where he earned his living painting aquatints; he did not paint in oils until 1807. He met the painter Thomas Girtin, the founder

The Preparation of the Bride.
GUSTAVE COURBET.

C

The Wheat Gleaners.
GUSTAVE COURBET.

of the Norwich Society, and traveled with him to Wales to work on landscapes. Later, he joined the group, participating in its exhibits and holding the office of president. Most of his etchings and watercolors, which are very lyrical and delicate, done with intense colors with hardly any drawing lines or contours, are from his constant trips to Yorkshire or Normandy. Noteworthy among his works are *Durham Cathedral* (1804), *Gaillard Castle* (1818), and *St. Marcouf Fort, near Quinéville* (1820).

COURBET, GUSTAVE

(Ornans, 1819–La Tour de Peilz, 1877)

French painter and founder and chief representative of **Realism**. Courbet was born in Ornans, a French town near Besançon in Jura, a province whose countryside often appears in his paintings. After studying in Besançon, he went to Paris in 1840, preferring to study independently on his own. His real masters were the great geniuses of art history, Velázquez, Zurbarán, and the painters of the Dutch school—especially Rembrandt—artists he discov-

ered in the Louvre and later on his trips to Holland (1846) and Germany (1853). His first paintings reveal certain Romantic influences. These were landscapes, especially of the forests of Fontainebleau, and portraits of friends and relatives. However, from 1849 onward, his paintings can be said to be realististic, such as the prestigious *Burial at Ornans* (1850). In this painting, his rejection of traditional subjects is clear, with the artist choosing to portray humble, hard-working, everyday rural folk, with a sober and simple treatment that is a departure from Academic grandiloquence and Romantic sentimentality. *The Stone-Breakers* and

The Wounded Man are also paintings that express his interest in depicting real things—everything that is visible and tangible—by employing a vigorous style that combines dark colors, impasto, and a judicious use of the palette knife. A friend of Baudelaire, whose portrait he painted, he also had a connection with **Corot** and **Daumier**. Although his work was criticized as "ugly painting," it was revolutionary for the time, especially when its strong real-

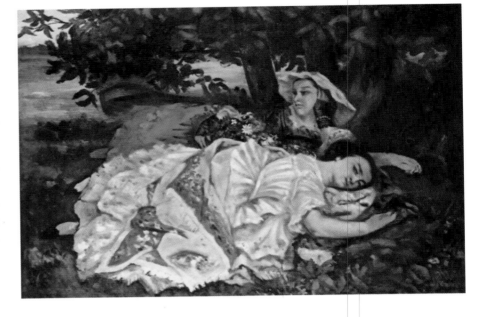

The Painter's Studio.
GUSTAVE COURBET.

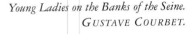

Young Ladies on the Banks of the Seine.
GUSTAVE COURBET.

6

ism became integrated with socialist ideas. Influenced by his friend Proudhon (founder of Philosophical Anarchism), his creative work became focused on achieving a social goal through art. He was invited to exhibit his work at the Universal Exposition in Paris in 1855 but did not accept the place that was reserved for him. Instead, he exhibited his work, a total of forty-three paintings, in a large shed installed at the entrance to the Exposition, bearing the name, Pavilion of Realism. He then exhibited his most on his political, artistic, and cultural beliefs. He actively participated in the revolutionary Commune of Paris of 1871 which followed the Franco-Prussian War and led to the overthrow of Napoleon III. For his role in this, he was arrested and sentenced to jail but managed to flee to exile in Switzerland in 1873. Four uears later, he died in a small town near Vevey. His artistic legacy lies in the fact that his realism became an expressive model for many painters and was especially enriching for the works of **Paul Cézanne**.

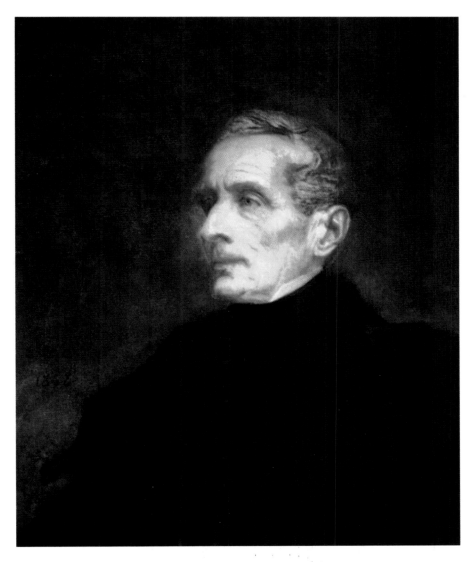

Portrait of Alphonse de Lamartine.
THOMAS COUTURE.

tige. The subject he chose refers to a Roman celebration, a seductive subject portrayed with flashy skill, careful composition, and a variety of characters, producing a baroque effect. The artistic precedents that inspired this painting are evident: Tiepolo and of the Venetian masters. In addition to his historical works, Couture created numerous portraits and was the teacher of **Anselm Feuerbach**, on whom he had a strong influence.

COX, DAVID

(Birmingham, 1783–Harborne, 1859)

English painter whose oil and watercolor landscapes are noteworthy and who was known as David Cox

Rhyl Sands.
DAVID COX.

6

COUTURE, THOMAS

(Senlis, 1815–Villier-le-Bel, 1879)

French painter. Couture's paintings, which deal with historical subjects, make him one of the painters who best represent nineteenth-century Realist Academicism. Trained in the traditional precepts of the Academy and a pupil of **Gros** and **Delaroche**, he created monumental paintings in a style that belonged to the historical eclectism of the time. His best-known work is the orgy painting he presented at the 1837 Exposition, *The Romans of the Decadence*, for which he won the Prix de Rome and enormous pres-

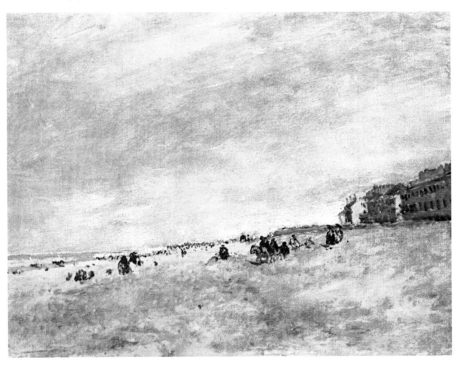

Sketch.
GEORGE CRUIKSHANK.

C

the Elder. The son of a tinsmith, he worked in different trades until he received a small amount of academic training, but he remained primarily self-taught. He exhibited at the Watercolor Society's annual shows in London and had a good reputation as a painter and engraving teacher. He traveled through Holland, Belgium, and France on several occasions and lived in London from 1827 onward. His first works were small watercolors of rural scenes that he later transferred to oil. Outstanding among his many works are the paintings *The Night Train* and *View of Herefordshire.*

CREMONA, TRANQUILLO

(Pavia, 1837–Milan, 1878)

Italian painter, classified as one of the strangest artists to represent **Romanticism** in Italy, particularly Milanese Romanticism. His style is vivid in coloring and luminousity, with an interest in compositions that are hazy or have a whitish penumbra. He studied in his native city and later in Venice and Milan and began his artistic career with historical paintings, such as *Mohammed II* and *Marco Polo*. However, it is in his portrayals of the human figure, always enshrouded in an opaque mist—such as in *The Ivy*, which shows two women embracing—where the pictorial and chromatic keys to this artist can be found. His method consisted of "small, fleeting" brush strokes, that bordered on **Impressionism**, to which he added almost spectral and phantasmagoric human figures, in a manner that approached symbolism.

CRUIKSHANK, GEORGE

(London, 1792–1878)

British painter, illustrator, and caricaturist. The son of a caricaturist, he dedicated himself at an early age to political and social parody, a field in which he quickly succeeded

The Ivy.
TRANQUILO CREMONA.

James Gillray as this art's greatest practioner. He worked for different publications in which he ridiculed figures in modern French history, criticizing them in a cruel and merciless fashion. He also lampooned the English society of the Victorian era in which he lived. In 1820, he began to illustrate books, an area in which he would also excel, contributing to a large number of works, including some by Dickens and Ainsworth. In the final stage of his life, he made woodcuts whose contents sought to point out the dangers of alcohol abuse. This theme was repeated in a large-format painting entitled *The Worship of Bacchus* (1860–1862). Though the subject matter was mythological, the work did not enjoy public favor.

The Fairy Feller's Master-Stroke.
RICHARD DADD.

6

DADD, RICHARD

(Chatham, 1819–London, 1887)

British painter. Dadd made a trip to Africa, and the images, scenery, and people of that continent provided the inspiration for notable watercolors, such as *Tomb of the Caliphs in Cairo*. His style is very personal, and although he is considered a **Romantic**, his work may also be classified as original, innovative, and marked by meticulous draftsmanship. His paintings deal with historical subjects, as well as with fanciful stories filled with the characters typical of this type of literature. Fairies, dwarfs, elves, and other strange creatures mix together in complex and fantastic compositions that may even be an indication of his incipient insanity. His style remained practically the same throughout his life, no doubt due to his illness, which kept him confined in mental institutions and isolated from new fashions and influences. He was also a good illustrator, as his work in *Books of British Ballads* (1843) shows. Among his noteworthy works are *The Fairy Feller's Master-Stroke*, *Titania Sleeping*, *Manfred*, and *Puck and the Fairies*.

DAHL, JOHAN CHRISTIAN

(Bergen, 1788–Dresden, 1857)

Norwegian painter. Of humble origin, Dahl was able to go to Copenhagen to study with to the aid he received from some art lovers in his city. Later, he traveled around several European countries to complete his training, going to Italy, Germany, Switzerland, and England. He lived in Dresden for quite a while, where he was appointed teacher at the city's art Academy in 1824 and of which he became a member. There he met **Friedrich**, who was an influence on his style, as was Salomon van Ruysdael. A landscape artist whose inspirations came from Romantics, Dahl painted the remote and tranquil Norwegian valleys for the first time, showing great sensitivity, a sense of the monumental, and notable light and color effects. A good example of this work is *A Birch Tree in a Storm* (1849), in which the style is very detailed.

DANBY, FRANCIS

(County Wexford, 1793–Exmount, 1861)

Irish painter. Danby studied at the Royal Dublin Society and continued his training with the landscape artist **James Arthur O'Connor**. His landscape painting was an important Romantic contribution to the genre, influencing later English landscape painters. Danby went to England, where he lived for much of his life. First he settled in Bristol, where he painted some small-format landscapes whose great lyrical qualities brought him fame. Later, he moved to London, where he repeatedly triumphed. His landscapes are poetic with an Intimist appeal, composed in ink, oils, and watercolors. In London, he met **William Blake**, under whose influence he produced visionary paintings, such as the four *Scenes from the Apocalypse* (1829), as well as subjects relating to religion and horror literature. Between 1825 and 1828, he traveled through Norway, Belgium, and Holland. In 1829, he settled in Paris, where he stayed until 1840 before moving on to Geneva and later back to London. He continue to seek scenes for his landscapes, while never losing his interest in more fanciful subjects.

Evening Landscape with Shepherd.
JOHAN CHRISTIAN DAHL.

DAUBIGNY, CHARLES-FRANÇOIS

(Paris, 1817–1878)

An outstanding landscape painter and etcher, Daibigny was a prominent member of the **Barbizon School**, continuing the style begun by **Rousseau** and **Millet**. The son of the painter Edouard-François Daubigny, who initiated him into painting, he studied with the historical painter **Paul Delaroche**. He finished his training with a trip to Italy and by illustrating books and magazines. His first work, *St. Jerome*, was exhibited at the 1839 Salon. During the next decade, he did etchings of landscapes, some of which were collected in portfolios that made him well known. In search of natural scenery, he devoted himself to touring different French regions and to traveling by boat along various rivers in order to find intriguing subjects for his paintings. In 1848, he built a houseboat, where he lived for long periods, painting the riverbanks he loved so much. His views of the Optevoz Valley, especially in the

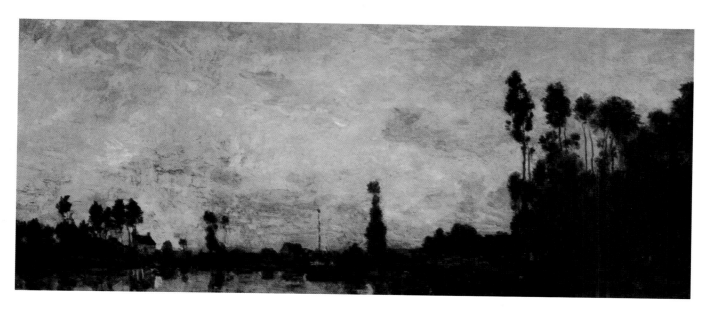

Sunset over the Oise.
CHARLES-FRANÇOIS DAUBIGNY.

paintings *The Flood Gate at Optevoz* (1859), *A River Landscape* (1860), and *Sunset over the Oise*, are works that reflect his notable sense of composition, and that are impressive because of their vast horizons and the deep

Crispin and Scapin.
HONORÉ DAUMIER.

sense of solitude they transmit. He traveled to London in 1869, where he made contact with **Monet**, and later traveled to Holland and to the Alps. There he painted *The Snow* (1873), a rendering of a landscape that approaches **Impressionism**. In general, his landscape work is peaceful and dedicated to studies of light and atmosphere. This is known as *plein air* or "open air" painting, a practice that was adopted by many of the Impres-

sionists. **Corot**'s fame and mastery eclipsed the prestige of this artist's work, though for some scholars the latter's work is just as impressive.

DAUMIER, HONORÉ

(Marseilles, 1808–Valmondois, 1879)

A French painter, cartoonist, sculptor, and engraver, he is considered the

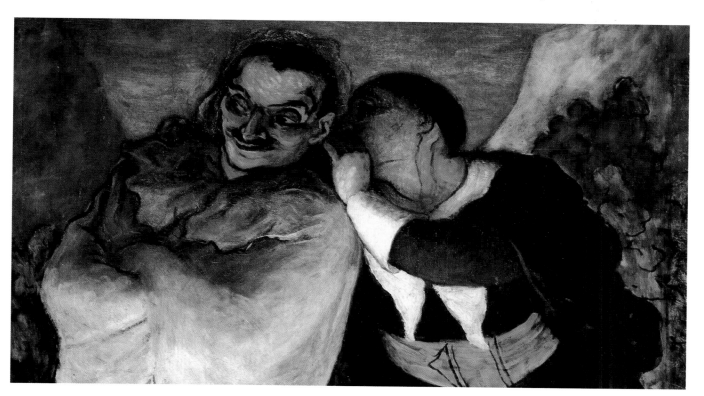

most outstanding lithographic artist of the nineteenth century. The son of a Marseilles glassworker, his family moved to Paris in 1816, where he spent nearly all of his life. He began by studying lithographic techniques and viewing the masterpieces in the Louvre. Very shortly thereafter, he started to work at a satirical newspaper, *Le Charivari*, as a political caricaturist, and very quickly showed his unprecedented creative and comic imagination which aroused great interest. However, this activity caused numerous problems for him throughout his career. The publication of a caricature of King Louis-Philippe as Gargantua in 1832 landed him in jail for six months. A committed Republican artist and defender of the oppressed classes, his graphic work dealt with the social matters characteristic of **Realism**: the everyday life of Paris in that era, with its streets, trains, and people, creating a noisy environment containing both well-to-do, middle-class life and the hardships of the poor. *The Laundress, The Soup, The Street Musicians, The Third-Class Carriage, The Thieves*, and *The Blacksmith* are some examples of Daumier's thousands of lithographs and drawings; all executed with great technical skill, elaborate dramatic structure, and strong, effective chiaroscuro. His figures often feature some type of grotesque deformity, especially in the political lithographs which are true manifestos attacking the government and politicians, such as *The Legislative Belly* and *Rue Transnonain, April 15, 1834*, and *The Inventor of the Needle Gun's Dream*, from 1866. Daumier never painted from life, only in his studio, using his memory as his sole

Laundress on the Quai d'Anjou.
HONORÉ DAUMIER.

Advice to a Young Artist.
HONORÉ DAUMIER.

model. His dedication to engraving prevented him from devoting himself to painting, and the few paintings he did create came to light only after his death. Deep in poverty and the victim of progressive blindness, he found refuge with his friend **Corot**, who provided him with a country house in Valmondois and gave him a monthly allowance so he could live his last days in peace.

DAUZATS, Adrien

(Bordeaux, 1804–Paris, 1868)

French painter, draftsman, writer, and lithographer. He is considered, along with **Pharamond Blanchard**, to be the chief painter of Romantic Spain, due to the large number of his works that were inspired by that country which he visited often. He produced oil paintings, as well as watercolors, lithographs, and drawings, with Spanish motifs (*Interior of the Barcelona Cathedral, Interior of the Church of San Juan de los Reyes in Toledo, View of Toledo*). He also traveled to other countries, such as Egypt, Algeria, and Germany, where he found additional sources of inspiration.

D

DAVID, JACQUES-LOUIS

(Paris, 1748-Brussels, 1825)

Politically committed French painter and artist, David is the representative par excellence of Neoclassical painting. His work personifies the idea of understanding ancient history as a metaphor and moral lesson for the present, a maxim that he applied to his paintings in favor of the 1789 revolution and Napoleon's rise to power. At the age of nine, his father died, and he came under the guardianship of an uncle who was an architect and a member of the Academy. He was placed in the atelier of François Boucher, a painter of scenes of gallantry; he also studied under J. M. Vien. Educated along the strict axioms of Academicism, his first works had many

Baroque elements, both in the portraits (*Equestrian Portrait of Count Potocki*) and in historical paintings

Madame David.
JACQUES-LOUIS DAVID.

The Sabine Women.
JACQUES-LOUIS DAVID.

(*Combat of Mars and Minerva* and *The Death of Seneca*). In 1775, after winning the Prix de Rome, he moved to that city with his teacher Vien and changed his style. The influence of the painters in Bologna, the excavations of Herculaneum and Pompeii, as well as his thorough studies of ancient times, caused David to radically eliminate any trace of the frivolous and the Rococo to become the leader of **Neoclassicism**. In 1779, he returned to Paris and began the painting that opened the doors of fame to him, *Oath of the Horatii*, an example of the use of ancient history as a moralizing message for his contemporaries. He finished the work in Rome when he returned in 1784, but it was exhibited in Paris to the admi-

ration of all those who were in favor of the Revolution. David joined this cause and in 1789, composed another painting, *The Lictors Bring to Brutus the Bodies of His Sons*, whose political connotations were associated with the beheading of Louis XVI. He also made sketches and did a drawing of Marie Antoinette before she died by the guillotine. Works such as *Andromache Mourning Hector* reflect his composition style in which draftsmanship and line are essential instruments, with a very careful wealth of details to shape heroic figures of the classical world, which are always idealized. His painting is above all a political agenda, a revolutionary manifesto, as one can see in *Oath of the Jeu de Paume* (1791). The assassination of the revolutionary writer and ideologist Jean-Paul Marat had such an impact on him that he portrayed the deed just as it had occurred, using a clear leaning toward Realism and without resorting to old techniques. Thus, he painted a true masterpiece, *Death of Marat* (1793), that records the assassination of the leader in his bath by Charlotte Corday. This painting is an authentic *pietà* of the revolutionary movement, a touching and moving work with a wise treatment of light, reminiscent of Caravaggio. One year later, David split with the political principles that guided Robespierre, and although he escaped the guillotine, he ended up in jail, where he continued to paint. What he saw through the bars of his window allowed him to create the only landscape in all of his work, *View of the Petit Luxembourg* (1794). During his oppressive imprisonment, he also painted his own portrait, with such verism that he didn't even disguise the tumor that disfigured one of his cheeks. His wife and his painter friends managed to win his freedom, and he returned to his studio and his favorite subjects, taken from the history of ancient Rome. As a message of reconciliation for a divided France, David painted *The Sabine Women*, However, peace and the heroes of ancient times quickly disappeared when he began to let himself be carried away by his admiration for Napoleon, with whom he had a significant friendship. His work became a testimony to and a glorification of the great Napoleonic exploits. This was a new phase in which his style grew more and more theatrical, culminating in *The Coronation of Napoleon* (1804–1807) and with the painting *Leonidas at Thermopylae*, completed in 1814. But the fall of the emperor meant the fall of the painter, who, rather than submit to the new king, Louis XVIII, and fall into disgrace for having voted in favor of the death of Louis XVI, decided to exile himself to Brussels. David was in that city from 1814 until his death, and there he painted one of his last metaphorical works, *Mars Disarmed by Venus and the Three Graces*, signifying the end of the god of war. In his portraits, David followed a strict Neoclassical aesthetic style, but in a freer form, studying the psychological traits and the personality of the subject, as in *Madame Chalgrin* and *The Gérard Family*. His numerous commissions and his abundant work were done in a studio that produced a notable school of French painters committed to Neoclassical painting. Noteworthy examples are **Regnault, Proudhon, Girodet, Gérard, Gros, Guerin,** and above all, **Ingres**.

The Death of Marat.
JACQUES-LOUIS DAVID.

Seascape.
EDGAR DEGAS.

DEGAS, HILAIRE-GERMAIN-EDGAR

(Paris, 1834–1917)

A French painter who belonged to the Impressionist group, although his work shows diverging interests. From a well-to-do family, Degas abandoned his law studies to devote

Café Concert at the Ambassadeurs.
EDGAR DEGAS.

Roman Beggar Woman.
EDGAR DEGAS.

himself to an artistic career. When he began to paint, he was influenced by different art movements—**Ingres**' Classicism and **Delacroix**'s Romanticism—and as a result, created historical paintings. He studied in **Corot**'s atelier and admired the Symbolist paintings and **Puvis de Chavannes**' work. In 1872, he briefly visited his brothers in New

Jockeys Before the Race.
EDGAR DEGAS.

D

At left: *Madame's Birthday.*
Overleaf:*The Dance Class.*
EDGAR DEGAS.

D

Orleans, where his mother had been born, and while there, painted portraits and scenes from everyday life.

On his return to France he continued in this vein. Of the paintings from this period, *The Cotton Ex-*

change in New Orleans* (1873) and *Place de la Concorde (Vicomte Lepic and His Daughters)*, from 1873, should be mentioned, along with his compositions devoted to the modern and hectic life of Paris, such as its horse races, one of his favorite subjects. An example is *Race Horses*, from 1874. In that same year, he participated in the Impressionists' first group exhibition, but Degas, unlike the others, maintained his own personal position by not abandoning draftsmanship and making it an essential element in depicting figures. Influenced by the graphics of Japanese woodblock prints, he tried to capture dynamism and movement through line in studio works, compared to the Impressionists' open-air

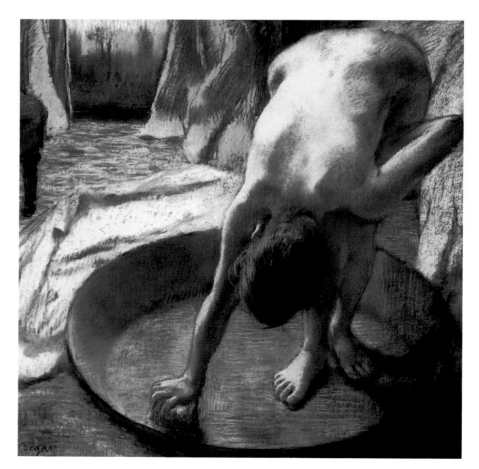

The Tub.
EDGAR DEGAS.

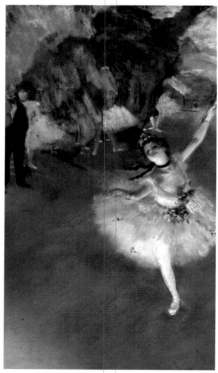

The Star.
EDGAR DEGAS.

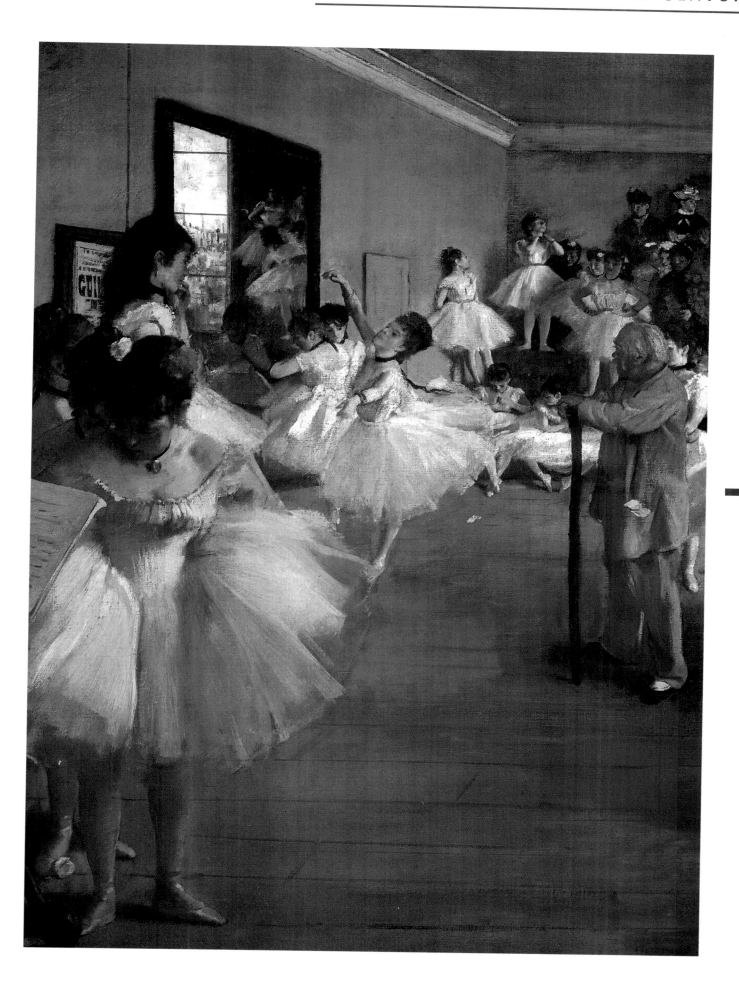

D

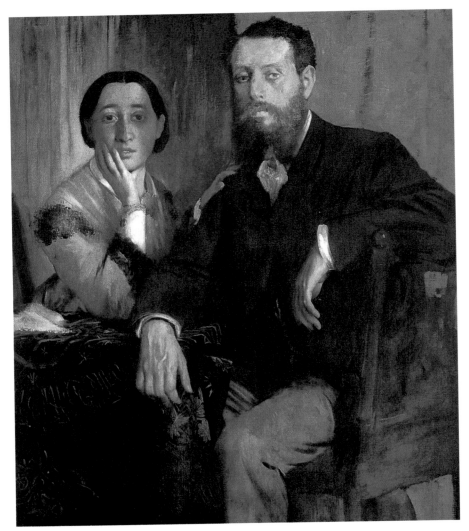

Edouard and Thèrese.
EDGAR DEGAS.

landscapes and their use of color. He also stopped using oils to devote himself exclusively to pastels and proposed a new focus for his compositions that made them more similar to a photograph. In addition to his everyday scenes showing women— laundering, ironing, or enjoying middle-class pleasures, such as (*Women on a Café Terrace*, 1877)—he also portrayed a series of dancers that brought him great fame, a series capturing spontaneity, depicting people in carefree poses, and showing keen realism. *Ballet Rehearsal* (1874) and *Blue Dancers* (1890) are two examples of the magic that he achieved through pastels, draftsmanship, and movement. Little by little, his sight grew weaker, so he dedicated himself to modeling figures in plaster and in wax, and making small sculptures, such as *The Little Fourteen-Year-Old Dancer* (1881). His work is stylistically related to **Toulouse-Lautrec's**.

DELACROIX, EUGÈNE

(Saint-Maurice, 1798–Paris, 1863)

A French painter, considered the most important, innovative, and driving figure in Romantic painting. He had a decisive impact on the later development of art and has been considered one of the first modern artists. He began his education in Bordeaux, studying music and learning the violin, a pursuit he did not give up and that later in his life would join him in friendship with Chopin and

At the Milliner's.
EDGAR DEGAS.

Berlioz. His father died when he was seven years old, and he went to Paris with his mother in 1805, where he received training in painting in the Classicist **Guerin**'s atelier. In 1816, he entered the Fine Arts School and met one of the artists he most admired, **Géricault**. His training was complemented by making copies of the great masters in the Louvre. In a very short time, at the age of twenty,

as much praise as criticism, comments that immediately made him the painter who represented artistic freedom, to which political and social freedom would be added when he exhibited his next works, such as *Massacre at Chios* (1823–1824). This grandiose and original painting revealed his mastery of color and his knowledge of Baroque painting. It was an expression of the fascination

felt by Romantic painters for the rebellion of the Greek people against Turkish oppression and specifically, for a battle in which twenty thousand Greeks had died fighting for their freedom. The painting, whose realism made it moving, was exhibited at the 1824 Salon, and its success made Delacroix one of the leaders of the Romantic movement and brought him into contact with Hugo, Stend-

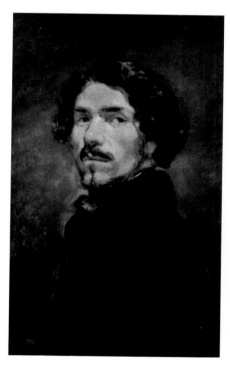

Self-Portrait.
Eugène Delacroix.

he painted his first masterpiece, inspired by Canto VIII of Dante's *Inferno*, (*Dante and Virgil in Hell*) this work was completed in 1822 and exhibited at that year's Salon. The painting surprised the public, because, although the subject matter was customary for the artworks of the era, his painting style was not, showing daring and experimental brush strokes and composition. It received

Baron Schwiter.
Eugène Delacroix.

The Collection of Arab Taxes.
EUGÈNE DELACROIX.

sive in the evolution of his painting and would firmly establish the use of Oriental subjects in his work. Some noteworthy paintings of this type are *Women of Algiers in their Apartments, Military Exercises of the Moroccans, Jewish Wedding in Morocco,* and *The Collection of Arab Taxes.* In addition, he made some splendid drawings, sketches, pastels, and watercolors with the same sense of color that is found in his canvases, placing him in opposition to linearism and the supremacy of draftsmanship espoused by the artists of the opposing movement: **David** and **Ingres.** From 1833 onward, he received official commissions placing him in charge of the decoration of various buildings —such as the library in the Palais Bourbon, the ceiling of the Apollo Gallery in the Louvre, and the Salon de la Paix in the Paris Town Hall— however, tuberculosis kept him from finishing the paintings in the Parisian Church of Saint-Sulpice. Among his many noteworthy portraits are those of Chopin, George Sand, Baron Schwiter, and his own *Self-Portrait.* His work in general, with his special interest in innovative composition in a Baroque manner, his explosive colors, and his sketched, fluid style, made him a model for the Impressionists and a source of enthusiastic admiration for painters like **Cézanne.**

hal, and Dumas. After seeing **Constable**'s work, he traveled to London in 1825, where he gathered new sources of inspiration and dedicated himself to illustrating Goethe's *Faust,* using prints as his medium. *Death of Sardanapolous,* composed upon his return to France, was a reflection of his change of course and the new aesthetic ideas that brought him closer to the whirlwind of Baroque composition and to exotic, Oriental worlds. On July 27,1830, Delacroix was on the barricades and participated in the uprising of the people of Paris, a revolutionary act that overthrew the Bourbons and gave rise to his most emblematic painting, *Liberty Leading the People* (1830). The work extolled the popular insurrection, and because

of it, the artist was awarded the medal of the Legion of Honor. Two years later, he set off on a trip to Spain, Morocco, and Algeria, on an official visit; this trip would be deci-

Princes in the Tower.
PAUL DELAROCHE.

DELAROCHE, PAUL

(Paris, 1797–1856)

French painter. Delaroche studied at the Fine Arts School and in Watelet's studio, before becoming a student of

D

Baron Gros in 1817. He primarily concentrated on historical paintings—which brought him great popularity—with subjects based on anecdotes from English history, treated melodramatically and using Romantic hues. His works were characterized by a perfect mastery of draftsmanship and a fondness for details, which are treated in a very meticulous manner, resulting in a naturalism that is almost photographic (*The Death of Queen Elizabeth*, 1827; *The Princes in the Tower*, 1831). He also painted Romantic portraits (*Duke of Angoulême*). In 1841, he painted an enormous mural in the hemicycle of the Fine Arts School in Paris, where he was a teacher and where some of the best painters of the next generation stud-

ied, among them **Millais**. In addition to the paintings already mentioned, the following are worthy of note: *St. Vincent de Paul Preaching to Louis XIII* (1823), *Death of Cardinal Mazarin*, *Assassination of the Duc de Guise* (1835), and *The Execution of Lady Jane Grey* (1853).

DELLEANI, LORENZO

(Pollone, Piamonte, 1840–Turin, 1908)

Italian painter. Delleani painted historical subjects and genre scenes, as well as landscapes and seascapes. He began by studying music in Paris, training that he abandoned to study

at the Albertine Academy and devote himself exclusively to painting. In 1863, he exhibited his first significant work, *The Siege of Ancona*, followed by *The Conquerors of Lepanto* and *Venice*.

DENIS, MAURICE

(Granville, 1870–Saint-Germain-en-Laye, 1943)

A French painter and critic. Denis was a member of the **Nabis** art movement along with **Bonnard** and Vuillard, among others, who were

influenced by **Gauguin**'s paintings, and by the theory regarding the subjective-objective dichotomy: an explanation of the artistic process in which both a subjective, spiritual element and an objective, technical, and material element take part. Attracted by the simple, rural life of Brittany, he lived in that region for long periods and gathered inspiration for his paintings there. His work often had religious and mystical connotations, causing him to be considered a part of the Symbolist movement. In this vein, *Breton Dance* (1891) is noteworthy. The composition of his paintings shows a high degree of simplification. Nevertheless, the composition of his paintings

shows a high degree of simplification, as seen in his work *Afternoon in a Park*, and supremacy of line, organized in arabesques and large curves that presage Art Nouveau. His painting *April* (1892) is significant, a suggestive and whimsical theme in which girls dressed in white are picking flowers; the flat colors he used followed Gauguin's methods. In 1901, he exhibited *Homage to Cézanne* in Paris.

DE NITTIS, Giuseppe

(Barletta, 1846–Paris, 1884)

A Neapolitan Realist painter, he was successful in Paris, painting portraits and genre scenes. There, he was a pupil of the sculptor and painter

Gérôme, and acquired recognition. His work is very close to the painting of the **Macchiaioli** group and related to the brilliant and euphuistic style of **Fortuny**. The coloring in his landscape paintings of Naples stands out, as in *Landscape* (1866), *Dinner at Posilippo*, and *Naples, Castellamore Road*. Street scenes of the French capital are also prominent in his work, such as *Paris, Place de la Concorde* (1875), *Paris, Place des Pyramides* (1876), and *Arc de Triomphe, Paris* (1878).

DÍAZ DE LA PEÑA, Narciso Virgilio

(Bordeaux, 1807–Menlon, 1876)

French painter. The son of an exiled Spanish family, he was orphaned

Afternoon in a Park.
MAURICE DENIS.

Breakfast in the Garden.
GIUSEPPE DE NITTIS.

while very young and began to work at the age of fifteen as a porcelain decorator in the Sèvres factory. His first exhibit was at the 1831 Salon. The influence of **Delacroix** and **Rousseau**, as well as his friendship with **Millet**, would lead him towards a type of landscape painting that was clearly personal and innovative, with a very sketched style, large brushstrokes, and patches of somber color. His stormy nature

Landscape.
NARCISO VIRGILIO DÍAZ DE LA PEÑA.

scenes often harbored lovers, medieval figures, or mythological characters, as in *The Pearl Fairy, Venus and Adonis, Oriental Woman*, and *Path Through the Forest*. A patron and friend of the young **Pierre-August Renoir**, he and his work merited the esteem of the Impressionists.

DOMÍNGUEZ BÉCQUER, VALERIANO

(Seville, 1834–Madrid, 1870)

Spanish painter. He was one of the most prominent Spanish Romantic painters of customs and manners. Brother of the poet Gustavo Adolfo Domínguez Bécquer, he began his training in the family studio, first with his father, José Domínguez Bécquer (1810–1845) and then, when he was orphaned, with his un-

Lithographs from Cervantes' Don Quixote.
PAUL-GUSTAVE DORÉ.

cle, Joaquín Domínguez Bécquer (1819–1879). The latter was the director of the Fine Arts School in Seville and steered him toward genre painting using popular and folkloric subjects. He moved to Madrid in 1861, and four years later, received a scholarship to travel around the Iberian Peninsula and study the clothing and customs of Spain. As his work progressed, he gradually departed from folklore and his style became increasingly personal and natural. Subjects relating to dances and pilgrimages are prominent in his work, such as *Rural Dance in Soria* and *The Fountain at the Shrine*, paintings with a precise and colorful style. A draftsman and illustrator depicting ordinary people and scenes, he was an excellent portraitist, as shown in *Family Portrait*. In 1868, with the coming of civil war, he lost his scholarship and began to contribute to *La Ilustración Española y Americana* and other magazines of the period, which allowed

Jacob Wrestling with the Angel.
PAUL-GUSTAVE DORÉ.

him to eke out a living. Poor and ill, he died at an early age.

DORÉ, PAUL-GUSTAVE

(Strasbourg, 1833–Paris, 1883)

French draftsman and illustrator, within late **Romanticism** and the Symbolism movement. Self-trained, Doré showed a great fondness for drawing as a child and practiced it with skill, although his lack of training is evident in some formal flaws in his work which are more than compensated for by his expressive strength and his dramatic power within somber and mysterious atmospheres. He soon excelled at caricatures and at the age of fifteen was already seeing them published in the *Journal pour Rire* in Paris. He had arrived in that city in 1848 and published a series of lithographs entitled *The Labors of Hercules*. In 1853, he began a very productive period and

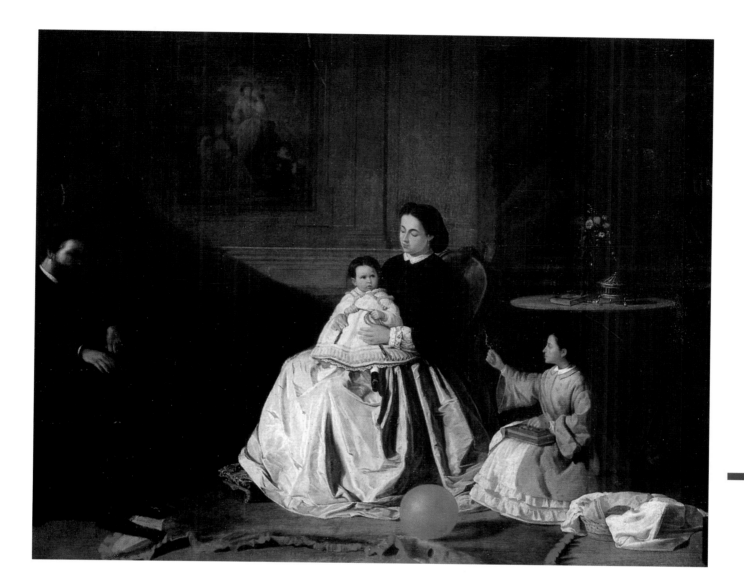

Family Portrait.
VALERIANO DOMÍNGUEZ BÉCQUER.

made lithographic illustrations for many works in world literature: (Balzac's *Droll Stories* in 1855; Dante's *The Divine Comedy* and Cervantes' *Don Quixote* in 1863; the Bible in 1864; Perrault's *Fairy Tales* in 1862; Lafontaine's *Fables* in 1867; and Rabelais' work in 1864). His engravings were imaginative and often humorous and theatrical, tending towards the "sublime," where movement played a fundamental role; they would make him the most famous illustrator of the time. To prepare his plates, he primarily made engravings on boxwood or drawings done with ink or gouache, which he would later give to specialists to convert into engravings. He made many trips to Spain, Russia, Switzerland, and other countries which provided him with inspiration for his drawings. Returning to Paris from his travels in 1872, he mainly devoted

In Nature's Wonderland.
THOMAS DOUGHTY.

himself to sculpture, painting, and watercolor—in which he demonstrated his draftsmanship skills—dealing with Biblical and military themes. He also created posters of great aesthetic value, foreshadowing the golden age of this medium.

DOUGHTY, THOMAS

(Philadelphia, 1793–New York, 1856)

American painter and lithographer. Self-taught, he initially painted in

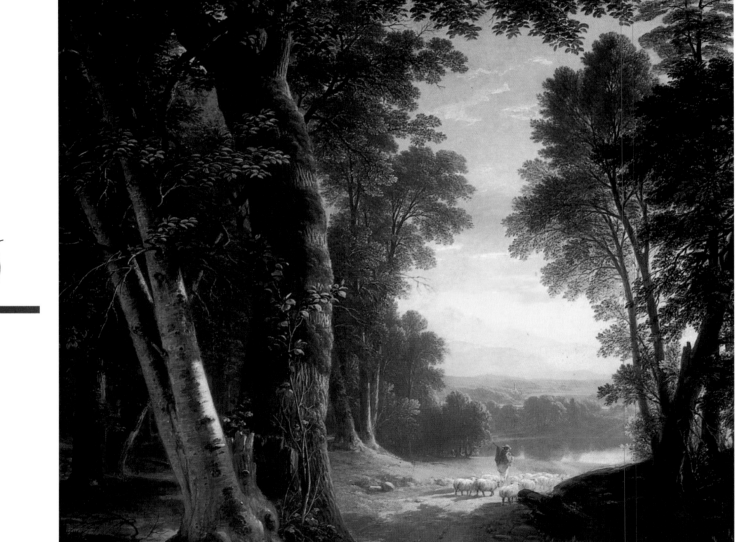

The Beeches.
ASHER B. DURAND.

his free time when not at work. Later, he dedicated himself to it full time and painted landscapes exclusively. Because he was one of the first Americans to do so, discovering the scenery of the virgin lands of this new country, he is considered to be one of the founding members of the Hudson River School. He applied paint directly onto the canvas, employing a fluid technique. In 1837 and 1845, he traveled to England and France. One of his noteworthy landscapes is *In Nature's Wonderland* (1835).

DUFOUR, CAMILLE-ÉMILE

(Paris, 1841–1918)

French painter. Dufour's landscapes place him within **Post-Impressionism,** and his work—full of successive triumphs, awards, and medals from 1877 to 1900—achieved official and public recognition. He started with the discovery of the Naturalist landscape, in search of light effects similar to **Corot's**, but his contact with **Monet**, with whom he painted in the town of Veteuil, brought him nearer to **Impressionism**. He found his favorite subjects in the scenery of Normandy, Brittany, and Provence, which he gradually treated with more and more independence and freedom, achieving a more innovative and advanced artistic style. Prominent among his works are *Village on the Banks of the Seine, View of Avignon*, and *View of Véteuil*.

DURAND, ASHER B.

(Jefferson Village, 1796–1886)

American painter and engraver and one of the chief representatives of the Hudson River School. Durand trained with the engraver Peter Maverick in New York City and was soon known as a virtuoso in engraving, whose principal characteristic was his mastery of detail; this was evident in his first major work, *The Declaration of Independence*, a replica of **Trumbull's** painting of the same name, which established his reputation. The detail in his engraving work also extended to his landscapes, a genre to which he would fully devote himself from 1835 onward. His work could now be considered **Romantic** and characterized by its lyricism and intimate atmosphere, reminiscent of Jacob van Ruisdael and evident in *The Beeches* (1845) and in *Kindred Spirits* (1849), his most representative work. Previously, he had made forays into portraiture; some examples of this are the portraits he made of all the presidents of the United States. He participated in creating The National Academy of Design and served as its president between 1846 and 1862.

Catskill Landscape.
ASHER B. DURAND.

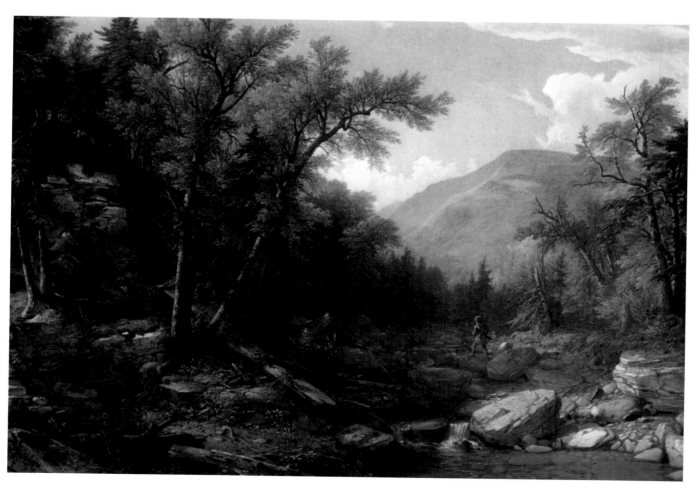

DYCE, WILLIAM

(Aberdeen, 1806–Streatham, 1864)

Scottish painter. Trained in Rome, where he encountered the **Nazarenes**, Dyce's work and style evolved until they were identified with the aesthetic ideals of the Pre-Raphaelites. He studied at the Royal Scottish Academy, Edinburgh, and later at the Royal Academy in London. He traveled to Rome on two occasions, first in 1825 and later in 1827, a stay that lasted for two years. There he painted *Madonna and Child*, which reflected his admiration for the Old Masters of Classicism, especially Raphael, to such a degree that this work attracted the attention of the Nazarenes. His deep religiousness and his somewhat delicate style drew him into friendship with this group, especially with its most representative members, **Overbeck**, **Cornelius**, and **Schnorr von Carolsfeld**. Even so, his work departed from the mysticism of this German group due to his interest in observing reality and nature. This trait is constant in the work he did upon his return to Scotland, especially in his portraits of the 1830s and in the landscapes he later painted. However, his frescoes and large-scale decorations were what brought him the most prestige and what made him the great expert on this subject in nineteenth-century England. He achieved this distinction due in large part to a prior official commission assigned to study fresco techniques in Europe. His works are found in the House of Lords, in Buckingham Palace, and in Lambeth and Osborne Palaces. Investigation also formed part of his education al duties, since from 1837 onward, he was a teacher at the School of Design in London, the first step on a progressive rise that culminated with his election as an associate of the Royal Scottish Academy. In his artistic evolution, his work gradually approached the philosophy of the Pre-Raphaelites. Religious subjects, some taken from the Old Testament, are prominent among his paintings

Titian's First Experiments with Color.
WILLIAM DYCE.

(*Christ and the Woman of Samaria* and *Joab Looses the Arrow of Grace*), as are landscapes, a genre in which he managed to capture realistically qualities of light and atmosphere through a precise observation of nature. Among all the disciplines he practiced, his cartoons for stained glass are outstanding. He was also excellent in music, as an organist who published studies on Gregorian chants.

Garden of Gethsemane.
WILLIAM DYCE.

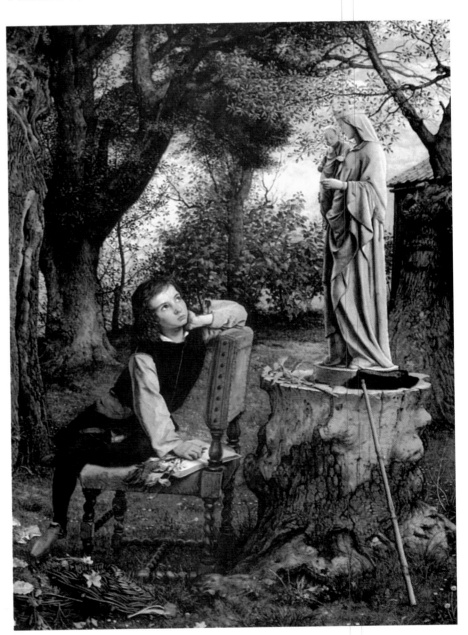

The Biglin Brothers Racing.
THOMAS EAKINS.

EAKINS, THOMAS

(Philadelphia, 1844–1916)

An American artist, a consummate painter in the historical genre and his country's chief representative of nineteenth-century **Realism**. Eakins studied in Paris from 1866 to 1870 with **Gérôme** and **Bonnat**. He made several trips through Europe and during those travels learned about the naturalism of the great Baroque masters, such as Ribera, Velázquez, and Rembrandt. This investigation and its influence led him to paint detailed works, using excellent draftsmanship that

had almost photographic realism This can be seen in his best work, *The Gross Clinic* from 1875, in which he employs knowledge gained from attending anatomy classes at Jefferson Medical College when he was a student in Philadelphia. However, he also demonstrates his desire for true realism, not just that which originated from Rembrandt's well-known work *Anatomy Lesson of Dr. Tulp*, but rather a scientific, contemporary realism, matching the reality of the major discovery of the effects of chloroform and anesthesia. With this painting, whose dimensions are large with life-size figures in the foreground, Eakins became one of the best Realist painters of the nineteenth century.

EASTLAKE, SIR CHARLES LOCK

(Plymouth, 1793–Pisa, 1865)

British painter and art historian. Eastlake studied with **Haydon** and **Prout** and broadened his knowledge during the trips he made to Italy and Greece. He soon made a name for himself with his famous painting *Napoleon on Board the Bellerophon* (1815), showing Napoleon and his party sailing away to exile on St. Helena. He lived in Rome from 1816 to 1830, during which time he produced landscapes of the environs of Rome and picturesque scenes of *banditti*, as well as numerous architectural studies. He also created religious and historical paintings, using a style in the manner of the Old Masters. From 1830

Lord Byron's Dream.
SIR CHARLES LOCK EASTLAKE.

onward, he dedicated himself primarily to arts administration and in 1850, was named president of the Royal Academy and director of the National Gallery. Another of his important works is *The Champion* (1824).

ECKERSBERG, CHRISTOFFER WILHELM

(Blaakrog, 1783–Copenhagen, 1853)

Danish painter, whose work can be classified somewhere between **Romanticism** and **Realism**. After studying in Copenhagen with N. Abilgaard, Eckersberg traveled to Paris in 1810, where he studied in **David**'s atelier and developed a close relationship with him. In 1813, he went to Rome to continue his training and stayed for three years. This was where he met Bertel Thorvaldsen, of whom he painted an excellent portrait in 1814, which was executed with a high degree of Classicism. Also, he painted numerous landscapes, among which the views of Rome—such as *View Through the Arcades of the Coliseum*—are outstanding. After returning to the city of his birth, he devoted himself to painting group portraits of lower middle-class people, with a detailed, almost naturalistic style, careful modeling,

and a great purity of line, reminiscent of **Ingres**. He also painted several seascapes, as seen from the Danish coast, showing tranquil, somewhat idealized waters, rendered with a marked Naturalism.

These brought him fame and had an influence on contemporary artists as well as establishing the bases for the Danish landscape painters who followed him. These disciples are considered to be their country's best painters in the first half of the nineteenth century. Eckersberg also created historical paintings and religious works with Biblical themes. In 1818, he was appointed professor at the Fine Arts Academy and its director in 1830. His painting progressively evolved towards an almost photographic, naturalistic realism, both in his landscapes and in his portraits. Other important works of his are *Portrait of Graf Preben Bille-Brahe and His Second Wife* (1817), *St. Mary in Aracoeli, Rome* (1813–1816), and *View of Copenhagen from the Trekroners Battery* (1836).

The Nathanson Family.
CHRISTOFFER WILHELM ECKERSBERG.

EDELFELT, ALBERT GUSTAV

(Helsinki, 1854–Borga, 1905)

Finnish painter. Along with Gallen-Kallela, Edelfelt was Finland's most important nineteenth-century painter. After beginning his painting studies in Helsinki and Antwerp, he settled in Paris for a time, where he was **Gérôme**'s student. At first, he painted historical subjects, but later, influenced by the "plein air" artists in the Naturalism movement, such as his friend **Bastien-Lepage**, he changed his approach to painting entirely. As a result, he produced works that had a wonderful light quality and depicted scenes showing the customs and manners typical of the Finnish and Russian people. Examples of this style can be seen in *December Day in Finland* and in landscapes with figures, which are at times Biblical, such as *Christ and Mary Magdalene*, which he painted in 1890. In his last stage as a painter, he devoted a significant part of his work to denouncing Finland's situation under Russian op-

ℰ

ℰ

Masks.
JAMES ENSOR.

pression, producing paintings that depicted moments in his country's history. He was also a notable portraitist and is probably the most famous of the numerous artists who painted the great scientist of the day; his *Louis Pasteur in His Laboratory* (1885) is world famous. He also did portraits of the family of Czar Alexander III, having been summoned to Russia by the Emperor to paint his daughters' portraits. He also worked in illustration. Some of his other noteworthy paintings are *Summer Afternoon in Finland* and *Copenhagen.*

Paris in the Snow.
ALBERT GUSTAV EDELFELT.

EGOROV, ALEXEI EGOROVICH

(Russia, 1776–St. Petersburg, 1851)

Russian painter. Trained at the Fine Arts Academy in St. Petersburg (where he would be a drawing teacher from 1798 onward) and a pupil of Grigori Ougriumov, he devoted himself to historical painting, although he also did some portraits and religious works as well. Egorov completed his training in Italy, which greatly influenced and altered his style. This caused problems for him when later he came to paint icons of Our Lady of Kazan, causing him to fall into disfavor with Czar Nicholas I who did not like the way he interpreted them.

Known as "The Russian Raphael," both his compositions and his draftsmanship were of high quality. Among his works, which are in museums in St. Petersburg and Moscow, the most prominent ones are the portrait of his student *Soukhnov* and the one he did of *Princess Galitzine Painted as 'Sybil.'*

ENSOR, JAMES

(Ostend, 1860–1949)

A Belgian painter and illustrator, Ensor's work was outside of the move-

101

Christ's Entry into Brussels.
JAMES ENSOR.

ℰ

However, he regularly sent his works to the Paris Salons, where they were rejected time and time again. He joined the *Les Vingt* ("The Twenty") group, which expelled him in 1888 because the subject matter of his *Christ's Entry into Brussels* was considered scandalous. In this painting, his interest in masks and skeletons can be clearly seen, an obsession that would accompany him throughout his career; also it expressed scathing criticism of the bourgeoisie. His work had a strong impact on the art movements of the first decades of the twentieth century, especially on the German Expressionists, and on some of the painters of the School of Paris (École de Paris), such as Marc Chagall and the Surrealists.

ments and the aesthetics of the nineteenth century. He began to draw and paint at a very early age, studying with some painters in his native city. In 1878, he took the only trip he made in his entire life, going to Brussels to study at its Academy; there his special focus was the paintings of the French Impressionists. Two years later, he returned to his hometown, where he lived for the rest of his life.

A Poetry Reading by Zorrilla in the Artist's Studio.
ANTONIO MARÍA ESQUIVEL.

ESPALTER I RULL, JOAQUÍN

(Sitges, 1809–Madrid, 1880)

Spanish painter, trained at the Lonja School in Barcelona and in Paris, where he was a student of **Gros**. In 1833, he traveled to Rome and encountered the group of Catalan **Nazarene** painters who had established themselves there. In 1842, he moved to Madrid, where he lived the rest of his life, and where he achieved fame as a high-society portraitist and painter of historical subjects. Noteworthy works of his are the portrait of his wife, *Señora Espalter* and his historical paintings, *The Moor's Sigh* and *Columbus at His First Meeting with the Indian Chiefs*. He was a member of the Academy of San Fernando from 1843 on and a teacher at the Fine Arts School starting in 1857. He also participated in the artwork decorating different buildings in Madrid, such as the Gaviria Palace, Congressional Palace, and the assembly hall of the Universidad Complutense.

ESQUIVEL Y SUÁREZ DE URBINA, ANTONIO MARÍA

(Seville, 1806–Madrid, 1857)

Spanish painter. A prominent figure in the cultural **Romanticism** of Isabelline Madrid. His training began at the Fine Arts Academy in Seville, following Neoclassical principles and those inherent in the Andalusian School. In 1831, he moved to Madrid and in that year, became a full academician, while later in 1833, he founded the Artistic and Literary Lyceum, which was sponsored by the queen. At that time, he composed religious works inspired by Murillo models. After his return to Seville in 1838, he was affected by an eye ailment which caused his vision to deteriorate. In a precarious financial situation and seriously ill, he was aided by **Genaro Pérez Villaamil** and other friends at the Artistic and Literary Lyceum, who took up a subscription which enabled him travel abroad and recover. He expressed his thanks by creating one of his most famous works, *The Fall of Lucifer*, which he presented to the Lyceum. Although he embraced all genres, including mythological and historical painting, his most brilliant and prestigious area was as a portraitist, especially in his well-known group portraits such as *A Reading by Ventura de la Vega to Actors of His Time*, and above all, *A Poetry Reading by Zorrilla in the Artist's Studio*, which pays tribute to the Romantic intellectual circles in Madrid.

ETTY, WILLIAM

(York, 1787–1849)

English painter. Most of Etty's work was in the historical genre using an eminently Romantic style. Of humble birth, he worked in different trades until, at the age of twenty, he entered the Royal Academy in Lon-

103

The Kiss.
EDVARD MUNCH.

don, where he studied under **Thomas Lawrence**. He devoted himself to copying the compositions of the great masters in museums and to creating his first works, such as *Sappho* and *Telemachus Saving Antiope*, which when exhibited, achieved great success and were immediately purchased. In 1816, he visited Paris and Florence. The prestige resulting from his grandiose compositions led him to study the classical Italians, returning to Italy in 1822 for this purpose. Among his prominent works are *Pandora Crowned by the Seasons* (1822), *The Coral Fishers* (1825), and the triptych known as *Judith* (1827–1831), which tells the story of the people of Israel. After a time, he resigned from his position as academician and left London to return to his birthplace, where he died.

EVENEPOEL, HENRI-JACQUES-EDOUARD

(Nice, 1872–Paris, 1899)

A French painter of Belgian parentage, Evenepoel can be considered as part of the Post-Impressionism movement, since his work fits within the various artistic trends that arose at the end of the nineteenth century. Coming from a family of artists, he studied in Brussels in the atelier of the painter Blanc Garin. In 1892, he went to Paris to continue his studies at the Fine Arts School. There he was influenced by **Gustave Moreau**'s work and made contact with the most advanced painters of that time, among them Henri Matisse and Georges Rouault. He also

admired the work of **Degas**, **Toulouse-Lautrec**, and **Manet**. The exhibitions of his work in Paris (1894) and Brussels (1898) were well received, but his true style was forged in a trip through Algeria, an experience that gave him renewed vigor in his compositions and in the luminosity of his colors. *The Spaniard in Paris* and *Portrait of the Painter Paul Baignières* are his most noteworthy works. He died at the age of twenty-seven.

EXPRESSIONISM

A cultural movement that affected art and painting, as well as literature, poetry, theater, and film. It is complex to define, since it is based on the theory that the subjective essence of the artist is a valid expression of the natural and external aspects of things. According to this theory, expressionist painting is an intellectually subjective interpretation which is a reaction against the exactness of a portrait or a landscape according to Realism, preferring instead the distortion and exaggeration of the natural qualities of reality: a whole area related to the recently discovered "unconscious," in which the theories of Sigmund Freud were very important. However, as an artistic attitude, the roots of expressionism can be sought in numerous works of art from the past, especially the painting of the European primitives, figures such as Cranach, Holbein, and Dürer. At the end of the nineteenth century, the first expressive contributions were a reaction to the pictorial representations of **Impressionism**, which was bent on capturing the reality of light and its atmospheric effects, of people and landscapes immersed in an atmosphere of light and shadow. From this perspective, expressionism reflects an internal attitude, painting with one's "soul" and interpreting reality. It is a term that is applied to German art, specifically to the artists of the "modern movement" of Berlin and Munich. However, the original bases of pictorial expressivity are found in artists such as **Cézanne** and, above

Landscape in the Bern Region.
FERDINAND HOLDER.

ℰ

Middle-Class Drawing Room.
JAMES ENSOR.

all, **Gauguin** and **Van Gogh**, and in all of those encompassed by the artistic renewal of **Post-Impressionism**. The painters **Ferdinand Holder** and **Edvard Munch**, with his works *The Kiss* and *Rue Lafayette*, as well as **James Ensor**, who painted *Middle-class Drawing Room*, among other artists, can be considered the starting point of the expressionistic esthetics that affected numerous cultural manifestations prior to and after the First World War, esthetics that continued up until the 1930's in Germany.

Rue Lafayette.
EDVARD MUNCH.

E.Munch 91

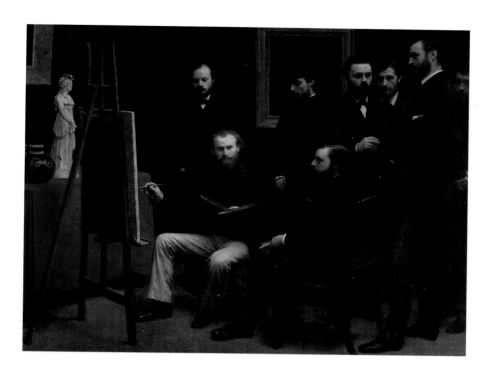

A Studio in Batignolles.
HENRI FANTIN-LATOUR.

and to show his deep admiration of Richard Wagner, he made a series of illustrations for the publication of his operas.

FATTORI, GIOVANNI

(Livorno, 1825–Florence, 1908)

An Italian painter, he was the most important representative of the

Self-Portrait.
HENRI FANTIN-LATOUR.

FANTIN-LATOUR, HENRI

(Grenoble, 1836–Buré, 1904)

French painter and engraver, his work can be classified as pictorial **Realism**. The son of a painter and a student of **Courbet**, he was an excellent artist, painting still lifes, flowers, and portraits with a stippled technique, soft colors, and a quality in the textures that give his work an almost photographic appearance. He was unsuccessful at the 1861 Salon, but the paintings he did years later were well received by critics, such as the famous *Homage to Delacroix*, from 1864, in which he portrayed himself along with **Whistler**, Baudelaire, and other artists and intellectuals. This group portrait was following by *A Studio in Batignolles*, in 1870. Also noteworthy are *Narcissi and Tulips* and *Still Life with Flowers and Fruit*, as well as his *Self-Portrait*. In addition to painting, he created lithographs,

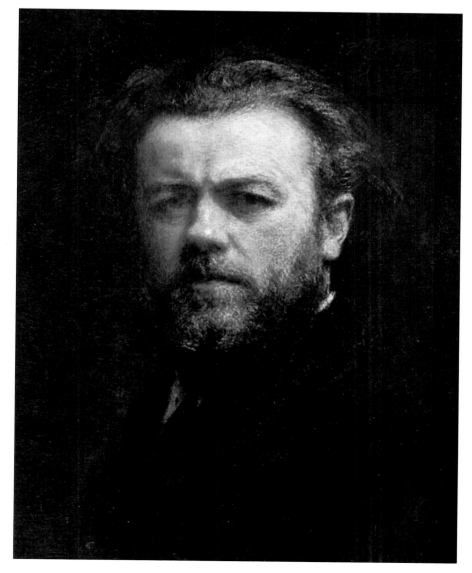

Still Life: Nasturtiums.
HENRI FANTIN-LATOUR.

F

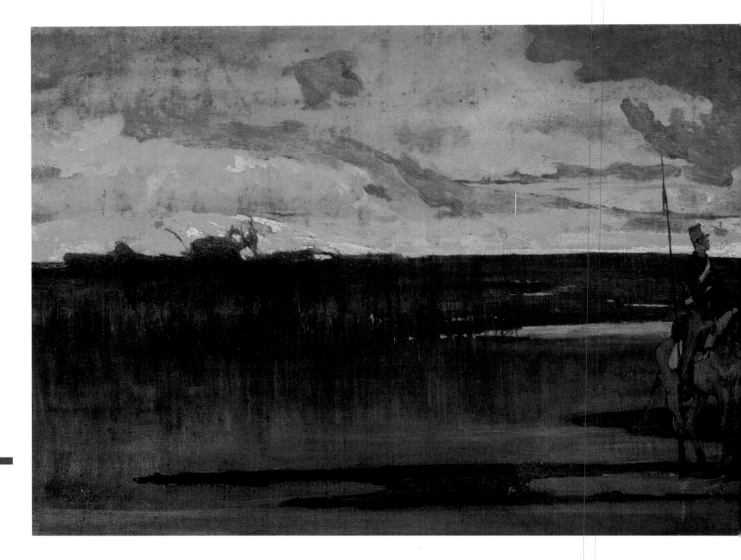

Lancer by the Sea.
GIOVANNI FATTORI.

Macchiaioli group, an art move-
ment that developed in Italy
around the 1860s under the aus-
pices of **Realism** and whose center
was Florence. Fattori began his
studies and his artistic creations at
the Fine Arts Academy in that city.
His first works were large paint-
ings on military subjects, such as
Battle of Magenta (1862); themes
that were very common among the
painters of the Macchiaioli group
and which were a result of the na-
tionalistic relationship they estab-

Mary Stuart and the Fallen Douglas.
GIOVANNI FATTORI.

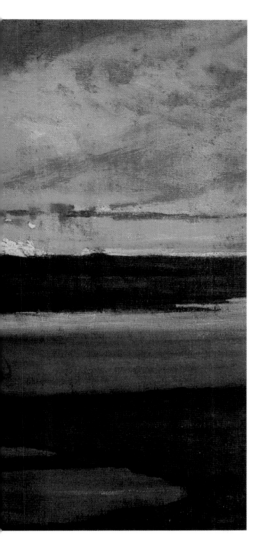

is considered his best work. His *Self-Portrait at the Age of Sixty-Nine* from 1894, is also worthy of mention.

FAVRETTO, GIACOMO

(Venice, 1849–1887)

Italian painter. At first, Favretto learned the basics of painting with an almost unknown painter, but his aptitude enabled him to enter the Venice Academy to study. This would influence his style, although his primary influence came from the masters of the past, whom he especially admired. For quite a long time, his work was close to the style of the **Macchiaioli**, but later it gradually evolved towards an accomplished **Realism** and at times Naturalism. He was also true to the Venetian tradition, especially in his marked sense of color, so characteristic of the painters from that city throughout history. His chromatic

values had a quality and strength that were special among all of the Venetian Naturalist painters of the time, who—along with Favretto—were reconsidering that movement's style in an attempt at innovation. Among his works, whose quality was very high, with refined, harmonious colors, *The Ribbon* and his portrait of *The Guidi Family* stand out.

FEDOTOV, PAVEL ANDREIEVICH

(Moscow, 1815–St. Petersburg, 1852)

Russian painter and poet working in the style of Realism. He joined the army, and at the same time, attended class sporadically at the Fine Arts Academy as an unregistered student; he was also a pupil of **Alexis Venetsianov**. His visits to the Hermitage and his relationship with **Briullov** rounded out his training. When he reached the rank of captain, he left the army in

lished with the wars of the Risorgimento, the struggle to unify Italy and drive out foreign domination. In fact, Fattori was a member of the Action Party in 1868. Another significant example of his patriotic art is *The Patrol* (1885). Fattori did a great variety of small-format work, varied in both the media used (oil, watercolor, ink, and pencil) and in the subjects these works encompassed (portraits, landscapes, and genre scenes). His most outstanding works are *French Soldiers*, *Diego Martelli on Horseback*, and *Woman in a Forest*, although without a doubt *La Rotonda di Palmieri*, from 1866,

The Difficult Bride.
PAVEL A. FEDOTOV.

Young Widow.
PAVEL A. FEDOTOV.

his artistic attention on genre and customs and manners painting, although he was also an outstanding portraitist. He painted from life, trying to reflect the world that surrounded him, in a style filled with humor, but at times cynical, in which an intent to moralize can be perceived. This is especially true in his small-format paintings, where he represented his country's bourgeoisie in a caricaturesque style: (*The Major's Courtship, Officer Making a Dog Jump,* and *The Proposal*). His work is along the same lines as **Boilly**'s, Paul Gavarni's and Russian satirical drawing, as well as that of the English school of caricature. However, his later works lost their caricaturesque content and their narrative skill, which had been significant in his first period. Now some paintings appeared in which the artist's solitude could be felt. His extraordinary **Realism** is noteworthy, leading some authors to call him "the Gogol of painting,"

Portrait of the Gerbine Children.
PAVEL A. FEDOTOV.

1843 to devote himself completely to painting: a profession he pursued until he was committed to a mental institution, where he would end his days after a life of deprivation. His time in the military affected the subject matter of his first paintings, many of them watercolors, alternating with pencil drawings, in which he represented life in the barracks. Later, he focused

and the way he composed his paintings is also notable, in the manner of a scene from a play. His works demonstrate great pictorial quality, supported by careful draftsmanship and brush strokes using little paint. Many of his paintings of interiors show the influence of the Dutch masters, especially in their meticulous detail. Unlike his genre painting, his portrait work is characterized by its intimism, and therefore, it avoids mockery: (*T. E. Jakovieff, E. P. Rostopchin*). Other important paintings from his extensive body of work are *In the Storeroom, Young Lady in Danger, Fidelka Ill, Young N. Idanova Playing the Piano, Capricious Bride, Young Widow*, and *Gamblers*. As with **Ivanov**, his art would also have a tremendous impact on later generations of Russians.

FERRANT Y FISCHERMANS, ALEJANDRO

(Madrid, 1843–1917)

Spanish painter of religious and historical subjects. He was trained under the purist influence of his uncle, Luis Ferrant Llausas, and at the Fine Arts Academy of San Fernando in Madrid. His participation in national exhibits brought him great prestige as well as financial assistance to study in Rome. He practiced genre, historical, decorative, and religious painting with equal skill. Among his religious works, *St. Ferdinand's Last Communion* is of special interest. Upon his return home, he devoted himself to the pictorial decoration of different buildings, producing one of his most noteworthy works,*Sibyls and Prophets* in the dome of the basilica of San Fran-

St. Ferdinand's Last Communion.
ALEJANDRO FERRANT Y FISCHERMANS.

cisco el Grande in Madrid. In that city, he also took the position of directing the Museum of Modern Art.

FERRANT Y LLAUSÁS, FERNANDO

(Palma, Majorca, 1810–El Escorial, 1856)

A Spanish painter with academic training, he reached a rather honorable position among Spanish landscape artists. He studied at the Royal Academy of San Fernando in Madrid, and with the patronage of the Infante Sebastián Gabriel, he obtained a grant for the Spanish Academy in Rome. In spite of his exces-

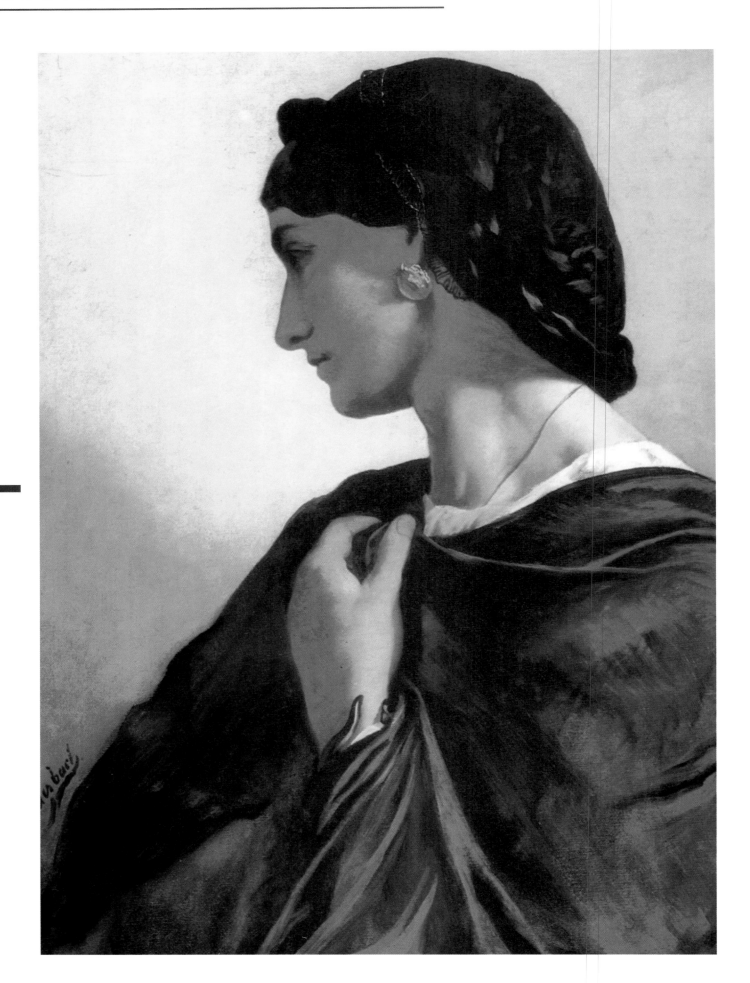

Nanna.
ANSELM FEUERBACH.

sively technical and elaborate style, some of his landscapes achieved a certain lyricism related to a Romantic view of nature, such as *Landscape with Lake and Shrine in Ruins*, a work dating from around 1845.

FEUERBACH, ANSELM

(Spira, 1829–Venice, 1880)

Considered one of the best German painters of the nineteenth century, his work fits within a type of intellectual painting, using heroic and mythological subjects and characterized by great refinement. Feuerbach was born into a cultured family and was the son of an archaeologist and the nephew of the philosopher Ludwig Feuerbach. He was trained at the Düsseldorf Academy, where he studied under the direction of the painter **Wilhelm von Schadow** and then at the Munich Academy; Carl Rahl was one of his teachers. He traveled to Paris in 1851 and lived there until 1854. He met two artists with diametrically opposite artistic backgrounds, **Courbet** the Realist and **Couture** the Academicist. The influence of both is reflected unequally in some of his works, such as *Hafiz Outside of the Tavern* (1852), which followed "Courbetian" innovation, and *The Death of Aretino* (1854), whose composition is rooted in academic tradition. His trip to Italy in 1855 marked a turning point in his work, when he devoted himself entirely to mythological and allegorical sub-

jects, working for Prince Friedrich von Baden. In Venice, Florence, and above all in Rome, where he studied the classics, he painted his most renowned compositions, such as *Medea* (1870), *Iphigenia* (1871), and the studies for *Battle of the Titans* (1873), works in which he attempted to capture a heroic and sublime personality, with refined colors and

somewhat melancholy figures. Summoned to take the position of teacher at the Fine Arts Academy in Vienna, he moved to that city in 1873 where he lived until 1876. He painted *Fall of the Titans* on the ceiling of one of the rooms in this institute: a painting that is Baroque in its arrangement and in the way it strives for effect. Three years lat-

Iphigenia.
ANSELM FEUERBACH.

F

Nude Young Man by the Sea.
HIPPOLYTE FLANDRIN.

er, he returned to Venice where he died in 1880.

FIELDING, ANTHONY VANDYKE COPLEY

(East Sowerby, Halifax, 1787–Worthing, Brighton, 1855)

English painter and watercolorist, primarily in the area of Romantic landscapes. At first, he studied with his father and later was a pupil of John Varley. Early in his studies he began specializing in watercolors. A prolific painter, he dedicated himself not only to de-

picting poetic landscapes but seascapes in particular, in which the influence of Richard Wildson can be seen and which would bring him popularity. Until 1814, his favorite motif for his paintings was Wales, but he later focused on coastal areas due to the long periods he was obliged to spend there. In 1824, his work was awarded a medal at the Paris Salon, and seven years later, he was named president of the Old Water-Colour Society. Among his many works, which are executed carelessly since he considered painting a vehicle to transmit feelings, *Sunset* (1819) should be mentioned. In addition to his acceptance in England, Fielding also had an influence on French Romantic landscape artists.

FLANDRIN, HIPPOLYTE

(Lyon, 1809–Rome, 1864)

French historical painter. He studied with **Ingres**, and in 1832, his work *The Recognition of Theseus by His Father* was awarded the Prix de Rome. His best works were the frescoes he painted to decorate the Parisian churches of Saint-Séverin (1839–1841), Saint-Germain-des-Prés (1842–1843), and Saint-Vincent-de-Paul (1849–1853), as well as those in Nîmes (1847–1849) and Lyon (1855), in which he totally distanced himself from Academicism and which because of their coldness and ostentation, approach the **Nazarene** style. He also excelled at portraits, becoming the official portraitist of

Napoleon III, whom he painted several times, as well as the great society personalities of the Second Empire (*Portrait of a Lady* and *Madame Vinet*).

FONSECA, ANTONIO MANUEL DA

(Lisbon, 1796–1890)

Portuguese painter dedicated to historical painting and portraits, who worked within the Neoclassical and Romantic styles, depending on the genre. A pupil of **Peter von Cornelius** in Germany, Fonseca was also in Rome for several years (1826–1834), training with **Camuccini**. The following year, now back in his own country, he set up a solo exhibition of his work which was the first one of its type in Portugal. Previously, he had been named court painter, and in 1836, with the creation of the Fine Arts Academy in Lisbon, he was named teacher there; this institute played a key role in the assimilation of **Neoclassicism** in Portugal. He was also a member of the Fine Arts Academy in Paris (1862) and of the Spanish Academy of San Fernando (1872). In his pictorial work, especially in his historical paintings, he observed the principles of mythological Neoclassicism that he had studied in Rome, an example of this being *Aeneas Fleeing Troy* (1843). A good many authors feel that this was the last work in the Neoclassical style to be done in Portugal.

FONTANESI, ANTONIO

(Reggio Emilia, 1818–Turin, 1882)

An Italian painter and engraver, he is considered to be one of the great masters of landscapes in his country, within a style that varied between elements taken from **Romanticism** and Symbolism. Trained at the Turin Academy, where later he would work as a teacher, he extended his studies by making several trips abroad. In Switzerland, he saw **Corot**'s work, and while in London he had the opportunity to be exposed to **Turner**'s painting, for whom he professed great admiration. Upon his return, he lived in the Tuscany region and had some contact with the **Macchiaioli** group. His rural scenes presented views of places as seen at twilight, with rich coloring. In works like *November, April* and *The Ford*, he achieved symbolic compositions of outstanding charm and lyricism.

April.
ANTONIO FONTANESI.

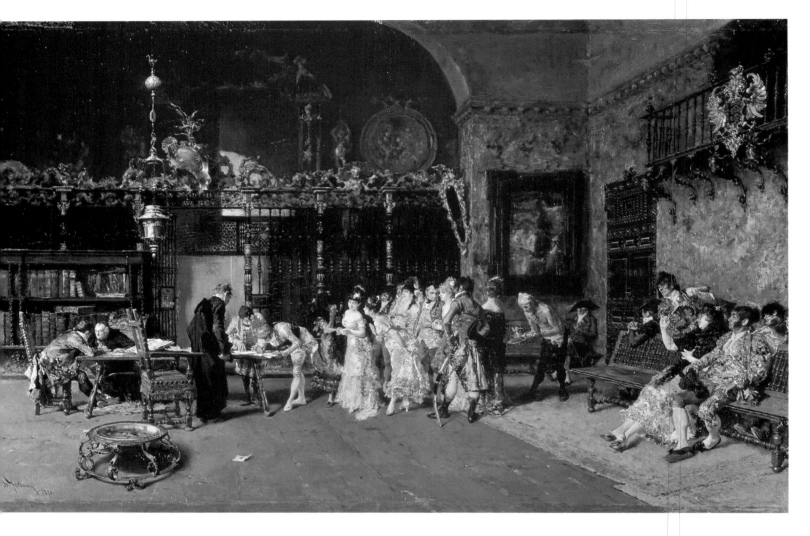

The Vicar's Office.
MARIANO FORTUNY.

FORTUNY I MARSAL, MARIANO

(Reus, 1838–Rome, 1874)

Spanish painter. This artist's careful and exquisite work is, without a doubt, among the most famous internationally, and a clear example of the Euphuistic movement that invaded areas of European painting beginning in mid-century. Orphaned as a child, he first was exposed to art in his grandfather's craftsman's studio and in the atelier of a humble painter in the city of his birth. At the age of fifteen, he moved to Barcelona to study as a scholarship student at the Fine Arts School. His teachers there were Pablo Milá i Fontanals and **Claudio Lorenzale**, **Nazarene** painters who influenced him in the subject matter for his paintings and led him to perfect the technique of engraving. In 1857, the Barcelona Council granted him a scholarship to study in Rome, and during this stay, he was able to initiate relationships with other painters established there, such as **Rosales** and **Palmaroli**. Two years later, he was sent to Morocco as a graphic reporter in the Spanish-Moroccan war. Some obvious traits of his African work were an orientalization of his subject matter, as well as a new way of understanding outline, light, and color; this work revolved around war sketches, street scenes, and fascinating odalisques. Upon his return to Madrid, he met **Federico de Madrazo**, whose daughter he would marry in 1867. In 1862, he made a second trip to Morocco in order to compose an enormous war painting of *The Battle of Tetuán* and document other important battles in the conflict. During a later stay in Rome, from 1865 to 1870, influenced by the *pompier* ("conventional") style and by **Meissonier**'s work, he began his own characteristic euphuistic style. The virtuosity and careful, formal quality of his technique informed his work in paintings such as *The Stamp Collector* and *The Vicar's Office*, which he completed in Paris. In 1870, he moved to Granada, a city where he began painting more decorative and

Chalk Cliffs of Rügen.
CASPAR DAVID FRIEDRICH.

picturesque subjects: views of the Alhambra and popular scenes. In 1872, he returned to Rome, where he died two years later, after having moved in his last work to a style that was closer to **Impressionism.**

FRIEDRICH, CASPAR DAVID

(Greifswald, 1774–Dresden, 1840)

A German painter and artist who was fundamental to the development of nineteenth-century landscape painting in Europe; it has been said that he was "the most Romantic painter." Friedrich trained at the Copenhagen Academy from 1794 to 1798. Afterwards, he settled in Dresden, where he lived for the rest of his life, making occasional trips to Central Europe, especially to northern Bohemia. He was elected to the Dresden Academy, and in 1824, was hired as a teacher. The German and Bohemian land-

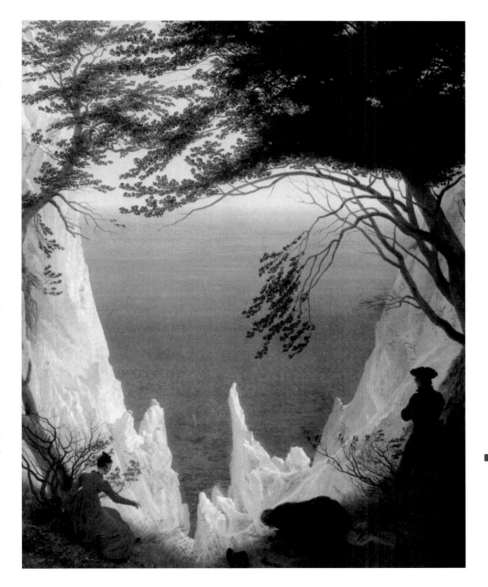

scapes that he studied on his travels decisively influenced his special and deep vision of nature. An example of this is the well-known *Tetschen Altar or The Cross on the Mountain* (1808), a painting that was initially intended for the altar of a private chapel and one of the first works on which he put the stamp of his concept of a "sublime landscape," a new style that would be widely imitated. His Realist style, unknown at the time and seen as outrageous, was marked by a feeling of loneliness and determined

Moonrise Over the Sea.
CASPAR DAVID FRIEDRICH.

by the strength and precision of his exemplary draftsmanship. In *Woman at the Window*, a painting from 1822, his interest in the use of solitary figures in his compositions can be noted. These beings acquire a great presence and poetry in his compositions of mountainous, rugged landscapes, frequently shown with cliffs and precipices, as in *Wanderer Above the Sea of Fog* (1818) and *Chalk Cliffs of Rügen* (1818), in which the figures in the

The Bridge of Love.
WILLIAM POWELL FRITH.

foreground with their backs to the viewer transmit a strong sense of solitude and melancholy. Considered a painter-philosopher, he had friendships with Central European painters, some of them belonging to the German **Nazarene** group that had settled in Rome, and also with scientists—a relationship that may explain the empirical objectivity that some of his works show: light at dawn, mists, fogs, rainbows, storms, and shady forests. Some compositions, such as *Hunter in the Forest* (1813–1814) and *The Sea of Ice (The Wreck of Hope)*, are a reflection

The Railway Station.
WILLIAM POWELL FRITH.

of the patriotism that characterized him. Other masterpieces are *Moonrise Over the Sea*, from 1822, and *Mountain Landscape with River*, a work painted between 1830 and 1835.

FRITH, WILLIAM POWELL

(Studley, 1819–London, 1909)

An English painter, specializing in historical painting and genre scenes, who had a brilliant career with one success after another at various exhibitions. His artistic beginnings were in Bloomsbury, and later at the Royal Academy, where he became a full member in 1855. His pictorial style shows very fine and precise brushstrokes, and among his works, *Village Shepherd* (1845), *Hogarth Brought Before the Governor of Calais as a Spy* (1851), and *The Derby Day* are the most noteworthy. This latter work is from 1858 and is one of the paintings that brought him the most renown. *The Railway Station* is also considered one of his best

Desert Scene.
EUGÈNE FROMENTIN.

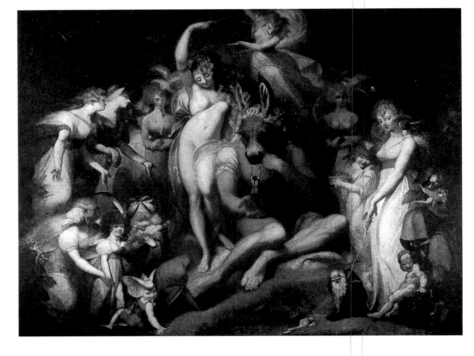

paintings, which was made popular through engravings.

FROMENTIN, EUGÈNE

(La Rochelle, 1820–St.-Maurice, 1876)

A French Romantic painter, he was first and foremost a novelist, critic, and art historian. At the age of twenty, he began his artistic activity, encouraged by the advice of Louis Cabat and the influence of the orientalist painter Prosper Marilhat. His enthusiasm for paintings with exotic and oriental subjects led him to make his first trip to Algeria in 1846. His sojourn there was quite productive, resulting in a series of landscapes with figures, executed in a refined style and with a warm palette, that he exhibited at the 1847 Salon. He returned to North Africa on two further occasions to create oriental landscapes of great charm, showing deep knowledge of the effects of sunlight on color. Among his works, *Egyptian Women Next to the Nile* and *The Pond at the Oasis* should be mentioned. However, Fromentin's real fame came from his novel, *Dominique* , and to his studies on art history, which surpassed his art work, especially an essay on the painting of the modern Dutch school, *Les Maitres d'Autrefois* ("The Masters of Past Time"), published in 1876.

FÜSSLI, JOHANN HEINRICH

(Zurich, 1741–London, 1825)

A Swiss painter, draftsman, illustrator, and writer, most of whose artistic career took place in England, where he adopted the name Henry Fuseli. His work, which chronologically fits into early Romantic Classicism, shows great originality, based on literature, epic poetry, and fantastic, dreamlike visions, that were unknown at the time. The son of an artist and an art critic with deep religious convictions, he began his studies in his native city, finishing with solid humanistic training and a deep knowledge of the great works of literature. He began his ecclesiastical career and, in 1761, was ordained a minister of the Swiss Reform Church. Because of political problems, he had to flee to Berlin in 1763, where he came into contact with Neoclassical circles and the

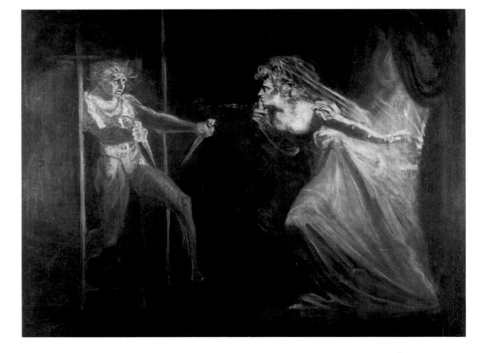

theories of Winckelmann and Mengs. One year later, he went to England, where he worked as a translator and earned his living illustrating the works of Shakespeare, Dante, and Milton. His friend, the painter **Joshua Reynolds**, encouraged him to devote himself to painting, so he set forth on a trip to Italy, where he indertook a self-taught apprenticeship that lasted for nearly eight years. After passing through Venice and Naples, he arrived in Rome in 1770 and dedicated himself to copying Michelangelo's Sistine Chapel paintings. This artist's influence is evident in the monumentality of Füssli's figures, in his Mannerist poses, and in the

The Nightmare.
JOHANN HEINRICH FÜSSLI.

destruction of real space. Over time, he wrote important studies on the genius he so admired. One of his first paintings was *Death of Cardinal Beaufort*, which he sent to the Royal Academy in 1774. However, the work that caused the greatest impact among his contemporaries was *The Nightmare* (1790), a creation of which he made four versions and which surprised the English public because of the extravagant and gloomy fantasy of the subject he chose: the nocturnal nightmare of a woman and the symbols that surround it, a subject that has a parallel in the horror literature that was in vogue at the time, especially in the Gothic novel. The same type of parallel is found in the fantastic works and visions of his friend **William Blake**. He made other

compositions that illustrated epic poems of Scandinavian or Greek mythology, such as *Thor Battling the Midgard Serpent* (1790) and *Ulysses Between Scylla and Charybdis* (1795), works in which he continued to demonstrate Michelangelo's influence, with monumental figures that lose their classic form in an unreal atmosphere and a treatment of color that was absolutely unheard of. The series of illustrations that he did for literary texts was important in his work, such as those for Milton's *Paradise Lost*, Fouqué's *Undine*, or those he did for the publication of different sagas, such as *Song of the Nibelungs*. He entered the Royal Academy in 1788 as a member, and two years later as a teacher of drawing, aesthetics, and the history of painting.

GALWEY, ENRIC

(Barcelona, 1864–1931)

Spanish painter, trained at the Fine Arts School in Barcelona. He specialized in landscapes and was a prominent member of the Olot School, along with **Joaquín Vayred**, under whom he studied. His work depicts rural settings with somber colors but with an intimate, vital quality caused by the atmospheric quality he creates in his paintings. Among his works, the most important ones are *Fertile Land* and *After the Storm*, the latter painted around 1906.

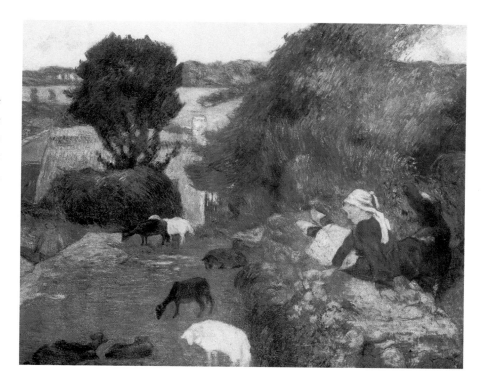

GAUGUIN, PAUL

(Paris, 1848–Atuona, 1903)

A French painter, Paul Gauguin was one of the leaders of the Post-Impressionist movement. Beacuse of his work, the Symbolist art movement found a new direction and opened the way for the development of the anti-naturalist, expressive tendencies of the twentieth-century avant-garde styles, such as Fauvism and **Expressionism**. He spent his youth as a sailor, and at the beginning of the 1870s, became a stockbroker. In the meantime, he was fond of painting and was a modest collector. Through his friendship with **Pissarro**, he left his job in 1883 to paint full time, adopting the technique of the Impressionists, with whom he exhibited until 1886. That year, he visited the Breton town of

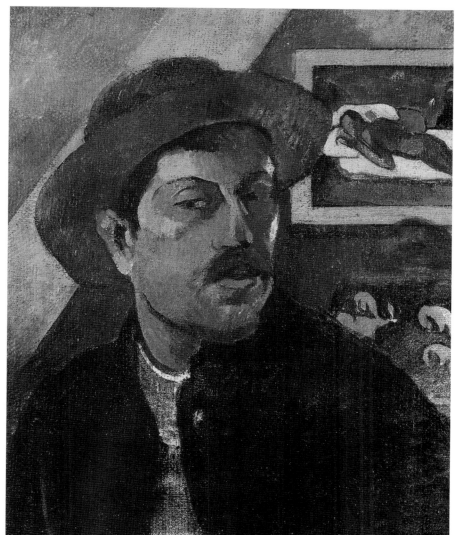

Left: *Martinique Landscape.*
Above: *Breton Shepherdess.*
Right: *Self-Portrait.*
PAUL GAUGUIN.

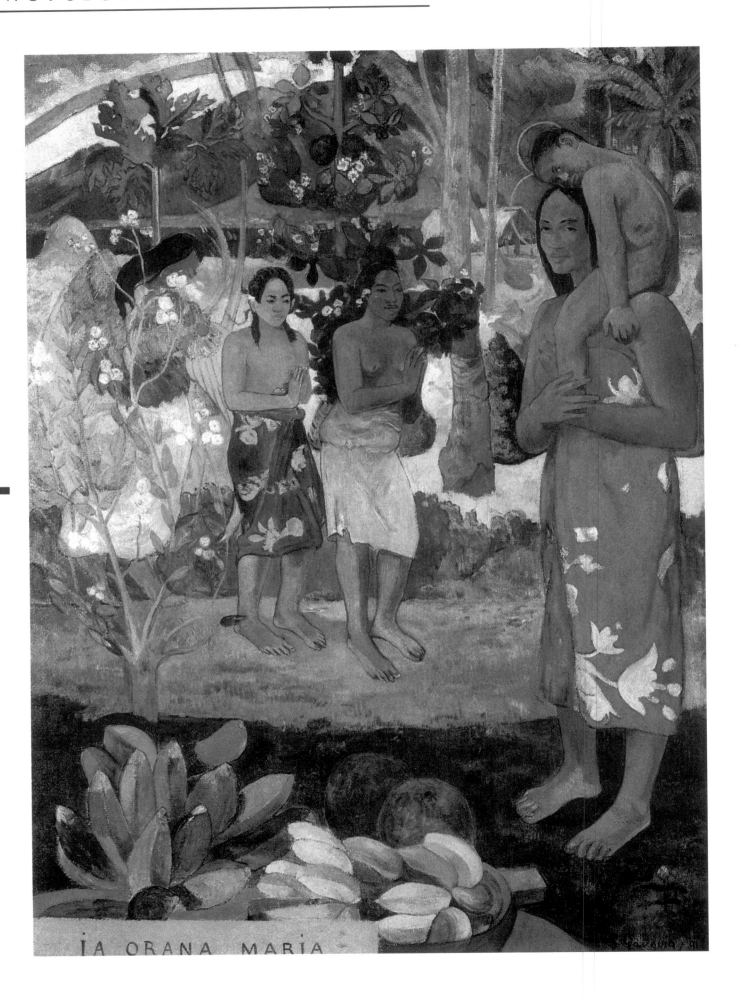

IA ORANA MARIA

Left: *La oura amaria.*
Right: *Old Women at Arlés.*
Below: *Arearea (Joyousness).*
PAUL GAUGUIN.

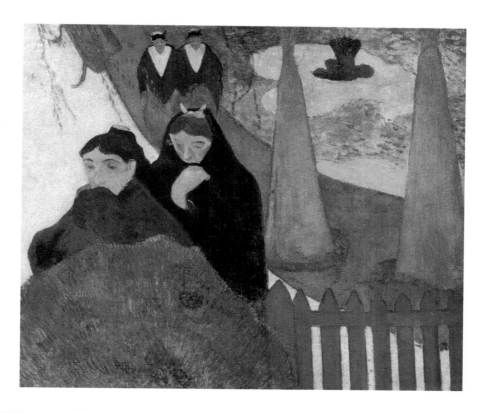

Pont-Aven for the first time, a place to which he would return in 1888, when he had abandoned **Impressionism** in search of a painting style that would be more synthetic and expressive, while at the same time symbolic and primitive. This change of direction became apparent in his exhibitions with the French symbolists in Paris and Brussels during 1889. His paintings at that time were simple compositions, rural scenes, and portraits that, nevertheless, were visual metaphors, such as *Vision After the Sermon (Jacob Wrestling With the Angel)* (1888), *Self-*

Vahine no te vi (Woman with a Mango).
PAUL GAUGUIN.

Portrait: Les Miserables (1888), and *The Swineherd* (1889), works that, like *Le Christ Jaune* ("The Yellow Christ"), presaged a tendency towards abstract compositions. In Pont-Aven, he encountered **Émile Bernard**, a painter who had experimented with form and color, giving rise to Cloisonnism or compartmentalism, a technique that enclosed colored areas within thick outlines. Gauguin made this technique a completely personal style, and a group of painters united around him to form the Pont-Aven school, linked to the **Nabis** movement. In 1891, he sold all of his paintings and set forth on a trip to Polynesia in search of the primitive world and the savage innocence that he needed for inspiration, away from reality and civilization. He lived there until 1893, when he returned to France and settled in Pont-Aven until 1895, while his fame grew in the artistic and intellectual circles of Paris. His painting was then an escape to a lost paradise and a primitive civilization, a recurring theme in his work for which he used rich and contrasting colors inserted within strong outlines, as shown in *The Spirit of the Dead Keeps Watch*, from 1894. One year later, he returned to Polynesia, where he lived until his death, and where he painted his most outstanding works, such as *Girl With a Fan, Two Maori Women, Nave Nave Mahana,* and *Te Avae No Mariae. Where Do We Come From? What Are We? Where Are We Going?*, a grandiose allegorical composition painted after he attempted suicide that was exhibited

Le Christ Jaune (The Yellow Christ).
PAUL GAUGUIN.

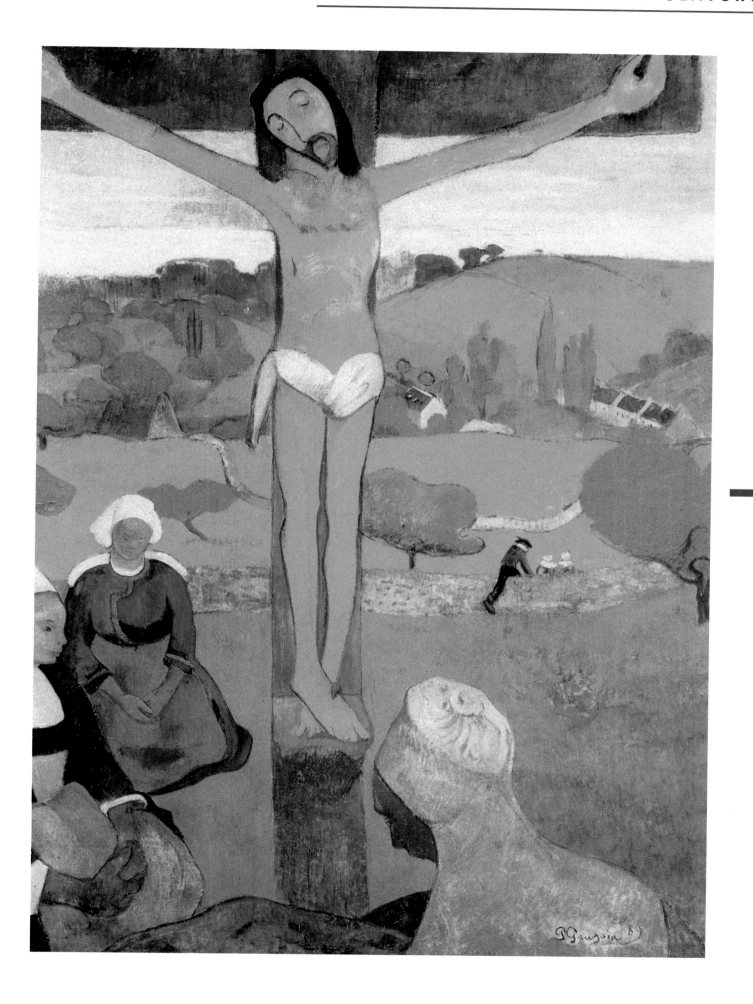

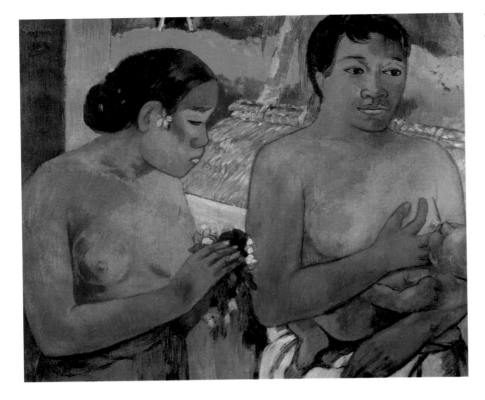

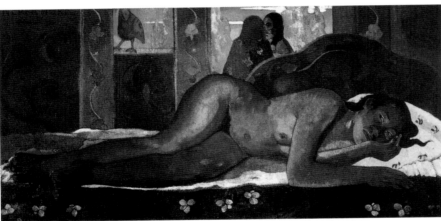

Te rerioa. (The Dream).
PAUL GAUGUIN.

at the Vollard Gallery in Paris in 1899. Gauguin's health began to deteriorate, and he died shortly after settling in the Marquesas Islands, a paradisiacal archipelago to the north of Polynesia, where he is buried. He left his reflections on a great deal of his artistic experience in a journal that was published under the title *Noa Noa*, which could be roughly translated as "Diary of a Savage."

The Offering.
PAUL GAUGUIN.

a member of numerous academies and received many honors. Although he painted some mythological (*Cupid and Psyche*, 1798), religious (*St. Theresa of Jesus*), and genre scenes, he excelled in historical painting—he would paint more than thirty pictures, with *Battle of Austerlitz* (1810) being the work that would consolidate his fame. He was particularly talented in portrait painting, an area to which he primarily devoted himself after 1800, and in which he did a large amount of work while in Napoleon's service, painting numerous portraits of Napoleon and his family. Later, during the Restoration, Louis XVIII appointed him court painter, enabling him to continue working with portraits, painting the king and his family, just as he would later do for King Louis-Philippe, who would commission some large allegorical works for Versailles. His portraits have a perfect finish but are somewhat superficial, bland, and lack the expressive power of his teacher David. They are distinctly Neoclassical in style, with the Rococo taste for pretty things and a cloying tone in the treatment

GÉRARD, FRANÇOIS

(Rome, 1770-Paris, 1837)

French **Neoclassical** painter. A pupil of the sculptor Pajou and of **David** beginning in 1786. Seven years later, he won first prize in the competition to commemorate the meeting of the National Assembly on August 10, 1792. He was elected

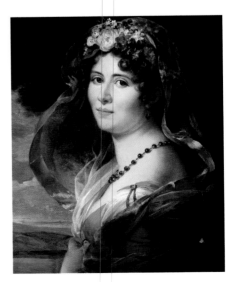

Constance Ossolinska Lubienska.
FRANÇOIS GÉRARD.

Lion Attacking a Horse.
THÉODORE GÉRICAULT

of his beautiful models. He painted the most important personages of Paris of the time, such as *Madame Recamier, The Family of Count Fries, Portrait of Moreau*, and *Talleyrand*. Also noteworthy are *The Four Ages* (1806), *Charles X*, and *Ossian on the Banks of the Lora, Invoking the Gods to the Strains of a Harp*, which, to a certain extent, is a forerunner of **Romanticism**.

GÉRICAULT, THÉODORE

(Rouen, 1791–Paris, 1824)

French painter. Trained in Neoclassical aesthetics and a forerunner of **Romanticism**, he produced work that was, to a large degree, a reflection of

the decline of the Napoleonic empire. Coming from a well-to-do family and the son of a lawyer, he had a predilection for horses from early youth, a passion that would carry over into his painting. At the age of seventeen, he entered the atelier of the Classicist master Vien and later entered the studio of one of **David**'s pupils, **Pierre Guerin**, along with **Delacroix**. He also adopted the brushstrokes of Rubens and the more Baroque compositional models. Fascinated by the figure of Napoleon and his exploits, he did a series of paintings of officers on horseback, war paintings that were well received by the critics at the Paris Salons. In 1812, he exhibited *An Officer of the Chasseurs Commanding a Charge*, an example of a warrior from the Napoleonic victories, and in 1814,

A Wounded Cuirassier, a figure symbolizing a group action: the retreat of the French army, representing the end of the emperor and very different from the usual battle paintings, such as those done by **Gros**. Disillusioned by the course the history of his country was taking, he turned his back on liberal ideas and went to Rome in 1816. He returned to the theme of horses, a true constant in his painting, and did numerous sketches and drawings for an enormous painting that he never finished. A tragic event that deeply stirred French public opinion inspired his masterpiece, *The Raft of the "Medusa"* (1816). This composition referred to the wreck of a French ship

131

off the coast of Senegal, in which all of the crew died except for fifteen members, most of them officers. To carry out this monumental work and achieve the right dramatic climax, he studied and drew cadavers and the ill, as well as studying reports and testimonies of the disaster. The painting, exhibited at the 1819 Salon, opened the door to Romantic painting and a new era for historical painting in the nineteenth century, as well as surprising the critics. However, it was a failure because of its thorny subject, earning him the enmity of the government. Discouraged, he left for England, struck up a friendship with **Constable** and devoted himself to his great passion— horses—by painting the traditional Epson races. When he returned to Paris in 1821, at the age of twenty-nine, he was overwhelmed by a feeling of artistic failure. Restless and changeable by nature, he went to a psychiatrist, who recommended that he paint a series of portraits of the mentally ill, among which *The Madwoman* and *A Kleptomaniac* are noteworthy. In these works, he revealed his ability to capture the psychology and the characteristic traits of the mentally ill on canvas. His small terracotta figures, works of inarguable interest for the study of Romantic sculpture, are also worthy of note, as are his few lithographs, such as *The Bagpiper*. A serious accident, a fall from a horse, left him bedridden, and he died after a year of suffering. He was thirty-two years old.

GÉRÔME, JEAN-LEON

(Vesoul, 1824–Paris, 1904)

A French painter and sculptor, his sculptural work is more important and consequential than his pictorial

A Chat by the Fireside.
JEAN-LEON GÉRÔME.

work. He trained with the painter **Delaroche**, and some of his paintings of historical subjects portraying the world of Ancient Greece were well received by the critics. He demonstrated his mastery of draftsmanship in the sketches and compositions he did after a trip to the Middle East.

Duel After a Masked Ball.
JEAN-LEON GÉRÔME.

GIERYMSKI, ALEKSANDER

(Warsaw, 1849–Rome, 1901)

Polish painter, whose style resembled Realism. He began his training in the city of his birth and continued it in Switzerland, Italy, and France. In the latter country, he abandoned his Academicism, giving himself up to **Impressionism** (*The Diner*, 1880). His style is characterized by draftsmanship with a high level of technical perfection, as well as by harmonious colors which produce attractive light effects.

GIGANTE, GIACINTO

(Naples, 1806–1876)

An Italian painter, Gigante was one of the founders and leaders of the Posilippo school, a group of painters in the south of Italy who were interested in painting Realist landscapes with light effects. They were forerunners of the even more Realist art movement that developed in Flo-

rence and was known as the **Macchiaioli**. He began his training with a Dutch artist, Antonio Snuck, practicing open-air painting with a Romantic vision, influenced by **Corot** and **Turner**. His landscapes reflect a typical southern light, as seen in some of his works: *Views of Naples from Posilippo* and *Grotto with Bather*. His watercolors are also noteworthy, such as *Caserta* (1857).

GIRODET DE ROUSSY-TRIOSON, ANNE-LOUIS

(Montargis, 1767–Paris, 1824)

French painter, illustrator, and writer. Pupil and follower of **David**, he was a prominent representative of **Neoclassical** painting, although his artistic career evolved toward **Romanticism**. Adopted by a military doctor after he was orphaned, he began his artistic training in David's atelier, and from there, entered the Prix de Rome competition on several occasions, winning the prize in 1789 with *Joseph Recognized by His Brethren*. He lived in Rome for five years at the French Academy and

Apotheosis of the French Heroes Who Were Killed in the Service of Their Country. LOUIS GIRODET DE ROUSSY-TRIOSON.

Sleeping Endymion.
LOUIS GIRODET DE ROUSSY-TRIOSON.

traveled to Naples, Florence, and
Rome. In *Hippocrates Refusing the
King of Persia's Gifts*, he showed his
exceptional talent for draftsmanship.
In 1793, he presented his painting
Sleeping Endymion at the Paris Salon,
a work that represents the linear for-
malism of the strict style he learned
from David, but with some dramat-
ic and sentimental effects that antic-
ipate Romanticism. In 1799, he sur-
prised the public with his *Mlle.
Lange as Danae*, a daring work la-
beled as lewd and causing a scandal
because it depicted the face of a well-
known actress of the time on a
mythological figure's body. How-
ever, his most valued work in the

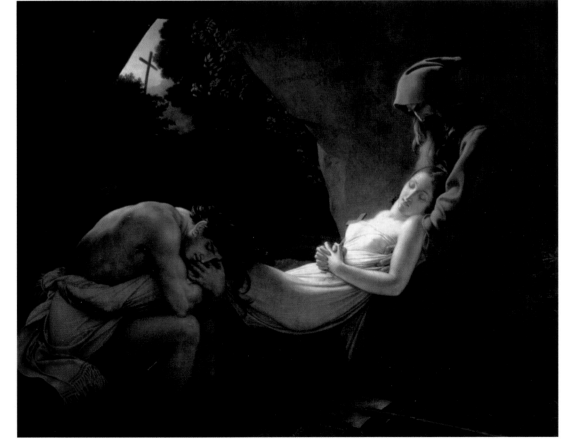

The Burial of Atala.
LOUIS GIRODET DE ROUSSY-TRIOSON.

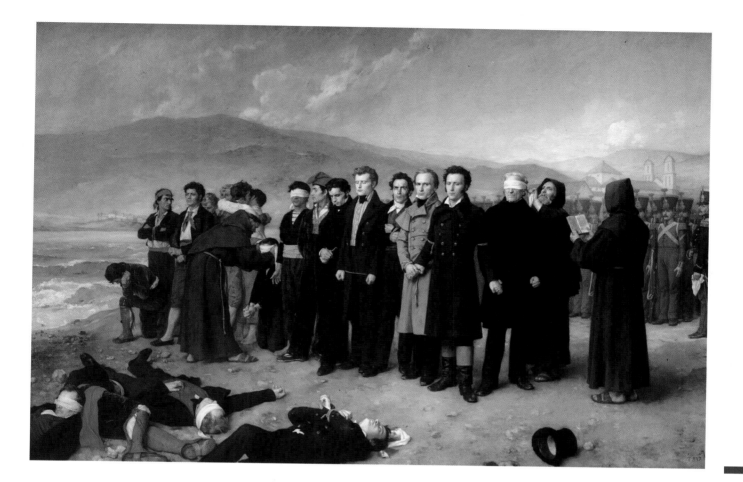

first years of the century was the commission he received to decorate one of the rooms of the Malmaison Palace with a composition dedicated to Napoleon. It is a clear departure from David's Neoclassical ideology with its references to Rubens' paintings and the value of color over draftsmanship. His painting *Deluge*, from 1806, also caused amazement and controversy; this work was honored above his teacher David's. *The Sabine Women.* From that time forward, his compositions can be included within the Romantic movement, such as the literary painting *The Burial of Atala* (1808) and *Revolt of Cairo* (1810), representing a recent event composed with a structure typical of the historical genre tradition and treated with free and expressive brushstrokes. His portraits are outstanding, such as the one of *Chateaubriand.* Finally, there is the

series of Romantic illustrations he did at the end of his life for literary classics by such authors as Virgil and Racine.

GISBERT PÉREZ, ANTONIO

(Alcoy, 1834–Paris, 1901)

Spanish painter. A representative of historical painting at the time of the transition from **Romanticism** to **Realism**, he studied in Madrid at the Academy of San Fernando and completed his training in Rome and Paris. He won the gold medal at the National Exhibition in 1860 with his painting *The Comuneros of Castile*, a work that revealed his figurative and expressive qualities, while being guilty to a certain degree of striving for effect. In his most famous painting, *The Execution of Tor-*

rijos and His Followers on the Beach at Málaga, he eliminated the grandiloquent effects for a more sober and restrained composition that would lead him to greater realism.

GLEYRE, CHARLES

(Cheville, 1806–Paris, 1874)

Swiss painter. As a child, he emigrated to Lyon with his family and later trained as a painter in Rome, where he lived from 1828 to 1834. In Rome, his contact with German painters residing in that city accentuated the influence of German painting on his works' which had already been visible in his *Self-Portrait* of 1827 and which was painted in

the Swiss city of Lausanne. In spite of this, the clearest tendency in his later painting would be French, starting from the time he settled in Paris in 1835. However, before establishing residence in that city, he traveled through the Middle East,

The Count of Cabarrús.
FRANCISCO DE GOYA Y LUCIENTES.

going to Egypt, Turkey, and Syria; countries where he drew natural landscapes, monuments, and popular scenes. In Paris, he became a teacher at the National Fine Arts School and opened a studio whose name enjoyed such prestige that such future renowned painters as **Manet**, **Renoir**, **Monet**, **Bazille**, and **Sisley**, among others, passed

through it before it closed in 1864. His specialty was mythological and Biblical painting, with Coture's influence evident in his scenes of ancient history. Noteworthy works are *Evening (Lost Illusions)* (1843), *Allegory of the Nile* (1843), *The Apostles' Farewell* (1845), *Dance of the Bacchante* (1849), and *La Charmeuse* (1868).

GOYA Y LUCIENTES, FRANCISCO DE

(Fuendetodos, 1746–Bordeaux, 1828)

A Spanish painter, draftsman and engraver, Goya is one of the great figures in the history of world painting. His work, created during the transition from the eighteenth to the nineteenth century, closed the cycle of an aesthetic style that began in the Renaissance and would soon give way to visions and structures that were ahead of the times. His work as a whole makes up a prolific and varied collection that reflects a progressive evolution and experimentation in subject matter, style, and technique and which goes from the Classicist style, typical of the eighteenth century, to an innovative and original manner that was expressive and subjective and characteristic of the vanguard of the contemporary world. Born in a small town in Aragon, he was the first-born son of a master gilder, professionally connected to the city of Saragossa. Very few documents offer information about his life in Saragossa before he settled in Madrid in 1774. What is known is that he studied at the Pious Schools, and around 1760, was working in the atelier of the Italian-educated painter, José Luzán. He tried to enter the Fine Arts Academy of San Fernando in 1763 and 1766, but failed.

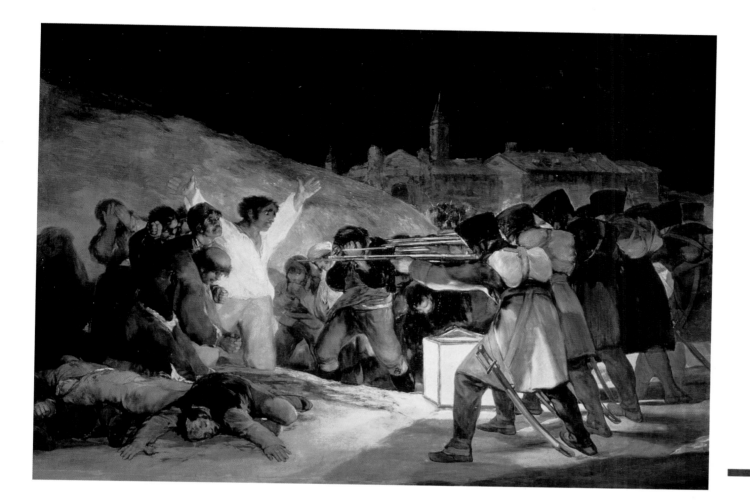

The Third of May, 1808.
FRANCISCO DE GOYA Y LUCIENTES.

In light of these failures, he decided to train on his own, and for a time, he dedicated himself to studying Italian masters such as Giambattista Tiepolo (1696–1770) and the German, Raphael Mengs (1728–1779). In 1770, with his own resources, he moved to Rome. In that city, he did one of his first historical paintings, *Hannibal Viewing Italy from the Alps*, a work he sent to the Parma Academy. It did not get an award, but it did receive praise from important personalities. In Italy, he perfected the technique of fresco painting, a skill that would bring him several commissions upon his return to Spain; around 1775, he painted the frescoes on the ceiling of the Pilar Basilica in Saragossa. At about this same time, he married Josefa Bayeu, the sister of court painter Francisco Bayeu, who introduced him into the

artistic and social circles of the Madrid court. Bayeu also recommended him for work in the Santa Barbara Royal Tapestry Factory in Madrid, where he devoted himself to preparing the cartoons for the tapestries commissioned by the royal family to decorate El Escorial and El Pardo Palaces. Between 1775 and 1792, Goya did more than sixty cartoons, the most noteworthy being *The Parasol, The Kite, and The Crockery Vendor*: works in which as many French as Italian influences can be seen. In that same period, he came into contact with Velázquez's paintings, some of which he began to engrave at the suggestion of the painter Raphael Mengs; his skill in this technique was already outstanding. His work and his gradual assimilation into the environment at court facilitated his entry into the Royal

Fine Arts Academy as a full academician through his painting *Christ Crucified* (1780): a composition that was clearly Classicist in nature. In addition, he participated more actively in work for the court, moving to Arenas de San Pedro (Ávila) in 1783 to paint a group portrait of the Infante Louis' family. In the same year, he undertook the portraits of illustrious and intellectual personages such as the one of *The Count of Floridablanca*, and some years later, that of *Jovellanos*, portraits that alternated with those of members of aristocratic society (*Marchioness of Pontejos* and *Duke and Duchess of Osuna and Their Children*) and the royal family (*Charles III, Hunter*). In 1785, he was named assistant director of painting

137

at the Academy, and the next year, the king's painter. His rise in this institute continued with his appointment as court painter in 1789. The French Revolution and the dramatic

The Colossus.
FRANCISCO DE GOYA Y LUCIENTES.

events caused by the French invasion of the Iberian Peninsula radically changed his view of life and society, a transformation that was heightened by his illness. This ailment that had begun to affect him years earlier, and its severity reached a peak during a trip to Cádiz in 1793, leaving

him completely deaf. Isolated from the world and withdrawn into himself, his style was then liberated enabling him to produce work that was very personal, departing from academic values. Portraits such as *La Tirana* (1799), or that of the *Duchess of Alba* (1795), or his first works

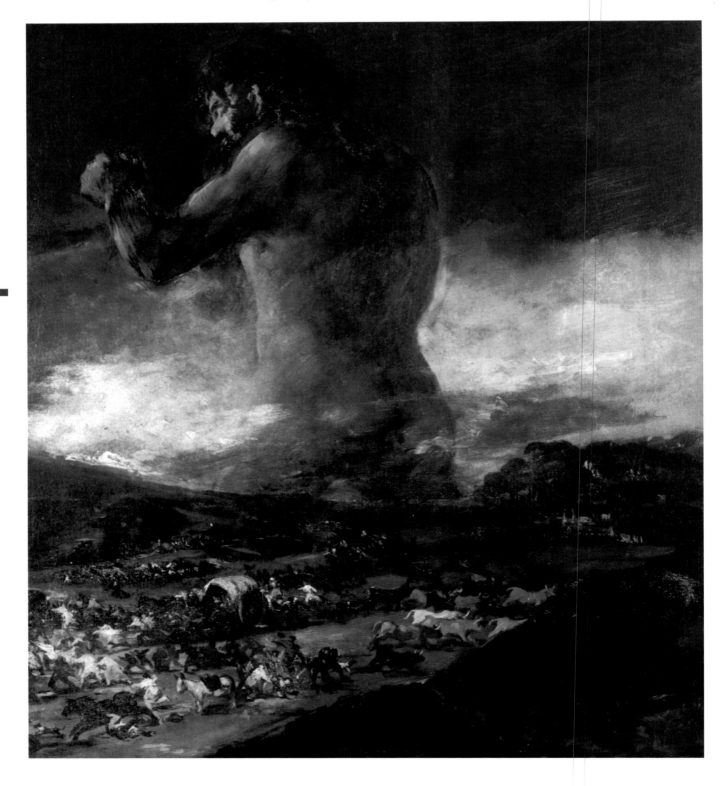

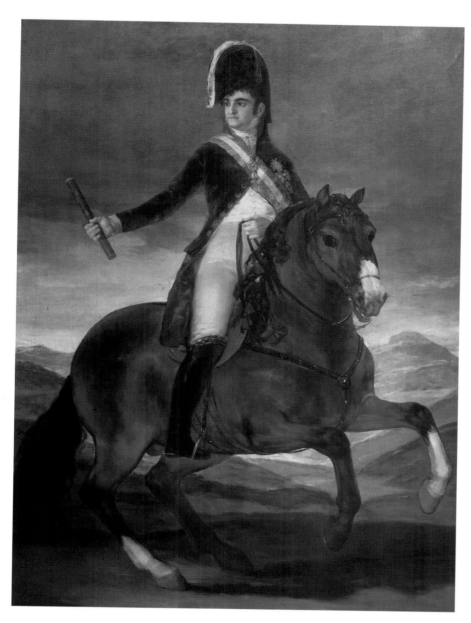

Ferdinand VII on Horseback.
FRANCISCO DE GOYA Y LUCIENTES.

dealing with witchcraft for the Alameda de Osuna Palace in Madrid, give testimony to his stylistic progress. At this time, his work in the area of drawings and etchings began what would become an unstoppable career. The collection of etchings known as *Los Caprichos* ("Caprices") of 1799 is indicative of his critical and caustic view of the society of the time. This was followed by *The Disasters of War*, a graphic piece reflecting the conflict of the War for Independence and demonstrating the power of man's destructive capacity. In his drawings and etchings, he used labels and inscriptions that emphasized the importance of the explicit messages of his images, exposing the miseries, lies, and vices of the society in which he lived and of human nature in general. Goya's personality is shown much more vividly and powerfully in his drawings and etchings than in his paintings. However, his sharp and biting criticism was also present in some royal commissions, such as the irony transmitted by *Family of Charles IV*. Nevertheless, respect and sensuality are also traits that were present in Goya's personality; the warm, golden atmosphere of *The Countess of Chinchón* and the two versions of the painter's supposed, aristocratic lover, *The Clothed Maja* and *The Nude Maja*, are among his masterpieces. Paradigms of his brilliance are two war-related paintings that were done in 1814: *The Second of May, 1808* (referring to the battle with the Mamelukes) and *The Third of May, 1808* (referring to the executions on Príncipe Pío hill), works that later had an enormous impact on historical painting. Another series of etchings is the famous *Tauromachy*, composed in the second decade of the nineteenth century. He also painted religious subjects; in 1788, he created *St. Francis Borja* for the Osuna family, and in 1819, *Last Communion of St. Joseph Calasanz*. That same year, now very ill, he bought a house on the outskirts of Madrid, the Quinta del Sordo ("The House of the Deaf Man"), whose walls he decorated with fifteen mural paintings called his "black paintings;" paintings that were incredibly modern because of their expressionism and reflection of a subjective, subterranean, and imaginary world. This complex work is linked to the series of etchings known as *Los Disparates* (Follies), a true declaration regarding dreams and the subconscious. Beginning in 1824, he lived in Bordeaux as an exile. At over 80 years of age, he painted a vital work in the progress of pictorial art: *The Milkmaid of Bordeaux* (1827), a painting in which he revived the interest he had had as a young man in popular characters, a painting that is prodigious because of its synthetic capacity and the lightness of its strokes, almost half a century ahead

Choir of the Capuchin Church in Rome.
FRANÇOIS-MARIUS GRANET.

G

of **Impressionism**. He died in the early hours of April 16, 1828 and was buried in the Bordeaux cemetery, where he lay at rest until 1901. His remains were finally interred at the church of San Antonio de la Florida in Madrid in 1919.

GRANET, FRANÇOIS-MARIUS

(Aix-en-Provence, 1775–1849)

French landscape and historical painter. A pupil of **David**, he traveled to Rome in 1802, where he remained until 1819, and where he was elected a member of the Academy of St. Luke. He soon distanced himself from **Neoclassicism**, preferring a more sensitive and less cold style with a freer technique. At the same time, he also took an interest in the light of dimly-lit rooms which was reminiscent of Dutch domestic paintings. He painted interiors of

Church of the Trinity on the Mount, Rome.
FRANÇOIS-MARIUS GRANET.

churches and monasteries, creating the works that would bring him the most fame, an example being *Choir of the Capuchin Church in Rome*, with which he would achieve great success at the 1819 Salon. He also painted Romantic genre paintings and schematic landscapes with an Italian feeling, based on cubic volumes, which in a way foreshadowed **Cézanne**, both in oil and in watercolor (*Dock by the Seine*, 1848). He was a friend of **Ingres**, who influenced his painting style, and who painted a celebrated portrait of him, which is in the museum bearing Granet's name in the city of his birth. Among his works, *Jacques Stella in Jail* and *Interior of David's Studio* (1814) must be mentioned.

GRANT, SIR FRANCIS

(Edinburgh, 1809–London, 1878)

Scottish painter. Although nearly all of his early paintings were hunting scenes, treated with great naturalness, he later dedicated himself to portraits, at which he excelled. He would become one of the most highly valued portraitists of his time, which led him to be elected President of the Royal Academy in 1866, upon **Eastlake**'s death. Due to his family's noble origins and to the social circles in which he moved, his clientele belonged to the highest classes of English society, and he portrayed them following the lines marked by Van Dyck, with a passionate technique within the Romantic concept. However, his best compositions were his small group portraits, called "conversation pieces," in which more than one of the painting's subjects are engaged in relaxed conversation or some other activity, apparently oblivious of the artist who is painting them. Among his most noteworthy works are *Derby*, *Portrait of Master Keith Fraser on His Pony* and *The Melton Hunt*.

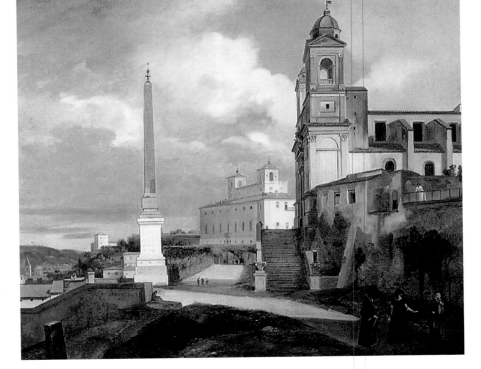

The Battle of Eylan.
ANTOINE-JEAN GROS.

GROS, ANTOINE-JEAN

(Paris, 1771–Bas-Mendon, 1835)

A French Neoclassical painter, his work continues **David**'s and is a testimony to Napoleonic feats. The son of a miniaturist, he began to paint in David's atelier, which he left at the age of twenty-two to go to Italy. There he met Josefina Beauharnais, the future Empress Josephine, who introduced him into Napoleon's circle. He joined the army's troops on their movements and lived as just another soldier on the battlefield, learning about the most important battles right down to the last detail. He became one of the first "war reporters" through his sketches and drawings of numerous military events, which he depicted in spectacular compositions. His painting

The Plague at Jaffa (1804) was the result of the expedition he made with Napoleon's troops to Egypt. It is a theatrical and pompous version of a true event: the emperor's visit to his sick and wounded soldiers. The objective of his painting was to exalt the figure of Napoleon and his expansionist campaigns, as can also be gathered from *The Battle of Aboukir* and *The Battle of Eylan*. His *Portrait of Second Lieutenant Charles Legrand* (1810), in which a young officer killed in Madrid in 1808 was portrayed as a charismatic hero, was also an attempt to further ennoble the members of the army. He became so completely involved in those events that his artistic career was inextricably linked to the emperor's fortunes, lasting barely more than twelve years or so. His work was criticized because of its clear political intentions, and although he received the title of baron, his lack of inspiration and of opportunities to look for new pictorial subjects, as well as his marital problems, led him to desperation, and he drowned himself in the Seine.

GUERIN, PIERRE-NARCISSE

(Paris, 1774–Rome, 1833)

French Neoclassical painter. He was a student of **Regnault** and devoted himself to painting ancient-history subjects for which he took inspiration from his observations of the classical world during his trips to Italy. Some of his paintings include (*Death of Cato*, (1797) and *The Return of Marcus Sextus*, (1799), as well as works based on mythological themes (*Hippolytus and Phaedra*, 1802). His style follows David's, although his paintings are less severe and at times somewhat more histrionic, with some light effects that already represent the transition to **Romanticism**, although still firmly within **Neoclassicism**, of which he is considered the last representative. A painter of Napoleon and of the

Iris and Morpheus.
PIERRE-NARCISE GUERIN.

Restoration, he was one of the most popular French painters of his time and, because of this, was appointed teacher at the Fine Arts School, where **Géricault** and **Delacroix** were his pupils. In 1822, he was named director of the French Academy in Rome. Other important works are *Napoleon Pardoning the Rebels at Cairo* (1808) and *The Vendéen General La Rochejaquelein* (1817).

GUILLAUMIN, JEAN-BAPTISTE-ARMAND

(Paris, 1841–1927)

A French painter, his work fits into the Impressionist movement, although its stylistic evolution enters **Post-Impressionism**. Fond of painting in his free time, he started working on the French railroads at the age of twenty. From 1863 onward, the year he dedicated himself

Bridge Over the Marne at Joinville.
JEAN-BAPTISTE-ARMAND GUILLAU-MIN.

G

The Coal Thieves.
ARMAND GUILLAUMIN.

to painting full time, he encountered the Impressionist artists in Paris, who were habitués of the Café Guerbois, as well as the work of **Cézanne** and **Pissarro**. Eventually, he exhibited in the Salón des Refusés. He primarily painted landscapes of the region of Provence, with peculiar and stereotyped colors based on violet and orangish tones, which he used to attempt to portray the effects of sunsets. This palette

Right:*Self-Portrait.*
Below:*The Bridge of Louis-Philippe.*
ARMAND GUILLAUMIN.

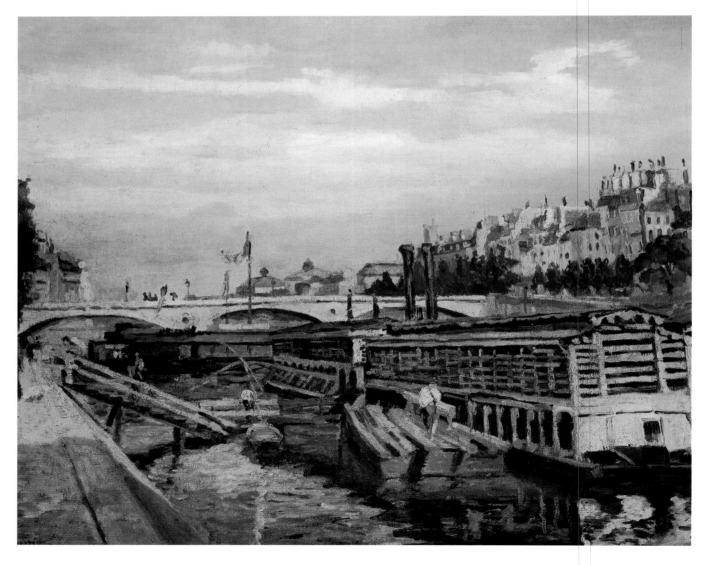

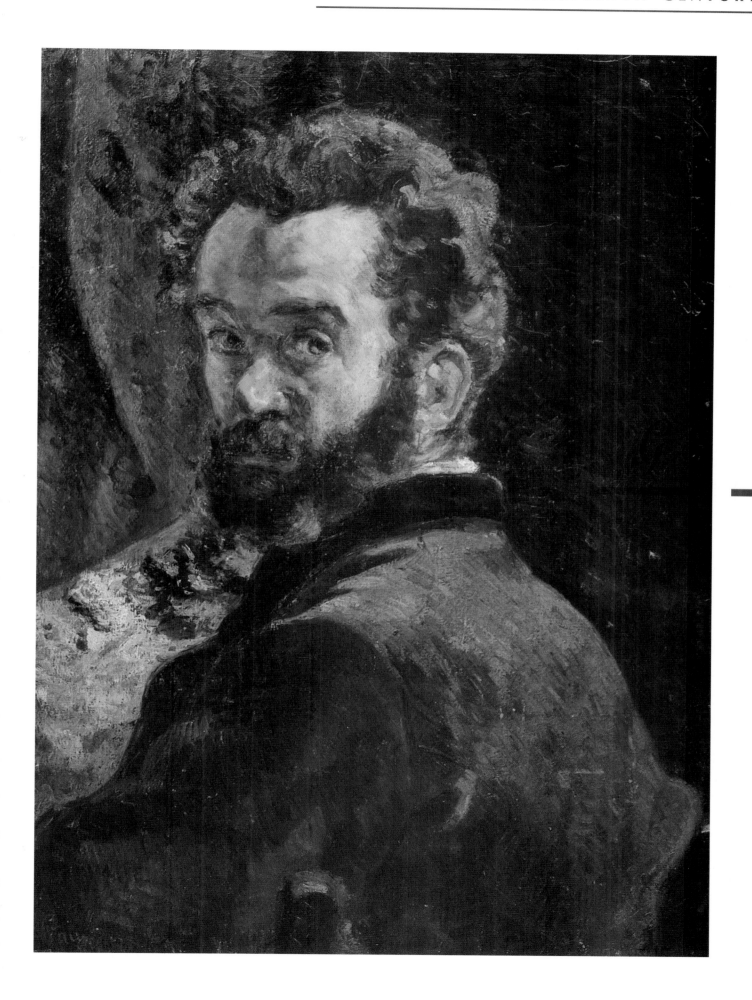

The Seine in Paris.
ARMAND GUILLAUMIN.

G

was an exaltation of color that approached Post-Impressionist principles and exercised significant influence on **Gauguin** and **Van Gogh**. Representative examples of his style are found in his paintings *Paris, Quai de la Gare*, *The Port at Charenton*, and above all, *Sunset at Ivry*, a work from 1873 that was the object of sarcastic criticism at the time.

GUTIÉRREZ DE LA VEGA, JOSÉ

(Seville, 1791–Madrid, 1865)

Spanish painter. A clear representative of Romantic painting, he painted portraits that make up one of the most interesting collections of portraiture as a whole in Spain. He studied at the Fine Arts Academy in his native city and in 1832 moved to Madrid. One year later, he was elected a full academician at the Academy of San Fernando. In addition to

the portraits of *The Queen Regent María Cristina*, *The Countess of Montijo*, and the one of Isabella II, he dealt with religious subjects in which the influence of Murillo's work is evident. In 1848, he resigned from his post as director of the Fine Arts Academy in Seville and returned to Madrid, where he later died.

GUYS, CONSTANTIN

(Flushing, 1805–Paris, 1892)

A Dutch draftsman and illustrator from a French family, of whose early life little is known. He was named a special correspondent in London in 1838 for the *Illustrated London News*, a role that he performed for quite some time. He had to travel around Europe and the East and witnessed the Crimean War (1853–1856) firsthand, where he made war sketches,without ever having had any artistic training, and showed that he was a true "graphic reporter." He settled in Paris around 1870 and encountered the Impressionists. His quick drawings and pen sketches, overlaid with washes, tints, gouaches, and watercolors, were taken from contemporary society and represent scenes of everyday, mundane life, at times reflecting the lowest of the rough ele-

The Romantic Wedding.
JOSÉ GUTIÉRREZ DE LA VEGA.

Episode from the Crimean War.
CONSTANTIN GUYS.

ment. He created very expressive images, both as far as atmospheres and people are concerned, which proved his draftsmanship abilities. Although according to some critics he lacked strength, these works can be considered little masterpieces. With these cheerful, natural, and vivid drawings, he acted not only as a chronicler of the Parisian society of the Second Empire, but also that of London and Madrid as well. In these drawings, he is considered a forerunner of **Toulouse-Lautrec** and **Manet**, especially in the subject matter. In his latter period, his favorite subject was women, ladies as well as prostitutes. He was, according to Baudelaire, "the painter of modern life." Clear examples of the work described are *Woman Standing* (ca. 1875–1880), *Dancer,* and *Two Ladies with Muffs* (ca. 1875–1880).

Galatea.
CONSTANTIN GUYS.

H

A Stream.
CARLOS DE HAES.

HAES, CARLOS DE

(Brussels, 1826–Madrid, 1898)

Belgian painter who specialized in landscapes. Originally from Holland, he moved with his family to Málaga where his father had found work. Haes began his training there, with the painter Luis de la Cruz y Ríos. From 1850 to 1855, he studied in Belgium as an apprentice to the landscape painter Quinaux. He returned to Málaga, became a Spanish citizen, and participated in several national exhibitions. He established his residence in Madrid in 1857, when he was appointed teacher of landscape painting at the Fine Arts School. He was soon highly esteemed in professional circles

and built up a considerable clientele. Elected to the Academy of San Fernando in 1860, his prestige grew as the result of the consecutive awards he won at national exhibitions. He traveled extensively thoughout Spain, painting in the open air. The subjects of his landscapes—from simple views of Castile to mountainous panoramas—are realistic in nature. He did numerous compositions of these settings, which he also captured in drawings and engravings. In 1878, he won the gold medal at the National Exposition in Paris with his painting *Environs of Vreeland*, which was representative of his more mature works such as *The Peaks of Europe* and *Manzanares Riverscape*. These are objective, almost topographical works in which he

shows his preference for gray tints and nebulous atmospheres. Haes' aesthetic position is linked to the Naturalism of the French **Barbizon School**, but his exact capturing of light and atmosphere, evident in the sketches made in the open air and the deliberately simple subject matter of his paintings, paved the way for **Impressionism**. **Aureliano Beruete**, with whom he traveled around Spain, and **Regoyos** were his best pupils. His extensive work—he did more than four thousand paintings and sketches—came to an end in 1890, when he was afflicted with a serious illness, from which he never recovered.

The Peaks of Europe: The Mancorbo Canal.
CARLOS DE HAES.

HAMERSHOI, VILHELM

(Copenhagen, 1864–1916)

Danish painter. He studied with Cristian Zahrtmann in his native city, where most of his artistic output was produced, traveling from time to time to Berlin, Dresden, Amsterdam, Rome, London, Oxford, and various cities in Italy. He painted portraits, that were somewhat reminiscent of **Whistler**, and landscapes, especially

Le Cannet.
JOSEPH HARPIGNIES.

from 1893 onward, as well as architectural subjects, such as *Fredericksborg Castle* (1896). However, his best-known pictures are those that depict serene interiors, in subdued tones of greenish-grays and browns, in which he creates a softly lit atmosphere evocative of Vermeer. The influence of the style of the French Impressionists can clearly be seen in his work. He also painted two murals for the Copenhagen Town Hall, and from 1898 to 1900, worked in a porcelain factory. Noteworthy works are *Jabersberg Ali* (1893), *Linden Trees* (1906), and *D'Amalienborg Castle*.

HARPIGNIES, HENRI-JOSEPH

(Valenciennes, 1819–Saint-Privé, Yonne, 1916)

French painter and engraver. A Romantic landscape artist, he was the last landscape painter in the **Barbizon School**. He did not begin his career as a painter until 1846, but from that time forward the abundance of his work made up for lost time, and he became famous. He began his studies in Paris with the landscape artist Achard, and later rounded out his knowledge of painting in Italy, where he lived for some years. He basically worked with landscapes, especially riverscapes, concentrating heavily on Auvers. His landscapes were natural, tranquil, and solitary, inspired by the lyricism and refinement of **Corot**'s work, and in which the influence of **Rousseau**'s and **Daubigny**'s landscapes can also be seen. He also worked in watercolor. Other works of interest are *The Coliseum in Rome* (1878), *Landscape under Moonlight* (1886), *Forest on the Banks of the Allier River*, *The Castle Oak*, and *The Loire*.

HAYDON, BENJAMIN ROBERT

(Plymouth, 1786–London, 1846)

British painter. A student of **Füssli** at the Royal Academy from 1804 to 1814, he went to Italy in the latter year with **Wilkie**. He was radically opposed to the academic painting of the time and struggled tenaciously to achieve renown, which always eluded him because of his lack of talent for painting. Even his death, by suicide, was caused by a failure, when the sketches he entered in the competition to decorate Parliament were rejected. He devoted himself to historical and religious painting, solemn and rhetorical in nature, along the lines of Sir Joshua Reynolds, but his paintings were full of vivid colors and characters and were too pompous, artificial, and melodramatic. He also painted genre scenes and humorous pictures, where some of the serpentine movement that his teacher Füssli liked so much can be seen in his fig-

Highland Lovers.
BENJAMIN ROBERT HAYDON.

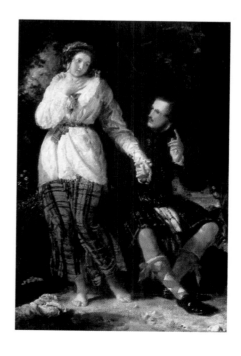

Eucles.
BENJAMIN HAYDON.

ures. Among his pictorial works, the following are noteworthy: *Mock Election* (1827), *Punch, or May Day* (1829), *Lady Macbeth, The Flight into Egypt* (1808), *The Raising of Lazarus* (1822), and *Christ's Entry into Jerusalem* (1820).

HAYEZ, FRANCESCO

(Venice, 1791–Milan, 1882)

An Italian painter, trained in Neoclassical aesthetics, he evolved towards Romanticism to such a degree that a large part of his work, devoted to historical themes, has been included within Italian Romantic Classicism. He began his studies in Venice in 1808, influenced by the strict compositions of the Neoclassical sculptor Antonio Canova. The perfection of his draftsmanship and the sharpness of his outlines, worthy of **Ingres**, are to a large degree the result of this early training. In 1810, having been given an award by the

Academy, he traveled to Rome, but left that city to return to Venice and dedicate himself to the lucrative work of decorating large villas and palaces. Summoned to the Brera Academy in Milan, he spent thirty years there, teaching painting classes. Eventually, he joined the Realist movement in historical painting spearheaded by Manzoni. His work shows a variety of subjects, such as portraits and religious and secular scenes. Some of his historical and literary subjects were

The Kiss.
FRANCESCO HAYEZ.

very much in tune with nationalistic and Romantic sentiments, depicting scenes of war and championing the cause of Greek independence from the Turks as seen in *Refugees from Parga* (1828–1831) and *Pietro Rossi Prisoner of the Scaligeri in Pontremoli*. He painted all these pictures within formal structures that belonged to the ideals and principles of Neoclassicism, enhanced by rich, brilliant colors, thus producing the interesting combination typical of this artist, who also painted famous pictures such as *Sicilian Vespers* (1846) and *The Kiss*.

HERMAN, KARL HEINRICH

(Dresden, 1802–Berlin, 1880)

A German painter, Herman, somewhat related to the **Nazarenes**, focused on historical subjects and religious matters. He was a pupil of the Nazarene painter **Cornelius** at the Fine Arts Academy in Düsseldorf. Later on, he studied in Rome where he specialized in fresco painting. He worked on the decoration of the Glyptothek in Munich, as well as the Temple of St. Louis in the same city, with paintings devoted to the prophets, patriarchs, apostles, and fathers of the Church. He made an interesting pictorial contribution that explored the history of Germany.

HERNÁNDEZ AMORES, GERMÁN

(Murcia, 1827–1894)

A Spanish painter, his style of very precise draftsmanship is set within the influence of the **Nazarenes**. He studied at the Fine Arts School of San Fernando and later in Paris, where he was a pupil of **Gleyre**. He received a scholarship for the Spanish Academy in Rome in 1857, and there painted *Socrates Reprimanding Alcibiades at a Courtesan's House*, a work that earned him second prize at the National Exhibition in 1858. Among his best-known creations, the most noteworthy is *The Holy Virgin's Trip to Ephesus*, which won the top prize at the National Exhibition in 1862. In addition to achieving great critical success at the time, he was appointed a teacher at the

Joseph Interpreting Pharaoh's Dreams. PETER CORNELIUS, *member of the Brotherhood of St. Luke.*

Higher School of Painting, and in 1892, was elected to the Academy of San Fernando. Among his later works, *Medea Fleeing Corinth* and

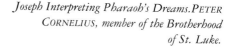

Noah's Ark.
EDWARD HICKS.

Offering to Pericles deserve special mention.

HICKS, EDWARD

(Attleborough, 1780–Newton, New Jersey, 1849)

American "naif" painter. He was self-taught in art, and his first jobs as a painter were to decorate carriages and make signs. A Quaker minister, he used Biblical themes in his paintings, especially *The Peaceable Kingdom*, which was painted for evangelical purposes and which illustrated a prophecy from the Book of Isaiah. He repeated it, with some small variations, more than one hun-

Sunset.
ANDO HIROSHIGE.

dred times. He also painted farm scenes and landscapes filled with animals, in a style approaching the naif, that was characterized by great **Realism**, almost Naturalism, and by flat painting of stylized forms and meticulous draftsmanship.

HIROSHIGE, ANDO

(Edo, 1797–1858)

Japanese draftsman, engraver, and painter. Hiroshige was the son of a rich courtier and a pupil of the woodblock artist Utagawa Toyohiro beginning at the age of fifteen. He took painting as his profession in 1823, primarily devoting himself to landscapes, in which he applied the standards of European perspective and varied and contrasting colors. He depicted the most diverse places, perfectly capturing changes in the atmosphere at different times of the day, or in different seasons, and peopled them with disparate characters. He is considered to be the first Japanese landscape artist of the nineteenth century, whose work was huge both in quantity and in quality, producing a preponderance of illustrations in series. He specialized in watercolors and prints, but also produced drawings and paintings. He belonged to the "ukiyo-e" school of colored printmaking, which produced innovations in landscapes, portraits, and genre scenes. He was its most prolific member (others were **Hokusai** and **Shakaru**). His prints would be known and admired by western European painters as a result of the showing of his works in the Japanese pavilion at the Universal Expositions in Paris. He would affect the Impressionists and Post-Impressionists. Members of the Art Nouveau movement would appreciate his precise and fluid sense of line, while the Expressionists would be taken with his portraits. In general, what primarily caught westerners' attention were his decorative sense and the great simplicity he used in representing reality. Hiroshige's style was characterized by **Realism** in capturing everyday life, by the precision of his draftsmanship, and by his harmonious compositions, which in his later periods increased in size. He also practiced "sabi," an aesthetic tendency that sought to suggest reality with the least possible number of elements. He strove for simplicity, which is the best way of transmitting inner beauty. He also decorated fans and kakemonos

Transfiguration.
FERDINAND HODLER.

and produced many illustrations in series of fish, birds, and plants. He had many followers, including his sons. Noteworthy among his works are numerous views and landscapes that, in general, make up series of illustrations, such as *Famous Places of the Eastern Capital* (ca. 1831), *Famous Places of Edo* (1831), *Fifty-three Stages of the Tokaido* (1833–1834), *Famous Places of Kyoto* (1834), *Eight Views of Lake Biwa* (ca. 1836), *Thirty-six Famous Views of Mt. Fuji* (1858), and *One Hundred Famous Views of Edo* (1856-1859). One of his best-known woodblock prints is *Great Bridge, Sudden Shower at Atake.*

HODLER, FERDINAND

(Bern, 1853–Geneva, 1918)

A Swiss painter, he is known for his compositions of Alpine figures and landscapes, which at times show characteristics parallel to Symbolism, and are forerunners of Art Nouveau painting. The son of a carpenter, he began to work with a local painter for whom he did small paintings of picturesque views for tourists. Later, he studied at the Fine Arts School in Geneva, where he settled and whose surrounding areas offered him landscapes for his paintings. However, in those paintings, he treats nature with neutral light and cold, intense color, usually using shades of blue. He repeats subjects, often with symbols, but always through precise, simple motifs that acquire the clarity of a poster, evident in *Lake Thun*, a painting from his last period. He had his first individual exhibition in 1885, fol-

lowed by his participation at the International show in Paris in 1889. Years later, he exhibited with the Symbolist painters. His best-known work, *The Night*, was removed from the exhibition in Geneva by order of the authorities, but from 1904 onward, as a result of exhibiting his work in Venice, he achieved fame and international prestige.

H

The Sataido of the Gohyakuji Temple.
KATSUSHIKA HOKUSAI.

HOKUSAI, KATSUSHIKA

(Homjo, 1760–1849)

A Japanese painter, he is his country's most prominent representative in the area of colored woodcuts. The son of a merchant, he was a pupil of an engraver specializing in theatrical subjects. In 1807, he received a commission to make an "ukiyo-e," a true innovation in Japanese engraving, which consists of using woodcut printmaking to illustrate books. Two years later, he had made a name for himself in this specialty and formed a school which would have many pupils. One of his noteworthy works is *Mangwa (Ten Thousand Sketches)*, fifteen volumes whose publication began in 1814 and for which he needed countless preparatory drawings; he did more than 300,000. In his color prints, he reflected contemporary Japanese life with keen powers of observation, and, at times, a witty point of view. His productivity was astounding, and among his most famous works are *Thirty-six Views of Mt. Fuji* and *The Great Wave off Kanagawa* (1823–1839).

HOLLAND, JAMES

(Burslem, 1800–London, 1870)

An English painter, specializing in landscapes. Noteworthy among his works are paintings of flowers, a subject he mastered through the skill and craftsmanship he acquir-ed in his youth at a porcelain factory. Floral subjects provided him with a means to earn a living when he went to London at the age of nineteen, a city where he took up residence and managed to exhibit at the Royal Academy in 1824. His personal discovery of Holland led him to paint landscapes, often in watercolor. He later would seek inspiration from places in other parts of Europe, especially Italy and Venice. Works about this city include *The Grand Canal, Venice*, *Piazza San Marco*, and *Rialto Bridge*.

HOMER, WINSLOW

(Boston, 1836–Prout's Neck, 1910)

An American painter, he is included in the group of artists from

The Langford Family in Their Drawing Room.
JAMES HOLLAND.

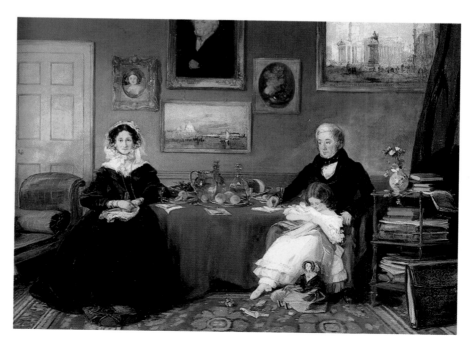

Curiosity.
KATSUSHIKA HOKUSAI.

H

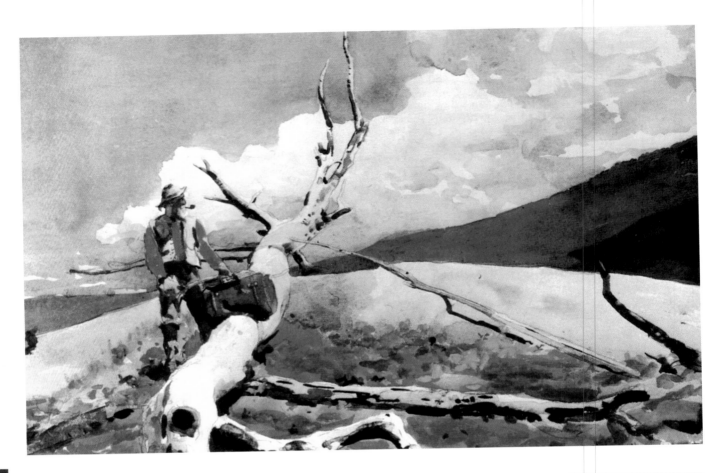

Upper left: *Woodsman and Fallen Tree.*
Below: *Long Branch, New Jersey.*
WINSLOW HOMER.

the period of the American Civil War, and whose work influenced the development of the country's national identity. As an illustrator of periodicals, he was sent by the newspaper, *Harper's Weekly,* as a war correspondent to make drawings at the front. Competing with the first war photographs in history by Mathew Brady and others, he did a series of drawings that would have a key influence on the evolution of his pictorial work. When the Civil War was over, he dedicated himself to painting full time and went to Paris in 1867 where he became acquainted with

Flood at Saint-Cloud.
PAUL HUET.

Impressionism. His best-known work, *Long Branch, New Jersey,* from 1869, is a model for understanding his synthesis between **Impressionism** and the new three-dimensional focus of photographic technique. Very clear evocations of the unsettling narratives of Henry James can be seen in his work.

HUET, PAUL

(Paris, 1803–1869)

French painter. His Romantic landscapes anticipated many of the elements of nature that so interested the painters of the **Barbizon School,** so he is often linked to this school. Trained at the Fine Arts School in Paris, he worked in **Gros'** atelier and met **Delacroix** and the

English landscape artist **Bonington.** In 1824, he saw **Constable's** work, whose atmospheric studies had an impact on him and influenced his work. He traveled to Normandy and set down the most active and dynamic phases of nature in preparatory studies and sketches, done *in situ* ("on site") or in *plein air* ("open air"): storms, breaking waves, and torrential rain, scenes of natural phenomena in which the human figure is absent. *Waves Breaking at Granville Point* from 1853, is one of the results of his investigations, and an example of his "wave paintings" done in the open air, which brought him fame. Other works are *Flood at Saint-Cloud* and *High Tide Outside Honfleur,* which should be analyzed from the sublime point of view and from the pathos characteristic of **Romanticism**.

H

HUGHES, ARTHUR

(London, 1832–1915)

An English painter, his work can be classified with the Pre-Raphaelites. In 1847, he entered the Royal Academy as a student and two years later, had his first exhibition, in which he received an award for his painting *Musidora*. His style caught the attention of **Hunt**, **Rossetti**, and **Brown**, when he showed his work *Ophelia* in 1852, a composition which brought him into the Pre-Raphaelite group. His style is delicate and poetic, as can be seen in *April Love* (1856). Starting in 1857, he worked with **Morris** in painting the murals at Oxford University. His illustrations are also noteworthy.

HUNT, WILLIAM HOLMAN

(London, 1827–1910)

An English painter, he forms part of the Pre-Raphaelite Brotherhood. His pictorial work was based on solid, formal execution and subject matter that was literary in nature or Biblical. He began to pain, when he was studying business, by copying masterpieces of the fifteenth-century Flemish and Italian schools. In 1845, he entered the Royal Academy and met **Rossetti** and **Millais**, founding the renowned Pre-Raphaelite Brotherhood with them in 1848. The subject matter of his paintings carries connotations of marked sentimentality. His first painting, *Hark*, dates from 1846, and a year later he produced *Flight of Madeline and Porphyro During the*

April Love.
ARTHUR HUGUES.

The Scapegoat.
WILLIAM H. HUNT.

Drunkenness Attending the Revelry, based on a scene from a poem by Keats, one of Rossetti's and Millais' favorite poets. Both works show intense coloring and minute detail, with certain symbolic elements, a trait which goes back to the formative influences of his youth, *quattrocento* painting and the Flemish primitives. He followed **Ruskin**'s theoretical principles, as well as the ideas of revitalizing the moral and religious principles of English society through art. From 1849 onward, with *Rienzi Vowing to Obtain Justice for the Death of His Young Brother*, he was characterized by the Pre-Raphaelite line of aesthetic performance, as well as his own virtuosity in light and color. A demonstration of the enthusiasm the painters of this art movement felt for Shakespeare is *Claudio and Isabella*, from 1850, based on Shakespeare's *Measure for Measure*. A year later, he did one of his best paintings, *Valentine Rescuing Sylvia from Proteus* (1851). He made several trips to Palestine, and from 1866 to 1868, he lived in Florence. He achieved success and critical recognition throughout his career.

Claudio and Isabella.
WILLIAM H. HUNT.

159

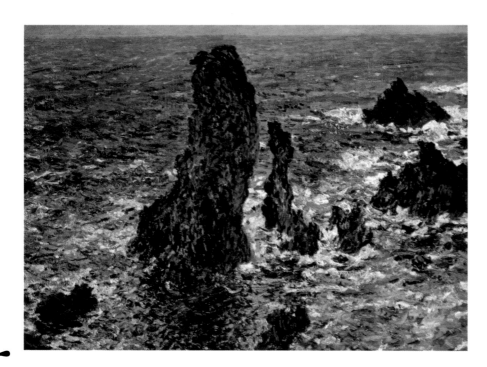

The Rocks at Belle-Isle.
CLAUDE MONET.

IMPRESSIONISM

Art movement that arose in France between 1869 and 1870. It reached maturity in 1874, when its first exhibition was held. The founders of this movement were a group of artists whose works had been systematically rejected at the annual shows put on by the Paris Salon, an official symbol of art and the institution that the Academicist painter **Ingres** dominated. The exhibition took place in a room attached to the photographer Nadar's studio, and the name of the art movement, **Impressionism**, came from the mocking term a critic from the satirical newspaper *Le Charivari* used in evaluating **Monet**'s painting *Impression: Rising Sun;* Monet also painted *The Rocks at Belle-Isle*. Impressionism appeared as a reaction to Realist Academicism and to the classical, excessively strict subject matter defended by the French Fine Arts Academy, which set the rules and standards at the annual Salon exhibitions. Although in many ways it continued and completed the naturalist concept of Western painting, it is considered an important point of departure for contemporary art and painting. An Impressionist painter's fundamental interest lay in studies of light and its impact on matter and on the landscape. For this reason, studio work was abandoned to soak up everyday experiences in the country or in the city. It is outside of the studio, in the open air, where the painter can study and test

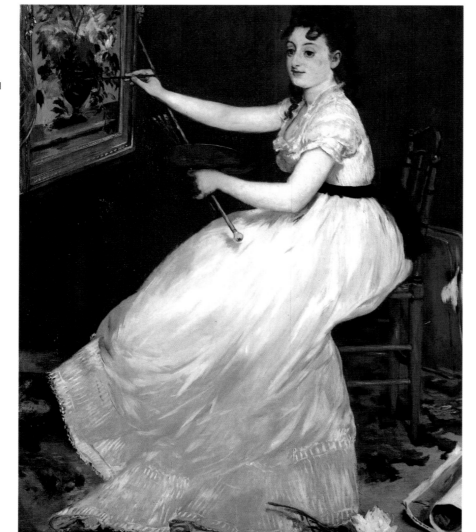

Portrait of Eva Gonzales.
EDOUARD MANET.

Mère Anthony's Inn at Merlotte.
PIERRE-AUGUSTE RENOIR.

J

The Orchestra of the Opéra.
EDGAR DEGAS.

the effects of light and its fleeting, transient moments. Obviously, this type of investigation affects technique, color, and composition, aspects that evolved with surprising

The Mother and Sister of the Artist.
BERTHE MORISOT.

speed towards fluidity and the transformation of the brushstroke, to the mixing of color on the canvas itself rather than on the palette, and to the elimination, in some cases, of drawing altogether. The main figures in this movement, at its beginnings, were **Degas, Monet, Renoir, Moris-**

sot, **Pissarro**, **Sisley**, and **Cézanne**. The attentive observation of nature reached its height in the series of paintings of Rouen Cathedral and Westminster Abbey that Claude

I

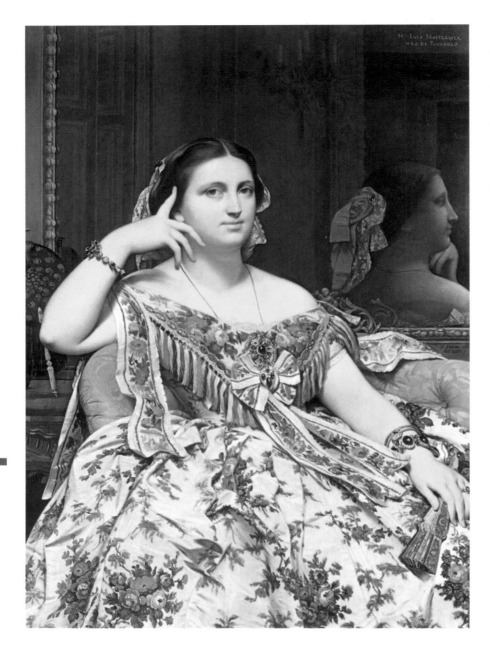

Madame Moitessier.
JEAN-AUGUSTE-DOMINIQUE INGRES.

Monet painted at different times of the day in order to capture the changes in light and atmosphere. Technically, it can be said that Impressionism was born with the first works of Pissarro and ended with the **Neo-impressionism** of **Seurat**, the first exponent of **pointillism**, a methodical and scientific process in the investigation of color and light, which the Impressionists had done in a spontaneous manner.

INGRES, JEAN-AUGUSTE-DOMINIQUE

(Montauban, 1780–Paris, 1867)

A French painter trained in Neoclassical principles, in fact, one of the best painters of nineteenth-century France. He is considered to be the last great representative of French historical Classicism. A native of a small episcopal village and the son of an artist who practiced all of the figurative arts, as well as music, he soon began to study drawing and the vio-

lin. In 1791, when he was still a child, his father took him to Toulouse to study in order to acquire a good foundation. Drawing was the basis of his education, first at school and then at the Fine Arts School. From there, he went to Paris in 1797 to the atelier of **David**, the great Neoclassical painter of Revolutionary France, who at that time was at the pinnacle of his art and genius, but also at the start of his political collapse and decline in social prestige. Ingres studied with David for four years, receiving an indelible influence on his style, and above all, on his draftsmanship and modeling. While studying at the Fine Arts School, he also exhibited his work in public. Trained in Davidian-style art, his style evolved in accordance with the typical artistic progression of the times, with risk-taking breaks in style and tendencies towards **Romanticism**. His work had a far-reaching effect on the artistic development of the nineteenth century. In 1801, he won the Prix de Rome with his work *The Envoys from Agamemnon*, which gave him the right to travel to that great capital as a scholarship holder. However, the French government was unable to pay him the scholarship until 1806, and it was then that he established himself in the Italian city with his *Napoleon on His Imperial Throne*, a painting done in strict Classicist style. Meanwhile, he sent a series of portraits to the Salons, which he had done for the Rivière family, for François-Marius Granet (1807), and for Madame Davaucey (1807), among many other figures in Napoleon's administration and government who were living in Rome. While in Rome, he took advantage of the opportunity to study his favorite artists, Michelangelo, Titian, and above all, Raphael, an essential

Paolo and Francesca.
JEAN-AUGUSTE-DOMINIQUE INGRES.

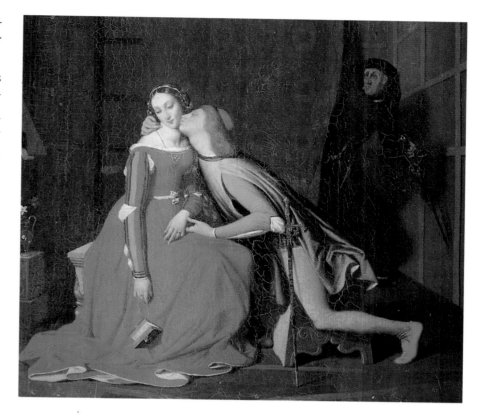

influence on his work. these studies made him evolve both technically and stylistically to create his own personal style. Thus, he gradually abandoned the classical precepts and the heroic style inherited from his teacher David, to enter into a more intimate and sensual artistic style, though he never abandoned the idea of the supremacy of line and draftsmanship. Examples of this transitional step are his most popular paintings of female nudes: *Woman in the Bath* (also known as *La Grande Baigneuse* or *The Valpinçon Bather*, from 1808) and *La Grande Odalisque* (1814) These are nudes with impossible anatomies where light and color are subordinated in order to exalt the importance of outline and everything linear. Ingres was married in Rome, and after the fall of the Empire in 1815, his usual clientele for portraits gradually diminished and a

few years passed in which he did a series of paintings very closely related to his Italian artistic idols. His situation worsened when his 1806 painting, *Napoleon on His Imperial Throne*

was once again exhibited at the Paris Salon and was considered politically

Antiochus and Stratonice.
JEAN-AUGUSTE-DOMINIQUE INGRES.

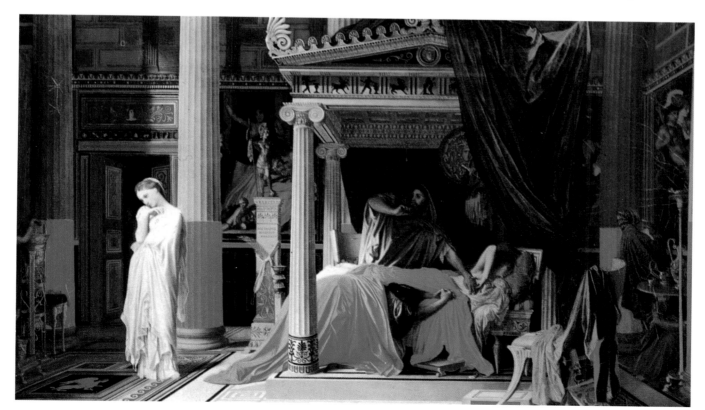

J

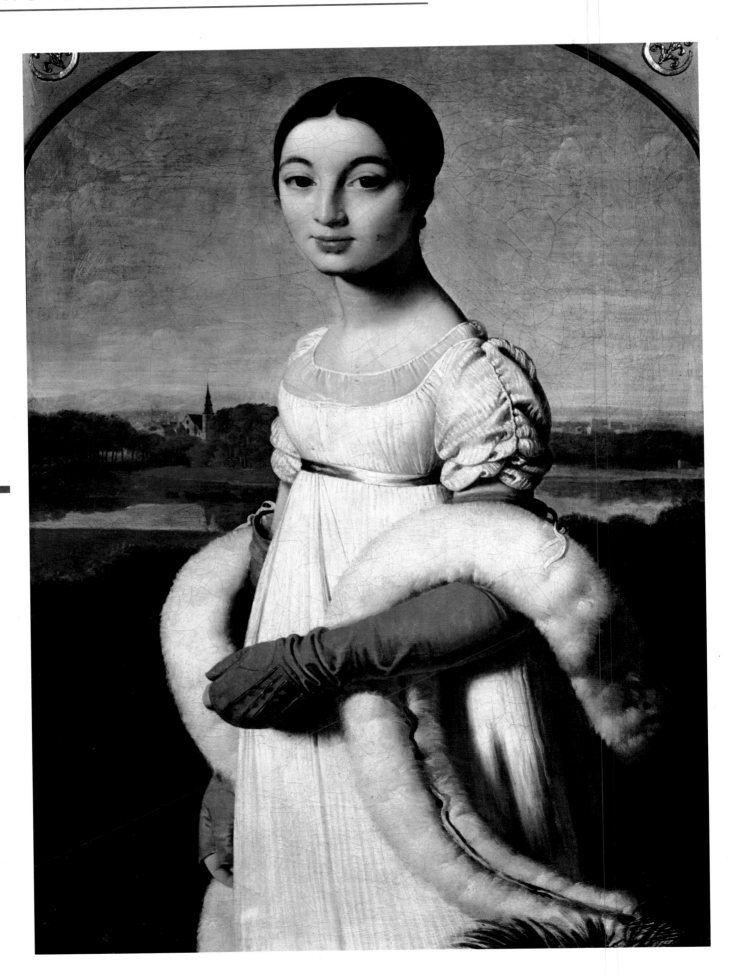

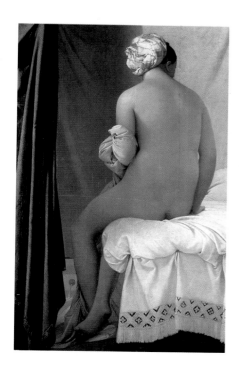

The Valpinçon Bather.
JEAN-AUGUSTE-DOMINIQUE INGRES.

incorrect. He went to Florence, where he lived until 1824, becoming familiar with the work of the fifteenth-century Tuscan painters. He developed a new compositional focus that was formal yet used subjects that displayed a certain hedonism, such as in *Oedipus and the Sphinx* (finished in 1825) or *Roger and Angelica* (1819). However, it was with *The Vow of Louis XIII* (1824), a commission from the new French regime, that he was reconciled with the Paris government. This painting was exhibited at the Salon along with **Delacroix**'s *Massacre at Chios*, and these two paintings perfectly represented the two opposing but not antagonistic movements of those years: **Neoclassicism** and Romanticism. In that same year, he returned to Paris to much recognition and was awarded the medal of the Legion of Honor. In another commission, *The Apotheosis of Homer*, from

Madame Rivière.
JEAN-AUGUSTE-DOMINIQUE INGRES.

1827, he shows signs of his classicist fervor and strictness, and of Raphael's influence, as well as his own peculiar way of understanding historical painting. He embraced the mythological subject matter so beloved by the Romantic painters and the Napoleonic revolutionaries, as he had already done in 1813 when, fascinated by Nordic legends, he painted *Ossian's Dream*. His continuous commissions and successes were unstoppable in those years, but his great work *The Martyrdom of St. Symphorian* (completed in 1834) was so badly received by the critics that he requested a transfer to the Rome Academy, a request that was granted naming him director of Villa Medici, a position he held from 1834 to 1835. In 1841, he returned to Paris, where he entered a phase in which he created orientalist paintings. These works became of great interest because that kind of subject matter was currently in fashion and held in esteem by the Romantic movement. However, in this type of exoticism, Ingres never strayed from the example set by the classical masters, such as Giorgione and Titian, whose stylistic maxims involved the exaltation

of line and draftsmanship. This is the case, for example, of *Harem Interior with Odalisque, Musician, and Attendant* (1839)and *The Turkish Bath* (1849–1863), an important creation in a circular format in imitattion the tondos of the Renaissance. Living until the age of eighty-seven, with work that extended into the 1850s and 1860s, Ingres is the definition par excellence of the Neoclassical painter, but his work evolved through channels that sharply diverged from those of the Davidians, channels that avoided everything static and heroic, giving a different vision—more human in portraits, more intimate in female nudes—but overall much more personal and innovative.

INNES, George

(Newburgh, 1825–Bridge of Alland, 1894)

American painter. His landscapes are outstanding. He achieved fame with them because of his original

Autumn Oaks.
GEORGE INNES.

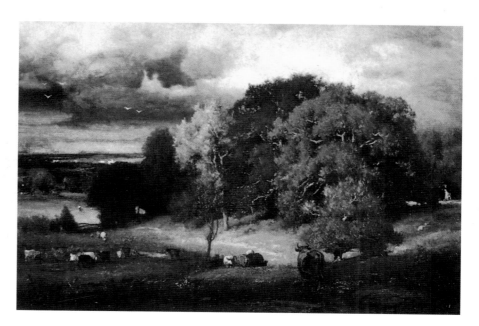

style, a synthesis of the technique and aesthetics of contemporary European painters. He studied the Renaissance masters in Rome, and in France he saw the painting of the **Barbizon School**. He settled in New England from 1859 to 1864 and devoted himself to applying the theories about color and light that he had learned in Europe; he then returned to Europe in 1870. When he came back home, in 1876, he was one of the most famous American landscape artists, the creator of harmonious scenes that were a departure from the "dramatic landscapes" characteristic of European **Romanticism**. An academician and a member of the Society of American Artists, he painted such noteworthy works as *Peace and Plenty* (1865), *Home of the Heron* (1891), and *Home at Montclair* (1892). His son, George Innes, Jr., was also a landscape painter, but did not achieve his father's celebrity.

ISRAELS, ISAAC

(Amsterdam, 1865–1934)

A Dutch painter, the son of **Josef Israels**—a key figure in his artistic career— he became one of the most important artists of the generation that gave the Hague school its name. He began to study at that city's Academy, along with Hendrik and **Breitner**. He sent his paintings to the Paris Salons and received an honorable mention in 1885. From 1903 to 1914, he worked in Paris and traveled around other European countries. His paintings include subjects typical of his time, representations of the world of the cabaret, the circus, the boulevard,

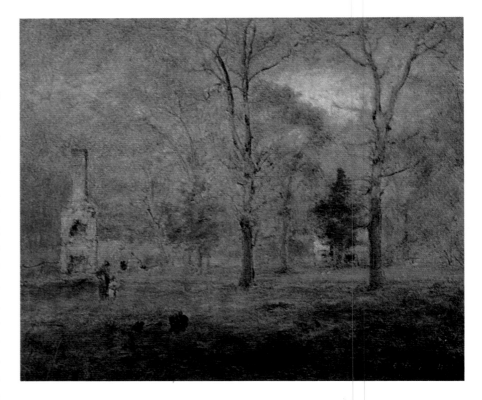

Autumn Oaks.
GEORGE INNES.

and the café, although he also did some portraits and military paintings. In 1921, he spent some time on the island of Java, where he composed a series of paintings depicting the people and the delicate atmosphere of that region of Indonesia.

ISRAELS, JOSEF

(Groningen, 1824–The Hague, 1911)

Dutch painter. A large amount of his work is dedicated to landscapes and the painting of customs and manners, within a Realist pictorial structure deriving from **Millet**'s work. He began to study painting in Amsterdam, and expanded this training in Paris in 1845, where he studied with François Picot. He frequented **Delacroix**'s atelier and those of other Romantic painters. In his works—within the field of genre

painting—the influence of seventeenth-century Dutch painters predominates, specifically Rembrandt. These compositions, such as *When We Grow Old* (1883) and *A Son of the Chosen People* (1889), reveal subject matter of a social nature, with a melancholy and sentimental tone. The compassion he successfully tried to show can be seen in many of his works devoted to the unhappy life of the Jews in Amsterdam or the inhabitants of small villages. He achieved this by forgoing color and painting monochromatic compositions in grays, dark ochres, and strong chiaroscuro—resources that contribute a unique delicateness of portrayal in many of his pictures. His work evolved in technique towards **Impressionism**, with evident concern for the effects of light. He exhibited at the Paris Salons on numerous occasions, always with notable success. He founded the

Young Daughter of Amsterdam.
ISAAC ISRAELS.

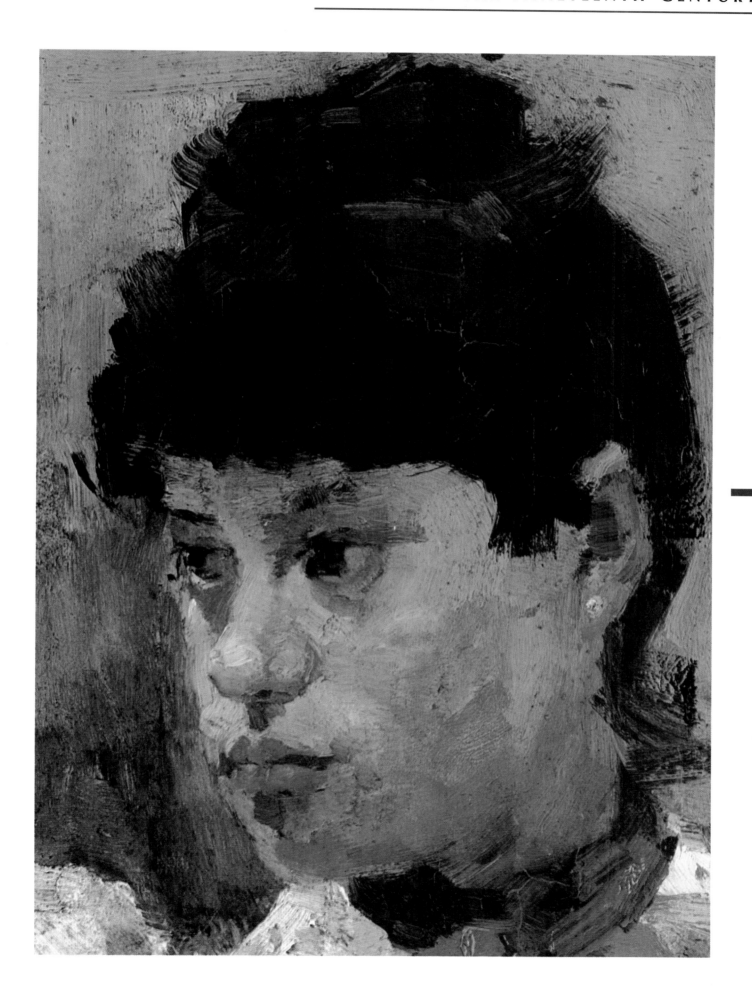

J

Café Singer.
JOSEF ISRAELS.

Hague school, a pictorial group formed by the **Maris** brothers, **Mesdag**, and **Mauve**.

IVANOV, ALEXANDER ANDREIEVICH

(St. Petersburg, 1806–1858)

A Russian painter, the last great representative of classical painting in his country. Ivanov also took part in the innovations of the new art movement, **Romanticism**, in such

a way that a synthesis of both can be seen in most of his paintings. From the former, he takes its strict-

ness and meticulousness of draftsmanship, its fine style, and use of detail; and from the latter, its concept of light and landscape, as well as its complex compositions. He began his artistic training with his own father, a historical painter, at the Fine Arts Academy in St. Petersburg, where he did his first known work, *Priam Asking Achilles to Return Hector's Body.* This work clearly shows the Classicism-Romanticism duality that would mark his painting, evident in its theatricality, which reveals the characters'

John the Baptist.
ALEXANDER A. IVANOV.

emotions and the intimate psychological conflict underlying the scene, which fills the painting with dramatic tension; however, the technical treatment is strictly classical. In 1830, he traveled to Germany and Italy, and through a scholarship, was able to establish his residence in Rome, where he would live for a large part of his life. There he came under the influence of the German **Nazarenes**, primarily devoting himself to religious painting. He painted his masterpiece, *The Appearance of Christ before the People* (1833–1858), which took him more than twenty years, until his

Detail of The Appearance of Christ before the People.
ALEXANDER A. IVANOV.

death, therefore leaving it unfinished. He made many sketches from it, showing innovative treatment, which presaged later art movements. These sketches are in and of themselves true individual works and may be one of the most interesting facets of his work. On the other hand, the painting shows a clear influence from the classics and the Italian masters of the Renaissance, accompanied by a tormented composition, entirely Romantic, and an innovative, clearly avant-garde, open-air treatment. In the last decade of his life, he did a series of drawings and watercolors, called the *Biblical Sketches*, in order to prepare for some frescoes that he never managed to do. These narrate passages from the Gospels in a mytho-

logical treatment that also mixes historical and genre painting. They clearly show the artist's intention to give the important role to the crowd rather than to an individual. Other less important, but still noteworthy, works are *The Appearance of Christ to Mary Magdalene*; *Apollo, Hyacinthus, and Cypress, Singing and Playing* (1831–1833); *A Tree Branch* (1840–1850); and *At the Bay of Naples* (ca. 1850), as well as numerous Italian landscapes and genre watercolors.

JONGKIND, JOHAN BARTHOLD

(Lattrop, 1819–Côte-Saint-André, 1891)

A Dutch painter, an essential figure in the evolution of the landscape during the second half of the nineteenth century. Jongkind spent a large part of his life in France, and his work was pioneering and decisive in **Impressionism**. He trained from 1836 onward at the Academy in The Hague, and was outstanding in the technique of watercolor, concentrating on landscape painting based on **Realism**. He traveled to Paris in 1845, where he worked with François Picot and exhibited at the 1848 and 1852 Salons. The praise he received in the latter year from the critics, published in magazines and newspapers, came from two famous writers, Charles Baudelaire and Èmile Zola, documents that provide the most reliable proof of the importance of this Dutch artist's creative work. It can be said that his work is an experimental beginning, that starting with Realist painting, paved the way to modern painting: a bridge between the **Barbizon School** and Impression-

J

House in Ruins.
JOHAN B. JONGKIND.

Boats Near the Mill.
JOHAN B. JONGKIND.

ism. His life in Paris had the most dramatic features of the legendary artistic bohemian lifestyle. In the midst of great financial difficulties, he fell into a depression from which he attempted to escape through alcohol. Drinking gave him back his artistic inspiration and even helped him increase his work capacity, but it ended up worsening his psychological torment. His painter friends, **Corot, Rousseau,** and **Boudin,** helped him overcome his misery on more than one occasion,

La Seine et Notre-Dame de Paris.
JOHAN B. JONGKIND.

and in 1863, they collaborated so that he could exhibit at the Salón des Refusés, where they introduced him to **Monet,** a painter who understood his way of expressing a landscape through a new painting style and a new work method. On the trips he made to Normandy and during his stay in Honfleur, he painted numerous sketches and watercolors in the open air, for the sole purpose of capturing nature just as he saw it, through light and using color in its different hues. Among his noteworthy works are *Dutch Canal by Moonlight, Harbor at Honfleur,* and *Memory of Le Havre,* painted in the 1860s. However, his numerous seascapes, painted with different climatic changes, different

atmospheric conditions, and variations in light are the pictures that provide the key to understanding Monet's later investigations, investigations that Jongkind perfected ten years before, from 1863–1864, when he did a series of paintings of the Cathedral of Notre Dame in different daylight conditions. In 1878, he went to Grenoble, but an alcoholic crisis drove him to madness, and he was committed to an insane asylum, where he stayed until his death thirteen years later. Later artists, such as **Manet,** considered him "the father of the modern landscape."

Doctor Auguste Tissot.
ANGELICA KAUFFMANN.

KAUFFMANN, ANGELICA

(Chur, Switzerland, 1741–Rome, 1807)

Swiss painter. Trained in the aesthetic assumptions of the late Baroque period, she spent most of her life in Rome. She began her artistic training with her father, who was also a painter. Kauffmann lived in London for some years, where she saw Reynolds' work, learned his style, painted his portrait, and became a member of the Royal Academy in 1768. She married the painter Antonio Zucchi in Rome and moved in the intellectual circles of the period, developing cordial relationships with Goethe, Robert Adam, and Cardinal Albani. Like all of them, she followed the artistic theories proposed by the Neoclassical painter and theorist Anton Mengs regarding a return to the aesthetic ideals of ancient times. Kauffmann stood out as an excellent portraitist, who abandoned Baroque compositional methods for a gentler, more intimate type of expression. For some historians, her art represents a union between the Roman, English, and German schools. Her work also included Biblical, mythological, and historical scenes, such as *Cleopatra at the Tomb of Mark Antony.*

KEIL, ALFREDO

(Lisbon, 1851–Hamburg, 1907)

A Portuguese painter and musical composer, Keil's artistic output consisted of many small paintings of genre scenes, landscapes, and seascapes. These portrayed Portuguese scenes and popular customs. He was awarded the bronze medal at the Universal Exposition in Paris in 1900. His operatic compositions and his musical studies also brought him renown.

KENSETT, JOHN FREDERICK

(Cheshire, Connecticut, 1818–New York, 1872)

American landscape painter. After his initiation into engraving in New Haven, he traveled to Great Britain with **Durand** in 1840, where he

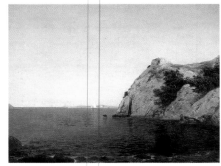

Beach at Beverly.
Newport Harbor.
JOHN F. KENSETT.

resided until 1845. From there, he traveled to other European countries and began began to paint seriously. After a time he returned his own country, whose varied scenery provided him with inspiration for numerous paintings. Once back in the United States, he was elected a member of the National Academy in New York in 1849 in recognition of his standing as an artist. In 1858, he joined the Commission in charge of decorating the Capitol and later, in 1870, was one of the founding members of the Metropolitan Museum of Art in New York. He is considered to be a member of the Hudson River School, since this region was an important subject in many his paintings. His approach to landscape painting is subjective and lyrical, and his paintings show his concern for atmosphere and light, in part due to his contact with Durand. Light is the element that transfigures his landscapes, making their reality changeable and giving his paintings a sensation of transience—a feeling of capturing a moment in time—while at the same time imparting a certain mysterious and idyllic feeling. However, in spite of this apparent artificiality, he stayed within the bounds of Realism. Notable works are *Bash Bish Falls, South Egremont* (1855); *Narragansett Bay* (1861); *View of Cozzen's Hotel* (1863); *Lake George* (1869); and *Newport Beach* (1869).

KERSTING, GEORG FRIEDRICH

(Güstrow, 1783–Meissen, 1847)

German painter and designer belonging to Romantic **Neoclassicism** within the Biedermeier school. Having completed his painting studies at

Portrait of Caspar David Friedrich in His Studio.
GEORG FRIEDRICH KERSTING.

the Fine Arts Academy in Copenhagen, he went to Dresden in 1808, where he settled. Ten years later, he was named director of the painting department at the Meissen porcelain factory, where he designed battle scenes for a set of dishes dedicated to Lord Wellington. In his painting, he rebelled against the Classicist purity that was in vogue and defended by the academies. Included in his work are portraits, landscapes, religious figures, and genre paintings. He is, above all, an excellent painter of interiors, preferably those that show a window and a single figure going

about his or her business. An example of this is *Portrait of Caspar David Friedrich in His Studio* (1811), of which he painted several versions and from which emanates a certain air of solemnity and solitude. In these paintings with their delicate light, a poetic and intimist atmosphere is created—all characteristics that fit perfectly into the Biedermeier style, as can be seen in *Man Reading by Lamplight* (1814). Another significant

K

175

work of this type is *Before the Mirror* (1827).

KHNOPFF, FERNAND

(Fremberger, 1858–Brussels, 1921)

Belgian painter, sculptor, and engraver. The influence of Symbolism and of the English Pre-Raphaelites can be seen in his painting. In Brussels, he combined law studies with his art training as a pupil of the painter Mellery. Later, he studied at the Academy in Paris and in 1879, met **Moreau**, who had a decisive impact on his work. He was a very

Portrait of E. S. Avdulina.
OREST A. KIPRIESNSKI.

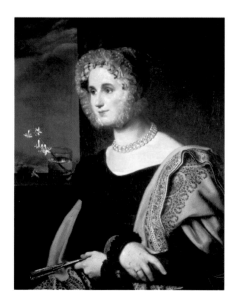

cultured artist, an excellent book illustrator, and a devotee of astrology, a science that guided many of his works. Many of his engravings are included in the works of contemporary Symbolist poets. *Under the Fir Trees* and *St. Anthony and the Queen of Sheba*[1] are compositions that accurately reflect his style.

KIPRENSKY, OREST ADAMOVICH

(Nesinskaya, near St. Petersburg, 1782–Rome, 1836)

A Russian painter from the transitional period between **Neoclassicism** and **Romanticism**. Kiprensky was the first artist from Russia to follow the Romantic movement,

The Caresses (The Sphinx).
FERNAND KHNOPFF.

not only with respect to his work, but also in his own life, which was infused with this new "philosophy" and corresponded to the typical artist's life known in other European countries. He was trained at the Fine Arts School in St. Petersburg, basically in the area of historical painting inspired by ancient times, a genre that was more closely linked with the Classical era that preceded Neoclassicism. He wanted to break away from this and soon discovered portraits, the genre he practiced most and which brought him the most fame. In this field, he painted magnificent works from life which depicted personalities of the day from the worlds of the arts and public life who were perfectly characterized with an intimist spirit, stronger in some (*A.A. Tchelitchev as a Child*, 1801–1809) than in others, such as the official portraits (*Evgraf Davydov*, 1809), but always avoiding affectation. With the pronounced chiaroscuro in his works, reminiscent of Caravaggio and with colors that evoke Van Dyck, some authors have found signifi-

Portrait of S. S. Uvarov.

OREST A. KIPRIESNSKI.

cant traces of Rubens in his portraits, to whose work he had access to at the Hermitage. This meant a complete break with everything that had been done up until then in that genre in Russia. His most innovative and prolific period was his earliest one—before his trip to Italy—when he concentrated on depicting childhood and youth, later devoting himself to painting portraits of military personalities, among others. One characteristic of his style is the power of his draftsmanship and the use of very small amounts of paint on the

Auditorium in the Old Burgtheater.
GUSTAV KLIMT.

brush which produces a very smooth style. In considering his work as a portraitist, his pencil drawings must also be mentioned, a technique that allowed him to capture the spontaneity of the subjects more quickly and naturally, achieving great technical perfection and expressive strength. He pioneered this technique in his country and showed great mastery of it, to the point that he had no rivals. In 1816, he traveled to Italy, where he took up residence until 1823, and where he would be significantly influenced by the Renaissance painters, eanabling him to perfect the execution of his portraits, such as the one depicting N.

Muravyov. After a short trip through Paris, he returned to Russia, then finally back to Rome to spend the rest of his days. He also painted genre scenes. Some other portraits from his extensive collection of work are *E. P. Rostopchina* (1809), *Young Tchelitchev* (ca. 1809), *P. A. Olenin* (1813), and *E. S. Avdulina* (1823).

KLIMT, GUSTAV

(Vienna, 1862–1918)

An Austrian painter and founder of the Viennese *sezession* ("secession") group. Coming from a family of

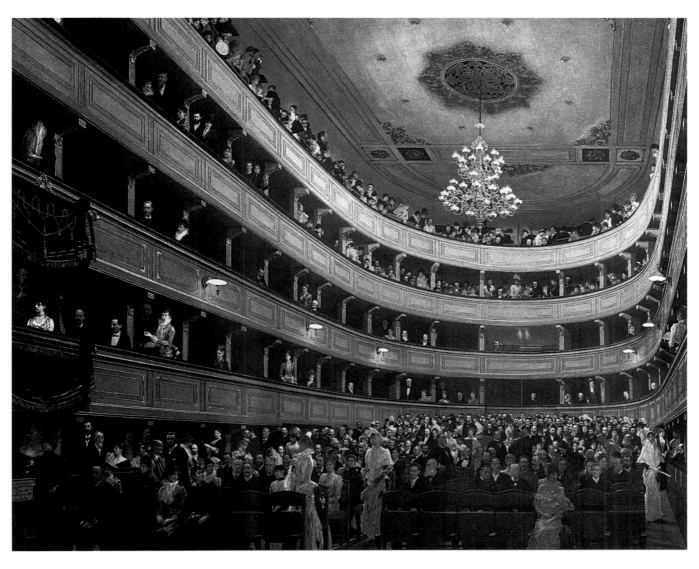

K

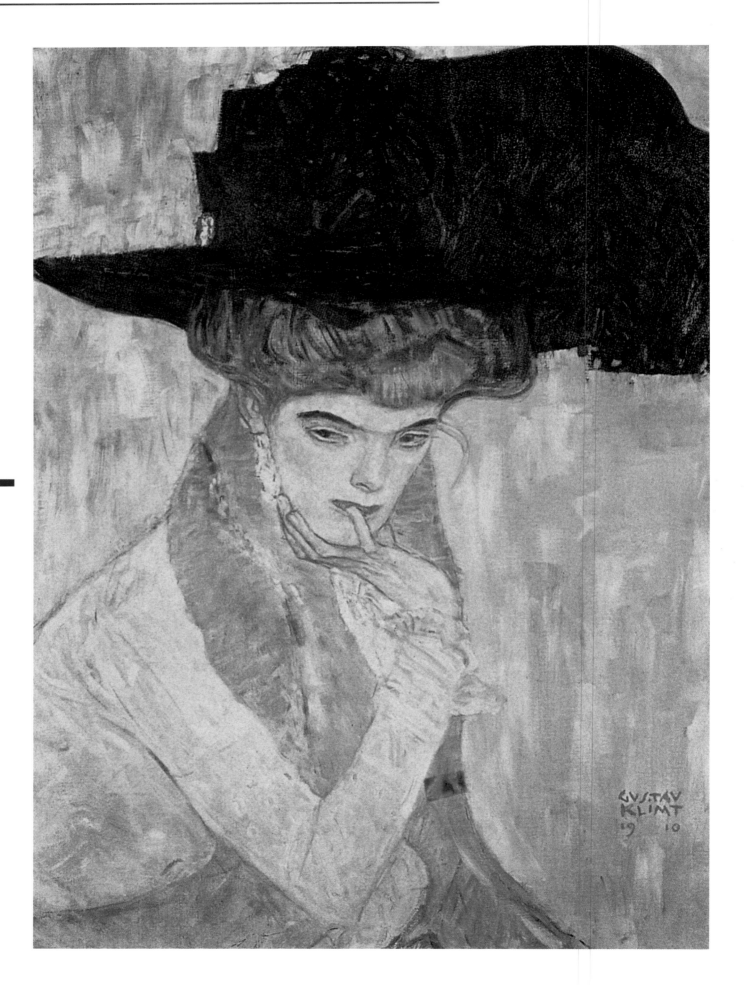

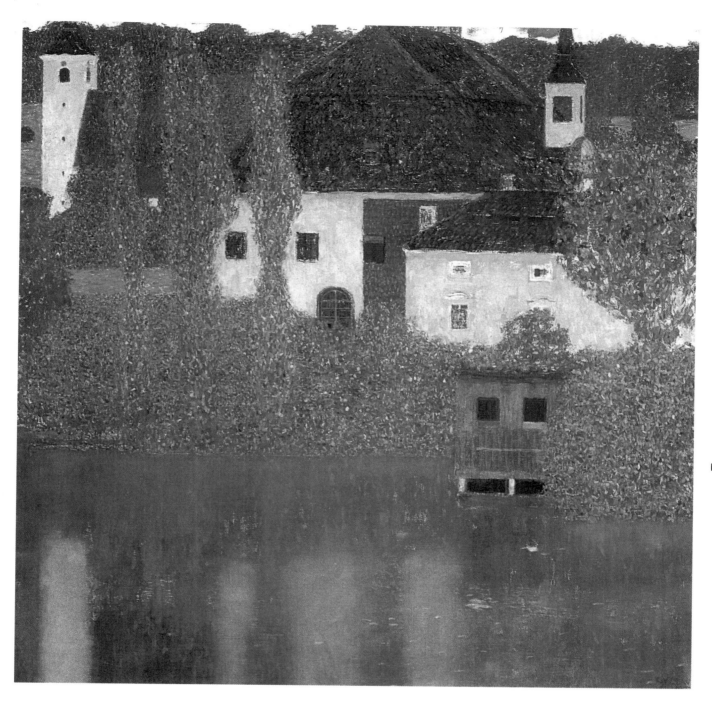

artists, he initially worked in decoration, along with the painter Franc Matsch, a practice he did not abandon throughout his artistic career. His style, a synthesis between **Expressionism** and modernist decoration, prevailed as a result of the formation of the secession group, an art movement in Austria that meant a

Schloss Kammer on the Attersee I.
GUSTAV KLIMT.

break with Academicism and whose work was usually very closely connected to architectural decoration. He excelled in this field, as he did in a series of allegorical paintings —which have since been de-

The Black Feather Hat.
GUSTAV KLIMT.

The Sunflower.
GUSTAV KLIMT.

179

K

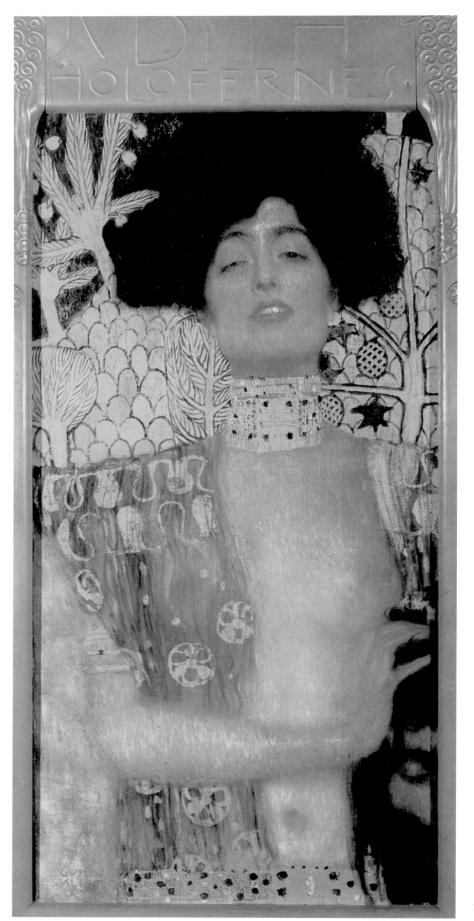

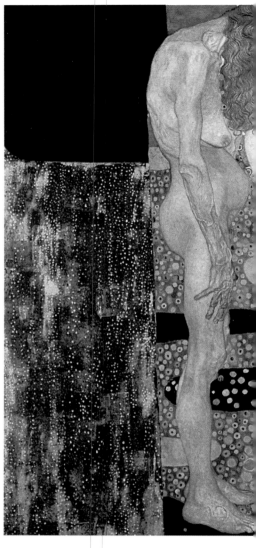

The Three Ages of Woman.
GUSTAV KLIMT.

stroyed— for the theater and the university of Vienna. His favorite themes were those of a symbolic and allegorical nature, and his pictorial compositions which are syncopated, with encircling curves and flat colors, incorporate backgrounds of gold and mosaic. Noteworthy among his works are *Judith* (1901), *The Kiss* (1908), *The Three Ages of Man* (1908), and *Judith II (Salomé)* (1909). His landscapes are very original, as are his portraits, such as *Portrait of Fritza*

Judith.
GUSTAV KLIMT.

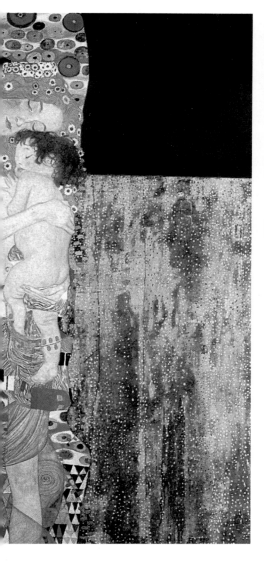

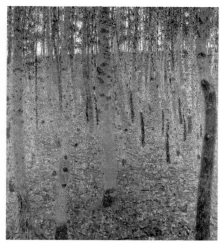

Beechwood Forest.
GUSTAV KLIMT.

Riedler from 1906 and *Adele Bloch-Bauer* from 1907.

KLINGER, MAX

(Leipzig, 1857–Nuremberg, 1920)

German painter, sculptor, and etcher, belonging to the Symbolist movement. He first studied in Karlsruhe with the genre painter Gussow and in **Böcklin**'s atelier in Berlin. His drawings (the early ones were very controversial because of their pronounced **Realism**) and his engravings, to which he gave a very innovative treatment, stand out among his work. He also did paintings, in which he showed great technical skill and originality, as well as great daring. This, along with his distinct tendency towards Realism, provoked such criticism that he was forced, in a way, to leave the country. He returned in 1892 and from that time onward, devoted himself to philosophical subjects, which made up his most interesting work. He also created historical paintings, in which he was influenced by **Menzel** in Berlin, producing *The Death of Caesar*, the greatest painting in the history of German Symbolism, and *The Judgment of Paris* (1885–1887). In addition, he produced religious paintings that showed a Renaissance influence. He is considered the most uniquely in-

Afternoon.
MAX KLINGER.

Portrait of the Artist F. Sodring.
CHRISTEN KOBKE.

Mountain Landscape.
JOSEPH ANTON KOCH.

K

dividual and influential artist in modern German painting, a forerunner of several art movements, both because of his subject matter, in the case of Surrealism, and because of his aesthetics, as in *The Blue Hour* (1890), a very advanced painting for its time. Other works of his are *Strollers*, his first painting, *Afternoon* (1872), *Sea Gods on the Reefs, Christ on Olympus* (1897), *Fisherman*, and *Crucifixion*.

KOBKE, CHRISTEN

(Copenhagen, 1810–1848)

Danish painter, engraver, and lithographer. He studied under the tutelage of **Eckersberg** and to round out his training, he traveled to Rome and Naples in 1838, although this trip had little influence on his style. In his early works, urban landscapes and portraits, his style was influenced by Jean-Baptiste Greuze. Later on, his landscapes were created with a greater restraint, becoming more intimate and with an evident luminosity. The latter characteristic can also be seen in his portraits of relatives and

friends, which show pronounced sensitivity and an intimist atmosphere. However, he primarily painted scenes showing everyday life in his city and its surroundings. In general, his style gradually evolved towards a purer Classicism. In 1844–1845, he collaborated in decorating the Thorvaldsen museum. Although he was not really appreci-

Schmadribach Waterfall.
JOSEPH ANTON KOCH.

ated during his time, today he is considered the most outstanding painter of that period. Other works of his are *The Artist F. Sodring* and *View of the Castle Defenses* (1831).

KOCH, JOSEPH ANTON

(Obergiebeln, 1768–Vienna, 1839)

An Austrian painter, he is considered one of the creators of the monumental alpine landscape. Coming from a rural family, he began to draw as a child while he tended the flocks. With the assistance of the Bishop of Augsburg, he was able to study at a seminary and later enter school in Stuttgart. He made several trips to Switzerland between 1792 and 1794. It was there that he discovered his attraction to mountainous scenery, and where he began his continuous sketches and studies of alpine mountains. In 1795, he went to Rome where he settled and lived for almost his entire life, except for stays in Vienna between 1812 and 1815 and during the last days of his life. In the Italian capital, he joined the group of

Landscape after the Rain.
JOSEPH ANTON KOCH.

German revivalist artists, known as the **Nazarenes**, and a circle of art specialists and experts, sharing a house with the Neoclassical sculptor Bertel Thorvaldsen. He studied the classical landscape, but his anti-academic position made him connect the exalted images of nature and the mountains to literary themes in which the compositions and some of the figures hark back to Mannerist principles. *Heroic Landscape with Rainbow* from 1815 and *Macbeth and the Witches* from 1829 are examples of his attempt to relate dramatic and historic conflicts to nature. One of his exhibitions, held in Munich, brought him enormous critical acclaim, but there were no buyers for his pompous and exalted landscapes. *Bernese Oberland* (1815) and *Schmadribach Waterfall* (1821) reproduced all possible elements of nature's scenery: forests, plains, rivers, streams, hills, and precipices, along with small figures of people and animals. In 1825, he received a commission to finish the decorative work that **Veit** had begun at the Cassino Massimo in Rome. To alleviate his severe financial problems, his friends pursuaded the Viennese government to provide him with a pension so he could eke out a living in the last years of his life.

KRAMSKOY, IVAN NIKOLAIEVITCH

(Ostrogozk, Voronej, 1837– St. Petersburg, 1887)

Russian painter and theorist of critical **Realism**. He studied at the St. Petersburg Academy from 1857 to 1863, when he left at the head of a group of like-minded classmates, who opposed the Academy. With them, he founded the Artel group of artists, who decided to capture reality on canvas by observing life and their surroundings, instead of using the classical painters as models. They began to travel all through Russia, painting and exhibiting, and around 1870, formed a Society of Traveling Exhibitions under the name "The Itinerants." Behind this method was a burning need to create a wider audience, that included people other than those who lived in big cities and who were already familiar with the artists' works. This goal was accompanied by a spirit of reformism and nationalism. Savrosov, Shiskin, Makovsky, and **Perov**, among others, formed part of this group. For Kramskoy, man would always be the main protagonist in his work, and his social concern increased as he matured, as it did with other realists of the 1860s. He was primarily a portraitist, who chose people from the world of Russian culture as his models, specifically progressives, as can be seen in his abundant work in this

Portrait of Leo Tolstoy.
IVÁN N. KRAMSKOY.

Portrait of T. Shevchenko.
IVAN N. KRAMSKOY.

genre. Common features of his portrait work are its great psychological depth, a noteworthy emotional restraint, and the palette of brown tones that he primarily uses, all of which give his work great expressive strength. Among his portraits, the following are noteworthy: *Portrait of T. Shevchenko* (1871), *Portrait of Ivan Shishkin* (1873), *Portrait of Leo Tolstoy* (1873), *Portrait of the Artist Ilya Repin*, and *Portrait of Pavel Tretyakov* (1876). Notable among his religious works is *Christ in the Desert* (1872), which is in the Tretyakov Gallery, showing the evangelical theme that was so popular at the time, with a

Children Bathing on Skagen Beach.
PEDER S. KROYER.

thoughtful and dejected Christ as the absolute protagonist of the painting, from which any other narrative element that might distract attention from Him is absent.

KROYER, PEDER SEVERIN

(Stavanger, 1851–Skagen, 1909)

Danish painter, who was Norwegian by birth and who worked in the **Realist** style. From childhood, he showed a great talent for drawing and painting, so much so that at the age of nine he illustrated a work on geology. He studied at the Fine Arts School in Copenhagen and in Paris, and also traveled to Italy and Spain,

which provided subject matter for some of his paintings. In 1882, he finally settled in Skagen, a small coastal town in an isolated and inhospitable region. This place would become a center of attraction for young Scandinavian artists, who would form a type of colony, with Kroyer as the leader. The exaggerated Realism he used in his paintings, which were sometimes quite crude, was occasionally rejected, as was the case with his *Italian Blacksmith* (1880). He tried to capture complex light effects in his works and painted numerous landscapes and popular scenes. Noteworthy among his paintings are *Gypsies' Room in Granada*; *Italian Hats*, which won the gold medal at the 1881 Salon; and *Self-Portrait*.

The Old Man and the New Trees.
CARL-GOLF LARSSON.

LAMEYER Y BERENGUER, FRANCISCO

(El Puerto de Santa María, 1825–Madrid, 1877)

A Spanish painter, draftsman and illustrator, he is a representative of the **Romanticism** of Madrid. He was self-taught and spent his life making various trips to Paris, Morocco, the Philippines, and Japan. Among the subjects he painted, the most noteworthy are the genre and popular paintings—along the lines of **Alenza**'s work following Goya's style—as well as oriental subjects rendered in a Euphuistic manner. He also composed historical works, such as *The Defense of Saragossa*. As an engraver, his illustrations for editions of Quevedo's works, such as *El Buscón*, are noteworthy.

The Challenge.
EDWIN LANDSEER.

LANDSEER, EDWIN

(Bristol, 1802–Saint John's Wood, 1873)

English painter and sculptor. Coming from a family of artists, he studied at the Royal Academy in London and specialized in painting animals, a genre appreciated by the upper classes of Romantic society and which grew and was perfected throughout the nineteenth century. He devoted himself to this field with such enthusiasm that he even dissected cadavers to become more familiar with anatomy. He achieved maximum Realism and extraordinary quality, producing works in which the animals usually appear to have human feelings, such as *The Old Shepherd's Chief Mourner* (1837), a touching painting whose sentimentality, like that of many of his other works, is somewhat excessive. **Ruskin** liked his work and mentioned him in his important biography of English painters. He did paintings of many animal species and as well as hunt scenes. A teacher at the Royal Academy from 1851 on, he achieved great success, even pleasing Queen Victoria, who often asked him to paint her pets.

LARSSON, CARL-GOLF

(Stockholm, 1853–1919)

A Swedish painter, trained at the Stockholm Academy, he quickly achieved official recognition with successive academic awards. He traveled to Paris and demonstrated his skill in watercolors when he exhibited at the 1880 and 1883 Salons. He then dedicated himself to illustrating books while continuing his painting. His paintings, as well as his watercolors and drawings of family life, are noteworthy, although they did not reach the same level of renown that he earned through his decorative painting in some of the official buildings in Goteburg.

Portrait of Mrs. Wolff.
THOMAS LAWRENCE.

LAWRENCE, SIR THOMAS

(Bristol, 1790–London, 1830)

An English painter and prominent portraitist of the English school, he succeeded Joshua Reynolds as Painter in Ordinary. From his youth, he showed precocious skill with his paintbrushes, and at the age of twenty, he entered the Royal Academy as a student, quickly standing out as a portraitist. His first subjects were personages from the aristocracy and royalty of Britain and other European countries, including such figures as George III, George IV, Lady Blessington, Charles X of France, and Duc de Richelieu. He also painted portraits of the painter **Füssli** and the actress Elizabeth Farren; the latter work was from 1789 and is very famous. His style is brilliant and fluid, although at times artificial. On occasion, he produced historical paintings, such as the commission he received to decorate the gallery of Windsor Castle in celebration of Napoleon's defeat and the English victory: *The Victors at Waterloo.*

L

Castilian City.
EDWARD LEAR.

LEAR, EDWARD

(London, 1812–San Remo, 1888)

An English painter and writer, his work is included in the English school of landscape painting. He was an excellent draftsman—his paintings of animals are outstanding— and because of the skill he was able to be one of the first to publish a treatise on ornithology with scientific drawings and designs. He traveled through most of Europe and the Near East and wrote several books about his travels. His painting *Dusk on the Island of Philae* is noteworthy, among other views of the Egyptian landscape which he produced.

LEGA, SILVESTRO

(Modigliana, 1826–Florence, 1895)

Italian painter working in the **Realist** style. Lega studied at the Academy in Florence, where his teacher was **Pollastrini**, and later in Mussini's studio and then in Antonio Ciseri's. At first, his painting showed the influence of his teachers and that of the **Nazarenes**, especially in his historical and religious work, but in 1860, he joined the **Macchiaioli** and became one of their most representative members, assuming their style which was based on the use of patches of color. The first paintings he did with this technique—of landscapes and scenes of customs and manners, representing bourgeois and rural life (*The Visit, A Stroll Through the Garden*)— are ingenuous and delicate. These characteristics would give way to drama after 1870, with accentuated contrasts in color and contrasts between light and shadow. In some of his works, the influence of **Impressionism** can be glimpsed. At the end of his life, man took the place of landscapes as the central motif in his painting. Other noteworthy works are *Song of the Starling* (1867), *The Arbor* (1868), *The Engaged Couple, The Paralytic's Life, Giving the Viaticum, After Lunch*, and *The Evil Woman* (1890).

LEIBL, WILHELM

(Cologne, 1844–Würsburg, 1900)

Prominent figure painter from German Naturalism. Leibl began to study in his native city in 1861 and in 1864, entered the Munich Art Academy under the direction of **Pi-**

Dying Manzzini.
SILVESTRO LEGA.

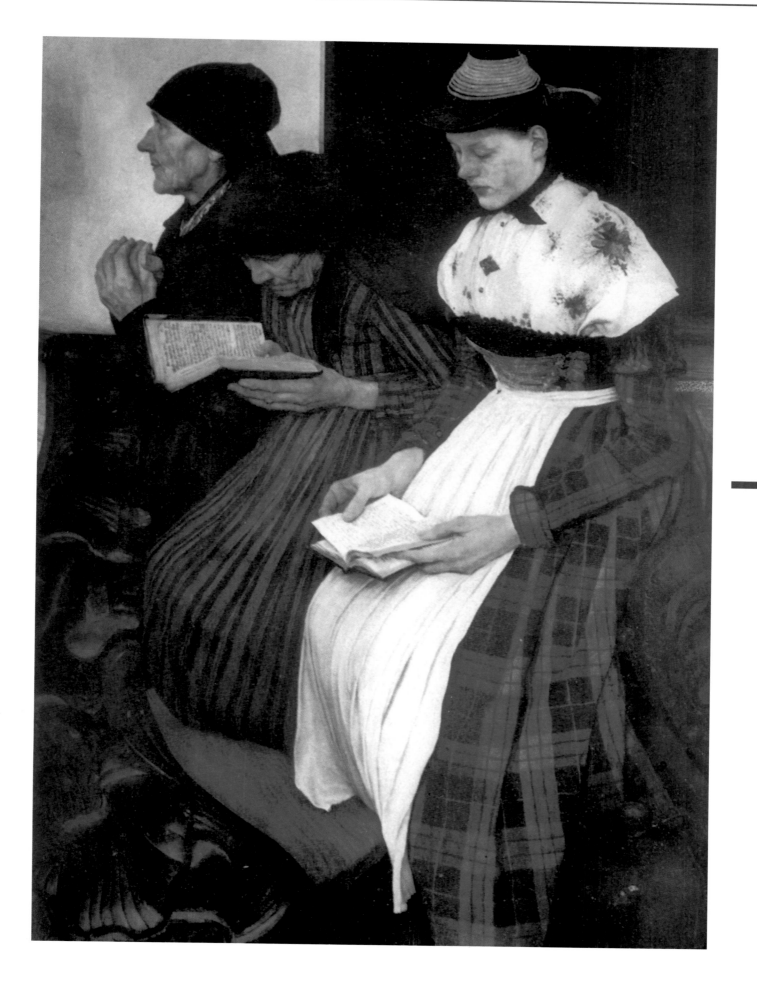

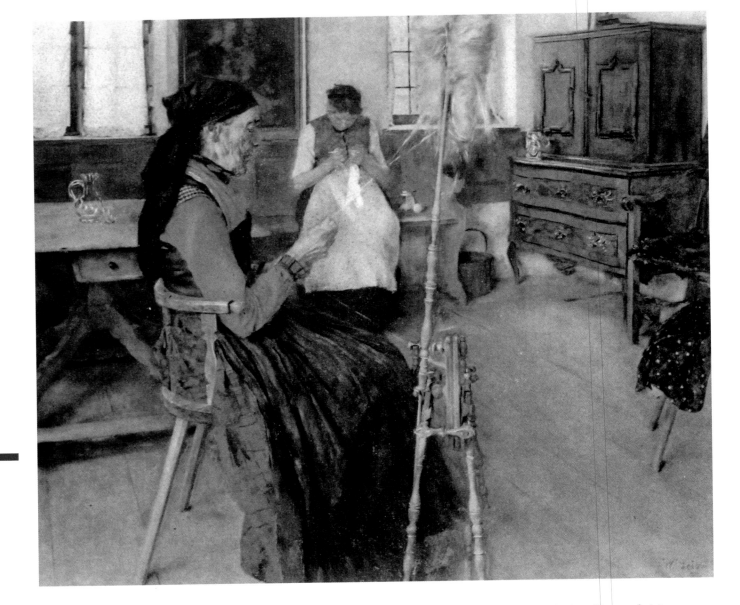

The Spinner.
WILHEIM LEIBL.

loty, a painter of historical pictures, and also studied with Arthur Ramberg, a painter of genre scenes. His first works were influenced by Dutch painting, especially by Rembrandt and Vermeer. The objects and figures he painted were simple compositions without the romantic sentimentality typical of the era. *The Critic* and *Portrait of Frau Gedon*, both from 1868, are representative of his work, which is characterized by a very limited range of subjects in portraits and groups of figures. In 1869, he moved

to Paris and worked with the painter **Courbet**, who approved of and valued his work. He immediately joined the Realism movement and did paintings such as *Old Parisian Woman* and *Cocotte*, both from 1870. Due to the outbreak of the Franco-Prussian War, he had to leave Paris and return to Germany. He settled in Munich until 1873 and traveled through several Bavarian towns to paint portraits of peasants and ordinary people, insisting on portraying the details and the souls of human beings. His painting *Burgomaster Klein* (1871) is from this period. To his simple compositions, he brought a great interest in

light and the effects of chiaroscuro, which was always a chief element in his work. He was also an excellent draftsman and engraver. Between 1878 and 1881, he settled in the small German town of Berbling, and there he painted one of his masterpieces, *Three Women in Church* (1881), a painting that reflects one of his artistic maxims—"human beings should be painted just as they are"— as well as his ongoing interest in seventeenth-century Dutch painting. His work was praised and studied by later painters, specifically by the "New Objectivists" of 1920 who reevaluated his work.

A Girl Feeding Peacocks.
FREDERICK LEIGHTON.

Jonathan's Token to David.
FREDERICK LEIGHTON.

LEIGHTON, FREDERICK

(Scarborough, 1830–London, 1896)

An English painter, his work in the Academic style and his religious themes brought him a brilliant and celebrated career in Victorian England and in addition, made him an honorary member of almost all of the Academies in Europe. His artistic training began in Rome and continued in Frankfurt. His first paintings covered subjects based on medieval Italian history, religious themes, and mythological tales. His work *Cimabue's Celebrated Madonna*, painted in Rome in 1852 when he met **Cornelius** and came to know **Nazarene** aesthetics, earned him great prestige. The painting, exhibited at the Royal Academy in 1855, was acquired by Queen Victoria. From that time onward, his career was stunning. He established his residence in London and beginning in 1866, traveled around Europe, visiting Spain and even Egypt. Noteworthy among his works are *Elijah in the Wilderness, Odalisque*, and *Perseus on Pegasus Hastening to the Rescue of Andromeda*. His frescoes in the Victoria and Al-

bert Museum and in the church in Lyndhurst are also worthy of mention.

LENBACH, FRANZ VON

(Schrobenhausen, 1836–Munich, 1904)

A German painter, primarily a portraitist of the Realist style. He began his artistic training at the School of Decorative Arts in Landshut and in 1857, entered **Piloty**'s studio after having taken some painting courses elsewhere. Afterwards, he traveled to Rome, where he stayed for a year, and there did his first sketches from life, which he used as the basis of some of his paintings. He later settled in Munich and met Count Schach, a collector of great works of art, with whom he traveled to Spain and Italy, where he became familiar with the paintings of the great masters, some of which he copied under a commission from the Count. Although he painted genre scenes and some landscapes, he especially excelled at portraits and became the painter who was most sought after by the greatest personalities of the time.

Kaiser Wilhelm II named him as his official portraitist, as German Chancellor Otto von Bismarck had done earlier. The series of Bismarck portraits, which was started in 1879, make up some of Lenbach's most noteworthy work. He painted innumerable portraits, which are very true-to-life and display a great virtuosity of technique in which the influence of Velázquez and Titian can be seen. Unfortunately, they lack the spontaneity of these painters and suffer from a certain degree of pomposity. Among these portraits, the following are noteworthy: *Ludwig II, Count Moltke, Richard Wagner, Count Schach, Johann Strauss, Pope Leo XIII, Emperor Franz Josef, Albert of Saxony, Princess Clementine of Coburg*, the explorer *Nansen, Doña Paz de Borbón*, and *Hans von Bülow*. His work is represented in Germany's principal museums.

LESSING, KARL FRIEDRICH

(Breslau, 1808–Karlsruhe, 1880)

A German painter, Lessing was one of the principal members of the

Bismarck.
FRANZ VON LENBACH.

191

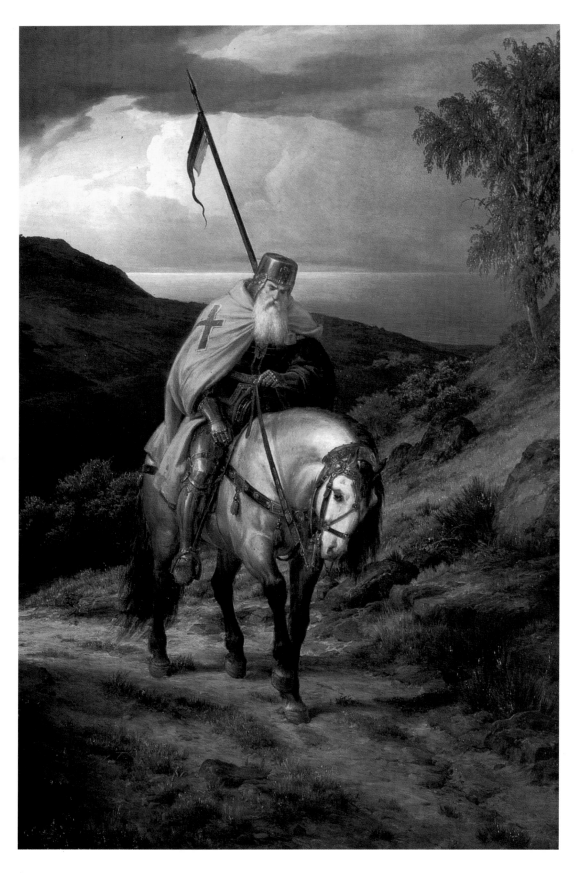

Return from the Crusade.
KARL FRIEDRICH LESSING.

historical paintings, some inspired by the fifteenth-century Hussite Rebellion, such as *Hussite Prayer* (1836), *Jans Hus Before the Council of Constance* (1842), and *Jans Hus on His Way to the Stake* (1850), he displays a melodramatic, academic **Romanticism**, but with studied historical detail, foreshadowing his progressive evolution towards Naturalism, both in his historical paintings and in his landscapes. He also painted Romantic, idealized landscapes, taking inspiration from **Friedrich** and from Carl Gustav Carus. He followed the Italian model of the ideal landscape, using his profound sense of nature and a high degree of schematism in his compositions. In his historical works. A certain amount of aridity and desolation is present.

LEUTZE, EMANUEL GOTTLIEB

(Schawäbisch-Gmünd, 1816–Washington, D.C. 1868)

American painter of German origin. He began his training as a painter in Düsseldorf and in 1859, emigrated to the United States, where he spent much of his life, alternating his stays there with stays in his native country. He painted several historical pictures, such as the well-known *Washington Crossing the Delaware* (1851), as well as genre paintings that are noted for their careful, meticulous style. He also painted landscapes and portraits, but primarily, he was occupied with the creation of large murals on historical subjects to decorate various buildings in the American capital. Perhaps the most no-

Düsseldorf School of historical painting, a genre that he studied with **Schadow**. In 1858, he was appointed director of the Karlsruhe Art Gallery and definitively established his residence there. In his

table of these is *Westward the Course of Empire Takes Its Way* (1861–1862) in the rotunda of the Capitol building: a statement of national pride

Bird Hunter.
HENDRIK LEYS.

and a tribute to the belief in Manifest Destiny.

LEYS, HENDRIK

(Antwerp, 1815–1869)

A Belgian painter who dedicated himself to the historical genre and to murals, he represents pictorial **Romanticism** in his country. Leys began his training by attending the Brussels Academy, where he studied with Gustave Nappers and with his brother-in-law **Braekeleer** between 1830 and 1835. A trip to Paris determined his compositional style which was influenced by the work of **Delacroix** and the French Romantics. His artistic education continued with a trip to Holland, where he studied the paintings of the Dutch school and became fascinated by Rembrandt's work. Another trip to Germany in 1852 gave him even wider exposure to the paintings of the past. Upon his return, he devoted himself to painting frescoes, especially one for the hall of honor in the Antwerp Town Hall, a work that was left unfinished when he died. In 1862, he was created a baron and elected to the Royal Academy of Belgium.

LIEBERMANN, MAX

(Berlin, 1847–1935)

A German painter and illustrator, his career took place within the artistic tendencies of the last third of the century, as reflected by his works *Papageienallee,*

A Restaurant Terrace.
MAX LIEBERMANN.

Jacob's Terrace and *Women in a Canning Factory*. He studied in Berlin, and in 1874, traveled to France to visit **Barbizon**—at the time the mecca of landscape painting—and to study the painting techniques of the artists who lived there. Of them all, it was **Millet** who had the greatest impact on him, because of his sincere and simple composition of rural and country themes. Some atmosphere and light effects characteristic of this school can be found in Liebermann's paintings, and above all, in his drawings and etchings. In these are seen the techniques he mastered and executed with a high degree of skill, causing him to be considered the true follower

of the German illustrator **Menzel**. In addition to works such as *Workers in a Field* (1876) and *The Cobbler's Shop* (1881), both reminscent of the Barbizon School, he painted other, later works with a style influenced by Im-

pressionism: *The Flax Barn* and *The Flax Spinners*. However, as soon as he settled in Berlin—where in 1884, he

Women in a Canning Factory.
MAX LIEBERMANN.

The Parrot Seller.
MAX LIEBERMANN.

Harvest Moon.
JOHN LINNELL.

was appointed teacher at the Academy—he and his work were linked to fin-de-siècle aesthetics as a representative of the *sezession*. ("secession") group. Works from this period include *Polo Players* (1902), *On the Way to School* (1904), and *Dutch Landscape* (1912).

LINNELL, JOHN

(London, 1792–Redhill, Surrey, 1882)

English Realist painter. A student of **West**, he painted numerous portraits (*Ann Hawkins, Samuel Rogers, Carlyle, Malthus*), which made him famous. He also worked with miniatures and, above all, landscapes (*Gravel Pits at Kensington*, 1812). Some of his portraits are somewhat visionary, perhaps

as a result of **Blake**'s influence. In 1852, he settled in Redhill and produced a large number of idyllic and more conventional scenes which made him enormously popular and wealthy. He was also a notable illustrator.

LLIMONA I BRUGUERA, JOAN

(Barcelona, 1860–1926)

A Spanish painter and the brother of the sculptor Josep Llimona (1864-1934), he was one of the most influential creators of the *Cercle Artistic de Sant Lluc*, of which he was the first director and whose members offered a peculiar version of Symbolism under basically Catholic ideology. He studied at the

Fine Arts School in Barcelona and was a pupil of **Martí Alsina**. Among his works, some country themes are outstanding, as well as others showing customs and manners in a very Intimist way, such as *The Wife* (1916). Also, his murals are noteworthy, especially the paintings he did for the dressing room in the Monastery of the Carmelites of Charity in Vic in 1904.

LÓPEZ PORTAÑA, VICENTE

(Valencia, 1772–Madrid, 1850)

Spanish painter. An exponent of the assimilation of Neoclassical expres-

sion, he is the most representative Spanish painter from the reign of Ferdinand VII. He was trained in his native city at the Academy of San Carlos and obtained financial assistance to study at the academy in Madrid. There he studied with Mariano Salvador Maella and used the work of Raphael Mengs as a model. From the beginning, he showed an amazing mastery of draftsmanship and design, although his colors were occasionally strident. A case in point is one of his first historical paintings, *Ferdinand and Isabella Receiving an Envoy from the King and Queen of Fez*. However, his best qualities were most evident in his portraits, a genre to which he devoted himself upon his return to Valencia from Madrid. When Charles IV visited the city, the painter made contact with court circles, and the monarch himself was surprised by the skill shown in his work, especially when he saw the picture the artist had painted for the occasion: *The Visit of Charles IV and His Family to the University of Valencia* (1801). After the end of the War of Independence, he was named court painter to Ferdinand VII. From that time on, a true artistic dictatorship existed, as he became the final authority on the official tastes of the period. In addition to his portrait of Goya, those of the successive queens are noteworthy: *María Isabel of Braganza, María Josefa Amalia of Saxony*, and *María Cristina of Bourbon*. In 1823, when the Prado was founded, López was named the first director of the museum. In the portraits he painted in his old age, certain traits of Romantic sentimentality can be seen, both in his composition and in his ex-

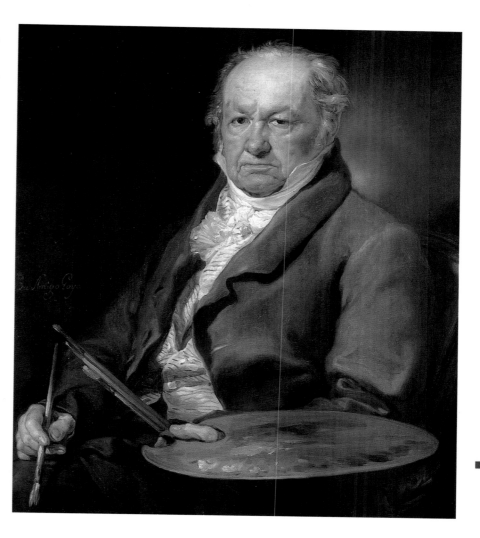

pression. Besides his interesting paintings on religious themes, his

Portrait of Goya.
VICENTE LÓPEZ PORTAÑA.

Don Antonio Ugarte and His Wife.
VICENTE LÓPEZ PORTAÑA.

frescoes are noteworthy, a technique that he mastered to perfection, as shown in the decoration of the dome of the San Carlos Hall in the Royal Palace in Madrid.

LORENZALE, CLAUDIO

(Barcelona 1816–1889)

A Spanish painter of Italian ancestry who worked in the style of the **Nazarene** school. He studied at the Fine Arts School (or La Lonja) in Barcelona and in 1837 obtained a scholarship to continue his training in Rome. There he settled until 1844, where he met **Overbeck** and the artists of the Nazarene circle. Upon his return to Barcelona, he was named teacher and director at the La Lonja School. His painting was mainly centered on portraits, with his excellent *Self-Portrait* (1843) being worthy of note. He also painted religious subjects, such as *The Birth of the Virgin*; historical paintings, such as *The Marriage of Queen Petronila and Ramón Berenguer*; as well as landscapes and allegories.

LUCAS VELÁZQUEZ, EUGENIO

(Alcalá de Henares, 1817–Madrid, 1870)

Spanish Romantic painter, heir to the inspiration and expressionism of Goya. He was trained at the Academy of San Fernando, through the patronage of Leandro Álvarez, chaplain of honor to Fernando VII. In that institute, he was influenced by the Neoclassical painter **José de Madrazo**, an influence from which he would promptly distance himself as he became fascinated by **Goya's**

Portrait of His Family.
CLAUDIO LORENZALE.

work. In his departure from the Neoclassical style, the work of the Romantic painter **Pérez Villaamil** also had an impact. He had four children by the latter's sister, among them the famous painter Eugenio Lucas Villaamil. Technically, he reflects Goya's **expressionism**, working in oil and gouache and even at times painting directly with his fingers. He used all the usual surfaces, such as canvas, board, copper, and paper. His genre work is noteworthy, such as *The Divided Bullring* (1848), the bullfighting scene that started his successful career. In 1850, when the Royal Theater was

built in Madrid, he received the commission for the tempera decoration of the ceiling of the auditorium. For this decoration, he did four trapezoidal panels that contain the symbols of art, dance, music, and poetry, separated by four Madonnas, all accompanied by images of Velázquez, Calderón de la Barca, Francisco Herrera, Bellini, and Moratín. He traveled to Paris on two occasions: first in 1852, to paint the portrait of Alexandre María Roche, and again in 1855, for the International Exposition. He exhibited his works there, such as *The 1854 Revolution*, with resounding success. A series of trips followed, to Italy (1859) and Morocco (1859), which would have an influence on

his future paintings. However, his best-known subjects are popular scenes (*The Hunter, The Enema*, and *Bullfight with Greased Pole*); as well as pictures related to Goya's last works: fantastic, sinister images; and those showing witchcraft, such as *The Witches' Sabbath, The Executed Criminal*, and *Condemned by the Inquisition*. Nearly all of these works are undated, and in addition to the difficulty of dating them, there is a certain amount of confusion between some of Goya's works and some of Eugenio Lucas Villaamil's. He was also a good landscape artist and portraitist. For political reasons, and because of his relationship with Francisca Pérez Villaamil, he gradually withdrew from social life and from the bourgeois clientele who bought his paintings.

LUPI, MIGUEL ÁNGEL

(Lisbon, 1826–1883)

Portuguese painter. He first studied at the Fine Arts Academy in Lisbon, but later was granted an allowance to continue his training at the Academy of St. Luke in Rome, where he would soon excel. Later, he went on to Paris, where he stayed for fourteen years until he returned to his own country in 1867 to replace Antonio Manuel da Fonseca as the director of the Academy in Lisbon. He was interested in historical subjects and portraits and achieved a high technical and expressive level in the latter genre, which would have a powerful impact on his pupil Columbano Bordalo Pinheiro. He was the first in Portugal to paint in the Realist style, more be-

cause of his subject matter than his artistic inclinations. He, therefore, is considered the forerunner of the movement whose style he assimilated and incorporated into his art on his trips to Paris. Among his historical compositions, the following are worthy of mention: *Ninguém, The Kiss of Judas*, and *The Marquis of Pombal Examining the Plans of Lisbon*. In his portraits, he employed a great deal of **Realism** and injected an undertone of social criticism, denouncing the mediocrity of most of his subjects who came from the bourgeoisie and Lisbon's high society. The portraits *Mother of Sousa Martins* (1878), *Duke of Ávila*, and *Bulhao Pato* (1883) are noteworthy.

Inquisition Scene.
EUGENIO LUCAS VELÁZQUEZ.

The Terrace of Palmieri.
GIOVANNI FATTORI.

MACCHIAIOLI, THE

Group of Italian painters, based in Florence, and particularly active in that city from approximately 1855 to 1865. The members of this group met regularly at the Café Michelangelo in Florence. Their name, which means "patchers," is a derivative of *macchia* ("patch"), since the use of many small patches of color was their basic building block of painting—ideal for capturing the dazzling luminosity of Italy—and which they applied in bright, pastel, and dark colors. This art movement brought with it a political undertone. The members, through their artwork, sought to contribute to the revival and unification of Italy by depicting the most natural, authentic, and vivid facets of the country's life at that time. To show the way for their country's renaissance, they focused on Italian traditions and painted scenes of rural life, often represented in the open air. At the same time, in a purely artistic aspect, they reacted against the classical rules of the Academy regarding both subject matter and style. On the one hand, they avoided historical and literary subjects in the acad-

The Arbor.
SILVESTRO LEGA.

Reading.
SILVESTRO LEGA.

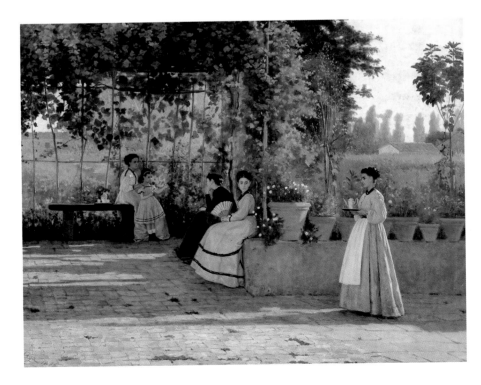

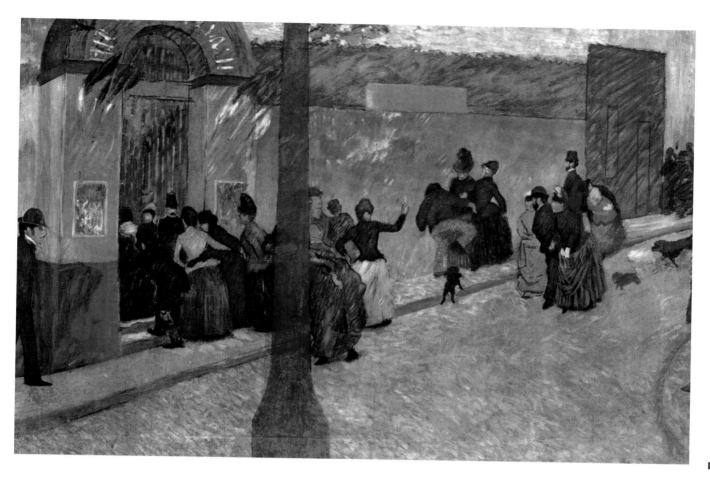

Le Moulin de la Galette.
ZANDOMENEGUI.

emic manner, which they felt had little to do with reality. Nonetheless there is a distinct literary component in the paintings done by these artists, as in Fattori's masterpiece, *Battle of Magenta*, which presents a thoroughly modern view of this event. On the other hand, they reacted against form, using patches of color to provide contrasts in light, while not allowing forms to lose their substance and solidity. This technique, opposed to conventional draftsmanship and *sfumato* ("shading"), gives their paintings a fresher look with simpler construction, all reduced to simple color contrasts. Although they painted many landscapes, which showed the influence of the **Barbizon School**, they also did portraits as well as genre and historical paintings, the latter being much fewer in number. "Macchiaioli" had a negative, derogatory connotation at first and came about as the result of a group exhibition of these painters' works held in 1862. The reaction to this and the application of an unflattering name to the movement is strikingly similar to what the Impressionists would experience later. While they were

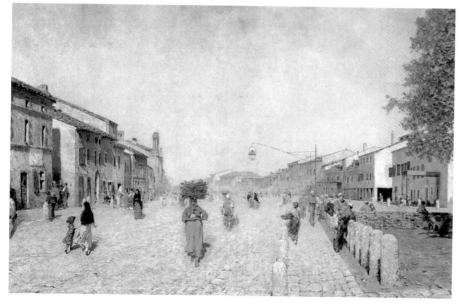

The Porta Adriana Suburb in Ravenna.
TELÉMACO SIGNORINI.

not well received by the critics of the day, their art movement is considered the most interesting one in nineteenth-century Italian painting. The most important individuals who made up the group, some of whom took part in the Italian Risorgimento struggle, were **Signorini, Fattori, Boldini, Lega, Abbati,** and the critic Diego Martelli, who was the group's theorist. Eventually, there were other members, as more painters gradually joined the group.

MACLISE, DANIEL

(Cork, 1806–London, 1870)

Irish painter, illustrator, and caricaturist. After beginning his studies in Ireland, he went to London in 1821 to continue his training at the Royal Academy, where, because to his abilities, he won the gold medal in the historical painting section in 1831. Considered the most important historical painter of his time, he was given two commissions to paint large murals to decorate the walls of Parliament: *The Meeting of Wellington and Blücher* (1861) and *The Death of Nelson* (1865), in which he depicted a hodgepodge of figures that complicate the composition and make comprehension difficult. However, they have strong expressive strength and are heroic in nature. He also painted portraits of notable quality and did caricatures, at which he excelled since he was a brilliant draftsman. He sketched a series of portraits that he contributed to *Fraser's Magazine* from 1830 to 1838. Other works of his are *The Spirit of Chivalry* and *The Spirit of Justice*, both for Parliament.

Madeleine after Prayer.
DANIEL MACLISE.

MADRAZO Y AGUDO, JOSÉ DE

(Santander, 1781–Madrid, 1859)

Prominent Spanish painter, truly representative of **Neoclassicism**. He began his art studies in Madrid with Gregorio Ferro, who taught him the style and technique of Anton Mengs. He acquired the strict principles of Neoclassicism from 1803 onward in Paris, where he went with a scholarship to continue his training in **David**'s atelier. There he struck up a friendship with his fellow pupil **Ingres**, and produced one of his first pieces, *Jesus Before the High Priest* (1805), using the cold and carefully drawn Neoclassical style to create a work that was praised by his teacher. While Joseph Bonaparte was in power in Italy, he traveled to Rome, again with a scholarship, and painted his best-known historical paintings, *The Death of Viriato* (1814) and *The Death of Lucretia*. These are works that followed the bombastic, somewhat spectacular and richly precise style he learned from David, which was in fashion throughout Europe. In Rome, he was named court painter to the deposed and exiled Charles IV of Spain. His opposition to the interloping French government and his loyalty to the Bourbons gave him great power in cultural and academ-

The Captain's Rest.
RICARDO DE MADRAZO.

Aline Masson with White Mantilla.
RAIMUNDO DE MADRAZO.

ic circles when he returned to Spain in 1819. Five years later, he managed to have the study of painting from life accepted at the Academy of San Fernando's School in Madrid. Apart from historical works, he also painted portraits and religious subjects. He created a large number of very important portraits in which he occasionally revealed certain nuances characteristic of **Romanticism**. Of special intrest are portrais of Charles IV, Isabella II, and the Count of Requena, as well as those of José de Madrazo y Agudo; his sons Federico, Luis, and Juan; and his grandsons Raimundo and Ricardo,thereby portraying an admirable dynasty of artists.

MADRAZO Y GARRETA,
RAIMUNDO DE

(Rome, 1841–Versailles, 1920)

Spanish painter. The son and pupil of the painter **Federico de Madrazo y Kuntz**, his works were some of the most representative and influential from the school of Spanish painters

in Paris. He settled in Madrid and added to his training throughout his life with trips to Paris and various countries in the Americas. Associated with **Fortuny** and **Rosales**, his most important work was an extensive series of decorative themes and portraits, in which cheerful and optimistic motifs prevailed. The portrait he painted of his sister, Cecilia, was widely commented on, as were the paintings *The Letter, Music Lesson*, and *Family Portrait*.

MADRAZO Y GARRETA,
RICARDO DE

(Madrid, 1851–1917)

The son and pupil of **Federico de Madrazo y Kuntz** and brother of **Raimundo de Madrazo**, his works were markedly influenced by **Fortuny**, both in their euphuistic technique and in their oriental subject matter. Some works in this vein are *Moroccans, Market in Fez*, and *Arab Caravan Stop*. He was an extraordinary portraitist, with the ability to capture the psychology and feelings of his subjects on canvas, thus achieving true likenesses. He was an expert on art history and a true authority in classifying old painted works.

MADRAZO Y KUNTZ,
FEDERICO DE

(Rome, 1815–Madrid, 1894)

The son of the Neoclassical painter **José de Madrazo**, he was one of the most celebrated and renowned nineteenth-century artists in Spain. Among the positions he held, some of the major ones were court painter,

director of the Prado Museum, and director of the Fine Arts School of San Fernando; and among his many honors was a knighthood in the Legion of Honor. His father started him in drawing and painting, and his training was consolidated in Paris, beginning in 1833, in **Ingres**' atelier. Upon going to Rome, he struck up a friendship with the German painters **Cornelius** and **Overbeck** and other artists of the **Nazarene** group. His works show the Neoclassical purism he learned in Paris; examples of this are *Godfrey of Bouillon, King of Jerusalem* (1837–1839) and *The Continence of Scipio*. In recognition of this latter work, he was elected academician of San Fernando in 1839. The Nazarene influence is evident in his paintings of religious subjects, such as *The Three Marys at the Sepulcher*, a work from 1842. In that year, he established his residence in Madrid, where he would acquire great prestige and begin his tri-

Amalia de Llano y Dotres,
The Countess of Vilches.
FEDERICO DE MADRAZO.

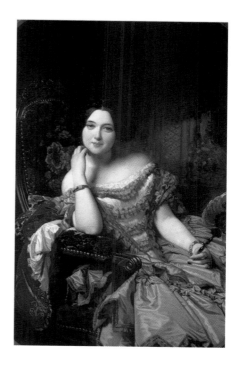

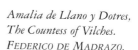

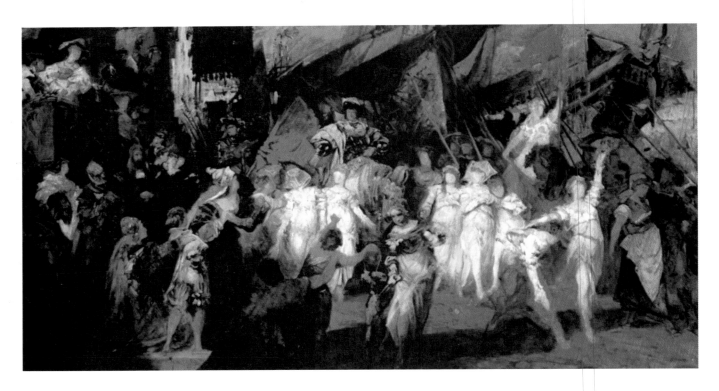

Entry of Charles V into Antwerp.
HANS MAKART.

umphal career as a portraitist. His portraits are characterized by their elegant draftsmanship and peculiar coloring. In addition, they cover a complete gallery of figures and personages of the era: Isabella II, Alphonso XII, Carolina Coronado, and Bravo Murillo, portraits that increasingly display expressive and realist traits.

MAKART, HANS

(Salzburg, 1840–Vienna, 1884)

Austrian painter, engraver, decorator, and stylist. At the age of eighteen, he entered the Fine Arts School in Vienna and in 1859, traveled to Munich, where he received training from **Piloty**. The latter helped him develop his rich sense of color and channeled his focus into historical painting, of which Munich was the most important center

at the time. In 1868 after traveling to Paris, London, and various cities in Italy, he went to Vienna, where he came under the patronage of the emperor Franz Josef, who provided him with a good studio, where he would achieve enormous success. He would later be appointed teacher at the Fine Arts Academy in Vienna. In addition to his historical painting (*Entry of Charles V into Antwerp*, 1875), a genre to which he gave special attention—particularly in large formats and with marked **Realism**, and which confirmed him as a well-known and important painter—he also devoted himself to mythological and allegorical subjects. Good examples of these are *The Five Senses*, *The Seasons*, *Night* and *Day*. His style is pompous and elaborate, and he was fond of marked contrasts in brightness, created by strong beams of light. He gave great importance to the figures in the foreground, with the background being rather sketchy. This is evident in *The Plague in Florence* (1868). He also did some portraits, such as the one of

Amalia Makart (1871–1872). Other noteworthy works are *The Death of Pappenheim* (1861–1862), *Fruits of the Land and Sea* (1870), and *Caterina Cornaro, Queen of Cypress*.

MANET, EDOUARD

(Paris, 1832–1883)

A French painter, considered the chief representative of **Impressionism**. In addition, his work is studied as the only valid way out of the crisis suffered in the long course of development of naturalism and French **Realism**. He was one of the greatest geniuses in the history of nineteenth-century painting. From the time he began studying at the College Rollin, he found that painting provided a powerful outlet for his creative energy. Coming from an upper-middle-class family, he was

Upper right: *Olympia.*
Below: *The Swallows.*
EDOUARD MANET.

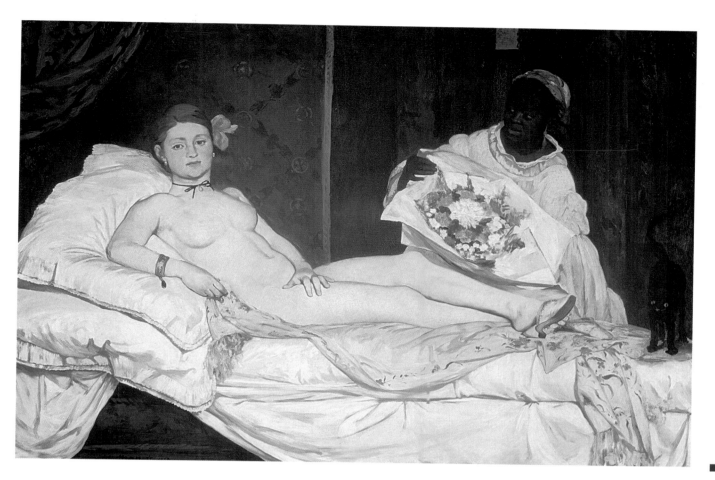

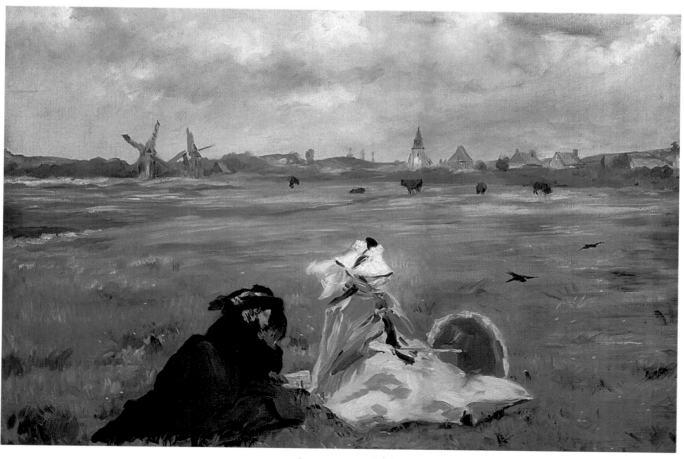

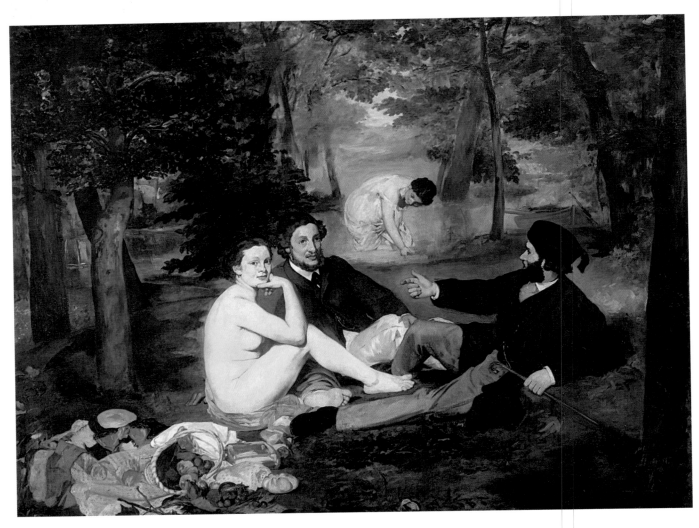

Le Déjeuner sur l'herbe.
EDOUARD MANET.

the son of a judge and brother of future civil servants, a context in which social traditions prevail and where not even the least bit of rebellion is expected. He tried to make his family understand his true interests, but it was useless. He was forced to study law which caused him to run away and enlist as a sailor. He arrived in Brazil, where he found his first exotic objects to draw. When he returned to France in 1850, he studied painting through analysing museum masterpieces and in the atelier of the most prestigious painter of that time, **Couture**, the creator of the work held in highest esteem by the pub-

lic and by official circles: *The Romans of the Decadence*. Thus, he was trained in historical painting and remained with Couture for more than six years, during which time he encountered the artists and literati of the times, including Charles Baudelaire. A trip around Europe liberated him from the academicist strictures he had learned and provided a broader, more mature training, as well as subject matter that he would later develop in his work. In 1856, he set himself up as an independent painter and began his true career. His painting *The Absinthe Drinker* was rejected for the 1859 Salon, but one year later he exhibited *Concert at the Tuileries* to much critical acclaim. In 1861, he was once again lauded for *Por-*

trait of the Artist's Father and *Spanish Guitar Player*; this latter work was praised by **Monet** and **Bazille**, and began a long series of topics reflecting Spanish folklore, characteristic of late European **Romanticism**. Included in this group are *Spanish Ballet, Lola de Valence*, and *Young Man in the Costume of a Majo*, all from 1862, the zenith of his artistic career, since in that year he also began his two greatest works. One of these is *Le Déjeuner sur l'herbe*, an updated version of Giorgione's *Concert Champêtre*, which, given the morality of the time, was truly an example of indecent exposure and which could only be exhibited at the 1863 Salon. The same thing happened with *Olympia*, his vision of Titian's *Venus of Urbino*, in which

he incorporated the image of a prostitute of his day into a composition that used a classical scheme. The fact that he had given the painting an artistic treatment from the past and then placed it into a coarse situation from the present created a monumental scandal at the 1864 Salon, causing a major controversy in some areas of high society, as well as the indignation of bourgeois moralists. By that time, Manet had already met **Morissot**, who would become his sister-in-law—whom he portrayed on several occasions—as well as his lover, Victorine Louise Meurent, a model for his provocative paintings. He traveled to Spain, where he met **Lucas** and once again returned to Spanish motifs and subjects. His work *The Fifer* was rejected at the Universal Exposition of 1867, so, tired of this arrogance, he began to exhibit on his own, despite the negative opinions he received at all of his exhibitions. *The Luncheon in the Studio, Reading*, and *Madame Monet at the Piano* among others, are from 1868. Ostracized by official art circles and accompanied by the constant taint of scandal, Manet became the leader of a group of painters who frequented the Café Guerbois, which was close to his studio. Among these artists were **Degas, Monet, Renoir, Sisley, Bazille**, and, at a later time, **Cézanne** and **Fantin-Latour**; the latter portrayed him with all of the group in *Homage to Manet*. The Franco-Prussian War of 1870 motivated him to create two lithographs evocative of the conflict: *The Barricade* and *The Civil War*. Surprisingly, Manet did not take part in the first exhibition put on by the Im-

The Fifer.
EDOUARD MANET.

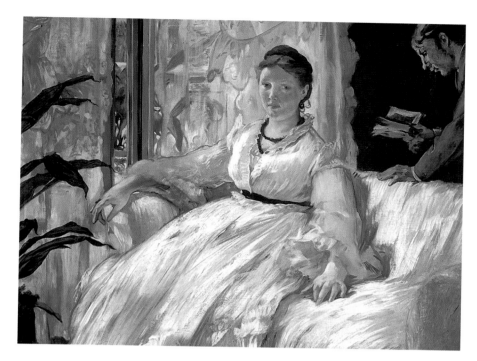

Reading.
EDOUARD MANET.

MARÉES, HANS VON

(Elberfeld, 1837–Rome, 1887)

A German painter, portraitist, and historical artist of the Impressionist movement. He studied in Berlin starting in 1854 and in Munich starting in 1857. He rounded out his training with a series of trips to France, Italy, and Spain. At the end of the 1870s, he returned to Italy,

The Waitress.
EDOUARD MANET.

pressionists, despite the fact that he took his brushstrokes, landscapes. and taste for painting in the open air from them. He also shared the subject matter that characterized the movement: subjects referring to modern life, as seen in *Nana* and *Singer at a Café Concert*. Among other great works, *The Balcony* from 1869, which took inspiration from Goya, is of special interest. Finally, in 1881, he achieved official recognition when he received the medal of the Legion of Honor, a validation of his career. However a serious disease in one of his legs prevented him from continuing his work with the same richness and intensity. He was determined to do a new series of paintings on floral subjects, presaging a change in his style, but his artistic evolution came to an abrupt end when he was forced to have his leg amputated in 1883 and died soon afterward. Fourteen years later, his magnificent and scandalous *Olympia* entered the Louvre.

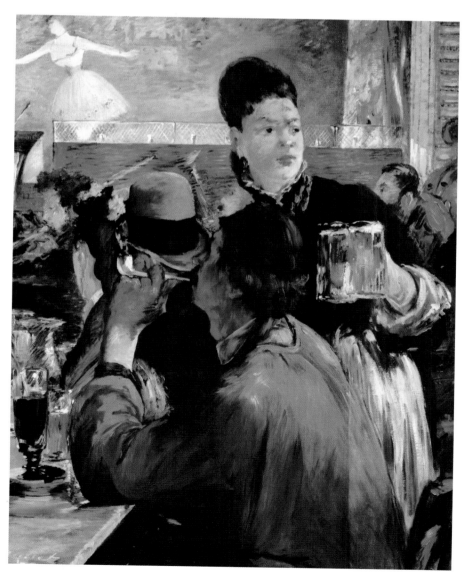

The Balcony.
EDOUARD MANET.

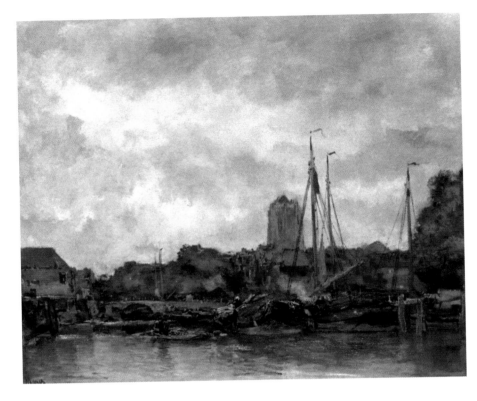

Dordrecht.
JACOB MARIS.

He studied in Antwerp and in 1865 moved to Paris. There he became acquainted with **Corot**'s and **Fantin-Latour**'s painting. In his early career, he dedicated himself to portraying genre scenes of Dutch everyday life, but he soon began to paint landscapes, creating pictures with a marked sense of the dramatic and employing powerful chiaroscuro. His technique approaches **Impressionism**, with a notable skill for light effects. In addition to representing natural scenery, he depicted urban landscapes; *Port Scene*, painted around 1885, is a typical example.

where he lived until his death. Representative works of his sketch-like painting, with its strong contrasts, are *The Rowers, The Bath of Diane,* and *The Standard Bearer.*

Port Scene.
JACOB MARIS.

MARIS, JACOB

(The Hague, 1837–1899)

Dutch landscape painter who, along with his brother **Matthijs Maris** and **Anton Mauve**, formed part of The Hague School founded by **Israels**.

MARIS, MATTHIJS

(The Hague, 1837–London, 1917)

A Dutch landscape painter, and the brother of **Jacob Maris**, he formed part of The Hague School, founded by **Israels**. He studied at the Academy in The Hague and at the one in Antwerp. From 1858 onward, he worked with his brother Jacob, with whom he went to Paris, where he remained until 1875. He started with landscape painting in a realist style that evolved under the influence of the German Romantic school and the Pre-Raphaelites, with whose paintings he became familiar in 1877 during a stay in London. His works incorporate a characteristic halo of half-light, as can be seen in *Memory of Amsterdam* from 1881. He filled his work with exquisite spirituality reminiscent of the masters of the Middle Ages.

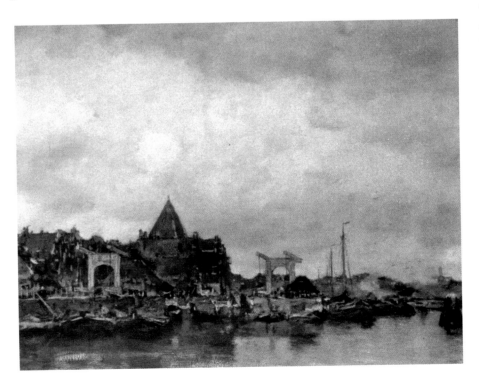

Nude Woman.
RAMÓN MARTÍ ALSINA

MARQUÉS DA SILVA OLIVEIRA, João

(Porto, 1853–1927)

Portuguese painter. He was a prominent representative of academic **Realism** in his country, and a friend of the painter **Carvalho da Silva**, with whom he studied in Paris and later collaborated with in founding the Leão group in Portugal. In the French capital, he began to work in the area of historical painting, and there he produced a good composition in the mythological genre, *Cephalus and Procris* (1879). However, landscape painting was the area that most interested him and in which he showed how much he owed to the influeneces of the **Barbizon School**. In one of his best works, *Povoa do Varzim* (1884), he demonstarted his skill at capturing light and atmosphere.

Woman from Laren with Goat.
ANTON MAUVE.

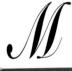

MARTÍ ALSINA, Ramón

(Barcelona, 1826–1894)

Spanish painter. He introduced Realism in landscapes to Catalonia, and his style and works were linked with other fin-de-siècle trends. At the age of fourteen, he attended night classes at the Fine Arts School in Barcelona. In 1848, he made his first trip to Paris and came to know **Courbet**'s work and the aesthetic principles of the **Barbizon School**, which would be decisive in his landscape work. In 1852, he earned the professorship in drawing at the Barcelona Fine Arts School and dedicated himself to teaching, introducing French developments into the Catalan scene. He made several trips to Paris and Holland and tried to present part of his work at the 1867 Universal Exposition, but was prevented from doing so by bureaucratic difficulties. Martí Alsina was also a prototypical Bohemian figure, suffering from financial problems, family misfortunes, and political conflicts, which forced him to resign from his professorship and work in several different studios at the same time, in an almost industrial fashion—a fact that explains the uneven quality of his work. Of special interest among his extensive collection of landscapes and portraits are *Snowy Day, The Civilian Militia, The Siesta* (1884), and *View of the Boulevard Clichy*. This latter work anticipates certain Impressionistic principles.

MAUVE, Anton

(Zaandam, 1838–Arnhem, 1888)

A Dutch landscape painter who, along with **Jacob Maris**, formed part of The Hague School founded by **Israels**. Despite the opposition

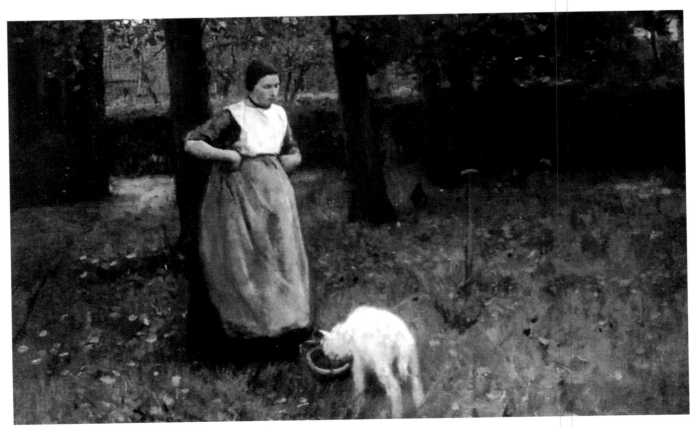

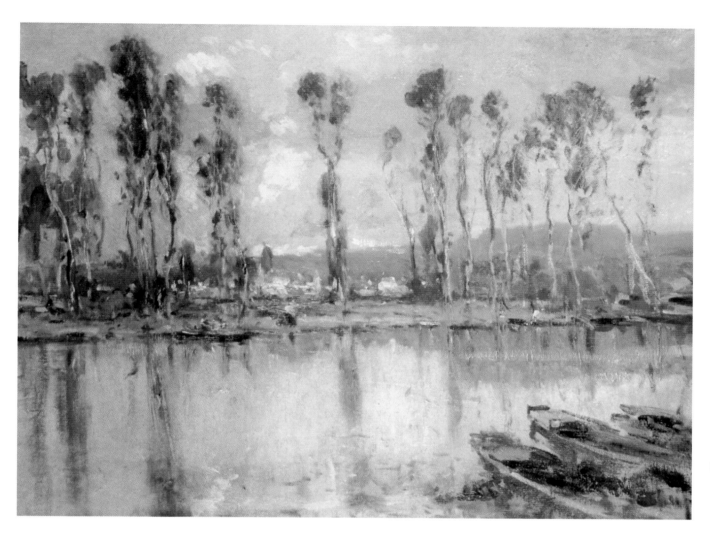

The Marne.
ELISEO MEIFRÉN I ROIG.

of his family, he began to train as a painter and was a student of Pieter Frederick van Os, a painter he portrayed in his studio (*The Studio of the Artist P. F. van Os*, 1856). Between 1856 and 1859, he painted with Jacob Maris' brother, Willen, in Oosterbeek. He moved to Amsterdam in 1865, and five years later, to Haarlem, and then finally to The Hague. In the latter city, he taught drawing classes to his cousin, **Vincent Van Gogh**, in 1882; both men suffered from illnesses and depressions. His landscape work is characteristic of The Hague School, whose attitude towards nature was very similar to that of the **Barbizon School**. *The*

Orchard and *Scheveningen, Covered in Snow* are of interest, as are his oil paintings and watercolors of trees, seascapes, and portraits, which are all characterized by his delicate use of color and his light effects. His skill was particularly acknowledged and valued in Great Britain and the United States, winning him several awards and medals.

MEIFRÉN I ROIG, ELISEO

(Barcelona, 1857–1940)

A Spanish painter, renowned for his seascapes, and one of the first in Spain to assimilate **Impressionism**. A pupil of the painter Antoni Caba, and trained at the Fine Arts School in

Barcelona, he traveled to Paris and met the painters **Casas** and **Rusiñol**. This would be decisive in his landscape painting, which was characterized by flowing, spontaneous brush strokes. His seascapes, done very quickly, with an excellent technique and pleasing tones, brought him general recognition, both in the national exhibits in which he participated as well as abroad. Noteworthy among his works are *Sea Folk* and *The Marne*, the latter dated 1933.

MEISSONIER, ERNEST

(Lyon, 1815–Paris, 1891)

French painter. His work, characterized by highly detailed **Realism**,

213

The Reader in White.
ERNEST MEISSONIER.

brought him great fame. However, his celebrity was also won by his depiction of many of the campaigns of Napoleon III. His mother was a painter specializing in miniatures and porcelain decoration, which decisively influenced his career as a painter, especially his style. He studied in León Cogniet's atelier and, at the age of sixteen, exhibited his first painting at the 1831 Salon. An early work of his, *The Barricade*, which evokes the revolutionary events of 1848, bears witness to his painting's high level of quality. In his early career, he also dedicated himself to religious and large-format painting, although his tendency toward meticulousness and detail led him to focus on genre paintings, such as *The Flute Player, The Card Players, The Bowling Party*, and *The Quarrel*, the latter from 1855. Many of these paintings are considered a clear extension of **Daumier**'s subject matter. Elected a member of the Fine Arts Academy in Paris in

1861, he painted historical pictures which exalted contemporary politics and the government, such as *Napoleon and His Staff*, as well as portraits of Napoleon III, whom he accompanied to Italy in 1870, commanding an infantry regiment, with the additional task of documenting the Italian campaigns. The resulting work is very interesting, since it depicts all types of war incidents in outstanding detail. His paintings of soldiers are executed with an outstanding degree Naturalism. Other works are *The Decameron, The Siege of Paris, Man with a Sword*, and the portrait of *Alexandre Dumas*. He also worked with engravings and collaborated as

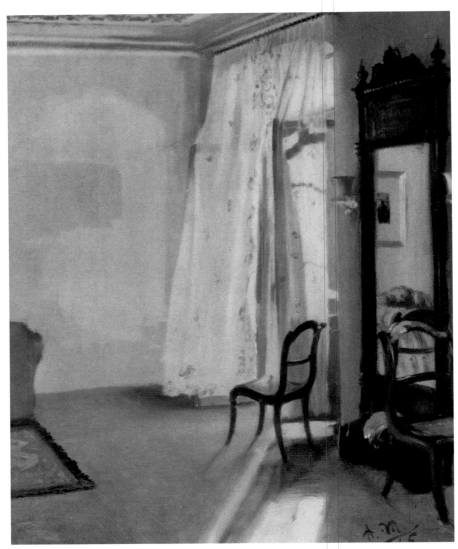

Court Dance.
ADOLF VON MENZEL.

the illustrator of Saint-Pierre's book *Paul et Virginie*.

MENZEL, ADOLF VON

(Breslau, 1815–Berlin, 1905)

A German painter and one of the most important illustrators of the nineteenth century. His painting represented the culmination of German **Realism** and clairvoyantly foreshadowed the Impressionistic style. A native of Berlin and orphaned at the age of seventeen—his

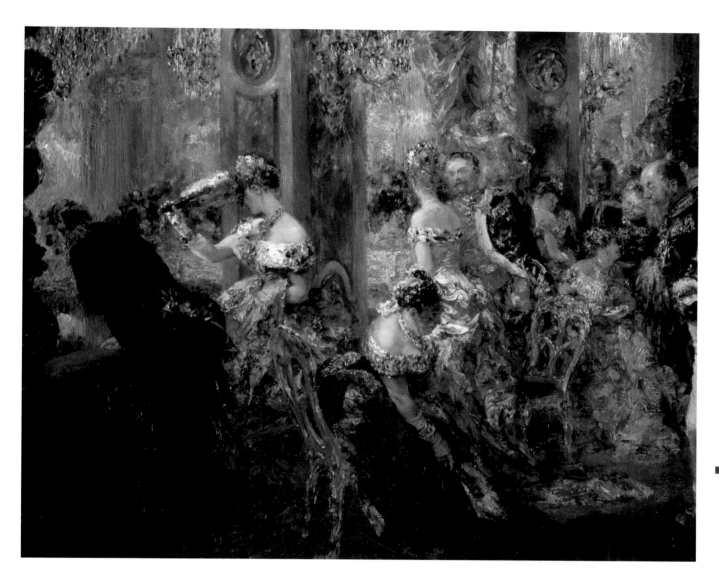

Baile de Corte.
ADOLF VON MENZEL.

father was a schoolmaster who had initiated him into lithography—his first success came from the lithographic prints that he made in 1834 for Goethe's works. In 1840, he received one of the most important commissions in his life: the creation of the illustrations for Franz Kluger's book *History of Frederick the Great*. He did four hundred designs for woodblocks, in a style that was fully Romantic. However, his careful studies for these designs were conceived with such imagination that they relate him to certain Symbolist movements, at the same time as they link him to the Realism that was in full flower at the time. Some examples of this are his famous en-

gravings, such as *Frederick the Great's Speech* (1858) and *Battle of Hochkirch* (1856), where he realistically captured military conflict, showing the agony, death, and misery caused by war. His illustrations would very quickly move beyond the German borders. In France, Menzel's excellent skill in his preparatory drawings was viewed with admiration. These were characterized by unusually imaginative choice of subjects that, nevertheless, seemed to throb with naturalism, in line with the most innovative movements of the era. From the second half of the 1840s onward, he applied his style to pictorial compositions that, like his works *The Balcony Room* (1845),

Garden in the Prince Albert Gardens in Berlin (1846), and *The Train from Potsdam to Berlin* (1846), were examples of his innovative paintings of both historical themes and everyday subjects, but which the critics of the times did not appreciate. Menzel is especially known for his graphic work rather than his paintings, despite the fact that his historical subjects and his portraits, above all the ones commissioned by King Wilhelm I of Prussia, are worthy of being included among the high points of the contemporary history of the German nation.

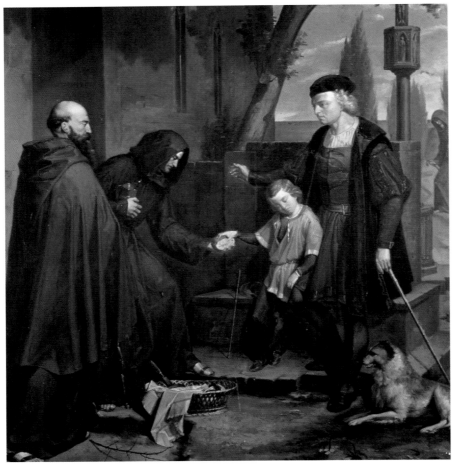

Columbus at the Monastery Asking for Water and Bread for His Son.
BENITO MERCADÉ Y FÁBREGAS.

MERCADÉ Y FÁBREGAS, BENITO

(La Bisbal, 1831–Barcelona, 1897)

A Spanish painter, he represents official painting in Catalonia and the eclecticism characteristic of the second half of the century. He began his studies in Barcelona and later trained in Madrid beginning in 1853. From his beginnings as a painter, he was inclined toward historic painting, winning several honorable mentions and medals at national exhibitions throughout his career, as he did in 1858 for his painting *Columbus at the Monastery Asking for Water and Bread for His Son*. That same year, he moved to Paris and later to Rome, where he met came in contact with the **Nazarenes** and received critical praise for his work. A teacher at the Fine Arts School in Barcelona, he also painted outstanding pictures of religious subjects, such as *The Last Moments of Brother Carlos Clímaco* (1862) and *The Transfer of St. Francis of Assisi's Body* (1876).

MESDAG, HENDRIK WILLEM

(Groningen, 1831–The Hague, 1915)

Dutch painter and patron. His paintings, which he began to produce in 1866 at nearly forty years of age, can be classified somewhere between Post-Romanticism and **Impressionism** and are related to The Hague School founded by **Israels**. He studied with **Alma-Tadema**. In the beginning, he painted landscapes with a pronounced sense of Realism, concentrating on coastal areas, such as seen in the broad view of *The Fishing Village of Scheveningen* (1881), his best-known work. Later he went on to create seascapes which project a certain air of drama. His landscapes, inspired by the North Sea, depict its dark, turbulent waters and stormy skies and are melancholy in tone. His treatment of nature is reminiscent of the landscapes of the **Barbizon School**, employing a style somewhere between **Realism** and **Romanticism**. These paintings follow the lines of the numerous representatives of the school of Dutch seascape artists. Despite these evocations, his art is very original and was greatly admired. In 1903, he bequeathed his collection of paintings to the Dutch government; today it is found in the museum in The Hague that bears his name. Distinguished works from among his paintings are *North Sea Surf*, for which he obtained a gold medal at the 1862 Salon, *Afternoon Effect in Scheveningen, Dusk in Scheveningen, Twilight* (1877), and *After the Storm* (1895).

METRASS, FRANCISCO AUGUSTO

(Lisbon, 1825–1861)

Portuguese painter. His style had a decisive influence on the development of painting in his country. He began his artistic studies in his native city and continued them in Rome, where he encountered the two most important representatives of the **Nazarene** group, **Overbeck** and **Cornelius**. However, the mark these masters left on him would fade

In the Black Country.
CONSTANTIN MEUNIER.

during his stays in Paris in 1847 and 1850, when he joined the historical **Romanticism** movement, as reflected in his paintings *Inés de Castro Waiting for Her Murderers, The Poet Camoens in the Grotto in Macao*, and the famous *Only God!*, a work from 1856. He was a teacher at the Fine Arts Academy in Lisbon

MEUNIER, CONSTANTIN

(Brussels, 1831–1905)

A Belgian artist, he was more known as a sculptor than as a painter, and his subject matter was largely derived from that of the **Barbizon School**. After his father's death, his mother steered him toward studying sculpture at the Academy in Brussels, although he would soon prefer painting and enter the atelier of the painter **Navez**. He exhibited for the first time at the 1851 Salon in Brussels. After his first Academic works, his style began to evolve, revealing influences from **Millet** and **Courbet**, noticeable in some religious compositions and historical paintings, such as *The Monk's Study* (1860) and the series *Episodes of the Peasants' War* (ca. 1862), whose preparatory sketches he did in the solitude of a monastery. However, he soon abandoned these pictorial genres to dedicate himself to social themes revolving around farm laborers, miners, and workers in general: a social panorama he portrayed in his paintings along with a certain amount of Romantic idealization. Between 1882 and 1883, he interrupted his painting to participate in an official mission to Spain, a country he toured with **Regoyos**. At this time, he once again felt the urge to sculpt. Upon his return, he was appointed

teacher at the Academy in Louvain and dedicated himself to sculpture, expressing the same social issues that he did in his paintings. He did not take up his paintbrushes again.

MICHALOWSKI, PIOTR

(Crakow, 1804–1855)

Polish painter. He was the only important artist in Polish painting in the first half of the century, and the first to be known internationally. He studied drawing with **Brodowski** and continued his studies in Germany, also traveling to Austria and Italy. However, he did nearly all of his painting in his native city. In 1831, he had to go into exile in

Christ in the House of His Parents (The Carpenter's Shop). JOHN E. MILLAIS.

Storm in the Seine Valley. GEORGE MICHEL.

France for political reasons and settled there and formed friendships with the painters **Vernet** and Charlet, and later met **Géricault** and **Delacroix**. The latter would wholly influence his style, clearly inclining him toward **Romanticism** and an

execution based on a loose technique and vigorous brushstrokes and using brilliant colors in his own personal manner, with light that is purely Romantic. Initially, he painted scenes involving the army and its cavalry at the time of the Napoleonic wars (*Blue Hussars*, ca. 1836 and *Battle of Somosierra*, 1837). However, later his painting focused on portraits (*Peasant Wearing a Hat*, 1846). After that, he chose Don Quixote as the subject of his paintings, in which his technique became looser and more daring.

MICHEL, GEORGES

(Paris, 1763–1843)

A French landscape painter whose work shows a style halfway between **Neoclassicism** and **Romanticism**. A student of Leduc and Bruandet and also of Nicolas Taunay, he traveled around Normandy, Switzerland, and Germany, gaining inspiration for

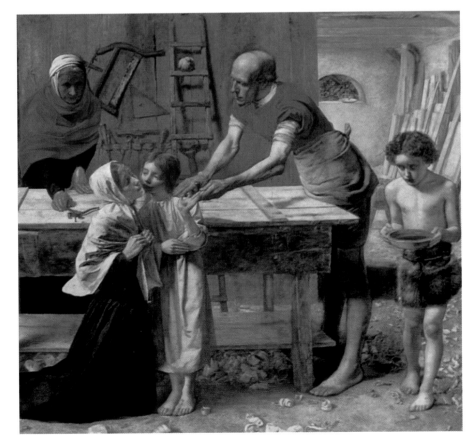

many of his works. In addition, his position as a restorer of paintings in the Louvre, where two of his own works are displayed, gave him the opportunity to become familiar with the seventeenth-century Dutch landscape painters, some of whose work he copied, particulalrly Ruysdael and Rembrandt. They influenced his landscapes, which primarily depicted the hills in the small towns surrounding Paris (Montmartre, Saint-Ouen, and others) in skillful compositions (*Landscape of the Environs of Chartres*). The pronounced contrasts between light and the shadowy areas in his paintings can be seen in landscapes such as *Storm in the Seine Valley* (1830). These contrasts and the intimist feeling he gave to nature are characteristic of his work, which later would incorporate ruins, an element typical of Romanticism. He was one of the first to paint in the open air, so he is considered by some critics to be a precursor of the **Barbizon School**.

MILLAIS, JOHN EVERETT

(Southampton, 1829–London, 1896)

An English Romantic painter, he was a founder and one of the most prominent members of the Pre-Raphaelite Brotherhood. His work initially reflected the aesthetic ideals of this association, although after the 1860s his evolution towards the canons of Academicism became increasingly evident. Highly gifted at painting from the time he was a child, he entered the Royal Academy at a very early age, where he met **Hunt** in 1845. These two artists formed a strong friendship, each recognizing in the other the same tastes in painting. In his own studio, he founded the Pre-Raphaelite Brotherhood in 1848, along with Hunt and **Rossetti**, and a year later, painted one of his most controversial works: *Christ in the House of His Parents (The Carpenter's Shop)*, which was rejected when he tried to exhibit it in 1850. This was a peculiar version of a traditional religious subject: the Holy Family with St. John the Baptist in a carpenter's shop. It is a descriptive work, meticulous in its detail, showing virtuosity of technique, and anecdotal in its treatment of religion. It scandalized conservative and Protestant circles and was harshly criticized. Millais' technical perfection can be seen in his painting *Lorenzo and Isabella*, and especially in *Ophelia*, a painting from 1852 which illustrates an especially tragic scene from *Hamlet*, giving a highly imaginative treatment of the moment when Ophelia, gone mad, is swept away by the waters of a stream while she sings. The painting, exhibited in Paris in 1855, was based on Millais' studies from life. It aroused admiration because of its psychological treatment of the fe-

Ophelia.
JOHN EVERETT MILLAIS.

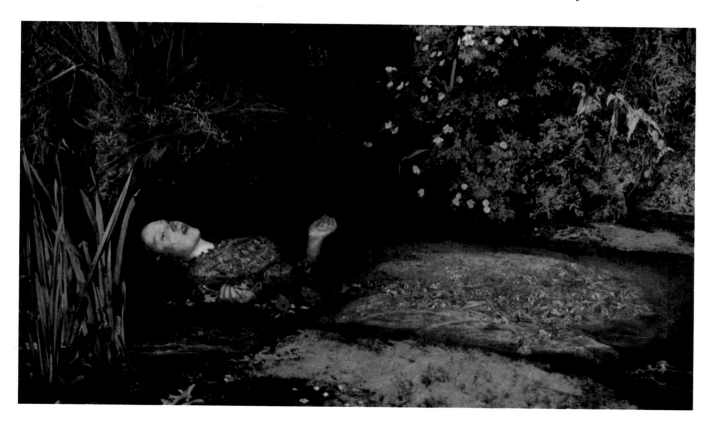

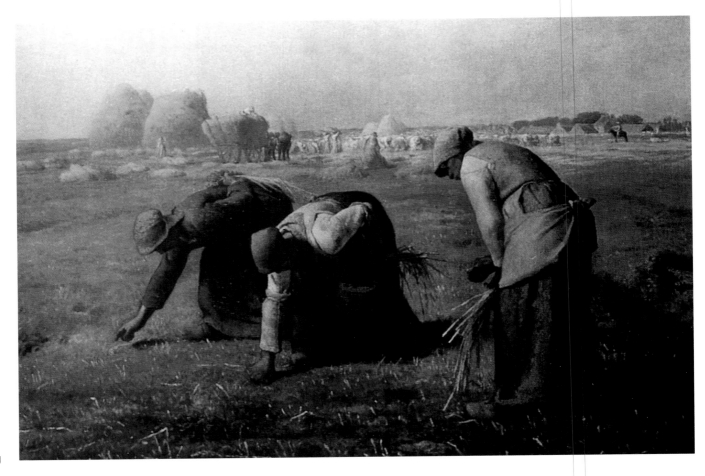

The Gleaners.
JEAN-FRANÇOIS MILLET.

male figure, represented by the model Elizabeth Siddal, Rossetti's lover and later wife, whose beauty personified the Pre-Raphaelites' female ideal. Despite its lack of depth, the scenery is detailed in the extreme, with extraordinary Realism in the exact depiction of the vegetation. *Escape of a Heretic* is a typical example of his emotional intensity and dramatic expressivity. He was also the best English portrait painter of his time, as can be seen in *Gladstone* (1885), *Cardinal Newman, Carlyle*, and so many others, among them his own self-portrait. The success he achieved and the quality of his work earned him election as an associate of the Royal Academy in 1853 and caused him to begin distancing himself from the rest of the

Pre-Raphaelite painters. Finally, in 1854, there was a definitive break with them, when he married John Ruskin's former wife, **Ruskin** being the ideologist of the Brotherhood. From that time onward, his painting departed from his former ideals and adapted to public tastes and to the academic tradition. He painted numerous portraits, scenes of customs and manners, and historical subjects. He was elected president of the Royal Academy in 1895, one year before his death.

MILLET, JEAN-FRANÇOIS

(Gruchy, 1814–Barbizon, 1875)

A French painter, he was one of the most prominent members of the **Barbizon School**. His work portrayed country life and rural work-

ers. The son of a family of Norman peasants, he took his first painting classes in Cherbourg at the age of nineteen, while at the same time helping his parents with farm chores. In 1837, a municipal grant allowed him to go to Paris, where he attended the Fine Arts School and entered in the atelier of the historical painter **Delaroche**. Despite this good beginning, his peasant customs and his coarse manner did not fit into the Parisian lifestyle, and he returned to Cherbourg three years later in 1840. Until 1845, he made a living by selling portraits and genre scenes, although he also did some seascapes—infrequent in his work— and one of his first quality paintings, *A Milkmaid* (1844), a work that, along with *The Riding Lesson*, was accepted at the Salon in Paris. After his marriage in 1848, he went to Barbizon, forming part of the school and

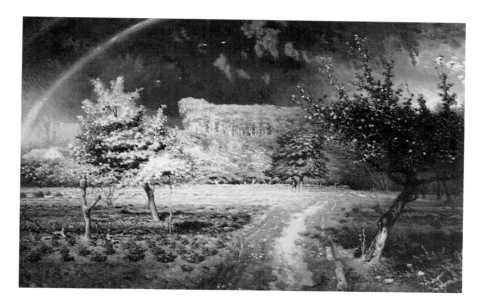

Spring.
JEAN-FRANÇOIS MILLET.

joining the group of resident artists, among whom was **Rousseau**, who helped him alleviate his financial difficulties. During these years, he painted *St. Jerome, A Girl*, and *Golden Age*. He worked hard, but his paintings were not accepted at the Salons. Throughout the decade of the 1850s, Millet explored subjects relating to rustic life, which would lead him to discover his true personal style: the depiction of life in the country with all of its harshness, sacrifices, and deprivations. With *The Sower*, from 1850, he made a name for himself at the 1851 Salon in Paris. This work was followed by *The Winnower, The Gleaners*, and *The Angelus*. The latter painting is, without a doubt, his best known, and was painted between 1858 and 1859. It is a true manifesto of his own particular vision of rural life, a subject that he depicted realistically and objectively, using light and atmosphere in such a way as to dignify and solemnize his figures with great poetic strength. Recognition of his work was only partial, since his subjects, symbolizing social injustice,

inequality, bitterness, and misery, were not pleasant but unsettling, if not distressing. These were paintings with a subversive message against bourgeois society. Nevertheless, the quality of his work won out, and he received a medal at the Universal Exposition in Paris in 1867. Years later, the French government gave him a commission to decorate the church of St. Genevieve, later the Pantheon of the Illustrious, with the theme of the four seasons. Death sur-

prised him as he was making the sketches. Millet's work, little appreciated during his lifetime, was revolutionary for later artists, who were impressed by paintings such as *The Reapers* and *The Angelus*. Among these artists were **Pissarro, Van Gogh**, and Salvador Dalí.

MINARDI, TOMMASO

(Faenza, 1787–Rome, 1871)

An Italian painter and a great draftsman, his painting was related to group of purists or Italian painters who assimilated the tendencies of European Romantic Classicism. He was a teacher at the Academy in Peruggia, and from 1828 to 1858, at the Academy of St. Luke in Rome. His perfection in draftsmanship allowed him to compose some works that, for the most part, were colored and completed by his pupils.

Young Woman.
JEAN-FRANÇOIS MILLET.

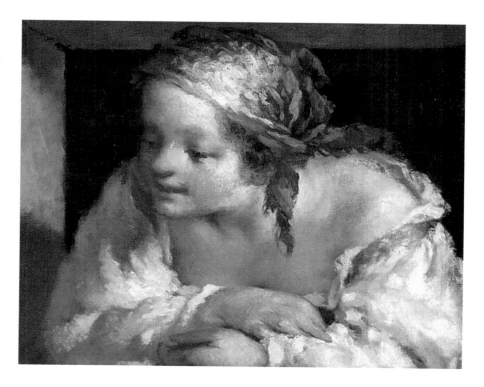

MIR I TRINXET, Joaquín

(Barcelona, 1873–1911)

A Spanish painter and innovator in landscapes at the end of the nineteenth century, his work meant a step forward in the ideas concerning this area of painting. He received his training by attending the Fine Arts School in Barcelona, as well as through classes at the painter Luis Graner's studio. An admirer of **Casas** and **Rusiñol**, he formed, along with some other painters (such as Nonell, Pichot i Canals, Gual, and Vallmitjana), a small movement at the beginning of the 1890s, known as the Colla del Safrá, which took an interest in suburban subject matter and the plays of light characteristic of **Post-Impressionism**. However, his artistic development was completely personal and evolved separately from the group. In the last years of the century, he became involved in the artistic environment at Els Quatre Gats, —a bar and meeting place favored by painters— and his work began to demonstrate more color and

Waters of Moguda.
Joaquín Mir i Trinxet.

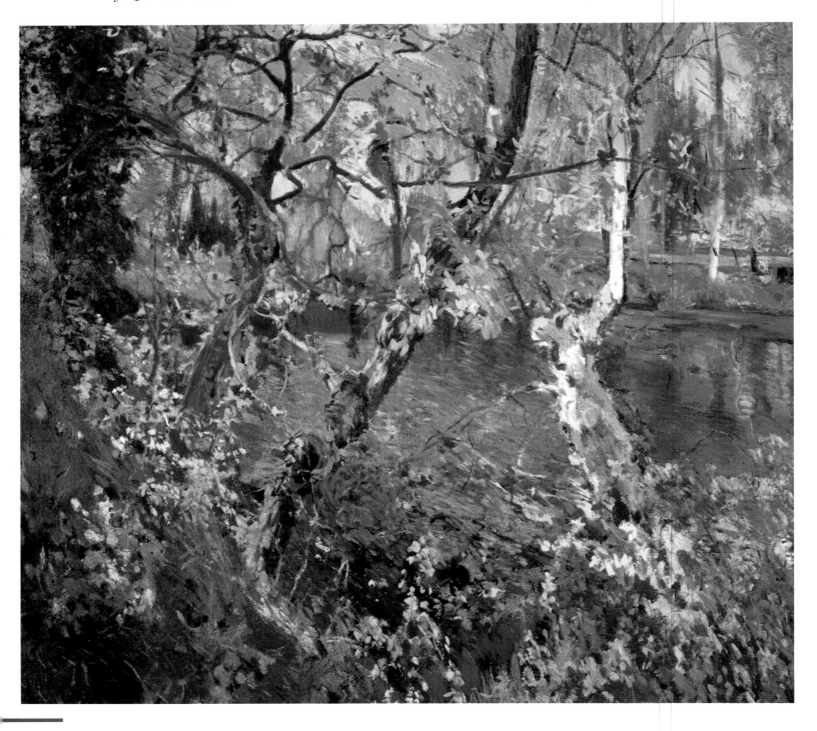

Gare Saint-Lazare.
CLAUDE MONET.

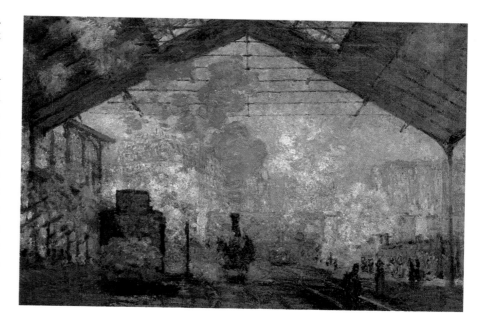

expressivity. In 1899, he award-
ed the silver medal at the National
Exhibition for his painting *The Gar-
den of the Shrine*. That same year, he
moved to Majorca with Santiago
Rusiñol, where he lived until 1904.
Some of his most representative
works are from that period, such as
Twilight and *The Enchanted Cove*. An
unfortunate accident caused a de-
pression that led to his admission to
a hospital for nervous disorders.
Upon his recovery, he went to Tar-
ragona and began a new painting
process that brought him closer to a
new breakthrough, which he applied
to his landscapes. In 1930, having
well established himself in his field,
he received a medal of honor for his
work as a whole.

MONET, CLAUDE

(Paris, 1840–Giverny, 1926)

A French painter with whose work
Impressionism reached its height.
The son of a modest merchant, he
moved with his family at the age of
five to the Atlantic port city of Le
Havre, where he soon began to draw
with charcoal. In 1855, he met
Boudin, the painter who encouraged
him to begin his artistic career, and
one year later, he returned to the city of
his birth. He enrolled at several acad-
emies, was exposed to the painting of
Delacroix, **Courbet**, and **Daubigny**,
and struck up friendships with **Pis-
sarro** and **Renoir** and the young
artists who would later make up the
Impressionist group. In 1861, he per-

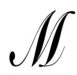

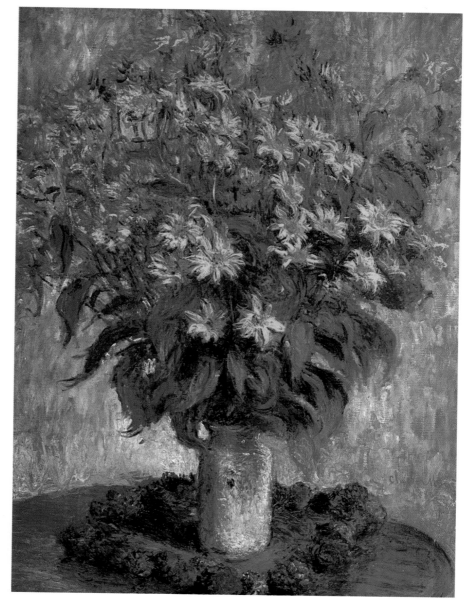

Vase of Chrysanthemums.
CLAUDE MONET.

M

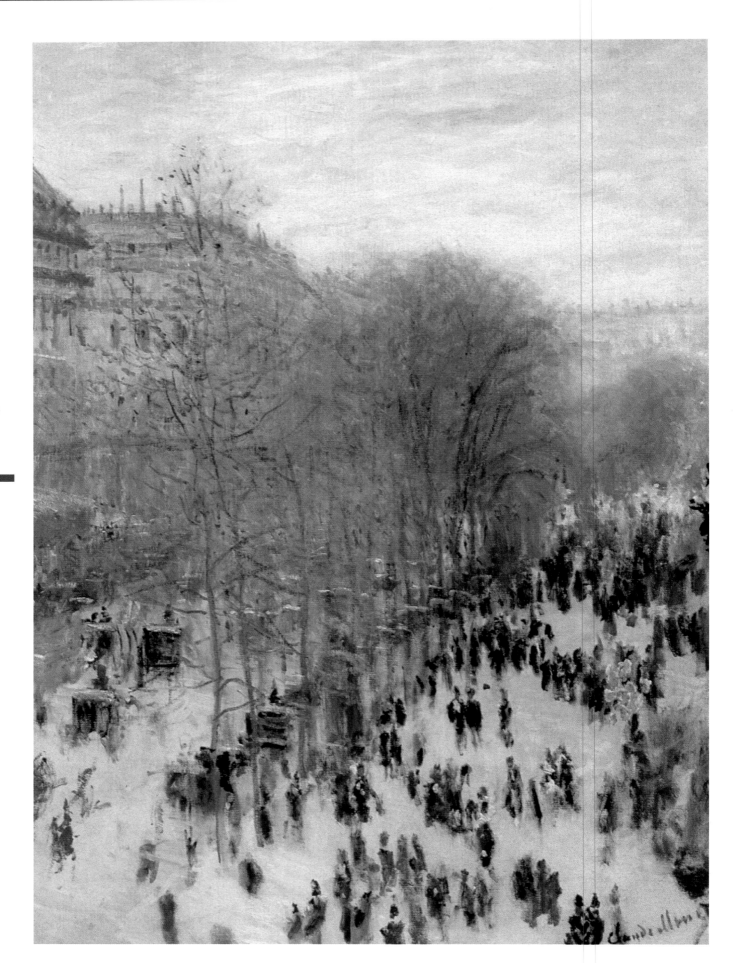

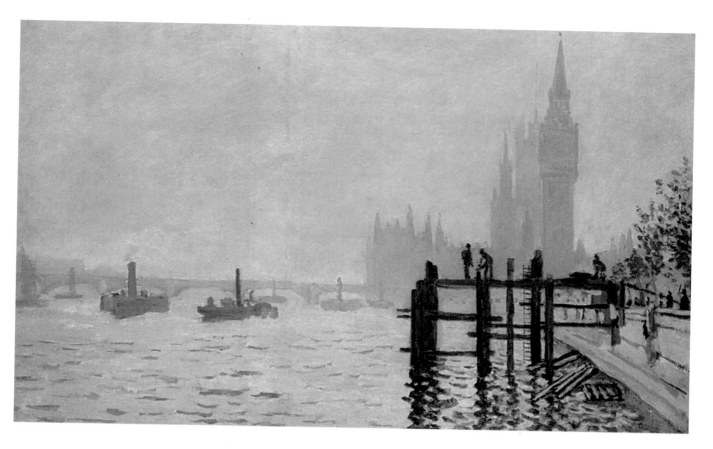

Above: *The Thames at Westminster.*
Right: *La Rue de la Bavolle, Honfleur.*
CLAUDE MONET.

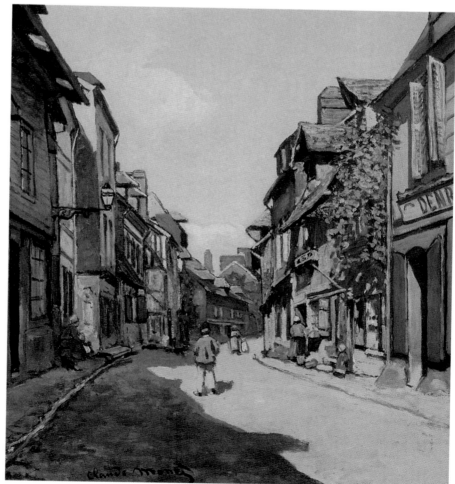

formed his military service in Algeria, a country that he found fascinating and through which he encountered a world of light and color, awakening new emotions. The next year, he became ill and returned to Le Havre, where he continued painting open-air landscapes along with Boudin and **Jongkind**. He moved to Paris once again and attended classes in **Gleyre's** atelier, along with Renoir, **Sisley**, and Pissarro. He left Paris with them and moved to a town near Barbizon, in the Fontainebleau Forest. In 1865, he began a composition paying homage to **Manet's** work, a painter he admired. However, he did not finish this work because of negative comments from Courbet. His first exhibition at the Sa-

Boulevard des Capucines.
CLAUDE MONET.

225

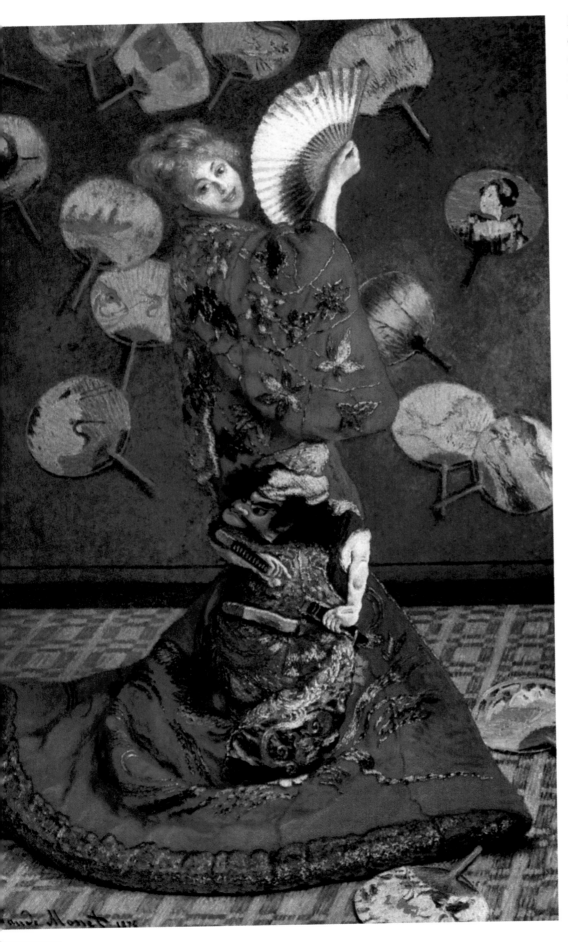

lon in 1865 went by unnoticed, but, one year later, he created *Women in the Garden*, for which he won one of his first awards, a late-coming success that did not improve his precarious financial situation; he could not even stop his paintings from being seized and sold cheaply by lots. The help he received from Manet and from the merchant Gaudibert encouraged him to continue painting, and from 1869 onward, he began to concentrate on his favorite subjects, the light at different moments and the movement of the Seine. Standing on the banks of this river, he and Renoir made numerous studies of the riverside and the docks, as seen in *Bathers at La Grenouillère*. In 1870, he married Camille Doncieux with the idea of settling in Trouville, but with the coming of the Franco-Prussian War, he decided, like many other painters, to flee France. He met up with Pissarro in London, and together they both discovered **Constable**'s and **Turner**'s landscapes. The misty atmosphere of the Thames fascinated them and confirmed their artistic goal of capturing the fleeting quality of the light reflected in the water, as demonstrated in *The Thames at Westminster (Westminster Bridge)* (1871). When the war was over, he visited Holland and toured its canals and windmills. He returned to his own country and settled in the town of Argenteuil, where he stayed until 1878, tirelessly painting scenic views and riverbanks with a technique using small brush strokes, touches of color juxtaposed with intense luminosity. On a short trip to Le Havre, he painted the most emblematic Impressionistic work, *Impression: Sunrise*, dated 1872. The painting was shown at the exhibition organized in 1874 by the

The Japanese Girl.
CLAUDE MONET.

The Grand Canal in Venice.
CLAUDE MONET.

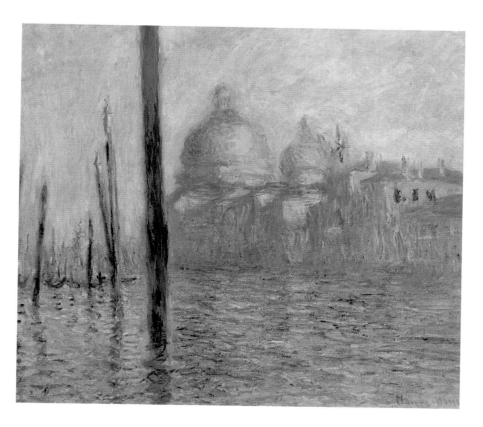

Anonymous Society of Artists, Painters, Sculptors, Engravers, etc. It was the first exhibition of the Impressionists, an innovative artistic group, who after being systematically rejected at the official Salons, decided to organize a parallel exhibition. Monet's painting was the object of ridicule from a journalist who satirically dubbed all of the artists "impressionists," giving rise to the name of the movement. Monet continued to live in Argenteuil, while still doing part of his work in Paris, where, in remembrance of Turner, he painted the series of *Gare*

Impression: Sunrise.
CLAUDE MONET.

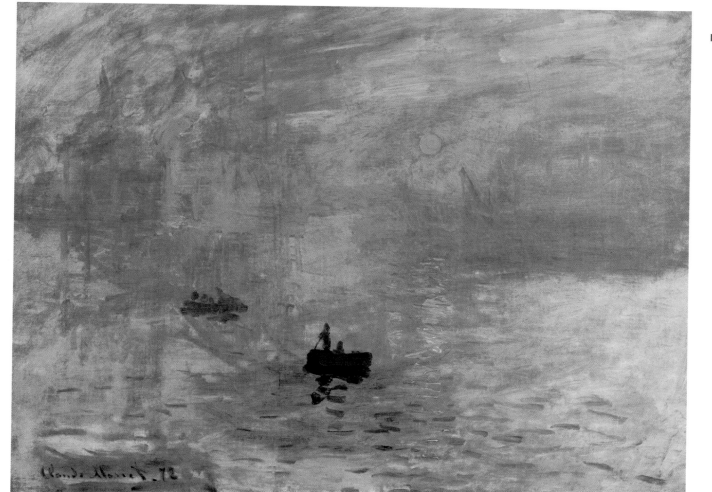

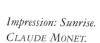

Saint-Lazare paintings which captured that place at different times of the day and in differing intensities of light and showed the different effects that the smoke from the locomotives produced. These works were followed by snowy landscapes, as well as by urban views and scenes, among which *Rue Montergueil with Flags* (1878) is striking, a true example of his technique and palette. In 1883, he bought a house and settled in Giverny. He then began a series of paintings of poplars, among which was *Poplars on the Epte* (1891). In 1892, in search of light and atmospheric sensations, he began his more than thirty versions of *Rouen Cathedral*, caught at different times of the day.

Women in the Garden.
CLAUDE MONET.

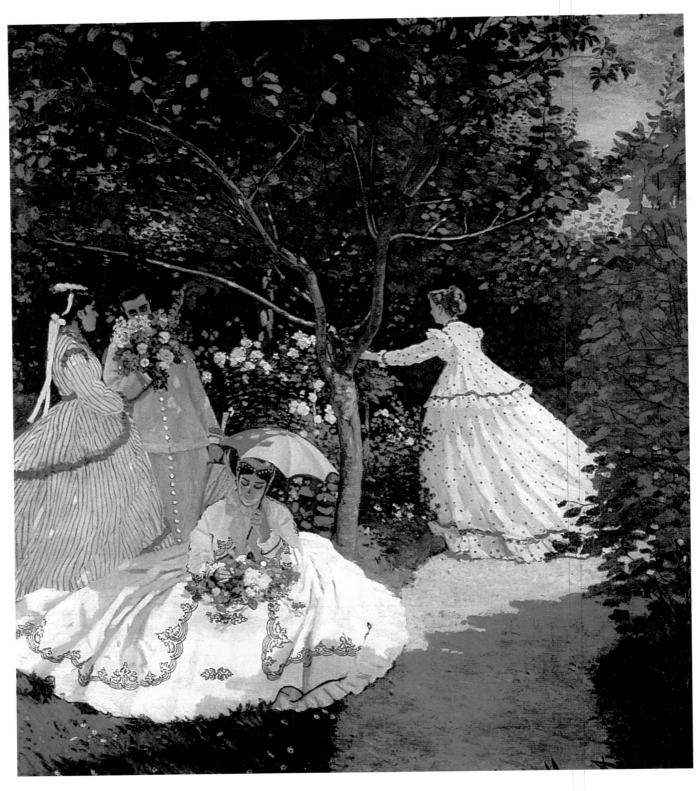

His style was already somewhat fluid and transparent. On another trip to London, he followed the same system with *Houses of Parliament, London* and *The Thames.* Suffering from a vision ailment, he spent his last years painting at his country house in Giverny, where he had built a lush garden with a pond that became the inspiration for a series on *Water Lillies,* large panels in which his style became nearly abstract, a style considered to be the height of Impressionism. Significant examples of his enormous artistic productivity are: *Gare Saint-Lazare, Vase of Chrysanthemums, The Thames at Westminster, La Rue de la Bavolle, Honfleur, Boulevard des Capucines, The Japanese Girl, The Grand Canal in Venice, Impression: Sunrise, Women in the Garden,* and *The Hunt.*

MONTEIRO DA CRUZ, ANDRÉS

(Lisbon, 1770–1843)

A Portuguese painter whose work was **Neoclassical.** He conectrated mainly on still lifes and landscapes and was appointed teacher of these specialties when the Fine Arts Academy was created in Lisbon. He was a pupil of Simón Cayetano Numes and of Baczynski. Of his work, the decorative paintings he did on the ceiling of the Ajuda Palace are of special interest.

MONTICELLI, ADOLPHE

(Marseilles, 1824–1886)

A French Romantic painter. He studied at the Fine Arts School in his native city and was a student of **Delaroche.** His study of the Old Masters in the Louvre greatly contributed to his education, as did the influence of painters such as **Díaz de**

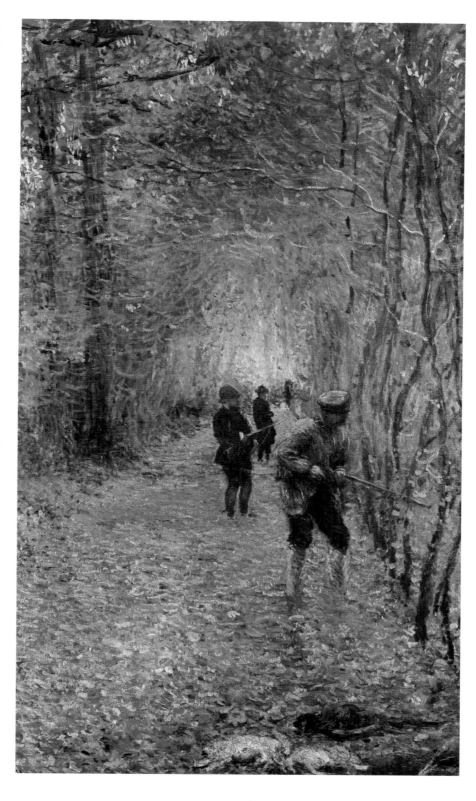

The Hunt.
CLAUDE MONET.

la Peña and **Delacroix**, which was especially important for him in the area of color. The result was a very personal style, characterized by a brilliant palette and the use of thick daubs of paint, which would give his paintings strength and would later influence **Van Gogh**. His portraits, executed with fine artistry, as is *Portrait of Madame René* (1871), are outstanding, as are his still lifes, Roman-

tic landscapes, and scenes portraying circuses and gallantry. Many of his paintings show groups of lively people in delicate Romantic scenery. His work achieved great success, but in 1870, he returned to Marseilles, where he led a life far from the hubbub he had experienced up until that time. Other important works of his are *Rendezvous in the Park, The Tumblers' Stop* and *The Serenade*.

MOORE, ALBERT

(York, 1841–London, 1893)

An English painter and illustrator whose work, basically in decoration, is a synthesis of different styles, mainly of Pre-Raphaelite and Classical modes. The son of William Moore, a portrait painter, he studied in London at the Royal Academy, which he left because that institution was incompatible with his artistic aspirations. He devoted himself to decorative painting in aristocratic mansions and public buildings. Many of his compositions were intended for stained glass windows and wallpaper. *The Shulamite*, a painting he exhibited in 1866, is an accurate reflection of his artistic ideas, and *The Dreamers*, his most famous work, is characteristic of the Victorian era.

MOREAU, GUSTAVE

(Paris, 1826–1898)

A French painter whose work developed within the Symbolism movement with Biblical, mythological, and fantastic compositions dealing with very complex subject matter. His initial style was based on the work of **Delacroix**, whom he admired during his youth. Later on, he was inspired by the Italian painters of the *quattrocentro,* especially the mythological works of Mantegna. His painting always evolved along the same thematic lines, with Greco-Roman and spiritualist subjects, and a high-quality, precise, and detailed technique using brilliant colors. *Oedipus and the Sphinx* (1864), *The Head of Orpheus* (1867), and *St. Sebastian* (1875) are works that demonstrate his color schemes, with richly-garbed figures wearing spectacular jewels, indicating a strong oriental spirit. In all of his paintings, he creates exotic atmospheres that were occasionally the target of the wrath of the most traditional critics. Despite his introverted and rather unsociable personality, Moreau was forced to work as a teacher at the Fine Arts School in

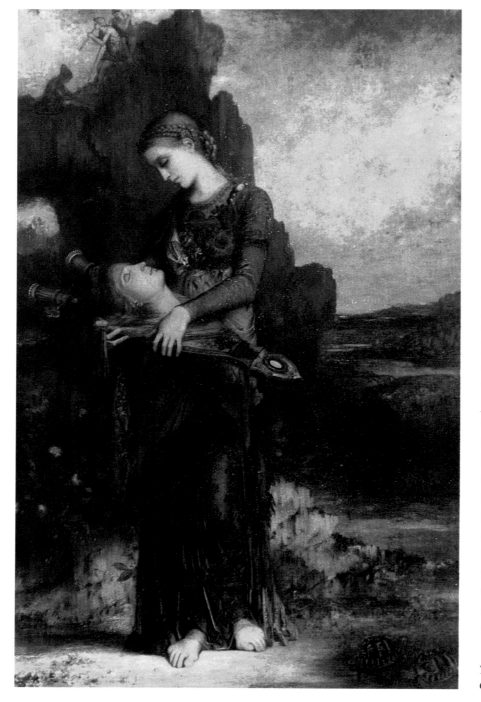

Thracian Girl Carrying the Head of Orpheus.
GUSTAVE MOREAU.

Salomé with the Head of John the Baptist.
GUSTAVE MOREAU.

The Unicorns.
GUSTAVE MOREAU.

Paris in the latter part of his life, from 1892 to 1898. There, he had as students some future geniuses of painting, such as Matisse and Marquet. He promoted another of his pupils, Georges Rouault, by making him the curator of his museum/house when he donated a large part of his work to the French government shortly before his death. Other outstanding works are *Prometheus*, *Hesiod and the Muses*, *Leda*, *The Apparition*, and *Salomé Dancing Before Herod*, the latter being one of his best-known paintings.

MOREL, CARLOS

(Buenos Aires, 1813–1894)

Argentinian painter, engraver, and miniaturist. His work can be classified as somewhere between **Romanticism** and **Realism**, He is also considered the first Argentinian

painter to be recognized for the quality of his work. He was a versatile painter who knew how to use all of the techniques—oil, drawing, watercolor—with a certain level of mastery, in works that encompassed a wide range of genres—portraits, landscapes, religious, scenes of customs and manners. His popular scenes of the Argentinian pampas are worthy of note, such as *Media Caña* (referring to a popular dance),

Customs in the Río de Plata Area (1844), *Gaucho's Song at the General Store*, and *El Cielito* ; as are some of his portraits, such as the one of *Juan Manuel de Rosas and His Wife* (1836); and pictures with religious subject matter, to which he would especially dedicate himself in the last years of his life. This change was due to

231

Catching Butterflies.
BERTHE MORISSOT.

the severe psychological depression he suffered as the resuilt of a dramatic family event related to the political situation in his country. One example of this religious painting is *The Descent*, also from 1836.

MORELLI, DOMENICO

(Naples, 1826–1901)

Italian painter. Most of his work are based on religious and historical subjects, which were tremendously successful in his day. A tireless traveler, he encountered the **Nazarenes** dur-

ing his visits to Rome, while his stay in Paris in 1855 allowed him to meet **Delacroix** and become familiar with the splendor of Romantic historical painting. Upon his return home, he brought to Italy the trends he had learned abroad and created compositions of a literary nature that were linked to Italian history, such as *Tasso Reading his Poem to Eleonora d'Este* (1863). His religious painting has some features in common with the work of the Brotherhood of St. Luke, but his treatment of light and shadow, full of contrasts and striving for effect, as well as his spectacular compositions, hark back to the Baroque tradition of the seventeenth century and depart from the Nazarenes' aesthetic ideals. An example of this is

The Burial of Christ, one of his best-known works. In the last phase of his artistic career, he evolved towards symbolist painting, in which he invented reality more than reflected it.

MORISOT, BERTHE

(Bourges, 1841–Paris, 1895)

French painter. The fact that she was a woman in a world of artistic creation that was dominated by men makes her work even more interesting in the overall panorama of the nineteenth century, as it is with some of the oth-

Psyque.
BERTHE MORISSOT.

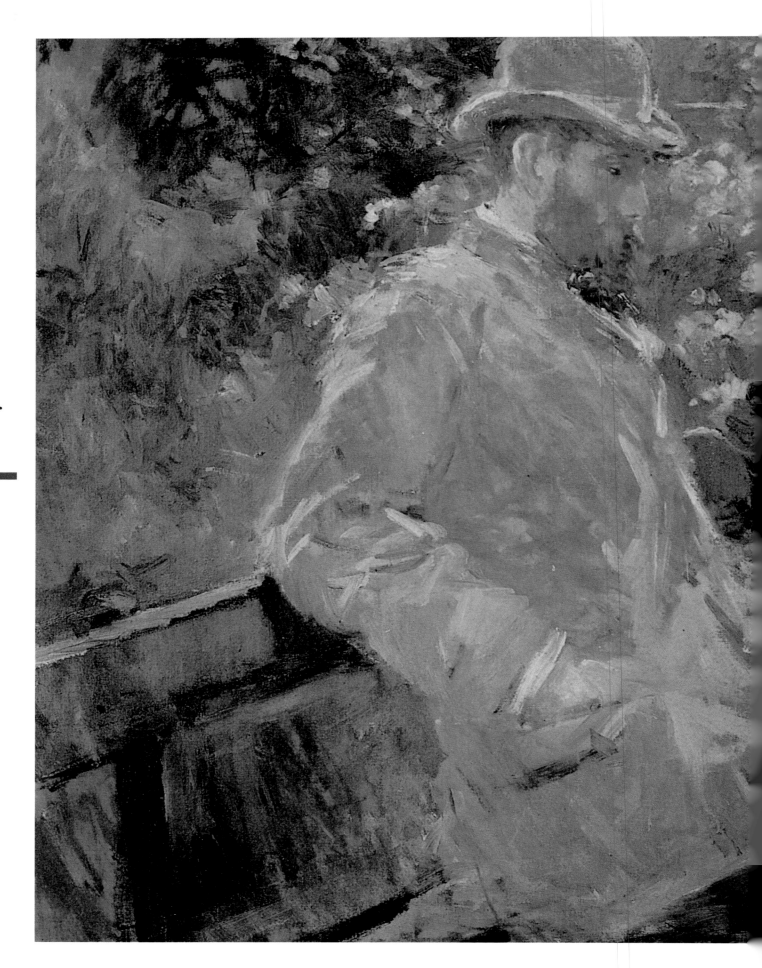

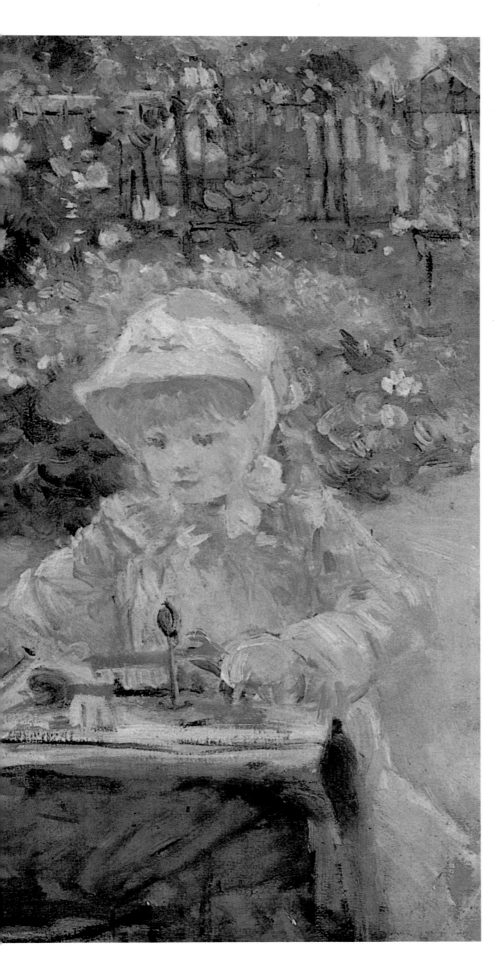

er women painters of this time. Encouraged by her parents to start painting, she began studying the masterpieces in the Louvre and painted from life under **Corot**'s guidance. Through **Fantin-Latour**, she met the painter **Manet**, who became her brother-in-law in 1874 and whose influence was decisive in her work. She also had an influence on him, since after seeing her work, Manet lightened his palette and abandoned his somber subject matter. Her artistic development began with advanced **Realism** and genre subjects painted in the open air and finally approached and became integrated into **Impressionism**. She showed a series of works in the group's first exhibit. Her energy and vigor were obvious in compositions that were gentle and dynamic at the same time. Her favorite scenes were those depicting families and the everyday life of the French bourgeoisie. Some of her most interesting works of this type are *The Cradle, Wheat Field, Catching Butterflies, Woman and Child in a Meadow in Maurecourt, Marine in England, In a Boat*, and *Argenteuil*, among many others. Her fresh and vivid colors, her luminosity, and the innovative pictorial space in which she sets her characters, are excellent examples of her affiliation with the first era of Impressionism, despite the fact that her works did not always receive critical and public acclaim.

MORRIS, William

(Walthamstown, Essex, 1834–London, 1896)

British painter, decorator, illustrator, poet, architect, and theorist. Along

Eugène Manet and His Daughter.
Berthe Morissot.

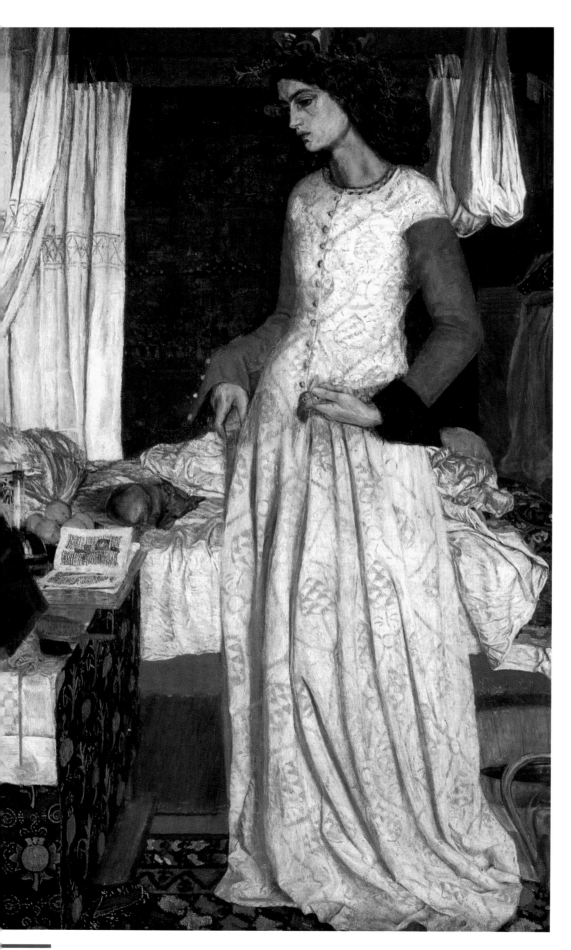

Guinevere.
WILLIAM MORRIS.

with **Brown**, who was a socialist like Morris, he sought to use art to serve the people and make it accessible to them. However, the craftsmanship and artistry involved in creating everyday objects put them out of the reach of most people. Nevertheless, they would both be important in the development of the plastic arts, founding Morris and Company, a decorative arts business, in 1861, along with **Rossetti**. This company used a type of decoration based on plant motifs, preceding modernism, that would later give rise to the Arts and Crafts movement. Morris belonged, as did the other two men, to the Pre-Raphaelite Brotherhood, and from 1856 onward, he primarily dedicated himself to painting, although it appears he only did one strictly pictorial work, his *Guinevere* (1858), also known as *La Belle Iseult*. This painting has a medieval tone, influenced by his admiration for the Middle Ages, with a melancholy beauty and gracefulness reminiscent of Botticelli, paving the way for Art Nouveau.

MOUNT, WILLIAM SIDNEY

(Setanket, 1807–New York, 1868)

An American painter, primarily specializing in genre painting which reflected American life and reality in the middle of the century. Starting in 1826, he began his artistic training at the newly created National Academy of Design in New York. An illness forced him to leave his studies and to return to his hometown. From that time onward, he dedicated himself to depicting religious subjects and to

painting portraits, until he was attracted by the everyday lives and routines of people in his surroundings. The thing that makes him interesting is that he was one of the first American artists to paint genre scenes and landscapes in the open air, achieving excellent work, both because of its documentary value and because of its compositional and technical skill. These were paintings that reflected trivial matters, with anecdotal interests and great simplicity. His style is linear because of his excellent mastery of draftsmanship, with luminous colors and brushstrokes that, at times, border on the Impressionistic. He never left the United States, but his

Raffling for the Goose.
WILLIAM MOUNT.

artistic experience has parallels to, and coincides with, some European movements. In this sense, the common points between the subject matter of his work and that of Central European works in the Biedermeier style have been recognized by scholars. Furthermore, the way his works parallel the contemporary literature of Washington Irving is also usually mentioned. Some of his most interesting works are *The Power of Music*, *Farmers*, and *The Horse Dealers*.

MUCHA, ALFONS

(Ivancice, 1860–Prague, 1939)

A Czech painter and draftsman, he was one of the promoters of Art Nou-

veau as well as a famous illustrator and poster artist, as reflected by his work *The Seasons*. With the aid of his patron, Count Karl Kluven Belasi—for whom he decorated the Emmahof Castle in Moravia (1881)—he traveled to Paris in 1887 to perfect his artistic training. There he was a pupil of the painter Laurens and focused on historical painting. However, the technique of illustration was what most interested him. He began to excel in this area when the Théâtre de la Renaissance commissioned him to design the poster advertising *Gismonda*, a work written by one of the most successful authors of the time, Victorien Sardou, and performed by the great actress, Sarah Bernhardt. From that time onward, he created the female prototype of Art Nouveau, per-

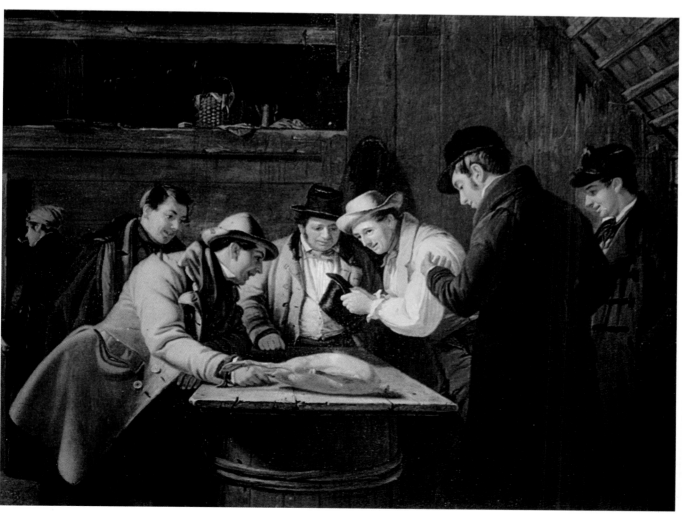

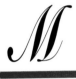

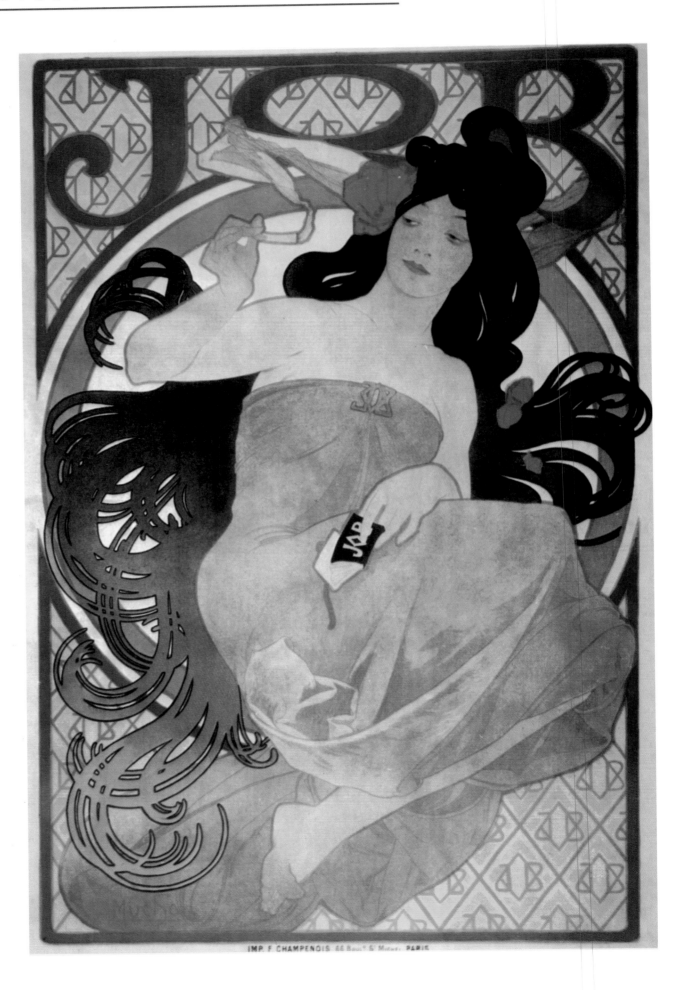

Label Design for "Job" Cigarettes.
ALFONS MUCHA.

sonified by this actress and the well-known series of color lithographs for *The Lady of the Camellias* (1896), *Medea* (1898), and *The Distant Princess* (1898). His reputation grew with the designs he created for labels of commercial products, such as champagne, cigarettes—such as the "Job" brand—, and candy. He also excelled at embossing leather for bookbinding and in designing bookplates. The style of his final works approached Symbolism. Upon his return to Czechoslovakia, he dedicated himself to religious painting.

MULREADY, WILLIAM

(Ennis, 1786–London, 1863)

An Irish painter, who did most of his work in England. He studied at the Academy in London and was a pupil of Graham, John Varley, and the sculptor Thomas Banks. Although he began by painting landscapes and historical and genre paintings, his first notable works were those that, influenced by **Wilkie**, depicted scenes of contemporary life. These achieved great popularity, especially those of schoolchildren. At first, his work showed the influence of seventeenth-century Dutch painters, with very meticulous brushstrokes, but from 1820 onward, his style became more mature and personal. He used light, strong colors on a white background, while still continuing to employ careful and perfect draftsmanship. Because of this, and because of the poetic tone of some of

his last paintings and their more spiritual nature—such as *The Sonnet* (1839), whose naturalism is excellent—he is considered a forerunner of the Pre-Raphaelites, since he was their friend and patron. He also illustrated novels with clever draw-

The Seasons.
ALFONS MUCHA.

ings. Of the rest of his work, *The Fight Interrupted* (1816) is considered his best work and *The Vicar of Wakefield* is also outstanding.

The Vicar of Wakefield.
WILLIAM MULREADY.

M

The Fisherman.
EDVARD MUNCH.

The Scream.
EDVARD MUNCH.

MUNCH, EDVARD

(Löten, 1863–Ekeley, 1944)

A Norwegian painter and engraver—considered one of the pioneers of the twentieth-century avant-garde—his painting contains the origins of Germanic and European **Expressionism**. A tragic childhood, caused by the deaths of his mother and his sister from tuberculosis, marked the subject matter of his works, a world of anxiety, loneliness, and at times frantic desperation. At the age of nineteen, he began painting in Oslo in an Impressionistic style, but his interest was in depicting the human figure. After a short trip to Paris in 1855, he created a painting whose subject matter was already characteristic of the death-related themes in his work: *The Sick Child* (1885-1886). By gaining a scholarship to study in Paris, he had access to **Gauguin**'s work at the Salon of Independent Artists in 1897. The French artist's simplification of form and his colors significantly influenced Munch's style and encouraged his tendency toward compositions that freed him from all the traditional resources. He is characterized by his vigorous colors that are secondary to his draftsmanship, with lines that are always undulating and sinuous, the true focal point of works such as *The Fisherman*, *Red House and Spruce Trees*, *Children and Ducks*, and *Madonna*. The exhibition he

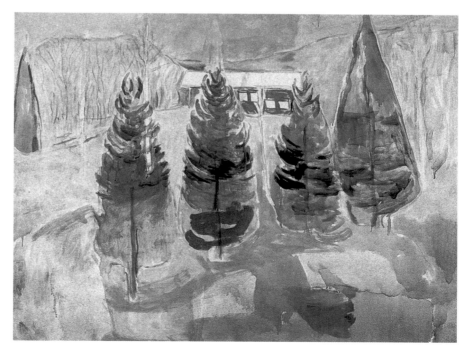

Red House and Spruce Trees.
EDVARD MUNCH.

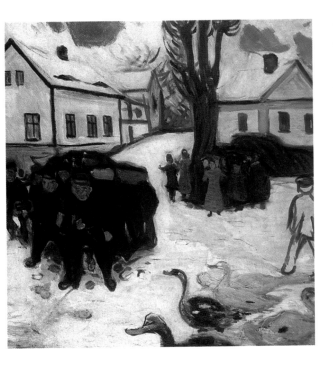

Children and Ducks.
EDVARD MUNCH.

M

put on in Oslo in 1892 was very important in his career, since, as a result, fifty-five of his works were selected to be exhibited in Berlin. This was significant because of the reaction they caused in Berlin and the weight they had in the formation of the *sezession* ("secession") group and the development of Expressionism. His painting, *Evening in Karl Johan* from 1892, shows his simplified forms and the vacant faces of his figures. Some of his subjects are derived from the writings of the Swedish author August Strindberg, who was a friend of his. The paintings known as *The Scream* (1893) and *Anxiety* (1894) are considered clear manifestos of Expressionism. His style became more effective when he began to work with prints, wood engraving, etching, and lithography, giving rise to more than fifteen thousand images

that are variations of his obsessions and that have strong negative connotations, such as the vampirical *Madonna* from 1895. Between 1896 and 1898, he lived in Paris and contributed engravings to the *Revue Blanche*. From 1900 onward, he painted a series of symbolic pictures, such as *The Dance of Life* and *Starry Night*, although his work was still clearly Expressionistic. Suffering from depression in 1908, he was forced to seek rest in Oslo, where he devoted himself to painting a series of frescoes for the University (1909–1915); he was already an officially recognized artist. *Galloping Horse* (1912) and *Winter Landscape* (1915) belong to realistic Expressionism. With *Starry Night* (1923), he returned to poetic Symbolism.

MUNKACSY, MIHALY VON LIEB

(Munkacs, 1844–Endenich, 1900)

A Hungarian painter, belonging to the **Realism** movement and one of the great masters of genre painting. Coming from a humble family, he learned the basics of drawing and painting with a painter from his hometown, but later, at the age of

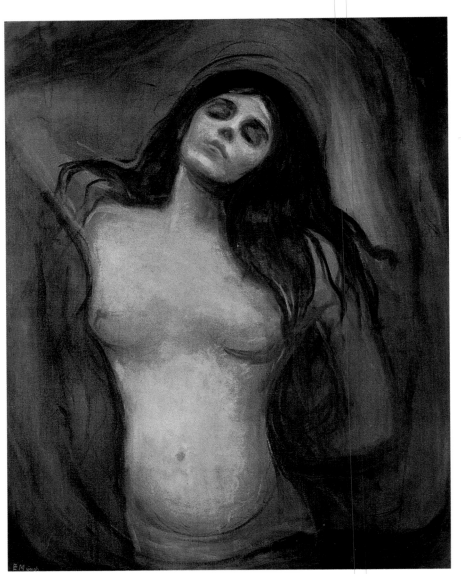

Madonna.
EDVARD MUNCH.

fourteen, he continued his studies—alternating them with his work as a carpenter—at the Academies in Vienna, Munich (where he met **Leibl**), and Düsseldorf. He moved to this latter city in 1868, where he painted genre scenes with strong characterization and great **Realism** in the treatment of detail. Although they were somewhat melodramatic. they clearly show the influence of the Knaus' genre painting, especially Ludwig's, as well as that of the historical painting of Kaulbach, all of whom were his teachers. These paintings were quite successful, such as *The Last Day of a Condemned Man*, his first major work, which was awarded a medal at the 1870 Salon in Paris, and *Making Lint* (1871). In 1875, he settled in Paris, which he had previously visited, for twenty-four years, producing gentle, bourgeois paintings. These were influenced by **Courbet**, whom he admired, and by the **Barbizon School**, as well as by **Manet** (*Parisian Interior*, 1877). His subject matter was primarily religious, in large format, and steeped with a deeply spiritual feeling, in an attempt to stir the emotions of the viewer. After 1878, because of his great fame, he exhibited at his own studio, showing such works as *Christ Before Pilate*, 1881 and *Christ on Calvary*, 1883. However, he also painted historical pictures, landscapes, and portraits, such as the one of *Franz Liszt* (1884). His paintings in general are done in dark hues and with a somewhat monotonous palette, with abundant contrasts between shadowy areas, which are almost black, and some touches of white that are almost dazzling, giving off a certain air of drama. His style is energetic, with loose brushstrokes and a high degree of techni-

Rain Shower in Granada.
ANTONIO MUÑOZ DEGRAIN.

cal perfection. His work is mainly found in the Budapest museum.

MUÑOZ DEGRAIN, ANTONIO

(Valencia, 1843–Málaga, 1924)

A Spanish landscape and historical painter from the end of the nineteenth century. He began by studying architecture, which he promptly abandoned for the fine arts at the Academy of San Carlos in Valencia. However, he was basically self-taught, which was more suitable to his temperamental and independent nature, traits that would be reflected in all of his work. In 1862, he made a name for himself as a landscape artist at the National Exhibition, a competition that he participated in regularly from that time onward, receiving numerous awards for paintings such as *View of the Murta Valley* (1864) and *Landscape of El Pardo with Fog Lifting* (1867), works showing great precision and brilliant luminosity. In 1870, he was asked by his friend, Bernardo Ferrándiz, to decorate the ceiling of the Cervantes Theater in Malaga, the city that would turn his

career around. It started with an important job at the San Telmo school, as a teacher and future master of an entire generation of artists, among whom the young Pablo Ruiz Picasso would be included. This teaching job culminated with his appointment as director of the Fine Arts School of San Fernando in Madrid. He succeeded **Haes** in the professorship of landscapes there in 1898. Two of his paintings, which he entered in different exhibitions, are of great interest: *Othello and Desdemona* —the prize he won for this work allowed him to travel to Italy—and *The Lovers from Teruel*, painted in Rome, which won the first prize at the 1884 National Exhibition and which is a key work in Spanish historical painting. Over time, his initial Realism of Romantic origin lost ground in the face of his unbridled, almost visionary, imagination, with certain implications of symbolism. One of his last landscapes, *The Tagus, Rain* (1915), is conspicuous, with its short, vivid brushstrokes which are reminiscent of late Impressionism.

243

After Lunch.
EDOUARD VUILLARD.

NABIS

Convinced of the need to look for a new direction in painting, based exclusively on color, a number of young artists formed the group called the Nabis. Its aesthetic proposal was ambiguous because of its mixture of Eclectism and Synthetism, following very diverse criteria. Nevertheless, they succeeded in giving a new direction to the Symbolist art movement. The group was formed in Paris, with the participation of painters such as **Bonnard,** who painted *Twilight (The Croquet Game)*, **Vuillard,** and **Denis,** author of *After Lunch* and *The Mantel,* as well as art critics, poets and the literati. The poet Cazalis gave the name "Nabis" to the group, a term that in Hebrew means "prophet." It grew out of admiration for Symbolist artists, like **Puvis de Chavannes** and **Moreau,** as well as **Post-Impressionists** such as **Cézanne** and **Gauguin.** The latter and the Pont-Aven school had extensive contact with the Nabis group. The aesthetic ideals of the group were expressed by Denis in an article published in the magazine *Art et Critique* in 1890, whose title was "A Definition of Neo-Traditionalism." According to Denis, the artist's role is not to imitate nature, but rather to visualize his dreams, and he defined a painting as "a flat surface covered with colors arranged in a certain order." By considering color an element that comes from our emotions, the Nabis bestowed an absolute decorative value on painting, which made them, in many ways, the forerunners of Art Nouveau. The first Nabis exhibition was held in 1892, but after their show in 1899, the group gradually disbanded.

NASMYTH, ALEXANDRE

(Edinburgh, 1758–1840)

Scottish painter. He was based as a painter in Edinburgh, but his

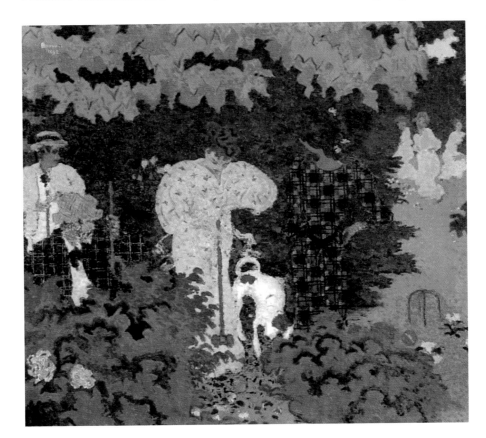

Twilight (The Croquet Game).
PIERRE BONNARD.

The Mantel.
EDOUARD VUILLARD.

teacher was Allan Ramsay in London, for whom he also worked as an assistant. In 1782, he set forth on a three-year trip to Italy, where he focused on landscapes as the main subject of his paintings. He was influenced by Italian landscape painters such as the Classicist Claude Lorrain and added features from his own naturalistic observations. He continued practicing this genre upon his return to Great Britain and gained a large number of young followers; he is considered the founder of the Scottish landscape school. He also painted portraits, such as the one of the poet, Robert Burns. In addition, he worked as a stage designer and architectural consultant.

NAVEZ, FRANÇOIS-JOSEPH

(Charleroi, 1787–Brussels, 1869)

A Belgian painter, the most prominent one representing **Neoclassicism**.

Trained in Brussels, he won a prestigious award at a very young age for a historical painting: *Virgil Reading the Aenead to Augustus*. At the age of twenty-six, he went to Paris and entered **David**'s atelier, where he studied from 1813 to 1816. He dedicated himself to portrait painting, a field in which he showed a high degree of mastery, as seen in *The de Hemptinne Family* (1816) and especially, *Portrait of David*, his teacher. Other representative paintings are *Agar in the Desert* and *The Spinners of Fundi*. He lived in Rome for several years, and upon his return to his own

Self-Portrait.
FRANÇOIS-JOSEPH NAVEZ.

245

Self-Portrait with His Brother Rudolf and the Sculptor Thorvaldsen.
WILHELM VON SCHADOW.

country, promoted Neoclassical painting and the new trends. He also became director of the Royal Academy of Fine Arts in Brussels.

NAZARENES

A German Romantic movement in painting, developed by a group of painters born around the1780s who were pupils together at the Fine Arts Academy in Vienna and who were headed by **Johann Friedrich Overbeck**. Among the other members were Ludwig Vogel, **Franz Pforr**, **Wilhelm von Schadow**, **Julius Schnorr von Carolsfeld** and Johann Konrad Hottinger. They were later joined by others in Rome, such as **Peter von Cornelius** and **Phillip Veit**. The group was formed in Vienna in 1809, with the clear intention of repudiating what was being done at the time in the German school—in other words, Winckelmann's official, academic painting. They established themselves in Rome, where between 1810 and 1815 they worked together and led an almost monastic life at the Convent of Sant'Isidoro sul Pincio, founding the Brotherhood of St. Luke. Their art was based on the first German **Romanticism**, medievally inspired and patriotic, but steeped in Christian mysticism and religion. They sought to return to the style of the painters who had worked before Raphael (Perugino, Fra Angelico, and others), aiming to revive the ingenuous idealism of the painting of the

Bianca von Quandt.
JULIUS SCHNORR VON CAROLSFELD.

Italian Trecento and Quattrocento. The influence of Baroque Classicism can also be seen in their work, making the resulting style quite eclectic. Furthermore, they give draftsmanship a dominant role as an expressive medium, as opposed to color. Their patri-

otic spirit led them to represent scenes from German history, both real and fictional, but they were also very fond of religious and allegorical themes, as well as illustrating literary subjects. The group had a special predilection for frescoes, which they often used to decorate houses, such as the Prussian consul's in Italy (1810–1816) with scenes from the *Life of Jos*eph, or the Massimi Palace (1817–1827) with themes from Dante's *Divine Comedy*, Ariosto's *Orlando Furioso*, and Tasso's *Jerusalem Delivered*. They were clearly forerunners of the Pre-Raphaelites.

NEOCLASSICISM

An art movement that appeared in Western culture beginning in 1750 and lasting until about 1800. A combination of factors, among them a new appreciation of the ancient, classical art forms, recent archaeological discoveries, and the fact that Baroque art had run its course, brought about the Neoclassical movement. There was an attempt to return to the simplicity of ancient times in the arts and to relate history to events of the present. In painting, the epicenter of the movement was in Rome, where many artists congregated around the German historian Johann Winckelmann, one of the main theorists of Neoclassicism, who defended the imitation of "the noble simplicity and the great tranquility of Greek and Roman style." Among those included in this circle were Anton Raphael Mengs, the painter and theorist; the Scotsman, Gavin Hamilton; and the American, **Benjamin West**. Simple compositions, the elimination of superfluous figures, and serene attitudes are elements that are obvious in Neoclassical painting, to which the importance of draftsmanship and line over color was added. Its starting point was established with the first works of the French painter **David**, one of the greatest exponents of this movement, whose heir was **Ingres**, an important figure who maintained the Neoclassical attitude throughout the nineteenth century. The spread of the movement affected all of Europe,

Cupid and Psyche.
JACQUES-LOUIS DAVID.

The Death of Socrates.
JACQUES-LOUIS DAVID.

and in Spain, prominent painters belonging to this movement were **José de Madrazo**, **José Aparicio** and **Carlos de Luis Ribera**.

NEO-IMPRESSIONISM

An art movement in painting, also known as "Pointillism" or "divisionism," which broke with the naturalistic aesthetics that had preceded it, and whose technique made systematic a formula that the Impressionists had applied intuitively. The starting point of this movement is found in a painting by **Georges Seurat** that was entered at the 1884 Salon of Independent Artists in Paris. The painting, entitled *Bathers at Asnières*, was Im-

pressionistic as far as its composition was concerned but revolutionary in its technique. Influenced by the optical theories of the times and by the scientific books of Michel-Eugène Chevreul (*An Education in the Spirit of*

Forms and *An Education in the Spirit of Colors*) and Charles Henry (*Treatise on Scientific Aesthetics*, 1885), Seurat ap-

Bathers at Asnières.
GEORGES SEURAT.

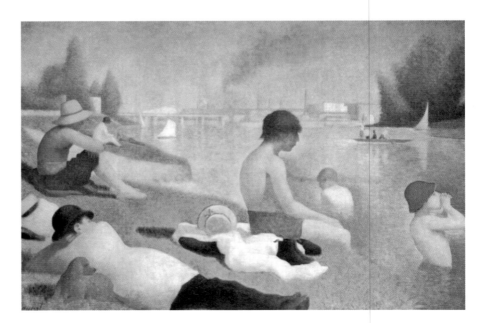

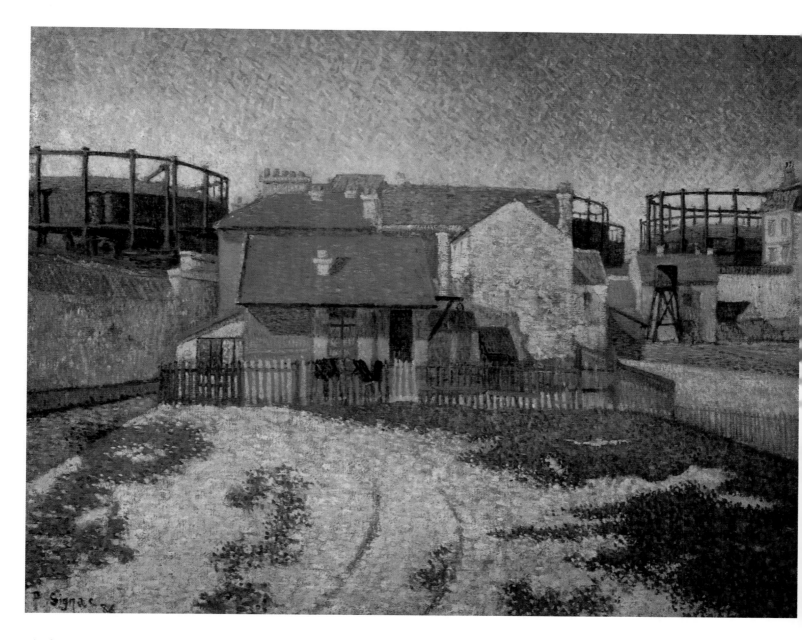

Gas Tanks at Clichy.
PAUL SIGNAC.

plied paint to the canvas using minuscule dots of unmixed pigment, in the primary and elementary colors, which formed an optical mixture when viewed at the right distance. The artistic process is laborious, slow, and systematic, because of the number of dots of color that the artist has to apply. This process results in suggestive compositions—which are cold because of their calculated precision—with well-defined outlines and highly structured, volumetric masses, giving an effect, nonetheless, of great charm and poetry. In many ways, Neo-Impressionism was a break with the previous form of painting, a way of surmounting the Impressionistic crisis. However, with regard to the subject matter, it follows the same lines as the **Impressionists**, choosing subjects that deal with the bourgeoisie, everyday life, lyrical landscapes, and interiors. Thus, it was a movement that tried to incorporate new logic and technical discipline into the painting that was in vogue at the time, **Manet**'s, **Monet**'s, and **Renoir**'s. The term "Neo-Impressionism" or "Pointillism" was coined by the art critic Félix Fénéon when he viewed Seurat's painting at the Salon of Independent Artists, where **Signac**—author of *Gas Tanks at Clichy* and *Antibes in the Afternoon*—also admired the painting and immediately joined the new esthetic phenomenon, becoming the group's theorist when his book *From Delacroix to Neo-Impressionism* was published in 1899. Other painters to join the movement were **Pissarro**, Henri Edmond Cross, Charles Angrand, and Albert Dubois Pillet, forming a group that was clearly opposed to the aesthetics of the **Nabis**,

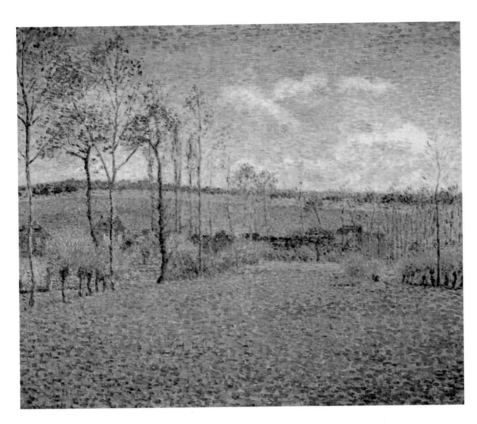

Spring at Eragny.
CAMILLE PISSARRO.

which was then coming into being. Other painters of the era tried the divisionist technique, such as Georges Lemmen, Maximien Luce, and **Van Gogh**. A group of "divisionist" painters was formed in Italy, evolving separately from the French group.

NONELL, ISIDRO

(Barcelona, 1873–1911)

A Spanish Modernist painter. Nonell formed part of the vanguard

Interior of a Restaurant.
VINCENT VAN GOGH.

Poor People Waiting for Soup.
ISIDRO NONELL.

of modern art in Spain. After receiving training at several academies, such as Luis Graner's, he became the most important painter in the group that met at Els Quatre Gats (Picasso, **Rusiñol**, and others), living, along with them, apart from the bourgeois circles in which they moved and which they criticized in their paintings. He, along with **Regoyos**, Solana, and others, became the painter who gave the most effective and conclusive treatment to what would later be called "black painting." Around 1891, he formed a small group of landscape artists and dedicated himself to this genre in small format. In 1893, he exhibited his work for the first time. In 1894, he began painting small but expressive pictures of cretins, a subject that would henceforth be a part part of his artistic output. In 1897, he went to Paris, where he shared a studio for a time with Picasso and held two exhibitions which gained a certain amount of success—although he would not achieve general recognition until 1910. He is primarily known for the people in his paintings, who come from very low social strata. He emphasized their misery and pain and represented them with dark, almost monochromatic tones and loose brushstrokes and impasto, in an attempt to jab the viewer's conscience. This resulted in very harsh images and marked the beginning of expressionistic painting in Spain. Beginning in 1907, he lightened his palette and painted female figures and sober still lifes of great artistic quality, around which he organized an exhibition in 1910. His satirical drawings are also very well known, showing Catalonia's social situation at the time in unadorned style. These were true chronicles of the era, which he contributed to satirical magazines such as *Papitu*. Many of his most important paintings are in the Museum of Modern Art in Barcelona. Some important works are *Two Gypsy Women, La Trini, Julia*, and *Woman with a Shawl.*

Italia and Germania.
JOHANN F. OVERBECK.

O

O'CONNOR, JAMES ARTHUR

(Dublin, 1793–London, 1841)

An Irish painter who specialized in landscapes; his work fits into the aesthetic parameters of the English school. He was the son of an engraver, but financial difficulties prevented him from pursuing artistic training. He lived in London from 1822 onward and in that year, exhibited at the Royal Academy. He made several trips around Europe, making sketches for his landscapes. He achieved considerable recognition, but this came only after his death.

ORPEN, WILLIAM

(Dublin, 1878–London, 1931)

An English painter who specialized in genre painting and portraits. He was initially trained in Dublin, but a large part of his artistic career took place in England, where he earned great esteem due to his ex-cellence as a portraitist, becoming one of the most highly respected painters of the early decades of the twentieth century. Noteworthy among the genre paintings he did in Ireland are *Bloombury's Family*, *Youth from Ireland*, and *Youth from the West*. Proof of his skill as a portrait painter can be found in his *Self-Portrait* and *The Archbishop of Liverpool*.

OVERBECK, JOHANN FRIEDRICH

(Lübeck, 1789–Rome, 1869)

German painter. He is a prominent figure in the history of nineteenth-century painting, one of the first

Homage to Manet.
WILLIAM ORPEN.

The Triumph of Religion in the Arts.
JOHANN F. OVERBECK.

painters representing German **Romanticism** and the founder of the Brotherhood of St. Luke, considered one of the first art associations, whose members in Rome were known as the **Nazarenes**. He belonged to an upper-middle-class family and trained at the Academy in Vienna beginning in 1806. From the outset, he was interested in the German painters of the late Middle Ages and the fifteenth-century Italians. This interest made him antagonistic to academic standards, and in 1809 together with **Pforr**, he founded an art brotherhood in honor of St. Luke, based on aesthetic approaches that combined religion with medievally inspired subjects. In that same year, the Brotherhood moved to Rome. where they occupied an abandoned monastery and prepared to live a life of seclusion in close communion with nature following a traditional lifestyle. Like many other painters in the group, Overbeck had a hand in the decorative work at the Palazzo Zuccaro and the Casino Massimo. His works were

O

clear exponents of the Brotherhood's ideology, an example being the portrait of co-founder *Franz Pforr* (1810). This was a composition with a Gothic focus and in the manner of a Gothic panel, in which he captured the Nazarene ideal of the painter-craftsman, with a complex iconographic scheme. *Joseph Being Sold by His Brothers* (1816–1817) reveals his interest in medieval religious iconography. In *Italia and Germania*, a work from 1828, he tried to reconcile the fusion of Italian and German culture, at the height of European nationalism, through the ingenuous and candid image of two young people holding hands, showing their friendship. His style adopted the linear and chromatic aspects of Italian art from the Quattrocento and from Raphael, as well as the Germanic painting on wooden panels from the late Middle Ages, including the significant influence of Dürer's work which was common to all of the members of the Brotherhood. When the Nazarene group eventually scattered, going to other cities and

The Concert.
VICENTE PALMAROLI.

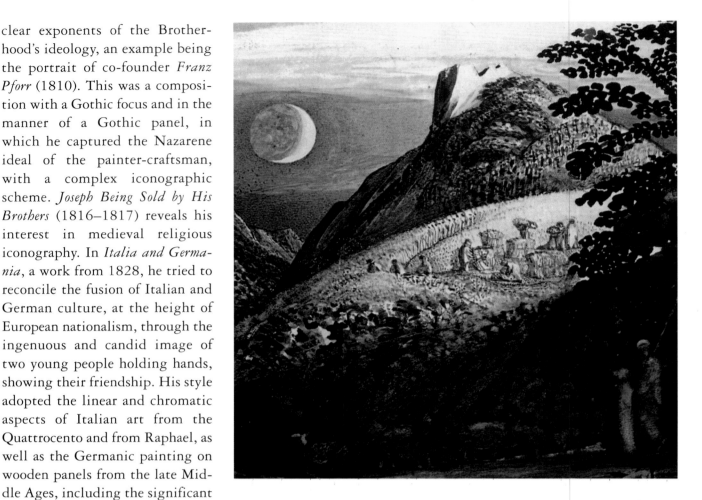

Nocturnal Landscape.
SAMUEL PALMER.

countries, Overbeck stayed in Rome, where he died.

PALIZZI, FILIPPO

(Vasto, 1818–Naples, 1899)

An Italian painter, he was one of the founders of the Neapolitan school of painting known as the Posilippo school, formed by a group of landscape and genre-scene painters who were interested in color and light. He started out with the painter Bonolis, but his friendship with **Morelli** influenced his artistic training. He specialized in realist paintings of tranquil, luminous subjects, reminiscent of the work of the Span-

ish painter **Barbizon**, showing rural scenes or animals grazing under the open sky. *Landscape after the Rain*, from 1860, is an painting that is typical of his work. Three of his brothers, Giuseppe, Nicola, and Francesco, were also painters. In 1892, he donated most of his work to the Italian government which sent it to the Museum of Modern Art in Rome.

PALMAROLI GONZÁLEZ, VICENTE

(Zarzalejo, 1834–Madrid, 1896)

Spanish painter. The son of an Italian lithographer, Gaetano Palmaroli, he was primarily a historical painter, an area of art that brought him success and awards. He began his studies at

the Fine Arts School of San Fernando and in the atelier **Federico de Madrazo**. In 1857, he went to Rome on a grant from the Academy and lived there intermittently until 1866. One year later, he made a trip to Paris as part of the Spanish delegation at the Universal Exposition. There he met **Meissonier**, who introduced him to eighteenth-century genre subjects which were so popular at that time. An important painting from his historical work is *The Third of May, 1808* (1871). In addition to pictures of this type, his paintings of women were highly praised. This subject dominated much of his early work and involved placing a female figure in such different settings as a garden, an interior, a boulevard, or a beach. He was also a portraitist in much demand among the bourgeoisie of Madrid; an example of this work is *Conchita Marimón*. Apart from being an academician of San Fernando and the director of the Spanish Academy in Rome, he also held the post of director of the Prado Museum from 1893 until his death. Other significant works of his are *In the Artist's Studio*, *Flirtation*, and *Lovesickness*.

PALMER, SAMUEL

(London, 1805–Reigate, 1881)

An English landscape painter, whose style can be described as late visionary **Romanticism**. He initially trained with his father and with a painter of landscapes in the traditional style, William Wate; however, it can be said that he was self-taught. His early work, influenced by **Turner**, was exhibited in public in 1819 at the Royal Academy. His style changed when, in 1822, he met **William Blake** at his friend John Linnell's house. Blake then became the source of inspiration for his work, which came to be based on a mystical concept of nature. Together with other artists, Edward Calvert and **George Richmond**, he formed a group that, aesthetically, was strongly influenced by Blake and proclaimed the superiority of man of ages past over modern man. His painting *Coming from Evening Church* from 1830, is representative of his interest in religious and medieval subjects, as well as being a work that harks back to a late Gothic panel. Starting in the decade of the 1830s, his style changed once again, and he began a phase, that would last until 1837, dedicated to painting watercolor landscapes that represented natural scenes with an

Coming from Evening Church.
SAMUEL PALMER.

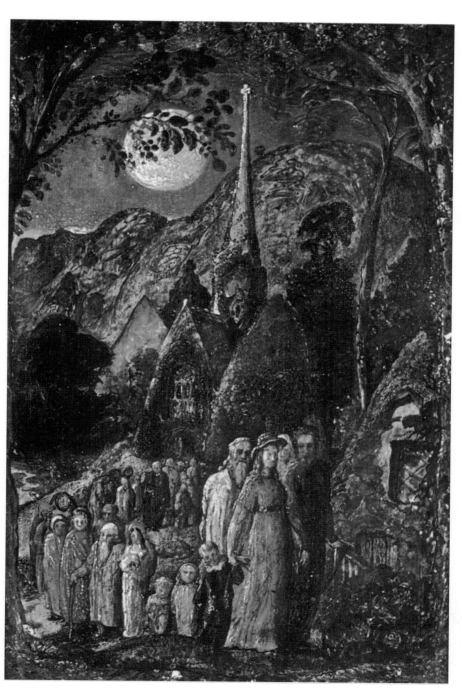

almost topographical precision. In 1837, he traveled to Italy, where he lived until 1839, specializing in bucolic landscapes. He also did pen-and-ink drawings, etchings, and some oil paintings.

PASSAVANT, JOHANN DAVID

(Frankfurt, 1787–1861)

A German painter and engraver, belonging to the Neoclassical movement. He established his residence in Paris to study painting with **David** and **Gros**. From 1817 onward, he lived in Rome and met the Nazarene painters **Overbeck, Cornelius**, and **Schnorr**. Of interest among his paintings are the portrait he did of *The Emperor Henry II*, without a doubt one of his best works, and his *Self-Portrait*.

PEALE, CHARLES WILSON

(Chesterton, Maryland, 1741–Philadelphia, 1827)

An American painter and engraver, he was a follower of John Singleton Cop-

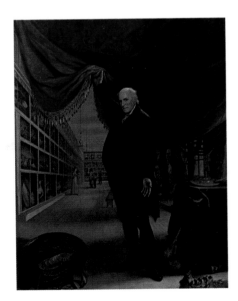

ley andwas trained by him in Boston. In 1770, he traveled to London, where he studied under the guidance of **Benjamin West**, from whom he learned painting techniques. Upon his return to Philadelphia, he founded the Peale Gallery. He was a typical figure of the American Enlightenment, for while he practiced painting, he was also interested in science, especially the natural sciences. This interest can be seen in works such as *Exhuming the Mastodon* (1806). His style, along the lines of Copley's Realism, is characterized by a great sense of detail and an understanding of the material, along with careful draftsmanship and his desire to capture the different nuances of light. He was a prominent historical painter but also a very successful portraitist, who was frequently called on to portray the leading citizens of his country, primarily those who played a significant role in the Revolutionary War, in which he himself had taken part. He painted more than one hundred portraits, many of which are now in Independence Hall in Philadelphia. Notable among his portraits are the ones he painted of George Washington (fourteen), ennobling and idealizing him, very much in the Romantic style. However, his masterpiece as a portraitist is the painting he called *The Staircase Group*, dated 1795, in which he employed genre-painting concepts along the lines of English **Romanticism**. Other portraits, of lesser importance but great quality, are the ones of Benjamin Franklin, John Hancock, Robert Morris, Alexander Hamilton, and his last work, his self-portrait at the age of eighty-three. He contributed to the creation the Pennsylvania Academy of Fine Arts and was

The Artist in His Museum.
CHARLES WILSON PEALE.

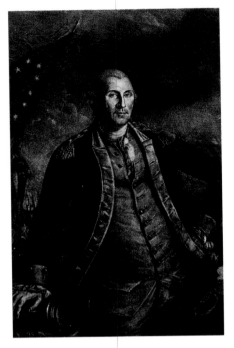

George Washington.
CHARLES WILSON PEALE.

the founder of the first natural history museum in the United States. He is considered the patriarch of the first dynasty of American painters, since he encouraged his sons and other family members to become painters.

PEALE, RAPHAELLE

(Annapolis, Maryland, 1774–Philadelphia, 1825)

An American painter, the son of **Charles Wilson Peale** and the brother of **Rembrandt Peale**. He specialized in still lifes, upon which he bestowed matchless quality and skill in representing the form and shape of objects. His *Still Life*, with its unrivalled transparency and simplicity, is proof of this fact. He was attracted by Zurbarán's painting, from which he skillfully imitated the rendering of the whiteness of fabrics. *Venus Rising from the Sea — A Deception* was an ironic criticism of the strict morality and anti-nude senti-

Venus Rising from the Sea—A Deception.
RAPHAELLE PEALE.

ments prevalent in American society. This painting best shows his fascination for imitating the white fabrics depicted by the Spanish painter.

PEALE, REMBRANDT

(Bucks County, Pennsylvania, 1778–Pennsylvania, 1860)

An American painter, the son of **Charles Wilson Peale**. In 1796, he settled in the city of Charleston, South Carolina, where he began his painting career as a portraitist, working within the style of Romantic Classicism. In 1801, he traveled to London where, for nearly four years, he expanded his technical knowledge under the guidance of **Benjamin West**. This training gave him the ability to work in Paris, where he painted many portraits of figures from Parisian high society, before returning to Philadelphia in 1809. Among his works, *The Roman Daughter* and *The Court of Death* are striking, as well as the portraits of

Rubens Peale with Geranium.
REMBRANDT PEALE.

Thomas Jefferson, General Armstrong, Commodore Bainbridge, and the sculptor Jean–AntoineHoudon.

PÉREZ VILLAAMIL, GENARO

(Ferrol, 1807–Madrid, 1854)

Spanish painter. He was the principal portrait painter working in the style of Spanish **Romanticism**. The son of a military topographer, he began his career in the army in Santiago de Compostela and went to Andalusia to participate in military campaigns. While in jail in Cadiz, he showed his

mastery of draftsmanship and began to paint. He moved to Puerto Rico with his brother, where he specialized in landscapes that showed Pre-Romantic qualities. In 1833, he returned to Spain. He met the painter **David Roberts** in Seville, who introduced him to **Turner**'s brand of English Romantic landscapes. He settled in Madrid in 1834 and in the next year, began his academic career as a landscape teacher at the Academy of San Fernando. He maintained his ties with artists and the literati, while receiving one appointment after another from official cultural circles. *Washerwomen at the Manzanares*

\mathscr{P}

𝒫

(1835) was one of the most outstanding landscapes of that era. As a result of a trip through Europe from 1840 to 1844, during which he exhibited his works in different cities in France, Holland, and Belgium, he became an international celebrity. In addition to panoramas showing ruins and oriental themes, such as *Oriental Landscape with Classical Ruins* and *Caravan in*

The Last Journey.
VASILI G. PEROV.

Sight of Tyre, he painted the mountainous views that so delighted the Romantic public, such as *Procession at Covadonga*. His contributions to one of the most important lithographic publications of the times, *España artística y monumental*, published from 1842 on, are exceptional.

PEROV, VASILI GRIEGORIEVICH

(Tobolsk, 1833–Moscow, 1882)

Russian painter who worked in the **Realist style**. Trained in Moscow,

The Drowned Woman.
VASILI G. PEROV.

under the tutelage of Mokritsky, he soon departed from conservative Academicism, preferring to do painting from life, depicting everyday scenes, especially those of his own country. He painted pictures, primarily showing customs and manners, in which his intent to criticize is evident. In some of these, his work was quite mediocre, because his style was somewhat affected and outdated. He was not very particular about his style, however, because he was more interested in the moral purpose of his paintings, which to his mind eclipsed form. Precisely because of this desire to moralize and to reform his country's customs, some of his paintings were banned because of their anti-clerical and social content, such as *Sermon in the Village* (1861) amd *Easter Procession* (1862), which nevertheless were very

well received by critics. Other works are *The Arrival of the District Commissioner to Hear a Case (1857), Guard Watching the Corpse of a Drowned Woman, Feast at the Convent, Portrait of F. M. Dostoyevski, Village Burial,* and *Troika.*

PFORR, FRANZ

(Frankfurt, 1788–Albano Laziale, Italy, 1812)

A German painter and draftsman, whose life was short, and who was one of the most prominent representatives of Nazarene art. His first teacher was his father, a painter of animals. In 1805, he continued his studies in Vienna, where he met **Overbeck** and with whom he founded the Brotherhood of St.

Luke, a group of artists determined to revive German art under strict religious principles. The Brotherhood moved to Rome in 1810, where it was joined by other artists and where it reached its height and became known as the **Nazarenes**. Pforr was especially interested in medieval historical subjects, steeped in patriotic connotations, such as the paintings he dedicated to Rudolf of Habsburg: *Rudolf of Habsburg and the Priest* (circa 1809) and *Entry of Emperor Rudolf of Habsburg into Basel, 1273* (1808–1810). Both works are representative of his somewhat artificial style, based on flat colors and tremendously pompous figures. Later, he traveled to Naples and to the

Entry of Emperor Rudolf of Habsburg into Basel.
FRANZ PFORR.

The Picador.
JOHN F. PHILLIP.

town of Albano, where tuberculosis ended his life at the age of twenty-four.

PHILLIP, JOHN

(Aberdeen, 1817–London, 1867)

Scottish painter. He studied at the Royal Academy in London and was a pupil of **David Roberts**. At first, he specialized in paintings of genre scenes and people from Scotland, in the manner of **David Wilkie**, as seen in *Baptism in Scotland*. Beginning in 1851, he made several trips to Spain, a country for which he felt a tremendous attraction and which inspired him to paint many representations of picturesque scenes, in a colorististic and fluid style. These gained him fame and caused him to be known as "Spanish" Phillip. Outstanding among these paintings are *Public Scribe in Seville* (1854), *Dolores* (1862), *Dying Smuggler* (1856), *La Gloria* (1864), *Social Gathering around the Brazier* (1866), and *Antonio* (1867). He also painted portraits.

PILOTY, KARL THEODOR VON

(Munich, 1826–Ambach, 1886)

German painter. After beginning his studies in Antwerp and Paris, he established his residence in Munich and was a student of **Schnorr von Carolsfeld** at the Fine Arts School there, where later he became a teacher and then director. He achieved fame with enormous, magnificent historical paintings, in which he depicted fabrics, furnishings, and other objects with an almost naturalistic precision. From the year 1842 onward, when he attended an exhibition of Belgian historical painters, his style began to depart from the strict, Academicist style of the **Nazarenes**, as is evident in *Seni before Wallenstein's Corpse* (1855). The

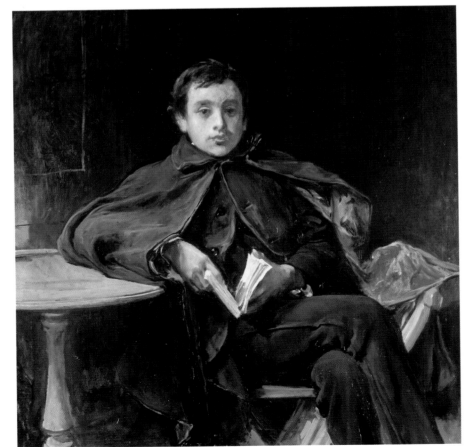

Lesson by Heart.
IGNACIO PINAZO CAMARLENCH.

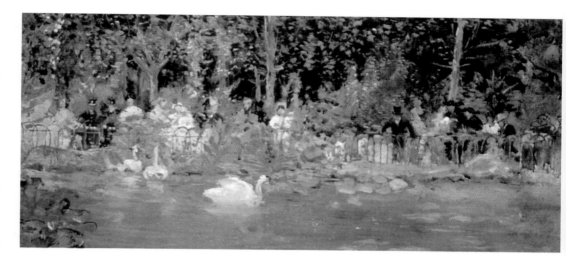

At the Edge of the Pond.
IGNACIO PINAZO CAMARLENCH.

chromatic influence of Rubens and Veronese can be seen in his paintings. He also painted genre pictures, such as *The Nurse*. He was appointed painting teacher at the Art Academy in Munich in 1858. Many pupils were trained under his tutelage, and his imposing manner of depicting history left its imprint on many of them. Some of his most interesting works are *Columbus* (1866), *The Death of Caesar* (1874), *Parable of the Wise and Foolish Virgins* (1881), and *The Death of Alexander the Great*.

PINAZO CAMARLENCH, Ignacio

(Valencia, 1849–Godella, 1916)

Spanish painter. He was one of the most prominent Valencian artists at the end of the century, and his work, on historical subjects, departed from the conventions of this form. Coming from a modest family, he had to work at different trades while he attended night classes at the Fine Arts Academy of San Carlos in Valencia. In 1873, the sale of a painting allowed him to make his first trip to Rome, a journey he repeated in 1876 on a scholarship from the Academy. There he began his great historical works, such as *The Daughters of El Cid*, a painting displaying great realism and freedom of composition, which he finished in 1879. In Rome, he also began the painting that won the second-prize medal at the National Exhibition in 1881: *The Last Moments of King Jaime (I) the Conqueror, Handing*

over *His Sword to His Son, Don Pedro*, considered an innovative work because of its loose technique and using color based on large patches. Pinazo worked along two very different pic-

torial and creative lines, which he was able to make compatible with each other: the first, for commissions and official exhibitions, was academicist in nature; and the second, after 1874,

The Daughters of El Cid.
IGNACIO PINAZO CAMARLENCH.

Kitchen Garden with Trees in Flower, Pontoise.
CAMILLE PISSARRO.

was more intimate, Impressionistic, and spontaneous, showing the influences of **Fortuny** and **Sorolla** and making him one of the forerunners of luminous Valencian painting. Examples of this are *The Linesman* (1877) and *Boat on the Beach* (1890). In 1903, he was elected an academician of San Fernando.

Morning Sunlight on the Snow, Eragny.
CAMILLE PISSARRO.

PISSARRO, CAMILLE

(St. Thomas, 1830–Paris, 1903)

French painter. Pissarro is one of the most prominent representatives of **Impressionism**. His work followed a line of development that sprang from a mature Realism, derived from the **Barbizon School**, leading him to become one of the pioneers of the Impressionist movement. Then for a time, he adopted the Pointillist technique of **Seurat** and **Signac**. The son of a merchant in the Danish West Indies, he went to

Paris in 1855 to study painting. When the Franco-Prussian War broke out, he took refuge in London in 1870, while the German troops demolished his studio and destroyed all of his work, which had been created under the influence of the Barbizon School. In the British capital, he discovered the work of **Constable** and **Turner**, met **Monet**, and received the full impact of Impressionism, joining the movement upon his return to France. His favorite area of painting was landscapes, and his interest in this field involved problems relating to the effects of light. Above

263

Boulevard Montmartre: Afternoon, Sunshine.
CAMILLE PISSARRO.

all, he painted rural scenes, rivers, and some urban views. *The Red Roofs* from 1877 and *The Wheelbarrow* from 1879 are paintings typical of the seventies, when he settled in the town of Pontoise. Always restless and anxious for change, he followed **Degas**' advice, who counseled him to dare to paint people. Thus, in 1881, he composed *The Shepherdess (Young Peasant Girl with a Stick)*, a portrait with divided brushstrokes, a clear foreshadowing of **Neo-Impressionism**. Beginning in the 1880s, he became a divisionist when he adopted Seurat's and Signac's Pointillist technique. However, he was not successful with this experience and returned to his freer Impressionistic style, to study the effects of light in a series of views that he painted of Paris in the 1890s, such as *Boulevard Montmartre: Afternoon, Sunshine* (1897). His educational work, as **Gauguin**'s and **Cézanne**'s teacher, is of interest to those who follow the transmission of technique and the evolution of style from one generation to another. Cézanne spoke of him with affection and respect, saying that "we have all come out of Pissarro."

The Pork Butcher.
CAMILLE PISSARRO.

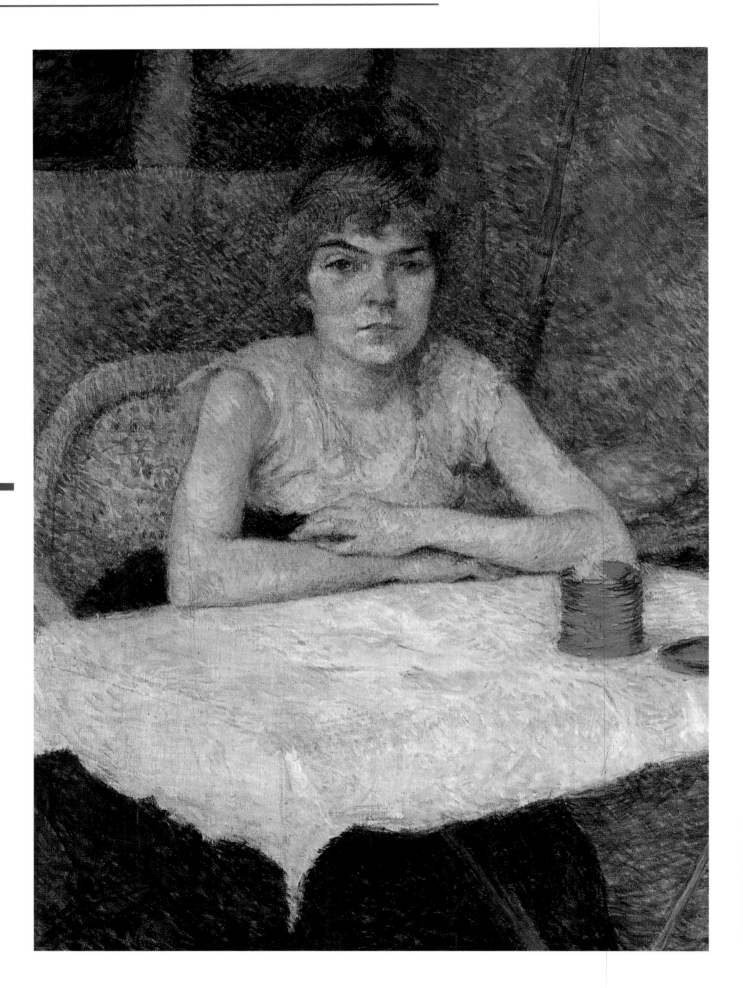

Sunset.
GEORGES SEURAT.

POST-IMPRESSIONISM

A term that encompasses the different artistic styles that succeeded **Impressionism**, a movement that was in crisis during the 1880s because of its dependence on nature and the objective portrayal of visual appearances. With regard to this naturalism, Post-Impressionist artists used a series of different alternatives, basing their work on new experiments with color and a subjective vision of reality. In this sense, divisionist or Pointillist painters like **Seurat** and **Signac** should be included among Neo-Impressionist painters, as should painters like **Toulouse-Lautrec** and

Rice Powder.
HENRI DE TOULOUSE-LAUTREC.

Gauguin, the Symbolists from the final period, and the **Nabis**, as well as **Cézanne, Van Gogh** and **Munch**. The work of these artists was fundamental to the avant-garde movements of the first few decades of the twentieth century.

POYNTER, SIR EDWARD

(Paris, 1836–London, 1919)

English painter. In 1853, he traveled to Italy, where he met Frederic Leighton and was able to admire the work of the great masters; he felt a special attraction for Michelangelo. Later in Paris, he studied with **Gleyre** (1856–1859). Back in London, his popularity began with an enormous painting based on ancient history, *Israel in Egypt* (1867), and would continue with many similar pictures of

the same genre, as well as other types, such as mythological works, painted in a realist style with a great mastery of draftsmanship. He also created watercolor landscapes and figures, as well

Cressida.
EDWARD POYNTER.

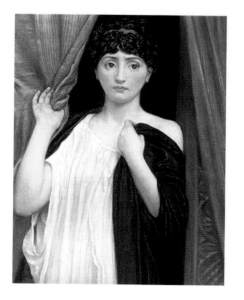

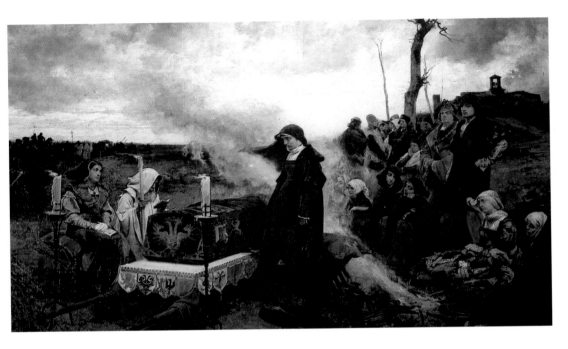

Doña Juana, "La Loca".
FRANCISCO PRADILLA ORTIZ.

as two series of magnificent drawings. In the last stage of his work, he tended towards small-format paintings, depicting genre scenes reminiscent of the classical works of **Alma-Tadema**. Due to his renown, he was elected to the Royal Academy and later, in 1896, appointed its president. Among his works, his *Self-Portrait* must be mentioned, as well as *Atalanta's Race* (1876), *A Visit to Aesculapius* (1880), *The Fortune Teller, The Visit of the Queen of Sheba to King Solomon* (1891), and *The Ionian Dance* (1899).

PRADILLA ORTIZ, FRANCISCO

(Villanueva de Gállego, 1848–Madrid, 1921)

A Spanish painter, one of the most influential in the historical genre. His artistic training began with the painter and set designer Mariano

Pescador and with studies at the Fine Arts School in Saragossa. From 1866 onward, he continued at Madrid's School of Painting, Sculpture, and Engraving, in **Federico de Madrazo**'s atelier, and at the Prado Museum, where he copied works of the great masters. In 1874, he traveled to the Spanish Academy in Rome on scholarship. There he painted his master-

piece, *Doña Juana, "La Loca,"* a painting that brought him immediate international prestige and the medal of honor at the National Exhibition in 1878. This composition is captivating because of its historical and literary value as well as its realist technique. The success of this work was so great that the Senate gave him a commission for another historical painting, *The Surrender of Granada*, a work clearly striving for effect, which he did in 1882. Ten years later, he repeated the theme of the war for Granada with the painting known as *El Suspiro del Moro* (The Moor's Sigh), in which the figure of the defeated leader was the focal point. He was appointed director of the Prado Museum in 1897 and continued to paint, focusing on genre scenes, such as *Grape Harvest in the Pontine Marshes* (1905), and *The Rastro Flea Market in Madrid*, as well as an extensive variety of other work, including portraits, landscapes, and seascapes. He made significant contributions as a draftsman to the magazine *La Ilustración Española y Americana*.

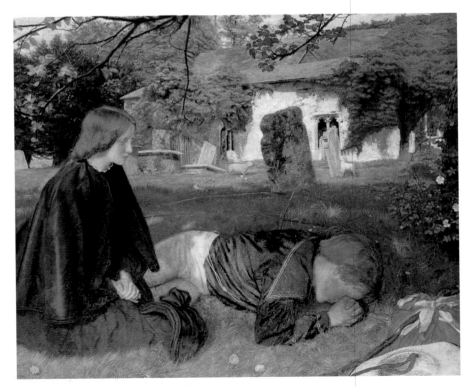

Home from the Sea.
ARTHUR HUGHES.

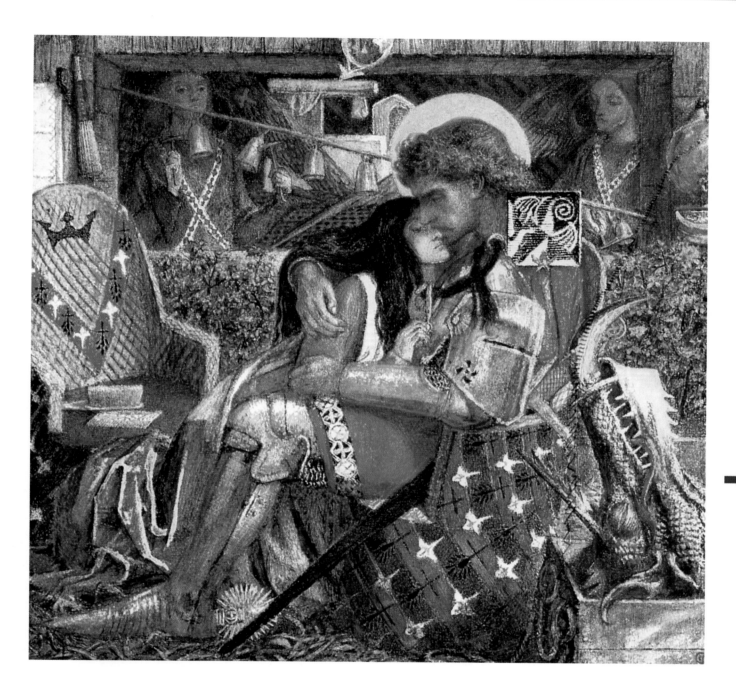

PRE-RAPHAELITES, The

An art movement that arose in England in the middle of the nineteenth century as a reaction to the Post-Romantic art of the era. It started with the association of a group of young artists—known as the Pre-Raphaelite Brotherhood—who tried to distance themselves from the frivolous subject matter of official painting and seek "truth in nature." To do this, they returned to simplicity in artistic procedures, giving new importance to the craftsmanship of the past, even to the medieval customs of anonymity, as many signed their works with only the initials P.R.B. (Pre-Raphaelite Brotherhood) instead of their names. They modeled their work after the primitive Italians, the artists of the *Quattrocento* and painters who worked before Raphael, who was venerated by art historians and contemporary critics, but whom they considered affected and theatrical. The Pre-Raphaelites criticized the Victorian hypocrisy in official art. However, they adopted an exces-

The Wedding of St. George and the Princess Sabra.
DANTE G. ROSSETTI.

sively moralistic attitude, and their work varied between Symbolism and a peculiar, unwieldy **Realism**. Despite their lack of popularity, they managed to exhibit at the Royal Academy, and in 1853, their style became dominant with the exhibition of **Millais'** paintings. In addition to this painter, **Hunt, Rossetti, Hughes,** and **Burne-Jones** were members of the group.

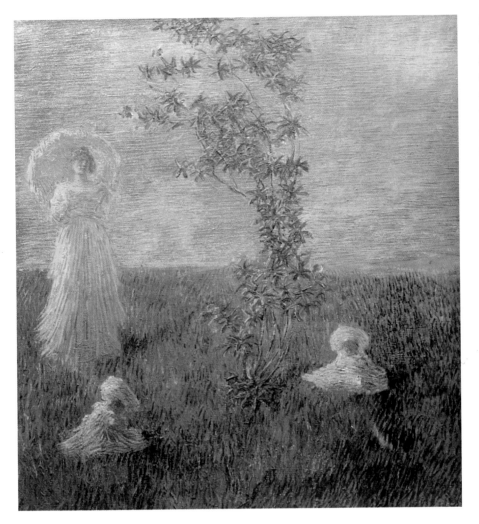

In the Meadow.
GAETANO PREVIATI.

PREVIATI, GAETANO

(Ferrara, 1852–Lavagna, 1920)

Italian painter. Previati specialized in historical painting, whose style gradually evolved toward that of the Symbolists. He began his artistic studies in his native city with the painters Domenichi and Pagliarini and continued them in Florence in the studio of Amos Cassioli and later, at the Academy in Milan under Bertini's guidance. He achieved his

first triumph in 1880, at the Turin exhibition, with his work *Cesar Borgia in Capua*. Other historically inspired compositions are *Cleopatra* and *Tasso, Dying*. From 1891 onward, his style became more artificial, and his religious paintings, such as *Madonna of the Lily*, *The Three Marys*, *First Communion* and *Angels*, have a mystical and visionary aura, tending toward clear Symbolist characteristics. He was also a painter of floral subjects.

PROUT, SAMUEL

(Plymouth, 1784–Camberwell, 1852)

English painter and art theorist. He traveled around Cornwall and did numerous sketches from life, many of which were used to decorate the work of the researcher Britton. He made extensive use of watercolor to depict, poetically and delicately, the ruins of monasteries, castles, and

Justice and Divine Vengeance Pursuing Crime.
PIERRE-PAUL PRUD'HON.

other buildings he visited while touring Cornwall. Added to these images were studies he made of picturesque buildings and streets in Normandy. These two series combined made him very popular. He published several series of his works, such as *Views of England* and *Sketches Made in Flanders and Germany*.

PRUD'HON, PIERRE-PAUL

(Cluny, 1758–Paris, 1823)

A French painter working in the Neoclassical style with expressive, sentimental, and dramatic overtones that foreshadow **Romanticism**. After his initial studies at the Academy in Dijon, he continued at the Paris Academy and in 1784, received a scholarship to complete his training at the Academy in Rome. He stayed in Italy from 1785 to 1788, a stay that was decisive in creating a compositional style that he developed after studying the great masters of the Renaissance, especially Leonardo, Raphael, and Correggio. In Rome, he met one of the painters who would become most famous in revolutionary France, **Jacques-Louis David**, a countryman, ten years his senior. However, it was not David who influenced his artistic development, but rather the Neoclassical sculptor Antonio Canova, who encouraged him to study the art of ancient Greece and Rome. He also had friends in the intellectual, scholarly, and archaeological circles of the time, such as the theorist Mengs and the painter **Angelica Kauffman**. When he returned to France, with the Revolution in full swing, it was very difficult for him to keep up with painting. However, years later in 1798, he received a

Psyche Carried off by the Zephyrs.
PIERRE-PAUL PRUD'HON.

commission for the fresco decoration of the ceilings of the palace at Saint-Cloud, work that brought him into court circles. He became the official portraitist of Napoleon's wives, first of the Empress Josephine, whom he painted in 1805 (*The Empress Josephine*) in the Malmaison forest, and later of the Empress Maria Louisa. Historical and mythological subjects are prominent among his works, such as *Andromache and Astyanax*, *Venus and Adonis*, *Psyche Carried off by the Zephyrs*, and *Cupid Punished*, but the painting that brought him true fame was *Justice and Divine Vengeance Pursuing Crime*, commissioned in 1804 for the Palais de Justice, and which he exhibited

at the 1808 Salon. At that early date, his Neoclassical style was evident because of the strength he gave to line. However, the magic and the artistic and dramatic mystery of this composition made it a forerunner of Romanticism.

PUEYRREDON, PRIDILIANO

(Buenos Aires, 1823–Barracas, 1871)

Argentine painter and engineer, he was the most representative nineteenth-century artist in his country.

Antibes in the Afternoon.
PAUL SIGNAC.

At a very early age, he went to France to study painting, before moving on for more study in Spain (1845–1847), specializing in portraits, a discipline in which he would excel. He also painted scenes of customs and manners in which he reflected Argentinian society of the era (*Elvira Lavalleja de Calzadilla*), as well as landscapes (*Rodeo*, 1861 and *A Stop in the Country*, 1861), and historical paintings. His style was quite academic, coloristic with Romantic tints. However, the influence of the French and Italian painters is barely noticeable, while that of the Spaniards, **Vicente López** and **José de Madrazo**, can be seen. Of his abundant portrait work, quite academic in style, related to the **Neoclassicism** of Mengs, the following are of interest: *Portrait of His Father* (1848), *Portrait of Manuelita Rosas*

(1851), *General Belgrado*, and *Self-Portrait with Palette in Hand, in Front of the Easel* (1859). He also painted two nudes in 1860, which caused an uproar at the time, *La Siesta* and *The Lady Bathing, Cecilia Robles de Peralta and Her Son* (1861). The painting entitled *A Popular Blind Man* was from his early work and was painted in Spain.

POINTILLISM

A painting technique that consists of distributing small touches of pure color, in the form of tiny, spherical dots, all the same size, evenly over the surface of a painting, so that, by applying the theory of complementary colors, they act on the retina, blending together when the painting is viewed from the right distance, creating more brilliant chromatic effects than if the colors had been physically

mixed on the palette. This technique appeared around 1883 and was begun by **Seurat**, who tried to give a strictly scientific basis to the style **Renoir** and **Manet** had intuitively found, by juxtaposing brushstrokes of pure colors. The French critic Félix Fénéon was the one who named this way of painting "Pointillism" ("peinture au point") in 1886, when he saw Seurat's painting *Sunday Afternoon on the Island of La Grande Jatte* , although Seurat and **Signac**, the two chief representatives of this style and the only ones to systematically use it, preferred the name "divisionism."

PUVIS DE CHAVANNES, PIERRE

(Lyon, 1824–Paris, 1898)

A French artist with Neoclassical training, his painting developed a personal style within the intellectual and Symbolist movement of the last third of the nineteenth century. He so admired the Neoclassicists that he began his artistic career vividly influenced by painters such as **David, Ingres**, and **Chassériau**; in fact, his work is largely a sequel to the murals painted by the latter. Equally distant from the official schools and from the small groups on the fringes, his primary contribution was to adapt his new ideas to traditional ones, a synthesis he achieved in the paintings he exhibited at the Paris Salons: *War* and *Peace* at the 1861 Salon and *Work* and *Rest* in 1863; works that immediately interested the critics. The latter two were acquired by the Museum in Amiens which commissioned him to do a series of murals (*Work* and *Repose, Ave Picardia Nutrix*, and *Ludus Pro Patria*, completed around 1881), a technique in which he specialized and

2

had made a name for himself. A true innovator in this area, he achieved fame and official commissions for the decorative murals in the Pantheon, showing scenes of St. Genevieve's childhood (1876–1878) and for murals in the Saint-Pierre Palace (today

The Return of Rip van Winkle.
JOHN QUIDOR.

the Fine Arts Museum) between 1883–1884). In addition, he created a series of allegories of *Arts and Sciences* for the amphitheatre of the Sorbonne in Paris (1887). Apart from these compositions, his paintings of religious, mythological, and allegorical subjects are of interest. These are pictures that are almost always set in a mysterious landscape, with brilliant

colors and a composition that is somewhat academic and cold, but free and calm in the development of the subject matter. An example is the enigmatic and startling painting *The Poor Fisherman* (1881).

QUIDOR, JOHN

(Tappan, New York, 1801–New Jersey, 1881)

An American painter who composed genre scenes with a realist style, inspired by the Romantic literature of the era. He was a student of Jarvis and of Inman. Much of his subject matter was provided by novels about the native tribes of the American wilderness—primarily those written by James Fenimore Cooper—although he also depicted ordinary lifestyles and the customs of other parts of the country.

R

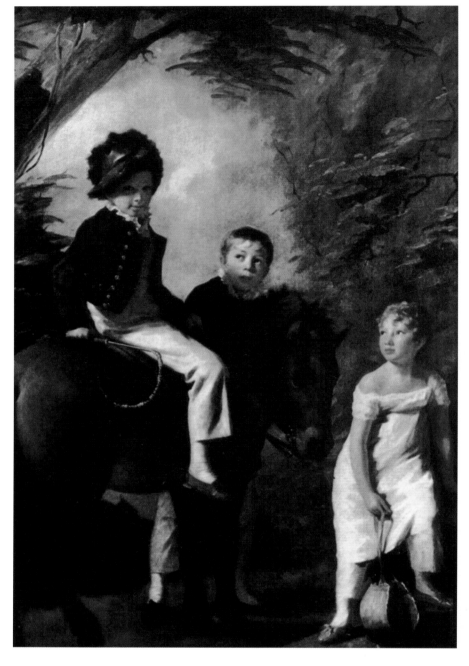

The Drummond Children.
HENRY RAEBURN.

RAEBURN, HENRY

(Stockbridge, 1756–Edinburgh, 1823)

A British painter, one of the best from Scotland, primarily a portraitist. He was self-taught, but Romney and the portraitist Joshua Reynolds, with whom he worked in London, influenced his style, as did a two-year trip through Italy. Upon returning to his own country, he settled in Edinburgh in 1787 and was appointed miniaturist to the Queen in Scotland, a post in which his prior apprenticeship to a goldsmith was a great help. He also painted the elite of Scottish society, and his portraits, numbering more than a thousand, became the most highly valued ones in Scotland at the time. This was due to their vitality, and the fact that he captured the sitters' psychological traits very well, using a style characterized by quick brushstrokes, applied directly to the canvas with a very confident technique and without preliminary drawings. He made the figures of his subjects stand out from a dark background, quite often a landscape. Some of his best portraits are *Sir John Sinclair, The Reverend Robert Walker Skating* (1784), *Sir John and Lady Clerk of Penicuik* (1790), *Miss Eleanor Urquhart Raeburn* (c. 1795), *Alexander Dyce, The McNab* (1803–1813), *Mr. Maclean of Kinlochaline, Colonel Alasdair Macdonell of Glengarry*, and *Walter Scott*. In recognition of his artistic achieve-

Portrait of Colonel Alasdair Macdonell of Glengarry.
HENRY RAEBURN.

ments, he was elected to the Royal Academy in 1815 and made the King's Limner for Scotland by King George IV in 1822.

RAFFAELLI, JEAN-FRANÇOIS

(Paris, 1850–1924)

A French painter, engraver, and sculptor, his painting varied between **Impressionism** and **Real**ism. He was of Italian origin and studied in **Gérôme**'s atelier. He exhibited his paintings beginning in 1870, but it was not until 1884 that his worth was truly acknowledged. His portraits are outstanding, such as the one of *Edmund de Goncourt*, but his genre scenes are more important: examples such as *The Beggar* and *Family of Farm Laborers* illustrate his interest in committed, social realism. Nevertheless, he also painted scenes of bourgeois life, urban landscapes of Paris, and some typical and picturesque scenes.

RANZONI, DANIELE

(Intra, 1849–1889)

An Italian painter, his work is part of Milanese **Romanticism**. He spearheaded the *scapigliati* ("disheveled") painters gathered together around the city of Cremona. He started out with a local painter in his native city and was trained at the Brera Academy in Milan and the Albertine Academy in Turin. He did his most interesting work between 1870 and 1880—ten years of intensive work, during which he lived in England for a while. He dedicated himself to genre painting and especially to portraits of the upper class, among which those of *The Princess of Saint-Léger, Princess Trubetzkoy,* and *Madame Luvoni* are are of interest. His style is delicate, with compositions in half-light. Some of his paintings are novelistic, such as *Sick Young Lady.* He had suffered from illness since his childhood and in 1887, was committed to an insane asylum. One year before his

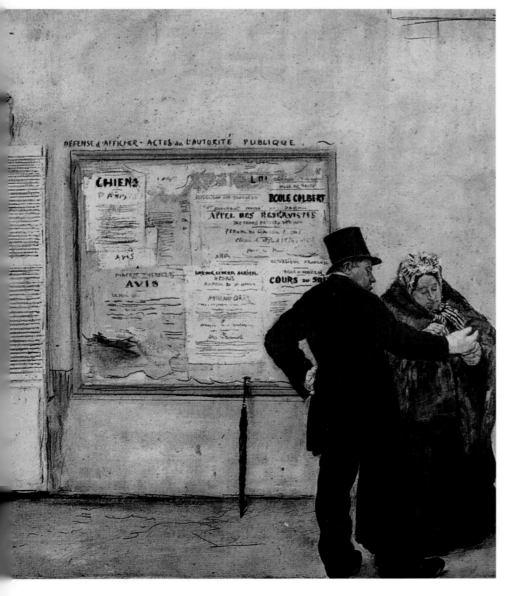

Wedding Guests.
JEAN-FRANÇOIS RAFFAELLI.

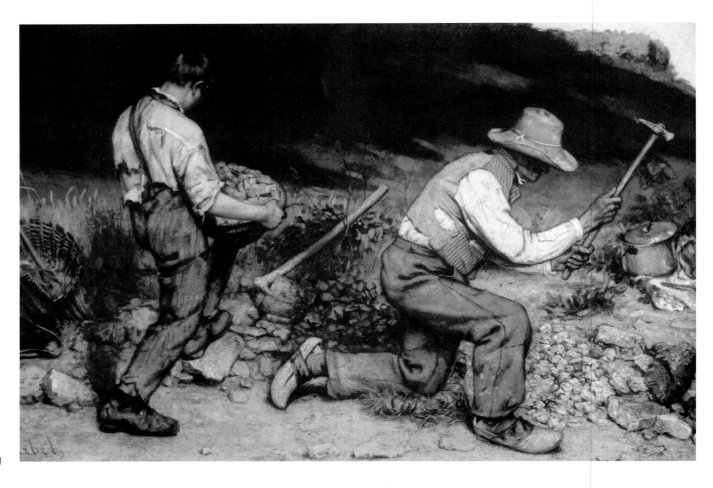

The Stone Breakers.
GUSTAVE COURBET.

death, he moved back to the town of his birth.

REALISM

This cannot be said to be a movement or school of art as such. The term "Realism" is usually used to define art and literary works that describe reality exactly as it is, in clear opposition to the fictional, idealized, or embellished molds of the "official culture" of earlier eras. The painters whose work fits into this so-called realism offer a vision that they perceive to be "realistic", inasmuch as it accurately and objectively reflects human behavior and the true environment. In this sense, the term also offers the idea of obvious criticism of human and social conditions. In nineteenth-century painting, some important artists who expressed themselves through different modes of Realism were: in France, **Courbet, Daumier**, and **Millet**; in the United States, **Mount** and **Eakins**; in Italy, **Lega**; and in Spain, **Rosales** and **Martí Alsina**, among others.

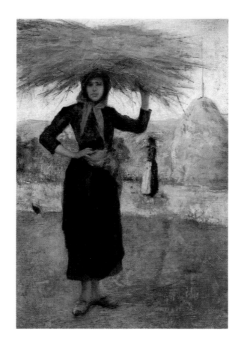

The Hay Seller.
SILVESTRO LEGA.

REDON, ODILON

(Bordeaux, 1840–Paris, 1916)

A French painter and writer, his work can be classified as Symbolist painting based on fantastic and visionary images. A trip to Paris and a visit to the Louvre had an impact on him at an early age and motivated him in his artistic training. He began in Bordeaux, studying watercolor and became interested in botany and the elements of nature, an interest that would be reflected in his work. He continued by studying architecture and sculpture in 1857 and in 1870, he went to Paris, where he

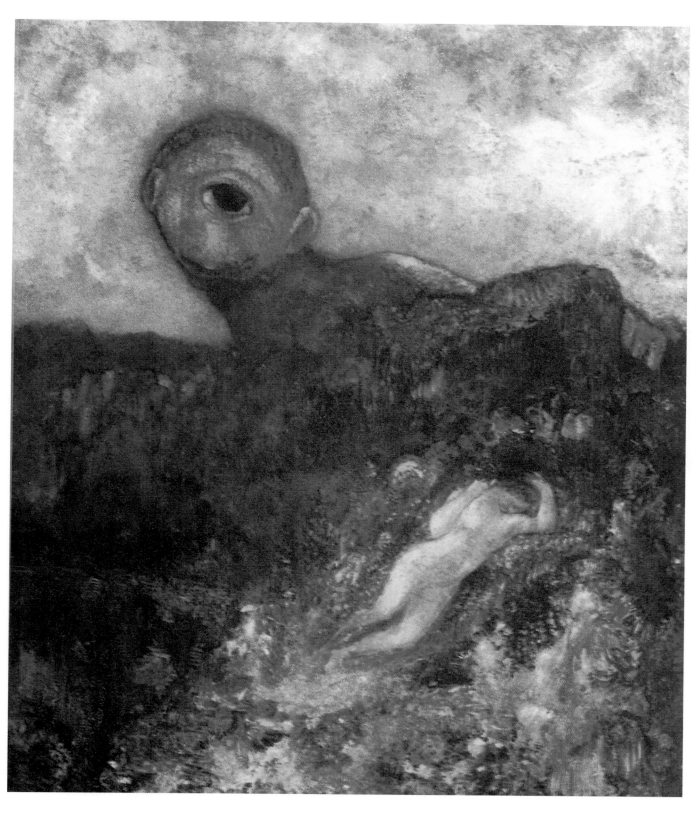

The Cyclops.
ODILON REDON.

lived the rest of his life. He settled in the Montparnasse district and was friendly with the great painters of those years: **Corot, Courbet,** and above all, **Fantin-Latour,** who taught him lithographic techniques. The series of lithographs he did between 1879 and 1889 are outstanding because of their literary vision and their incredible imagination, largely reflecting the works of tormented writers, such as the American, Edgar Allan Poe, and the Frenchman, Charles Baudelaire, as well as the serene philosophical spir-

R

R

The Birth of Venus.
ODILON REDON.

it of the Hindu poets. Some of his best-known prints are *The Smiling Spider* and *The Dream is Consummated in Death*. Using black or very dark tones, the lithographs show monstrous, improbable beings, such as plants with human heads or Cyclops: nightmare images that he also captured on canvas. Redon may have had the works of Bosch or **Goya** in mind when he created this series, and his work is also related to the visionary and dreamlike style of **Füssli** and **Blake**. He created work that was more lyrical, although still not devoid of mysticism, in his series of flower and landscape paintings. His work was not well known until, in 1899, his friends held an exhibition in his honor that confirmed him as an artist and brought him lasting fame. His vigorous style and his peculiar subject matter made Odilon Redon an important forerunner of some of the historic avant-garde movements of the future, such as **Expressionism** and Surrealism.

REGNAULT, HENRI ALEXANDRE GEORGES

(Paris, 1843–Buzenval, 1871)

French painter. His work was influenced by his teacher **David** and is very representative of official French art during the second half of the century. He studied at the Fine Arts School in Paris in 1860 and six years later, won the Prix de Rome for his work, *Thetis Offering Achilles the Ar-*

Vase of Flowers.
ODILON REDON.

mor Forged by Vulcan. He lived in Italy until 1868, during which time he did a series of portraits, such as the one of *Madame Duparc*, and pursued his interest in mythological compositions in the Neoclassical style. The following year, he traveled to Morocco, passing through Spain, where he painted an equestrian portrait of *General Prim*, for which he was awarded a medal at the 1869 Salon. The work he did in Morocco reveals a sense of color that was new to his style. Works such as *Salomé* and *Judith* are famous, as are the scenes in which he recreates exotic settings and images of the Alhambra in Granada, such as *Execution under the Moorish Kings of Granada*. He died in the Franco-Prussian War.

REGOYOS VALDÉS, DARÍO DE

(Ribadesella, 1857–Barcelona, 1913)

A Spanish painter, and a key figure in the artistic innovations of the nineteenth-century, especially in the area of landscape painting, where he developed a synthesis of the most avant-garde values produced in Europe during that time: **Impressionism**, **Pointillism**, and **Expressionism**. An Asturian by birth, he spent his childhood and adolescence in Madrid,

Dolores Otaño.
DARÍO DE REGOYOS VALDÉS.

ship in this group he met the most restless and avant-garde painters of the time, such as **Meunier, Ensor,** Auguste Rodin, **Signac,** and **Pissarro.** In 1882, he returned to Spain with Meunier, Rysselberghe, and Charlet, to make a tour of Andalusia and Morocco, composing a series of works that was exhibited in Brussels in 1883. He took part in the exhibits of the Salon of The Twenty and the Salon of Independent Artists in Paris and demonstrated that he was familiar with the two reigning European artistic trends, as evidenced by the *Portrait of Emma Bogaerts*, a psychological study that is obviously expressionistic. From 1890 to 1911, he lived in San Sebastián. At that time, his painting was related to northern landscapes and to rural and sea themes, in which he continued to show his interest in pointillism and the fragmentation of color. *San Sebastián Beach* (1893) and *Bulls in Pasajes* (1900) are characteristic of this period. Two years before his death, he stayed for a time in Granada, before moving on to Barcelona, where he spent his last days.

REIS, CARLOS

(Lisbon, 1863–1940)

Portuguese painter noted for his genre painting. He was trained in his native city and later in Paris, between 1889 and 1895. His works depict highly varied popular subjects, as well as portraits and landscapes. In Lisbon, he taught at the Fine Arts School and beginning in 1911, he assumed the position of director of the Modern Museum. His most important works are *The Bagpipers, The Fair, Woman Ironing, En Famille,* and the portrait of *Adelaida Lima Cruz.*

where he began his art studies at the Academy of San Fernando and was encouraged by his teacher, **Haes,** to pursue his interest in landscapes. In 1879, he went to Belgium to take up residence in Brussels for several years, along with his friend, the violinist Enrique Fernández Rabos, who brought him into the group of artists known as *Les Vingt* ("The Twenty"), formed in 1883. Through member-

On the Trail.
FREDERIC REMINGTON.

REMINGTON, FREDERIC

(Canton, New York 1861–New York City, 1909)

An American painter, engraver, sculptor, and writer, his work is known for its treatment of typical subjects from the American West, such as horses, Indians, cowboys, and landscapes, all done with a high degree of verism. He studied art in New York, but soon abandoned all academic training to learn on his own, especially when he traveled to the western states and discovered the sights and people of the Golden West, which were beginning to disappear even as he tried to capture them on canvas. In his own country, he is one of the most beloved American artists.

RENOIR, PIERRE-AUGUSTE

(Limoges, 1841–Cagnes-sur-Mer, 1919)

French painter. Renoir was one of the great masters of **Impressionism**, to

Dance at Bougival.
PIERRE-AUGUSTE RENOIR.

which he a dazzling array of paintings brimming with sensuality and the joy of living. From a family of very humble craftsmen, he began to work at the age of fourteen as a decorator in a ceramic factory in Paris, where he painted flowers on dishes and re-

281

Les Grands Boulevards.
PIERRE-AUGUSTE RENOIR.

vealed his artistic talent. When the factory went bankrupt, he went on to decorate fans and parasols, a specialty that required him to copy eighteenth-century French paintings, especially scenes of gallantry by Watteau, Boucher, and Fragonard, artists from whom he developed a taste for light tones and pleasant subject matter. In 1862, he entered the Fine Arts School and attended **Gleyre**'s atelier, where he met **Monet, Sisley,** and **Bazille,** as well as **Cézanne** and **Pissarro** at a later date. He began to paint landscapes in the open air, especially in Fontainebleau Forest, although what

R

The Luncheon of the Boating Party.
PIERRE-AUGUSTE RENOIR.

most interested him was the study of the human figure, especially the female figure. In 1863, he exhibited a painting at the Salon that was based on the protagonist of a work by Victor Hugo,

At right: *The Swing.*
PIERRE-AUGUSTE RENOIR.

whom he admired. The painting shows **Delacroix**'s influence in his treatment

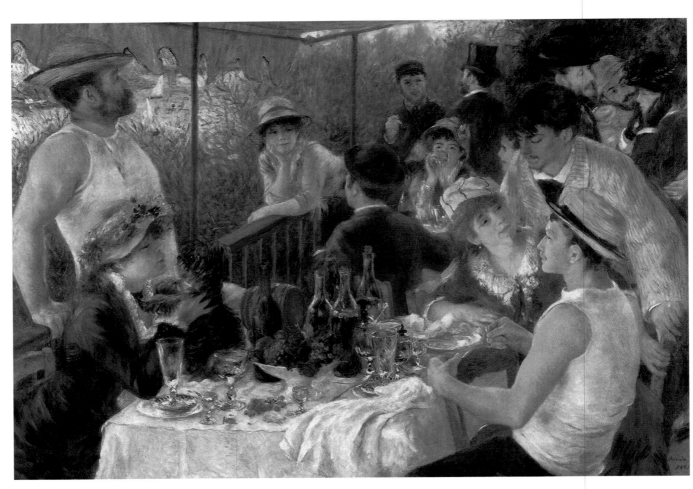

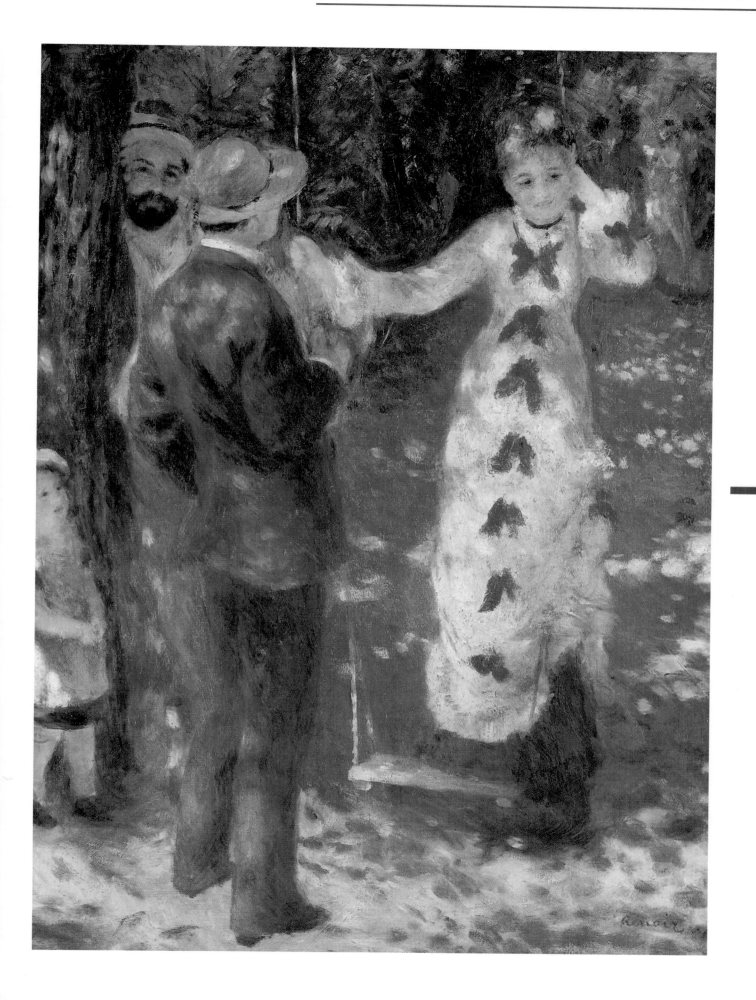

of color, and Monet's in the study of light. After the break in artistic activity caused by the Franco-Prussian War of 1870–1871, his work began to anticipat the Impressionists' style, whom he joined in their first exhibition in 1874. Among his best-known works are *The Swing*, reminiscent of Fragonard's work, and *Le Moulin de la Galette*, both colorist paintings that are filled with light. He also painted portraits (*Madame Charpentier and Her Children*, 1878) and traveled to Algeria and Morocco. Upon his return, he settled in L'Estaque, near Marseilles, along with Cézanne, and although he continued painting cheerful subjects and kept up his interest in depicting figures (*The Rowers' Lunch*, 1881, and *Dance at Bougival, Dance in the Country*, and *Dance in the Town*, all from 1883), his style began to increasingly reflect tradition and Classicism, taking an interest in volume and its artistic value. He took up the subject of female nudes (*The Great Bathers {The Nymphs}*) and persisted in depicting children and family groupings, as in his 1896 work, *The Artist's Family*. The arthritis that had afflicted him for quite some time grew worse after 1894, and he needed to tie the paintbrushes to his stiff fingers in order could paint. He tried sculpture, but in 1913, he became completely immobilized and remained so until he died six years later.

REPIN, ILYA EFIMOVICH

(Jarkou, 1844–Kuokkala, 1930)

A Russian painter, he is his country's most prominent representative of **Realism** in painting. He studied at

Seated Couple.
PIERRE-AUGUSTE RENOIR.

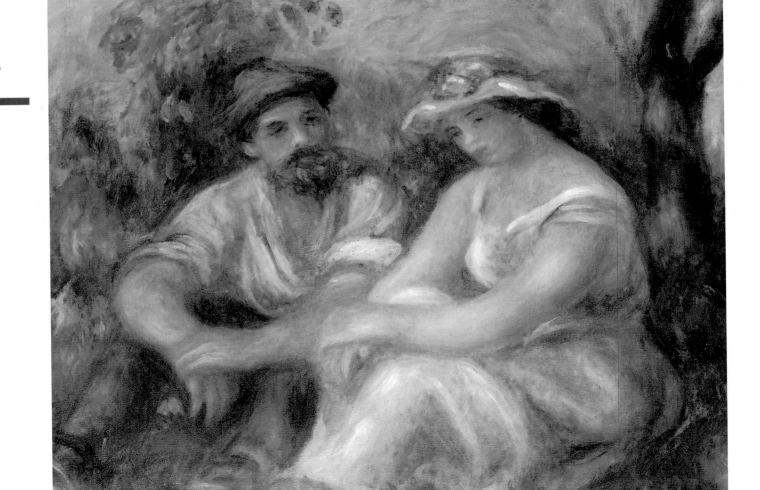

R

the Fine Arts Academy in St. Petersburg and because the success of his painting *The Resurrection of Jairus' Daughter* (1870), he won a scholarship to continue his training abroad. Before leaving on his trip, he painted and exhibited what is considered the first masterpiece of Russian Realist art, *The Volga Boatmen*. He acquired more artistic experience and a good technique in Rome and in Paris. In the latter city, he was appreciated in artistic circles and achieved a certain amount of popu-

larity. Upon his return to Russia, he became a revolutionary and a critic of official academic circles and showed his pessimism in paintings of melancholy Realism that depicted the oppression of the Russian people. A large part of his work was dedicated to compositions about Russian history, and above all, to portraits, a genre in which he left beautiful documentation of artists and writers such as Turgenev, Borodin, Moussorgsky, and especially Tolstoy, whom he portrayed with keen vision

They Did Not Expect Him.
ILYA EFIMOVICH REPIN.

and dramatic expression in *Portrait of Tolstoy as a Plowman*.

RETHEL, ALFRED

(Diapenbend, 1816–Düsseldorf, 1859)

A German painter and illustrator, his work is divided among engrav-

Another Dance of Death.
ALFRED RETHEL.

ings, drawings, and battle and heroic scenes. Born in a village near Aachen, his talent for drawing became evident when he was a child; he did more than one hundred drawings before the age of thirteen. He studied at the Düsseldorf Academy, where he remained for seven years and learned the painting style of German **Romanticism** under **Schadow**'s tutelage. Between 1836 and 1847, he lived in Frankfurt, except for a year of travel in Italy. In 1840, he was given a commission to decorate the Imperial Room of the Aachen Town Hall, for which he had to do a series of fresco panels with scenes from the life of Charlemagne. After protracted negotiations, he began this work in 1847 and by 1852, had only completed four of the eight scenes that were planned. The designs and scenes that he created for this decorative work were highly original, with very dramatic compositions. His paintings are scarce, but show great quality, as evidenced by the portrait he did of his mother at a very early date. However, his fame lay not so much in his paintings as in his skill at drawing and engraving, for which he preferred historical subjects. Outstanding drawings are *Street Fight* from 1848 and *A Medieval Battle*, done around 1850. His wood engravings are even more important—in which the theme of death is given special emphasis—using the allegorical **Realism** with which he represents the history of his own country, including scenes from the Revolution. This is the case of *Another Dance of Death, Death as a Strangler,* and *Death as a Friend.*

The significant influence on this artist by the German engravers of the Reformation has often been pointed out, especially that of Dürer and Holbein. Six years before his death, he became ill and went mad, forcing him to abandon all of his artistic activities and live under the care of his mother and sister.

Song of the Nibelungs.
ALFRED RETHEL.

RIANCHO GÓMEZ, AGUSTÍN

(Entrambasmestas, 1841–Santander, 1929)

A Spanish painter who specialized in painting the mountainous scenery of his native land, which he treated with great precision and Realism. Of peasant origin, he was able to go to Madrid to study through the patronage of a rich printer from Santander

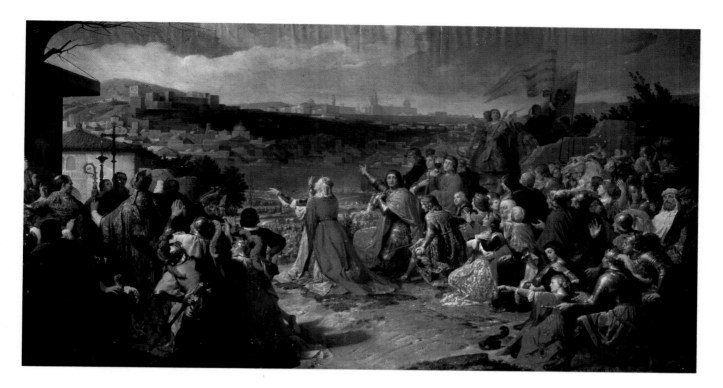

The Conquest of Granada.
CARLOS L. DE RIBERA.

and studied at the Fine Arts School of San Fernando, under the guidance of the landscape painter **Haes**. He later made a trip to Belgium, where he came into contact with the painters of the **Barbizon School** and took part in various exhibitions, winning several medals. After that, he returned to Santander to stay and achieved a certain amount of recognition there. Works such as *The Tree*, dated the year of his death, are exponents of his final evolution towards Impressionistic techniques.

RIBERA Y FIEVE, CARLOS LUIS DE

(Rome, 1815–Madrid, 1891)

Spanish painter Born in Rome, he was the son and pupil of Juan Antonio de Ribera. He produced numerous paintings in the historical genre, and later on, a few with religious sub-

jects. He was trained at the Academy of San Fernando in Madrid and on scholarship at the Rome Academy, beginning in 1831. After his studies there he made a trip to Paris, where he studied with **Delaroche**. His early works were characterized by patriotic and historical subjects, among

Portrait of a Girl.
CARLOS L. DE RIBERA.

which *Don Rodrigo Calderón on His Way to the Scaffold* and *Granada Being Taken by Ferdinand and Isabella* outstanding. Among his character work and his religious paintings, which reflect the ideals of the **Nazarenes**, *The Conversion of St. Paul* and *Assumption of the Virgin* should be mentioned. His various official posts in Madrid, such as court painter to Isabella II, advisor on public education, and director of the Academy of San Fernando, did not prevent him from decorating the interiors of large buildings and institutions in the Spanish capital, such as the Congress of Deputies, in 1850, and the church of San Francisco el Grande.

RICHMOND, GEORGE

(1809–London, 1896)

English painter. The son and student of the miniaturist Thomas Richmond, he later continued his training at the Royal Academy, where he studied with **Füssli** and met **Palmer**,

287

View of Guadarrama.
MARTÍN RICO ORTEGA.

who would become his friends and with whom he would later join the group devoted to **Blake**'s visionary style, known as "The Ancients." He portrayed landscapes and phantasmagoric scenes, both in oil and in

Crossing to Schreckenstein.
ADRIAN LUDWIG RICHTER.

drawings and engravings, filled with sensitivity and delicateness. Although while somewhat exaggerating Blake's style, these traits can be seen in *Christ and the Woman of Samaria* (1828) and *The Eve of the Separation*, done in 1830. After that date, he abandoned religious and poetic subjects for portraits, which made him greatly popular. His first work, *Abel*, exhibited in 1825, before he came under the influence of Blake, is striking.

RICHTER, ADRIAN LUDWIG

(Dresden, 1803–1884)

German painter, illustrator, and engraver. His pictorial and graphic work have a personal and original stamp, although they clearly fall within the Beidermeier style. He was the son of an engraver of copper and mastered that technique, practicing it from 1838 onward, to illustrate numerous books, stories, and lyrics of sentimental songs. Interested in landscape painting, he trained at the Academy in his native city, where he learned to paint in the style of the movement exemplified by **Friedrich**, to which he added a personal touch borrowed from the masters of the Dutch school, as well as from the style of **Schnorr von Carolsfeld**. In 1823, he obtained a scholarship to travel to Italy and study classical landscapes. There he encountered the doctrine of the **Nazarenes** and met the painters **Cornelius, Koch**, and **Overbeck**, dedicating himself to painting pastoral, idyllic landscapes, such as *Harvest Time in the Roman Country-*

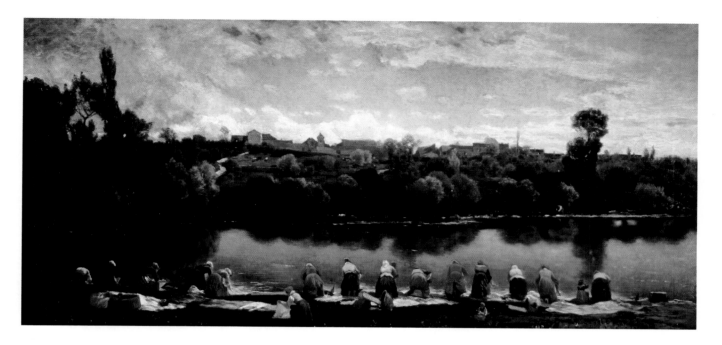

The Washerwomen of La Varenne.
MARTÍN RICO ORTEGA.

side. He returned to Dresden and in 1836, obtained the post of landscape painter at the Academy in that city. He organized many excursions with his students to the Elbe valley and the province of Bohemia and made numerous sketches for his later compositions. *The Church in Graupen* (1836) and *Two Shepherds in the German Countryside (Spring Afternoon)* (1844) are paintings from this period and reveal his interest in idyllic, local, and ingenuous scenes, where man is in harmony with nature and is always shown in a peaceful and serene setting. The absence of Romantic drama in his landscapes and his pleasant scenes featuring happy people cause his work to be included in the Biedermeier style. However, he was also interested in expressing his personal vision of the life of the German people. Some of his compositions, such as *Pond in the Reisengebirge Mountains* (1839) and the famous painting *Crossing to Schreckenstein* (1837), also reflect his in-depth study of nature, with almost topographical nuances and precision. In 1847, he stopped painting in oils to devote himself to

prints and wood engraving. Among his illustrations, the ones he did for Andersen's *Fairy Tales* and Schiller's *The Bell* are of special interest.

RICO ORTEGA, MARTÍN

(Madrid, 1833–Venice, 1908)

A painter from Madrid who dedicated himself to landscape painting. His style evolved from Realist approaches towards works of great luminosity that similar to **Impressionist** paintings. He began his training at the Fine Arts School of San Fernando, under the direction of **Pérez Villaamil**, who indoctrinated him into a clearly Romantic style. Starting in 1854, he began a series of trips around Europe, first to Paris and later to Switzerland and England, which caused an impact on him and affected his artistic development. Interested in the qualities of British artists, such as **Turner** and Ruysdael, his palette underwent a change, and his landscapes became more humanized, as can be seen in *The Washerwomen*. His continuous trips to Paris and Italy—espe-

cially to Venice—as well as his friendship with **Fortuny**, led him toward a more Euphuistic and detailed style, as evidenced by his landscapes of Granada and Venice, painted with luminous and impressionistic brushstrokes. His memoirs, *Memories of My Life* (1907), were published before he died.

RIGALT I FARRIOLS, LUIS

(Barcelona, 1814–1894)

A Spanish painter, decorator, and illustrator, he established the bases for the development of landscape painting in his native land. The son of a renowned set designer, he studied at La Lonja Fine Arts School in Barcelona, an instituttion where he worked as a teacher from 1841 onward, and where he eventually held a professorship. He was elected academician of the Fine Arts Academy of San Fernando in 1858 and participated in the National Exhibition

Landscape with Ruins.
LUIS RIGALT I FARRIOLS.

with his work, *Memories of Catalonia*. He contributed illustrations to the publications *España Pintoresca* and *Historia de Cataluña*, reflecting clearly Romantic qualities. Among his most noteworthy works, his landscapes should be mentioned, such as *View of Mongat*, *Foothills of Montjuich*, and *Montserrat*, among others.

ROBERTS, DAVID

(Stockbridge, 1796–London, 1864)

British **Romantic** painter. He began his painting career in Edinburgh with an interior decorator and worked as a decorator of theaters and at a circus. In 1822, he settled in London, where he continued painting theatrical scenery. However, from 1831 onward, he traveled around Europe, visiting—among other countries—Spain, which was very fashionable among the Romantics and which inspired many of Roberts' paintings, as did other countries of the Mediterranean basin. He painted many landscapes

A Street in Cairo.
DAVID ROBERTS.

on these trips, both in oils and in watercolors. His work, which achieved renown, was generally characterized by great descriptive accuracy, with bold draftsmanship, and by its picturesqueness, very typical of the art movement to which he belonged. Apart from inspiring paintings, the trip to Spain provided ideas for a series of steel engravings which brought him great success and which served as a means of spreading the Romantic image of Spain. He also created illustrations for books. Noteworthy among his works are *View of La Torre de Oro (The Golden Tower)* (1833), *Seminary and*

View of the Nile.
DAVID ROBERTS.

Portrait of David Roberts in Arab Dress.
ROBERT SCOTT LAUNDER.

Cathedral in Santiago de Compostela (1837), *Alcalá de Guadaira Castle, The Chapel of Ferdinand and Isabella, Granada* (1838), and several views of London.

RODAKOWSKI, HENRYK

(Lemberg, 1823–Crakow, 1894)

Polish painter. He studied in Vienna—where he had Joseph Danhauser and **Amerling** as teachers—and later in Paris, under Léon Cogniet. Their influence caused him to paint his portraits with

great **Realism**, as can be seen in the one he did of *General Dembins-*

ki. This was the first work he entered at the Salon in Paris in 1852, with which he achieved notable success, winning a first-class medal. He also exhibited some other portraits which, like the first, were well received by the public, such as *Frédéric Villot* (1855) and *Prince Czartoryjski* (1857). Other works of his are *His Mother* (1853), *People of Galitzia in a United Greek Rite Church, The Preacher* (1866) and *Countess J.D.* (1875). He was appointed director of the Fine Arts School in Crakow.

ROMANTICISM

An esthetic attitude and a cultural, literary, and artistic movement, that lasted from approximately 1800 to 1850. Romanticism did not have its own unique style and technique, but rather, encompassed and combined different tendencies and movements that corresponded to a

Woman with a Parrot.
EUGÈNE DELACROIX.

series of common sentiments. Among these were the expression of intense moods, mystical feelings, and certain ideas and reflections on the past and the present. Thus, it is art and painting that are close to nature, very imaginative and emotional, even mystical and visionary, without discarding a taste for historical knowledge and an exaltation of the present, an aspect that was parallel to the development of nationalism. In France, the beginning of Romanticism coincided with the Napoleonic Wars, from 1799 to 1815. Prominent French artists who specialized in this type of painting were **David** and **Ingres**, who, despite the fact that they were Neoclassical painters par excellence, did some of their last work using the principles of Romanticism. However, its chief representatives were **Delacroix, Gros**, and **Géricault**. In Germany, its main representative was **Friedrich**, the most outstanding Romantic landscape painter, as well as the painters forming the so-called Brotherhood of St. Luke, known as the

Nazarenes, a group of artists who settled in Rome and whose goal was to recover the style and spirit of medieval painters. Their chief representative was **Overbeck**. In England, Romantic landscapes were the area in which **Palmer**'s markedly sentimental artistic style developed. This was also the case with the genius of **Constable** and **Turner**, the

latter being the most radical and innovative of the Romantic landscape painters. In Spain, the introduction of Romanticism was delayed and was manifested through **Federico de Madrazo, Esquivel, Pérez Villaamil, Alenza**, and **Lucas**, the latter following in the wake of Goya's Romanticism. In Catalonia, the Nazarene style inspired a number of painters such as **Espalter** and **Clavé**. In the development of nineteenth-century painting, the Romantic movement would persist in later works by Constable, in the beginnings of the **Barbizon School**, and also with the Impressionists. Symbolism was the later movement most directly affected by Romanticism.

ROPS, Félicien

(Namur, 1833–Essonnes, 1898)

Versatile Belgian artist who dedicated himself to painting, drawing, and caricature, as well as engraving,

Weymouth Bay.
John Constable.

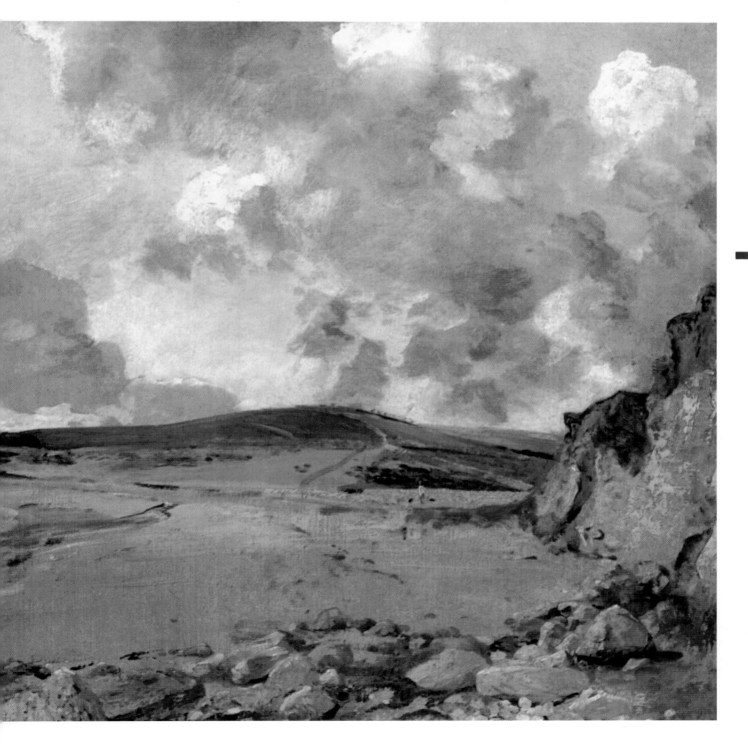

Death at the Ball.
FÉLICIEN ROPS.

R

lithography, and etching, techniques he practiced from a very early age. He studied at the University of Brussels and founded a small group of artists in the 1860s. He drew caricatures for satirical newspapers, while he was learning to paint, and also created etchings which won him recognition; many of these were intended to illustrate literary texts. His drawings and, especially, his watercolors are outstanding. Two examples of these are *The Absinthe Drinker* and *The Temptations of St. Anthony*.

ROSALES GALLINA, EDUARDO

(Madrid, 1836–1873)

Spanish painter. A pupil of **Madrazo**, he was one of the principal nineteenth-century historical painters of Spain, whose work evolved towards new perspectives ranging from **Realism** to Pre-Impressionism. After his studies at the Piarist school and the San Isidro Institute in Madrid, he entered the Fine Arts School of San Fernando in 1851. There, he acquired his primary training, in between financial difficulties and precarious health which caused him to be admitted to the Montserrat hospital in Catalonia in 1857. When he recovered, his hard work paid off with a scholarship in 1860 to study in Rome at the Spanish Academy of Fine Arts. In the Italian capital, he painted his work *Tobias and the Angel*, although he did not manage to finish it. Then, he sent his painting *The Little Girl* to the Spanish National Exhibition in 1863, for which

Scene from the Battle of Tetuán.
EDUARDO ROSALES GALLINA.

The Annunciation.
DANTE GABRIEL ROSSETTI.

he received an honorable mention. One year later, he was awarded his first medal in the same competition, for *Queen Isabella's Will*, a work whose resounding acceptance alleviated his financial woes. He once again reaped success with *Death of Lucretia*, a work painted in Rome, with a markedly dramatic nature, but different from the academic traditionalism that had characterized his early works. From that time onward, he developed a more personal style, independent of official tastes, as can be sen in his works *Female Nude* and *Portrait of the Violinist Pinelli*, both which show a style with free, spontaneous brushwork that approaces **Impressionism**. His watercolors, drawings, and numerous portraits are of interest. With the advent of the First Republic, he was offered the directorship of the Prado Museum, as well as the directorship of the Fine Arts Academy in Rome in 1873, but his severe tuberculosis prevented him from accepting these posts. He died that same year in Madrid.

ROSSETTI, DANTE GABRIEL

(London, 1828–Birchington-on-Sea, 1882)

An English painter and poet, he was one of the founders of the Pre-Raphaelite Brotherhood. His father, Pasquale G. Rossetti, curator at the Naples Museum, had had to exile himself from Italy for political reasons, so he settled in London, working as an teacher of Italian. Dante Gabriel Rossetti began to study languages at King's College and began learning the technique of engraving.

In 1846, he began his artistic training at the Royal Academy and started to paint, along with **Hunt, Millais, Burne-Jones**, and **Brown**. With them, he co-founded the Pre-Raphaelite Brotherhood, an art association that tried to give new value to craftsmanship, medieval styles, and the Italian artists who had worked before Raphael. They

Lady Lilith.
DANTE GABRIEL ROSSETTI.

R

proposed spontaneous and ingenuous art, creating a new ideal of feminine beauty while repudiating industrialization and Victorian morality. His first works date from the second half of the 1840s. In 1845, he exhibited *The Girlhood of Mary Virgin*, a painting filled with devotion and serenity which was rejected by the critics. The same reaction was accorded *Ecce Ancilla Domini! (The Annunciation)*, from 1849–1850, a luminous composition of great chromatic harmony based on the use of shades of white, harking back to primitive fifteenth-century panels. This laborious effort

was resoundingly rejected by Protestant critics. These first paintings were followed by a series of watercolors illustrating Romantic legends, as well as passages from Dante's life and works, an author Rossetti deeply admired. In 1850, he met the model Elizabeth Siddel, whom he married ten years later. She personified his ideal of female beauty. When she died two years later, Rossetti immortalized her in *Dante's Dream at the Time of the Death of Beatrice* (1856) and in *Beata Beatrix* (1863), a work that demonstrates the painter's inclination toward greater ornamentation and symbolism, a trait that had already been accentuated by the influence he received from **Ruskin**'s and **Burne-Jones'** work. In 1863, he left the Brotherhood, although his style would continue to be Pre-Raphaelite, as evidenced by *The Beloved* (1865) or by the eight versions, starting in 1874, of *Proserpine*, compositions with numerous symbolic elements and arabesques evoking Ruskin's work (*The Stones of Venice*, 1851). After the death of his wife, his personality became very unbalanced, with moments of great anxiety, followed by an uncontainable capacity for work, causing him to paint almost compulsively while showing a rare degree of perfection. Certain scholars consider some of the titles from his last period especially admirable: *La Donna della Finestra* and *The Blessed Damozel* (1879), *The Day Dream* (1880), *La Pia de' Tolomei* (1881), and *Joan of Arc* (1882). He spent his last years in a state between madness and desperation. He died after suffering a stroke.

Beata Beatrix.
DANTE GABRIEL ROSSETTI.

ROUSSEAU, HENRI

(Laval, 1844–Paris, 1910)

A French painter, known as *Le Douanier Rousseau* ("The Customs Officer Rousseau") he can be considered a naif artist—ingenuous naturalism evocative of the art of primitive cultures—whose genius was unarguable. His work is unique and had a great influence on the artistic development of the first decade of the twentieth century. The son of a tinsmith, he had a miserable, nomadic childhood. A sentence for a criminal act at the age of nineteen forced him to join the army, enabling him to fight in the Franco-Prussian War of 1870–1871. The following year, he found work as a customs employee (hence his nickname), an occupation he left in 1884. He began to paint around 1880 and after obtaining a position in the Louvre as a copyist, he decided to paint full time. From 1885 onward, he exhibited his paintings at the Salon of Independent Artists, participating year after year. The critics, who initially reacted ironically and even sarcastically because they considered his work "amusing and ingenuous" and saw him as a painter of work that was "not very serious, lacking any type of importance," eventually appreciated his innovation and primitivism. At the same time, he caught the interest of the avant-garde artists, among them **Gauguin**, who was an enthusiastic admirer of his work at the 1892 Salon. In 1905, at the Autumn Salon, his paintings were the object of praise due to their sense of form and composition and the strength of their colors, although they were, in general, not very commercial. Misery and misfortune accompanied him throughout his life, and in 1907, he was sentenced to two years in jail for an alleged swindle at the Bank of France. Pablo Picasso, whom he met in 1905, bought one of his paintings and organized a dinner in his honor; it was attended by the cubist painter Braque and the poet Gillaume Apollinaire. Kandinsky also bought one of his works. Outstanding among his output are *Carnival Evening* (1888), *Poetical Flowers* (1890), *Tropical Storm with Tiger* (1891), *The Sleeping Gypsy* (1897), *The Snake Charmer* (1907), *The Cart of Père Juniet* (1908) and *Portrait of Joseph Brummer* (1908). In all of these works, he shows, through the use of simple and pure colors and

Virgin Forest at Sunset.
HENRI ROUSSEAU.

sharp outlines in his drawings, a spontaneous type of art, simple in appearance but highly sophisticated.

ROUSSEAU, THÉODORE

(Paris, 1812–Barbizon, 1867)

A French painter, he was one of the greatest figures in landscape painting, and the creator and inspirer of the **Barbizon School**. His artistic studies began when he was fourteen, with the Classicist painter Lathière and from 1829 onward, at the Fine Arts School in Paris with Charles Rémond. Interested in landscapes, he made copies in the Louvre of works by Claude Lorrain, the Dutch masters, and especially **Constable** and **Bonington**, painters he admired and who influenced his work. From a very early age, he painted in the open air, a procedure that was not very usual in academic land-

Clump of Oaks.
THÉODORE ROUSSEAU.

scapes and an experience that was an innovative technique of great importance. He showed his first paintings at the 1831 Salon, and at the Salon in 1834, he sold one of his landscapes to the Duc d'Orléans.

However, starting in 1836 and for seven consecutive years, beginning with *Descente des Vaches*, his compositions were rejected by the jury, made up of academic painters who did not understand Rousseau's new esthetic approaches. As his work was pleasing to neither official tastes nor to the market, he suffered from great loneliness and every type of difficulty that tormented the Romantic artist. In order to paint his landscapes, he traveled around different areas of France beginning in 1830 (Auvergne, Brittany, Normandy, and other places). Among his works from those years, *Valley of Saint-Vincent* (1830) and *Avenue of Chestnut Trees* (1837) are noteworthy. However, his paintings also represented natural scenery from the area surrounding Paris, such as *Plain of Montmartre* (1835) and his studies of the Fontainebleau forest. Near this location was the town of Barbizon, where he settled in 1840 and founded, together with **Millet**, the school of the same name. The subjects he painted from that time onward were

Landscape with Laborer.
THÉODORE ROUSSEAU.

The Hülsenbeck Children.
PHILIPP OTTO RUNGE.

landscapes, where woods and trees predominated, or spacious plains, depicted with a precise and objective vision of nature based on direct, open-air observation. His painting is Realist, but there is an element of Romantic drama in it, perhaps in the gloomy and somber tones, in the sobriety of nature and the melancholy atmosphere that characterizes his landscapes. The paintings that were previously mentioned and *Edge of the Woods* (1854) are indicative of

these traits. One of his innovations was to paint the same scene during different seasons of the year or at different times of day, an analysis that the **Impressionist** painters used, particularly **Monet**. Official recognition came to him after the 1848 revolution. Selling his paintings and presiding over the jury at the Universal Exposition in Paris in 1867 did not keep him away him from his tranquil and artistic life in Barbizon, where he died at the age of fifty-five.

RUNGE, PHILIPP OTTO

(Wolgast, 1777–Hamburg, 1810)

German painter, designer, poet, and painting theorist. He was the chief representative of German Romantic painting, along with **Friedrich**. However, it should be pointed out that Runge's **Romanticism** was

R

299

still somewhat close to Classicism in form, without going as far as the unrestrained form of French work. He began his training in Hamburg with Herterich and Hardof and later studied at the Fine Arts School in Copenhagen and the one in Dresden, coinciding with Friedrich at the latter in 1801. Together with Friedrich, he flatly opposed the forms imposed by classicist academicism. Because of their subject matter, the work of both painters can be, in some aspects, considered forerunners of the English Pre-Raphaelite movement and of Symbolism, a movement that would be widely practiced in Germany due to the idealistic tendency that is generally seen in the artists of that country. In his desire to continue his training, he dedicated himself

Montmartre Café.
SANTIAGO RUSIÑOL Y PRATS.

to copying the works in the Dresden museum and was primarily attracted to those by Raphael and Correggio. In 1802, he participated in a competition to represent a subject from Greek mythology, specifically the Odyssey; unfortunately, his sketch was rejected by Goethe. His beautiful portraits, which he primarily did beginning 1803 when he returned to Hamburg, are full of sensitivity that is easily transmitted to the viewer, and the sensation of volume produced by his figures is almost sculptural. Noteworthy examples of his portraits are *Self-Portrait with His Wife and Brother* (1805), *The Hülsenbeck Children* (1805), *His Parents* (1806), and *Self-Portrait* (1809–1810). With regard to his landscape painting, it should be mentioned that his deep spirituality is reflected in it, filling it with a certain mysticism, as can be seen in

The Nightingale's Singing Lesson (1804–1805), and especially in the sketches that the artist did for what would be his most important work, *The Times of Day*. He began this work, which was an allegory on human life, around 1802, and would only complete *Morning*. As can be seen in *Christ on Lake Tiberias* (1806–1807), the artist very clearly reflects his religiousness.

RUSIÑOL Y PRATS, SANTIAGO

(Barcelona, 1861–Aranjuez, 1931)

Catalan painter, writer, and prominent representative of Modernism. In his native city, he started out in painting with Tomás de Moragas, working with rural and urban landscapes, within a traditional style. At the end of 1889, he moved to Paris and met **Casas**—reflected by his painting *Rusiñol and*

Rusiñol and Casas Painting.
SANTIAGO RUSIÑOL.

Casas Painting—and Ignacio Zuloaga. He studied at an academy on the Avenue de Clichy that contributed influences from the Impressionists and Symbolists. In 1892, he returned to Spain and settled in Sitges, alternating with continuous trips to France and other regions of Spain to paint landscapes. Works such as *Montmartre Café*, *La Galette Laboratory*, *A Reader*, *Symphony* or *Morphine*, the latter from 1894, are exponents of a peculiar interpretation of Modernism combined with Symbolism. On a trip around Andalusia in the winter of 1896, he began to paint gardens and parks with rich color and shading, as seen in the

La Galette Laboratory.
SANTIAGO RUSIÑOL.

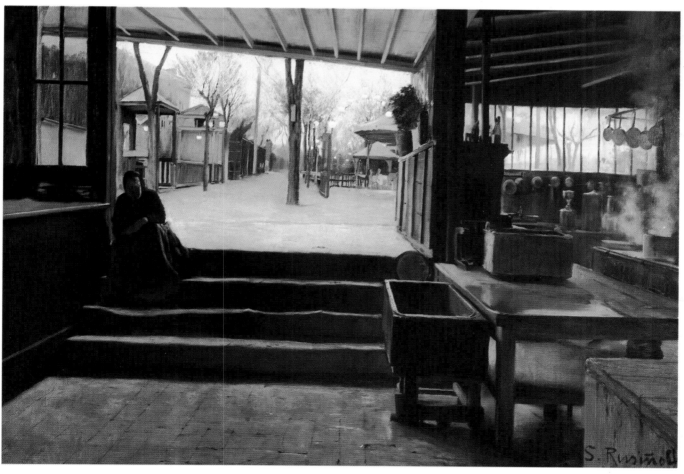

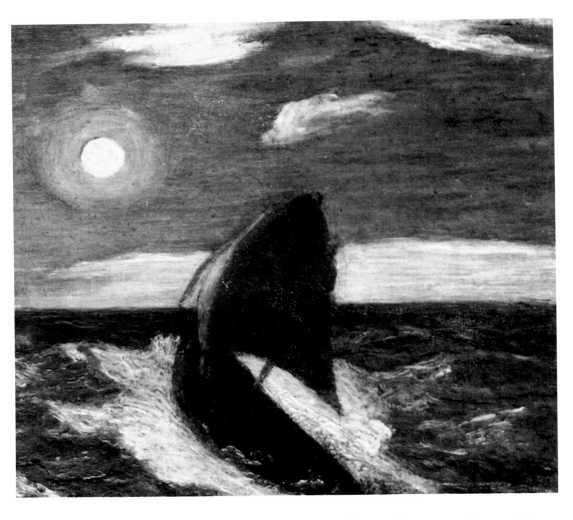

Toilers of the Sea.
ALBERT P. RYDER.

series of paintings dedicated to the gardens of the Generalife and of Aranjuez. The decorative work in his house, Cau Ferrat, in Sitges, is of interest, with allegorical frescoes showing Pre-Raphaelite influence. It is currently an important museum.

RUSKIN, JOHN

(London, 1819–Brandtwood, 1900)

English painter, art critic, and writer. Artistically trained during the trips he made around Great Britain and Europe, he was a renowned watercolorist and a notable draftsman and illustrator, who left proof of this fact in the excellent watercolors and drawings that he did in Venice. In his early works, he was influenced by **Turner**, until he found his own style that, along with his critical book on art, *Modern Painters*, would influence the Pre-Raphaelites. In 1869, he was appointed professor at Oxford, and founded a drawing school, in which he taught his ideas about innovation in the applied arts. He had a very pronounced social conscience, and like **William Morris**, was in favor of bringing art into the daily lives of workers, in the belief that art should perform a social function. He was the most influential English art critic of his time, and among his numerous written works on this subject, the most famous is *Modern Painters*, which he began at the age of seven and which he illustratrd with draw-

ings of great delicacy. In painting, he held the work of the painters of the Italian Trecento in high esteem.

RUSSELL, WALTER WESTLEY

(London, 1867–1944)

An English painter, his portraits and paintings of interiors with figures are striking. Trained at the Fine Arts School in Westminster, he exhibited his work for the first time in 1891. His mastery of the portrait genre during the first decades of the twentieth century earned him the esteem of the Royal Academy. Outstanding are his *Portrait of Mr. Minney* from 1920 and *Juliette* from 1921.

RYDER, ALBERT PINKHAM

(New Bedford, Massachusetts, 1847–Elmhurst, New York, 1917)

An American painter, he was one of the most authentic representatives of the Symbolist movement in his country, reaching imaginative heights worthy of the best European examples. His training was academic, and he was a student of the painter Marshall, receiving several awards at some of the international exhibitions held in the United States. His landscapes are highly personal. Legendary subjects and literary scenes are the motifs that are most common in his painting, such as *Siegfried and the Rhine Maidens*, *Macbeth and the Witches*, and *Death on a Pale Horse*.

Washerwomen
CASIMIRO SÁINZ SÁIZ.

The Source of the Ebro.
CASIMIRO SÁINZ SÁIZ.

S

SÁINZ SÁIZ, CASIMIRO

(Matamorosa, Cantabria, 1853–Madrid, 1898)

A Spanish painter, known for his landscapes and interiors with figures. He was a pupil of **Palmaroli** at the Fine Arts School of San Fernando in Madrid, which he attended on a scholarship from the Santander Council. He followed the realism of **Haes** in landscapes and was awarded prizes at the national exhibitions of 1881 and 1890. Noteworthy works are *View of a Garden, The Source of the Ebro,* and *The Garden.* He suffered from nervous breakdowns that were difficult to diagnose and was treated by Dr. José María Esquerdo, a brilliant specialist in mental pathology, who through his tenacity, succeeded in having the mentally ill treated humanely and with dignity instead of with the contempt and violence that had been customary. In 1887, he was admitted to the insane asylum that Dr. Esquerdo ran in Madrid. Nevertheless, his illness prevented him from painting during the last eleven years of his life.

SÁNCHEZ BARBUDO, SALVADOR

(Jerez de la Frontera, 1857–Rome, 1917)

A Spanish painter, who specialized in subjects in the historical genre,

Portrait of Gabriel Faure.
JOHN SINGER SARGENT.

he mainly worked in Seville, London, and Rome. He became popular in this latter city with *The Last Scene from Hamlet* (1884), a work for which he was awarded the second-place medal at the National Exhibition. He also painted some satirical

Claude Monet Painting at the Edge of a Wood.
JOHN SINGER SARGENT.

and genre scenes which were reminiscent of **Fortuny**.

SARGENT, JOHN SINGER

(Florence, 1856–1925)

An American painter, mostly known as a portraitist. He spent most of his youth in Europe, studying in Italy and Germany and from 1874 onward, in Paris, where he successfully exhibited his portraits and achieved his first triumph at the 1879 Salon. This was followed by other awards, in spite of the negative critical reviews that his controversial *Portrait of Madame Pierre Gautreau* received, also known as *Portrait of Madame X*. Some of his most distinguished portraits are *Portrait of Carolus Duran* (1879), *Isabella Stewart Gardner* (1888), *The Wyndham Sisters* (1900), and *Portrait of Millicent, Duchess of Sutherland* (1904). During the first decade of the twentieth century, he began to do wa-

305

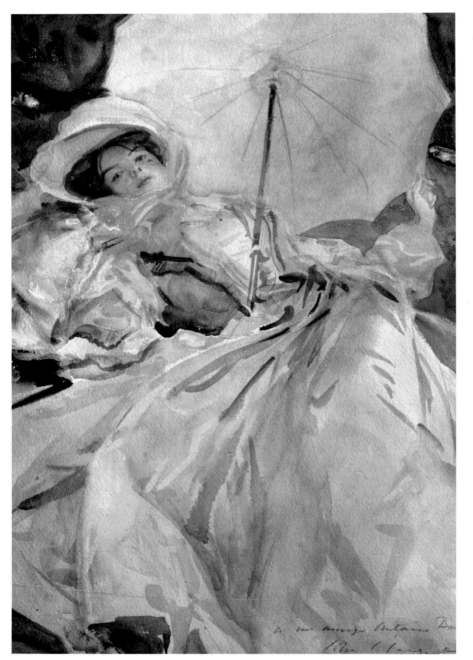

Lady with a Parasol.
JOHN SINGER SARGENT.

Brotherhood. He participated in the fresco decoration of Casa Bartholdy from 1816 to 1817. In 1826, he was appointed director of the Düsseldorf Academy. His work is characterized by his choice of religious subject matter, painted with a delicate and painstaking style, such as *The Four Evangelists* (in the Werder Church in Berlin) and *The Assumption of the Virgin* (in St. Paul Church in Aachen). In his *Pietas and Vanitas (Parable of the Wise and Foolish Virgin)* from 1840, he also employs another trait of the pictorial compositions of the Nazarenes: a direct reference to late Gothic and Quattrocento models.

SCHEFFER, ARY

(Dordrecht, 1795–Argenteuil, 1858)

A Dutch painter, engraver, and book illustrator, specializing in the Romantic landscapes of the French school. He was first trained by his father, who was a painter, and later completed his education in Paris, where he spent most of his life, with **Guerin** and **Prud'hon**. His works, very popular at the time, at first were based on literary themes (*Francesca da Rimini*, 1835), taken from Dante and Byron and of a Greco-Roman type, with the evident influence of **David** in his academic style. Later, he created religious works, medieval in style (*St. Louis Visiting the Plague Victims*, 1822; *Saints Augustine and Monica*, 1854). He also painted portraits of members of high society and of important personalities from cultural circles (*Portrait of Liszt*), as well as large-format historical paintings. His scenes in general are quite theatrical, with marked con-

tercolors, with a marked Impressionistic technique.

SCHADOW, WILHELM VON

(Berlin, 1788–Düsseldorf, 1862)

A German painter and a representative of the artistic group known as the **Nazarenes**. The son of the Neoclassical sculptor Gottfried Schadow and brother of the Realist sculptor Rudolf

Schadow, he began his training in painting at the Berlin Academy in 1808. He traveled to Rome in 1811 and joined the Nazarenes of the Brotherhood of St. Luke through the painters **Cornelius** and **Overbeck**. There he painted one of his best-known works, *The Schadow Brothers with the Sculptor Thorvaldsen* (1815), in which he portrayed himself along with the two sculptors, thus illustrating the integration of the arts that was sought by the aesthetic ideal of the

trasts in light and shadow, but with figures that are too plaintive. He painted small customs and manners paintings which were reproduced in lithographs. Other important works are *The Burghers of Calais* (1819), *The Death of Géricault* (1824), *The Soldier's Widow, The Return of the Invalid, The Death of Gaston de Foix in the Battle of Ravenna* (1824), and *David Dángers*.

SCHICK, GOTTFRIED

(Stuttgart, 1776–1812)

German historical painter and portraitist, belonging to the Neoclassi-

cal movement. From 1787 to 1794, he studied in Stuttgart with **Friedrich** and later was a pupil of **David** in Paris. In 1802, he settled in Rome, where he would spend nine years, being exposed to the Romantic cultural atmosphere in the Italian capital, whose personalities he would portray in excellent works of great Classicism. He made his name with *The Daughter of A. von Humboldt*. He also depicted Biblical and mythological scenes, in the style of Anton Raphael Mengs, such as *Apollo among the Shepherds*.

The Death of Géricault.
ARY SCHEFFER.

SCHNORR VON CAROLSFELD, JULIUS

(Leipzig, 1794–Dresden, 1872)

A German painter of religious subjects and events from medieval history, he is clearly a representative of the purest **Nazarene** style. He began his artistic studies in the atelier of his father, Viet Hans Schnorr von Carolsfeld, and continued them at the Academy in Vienna. In that city, he began his artistic work, painting *Battle Between Three Christian Knights and Three Pagans* and *Saint Roque Giving Alms*. He used medieval works

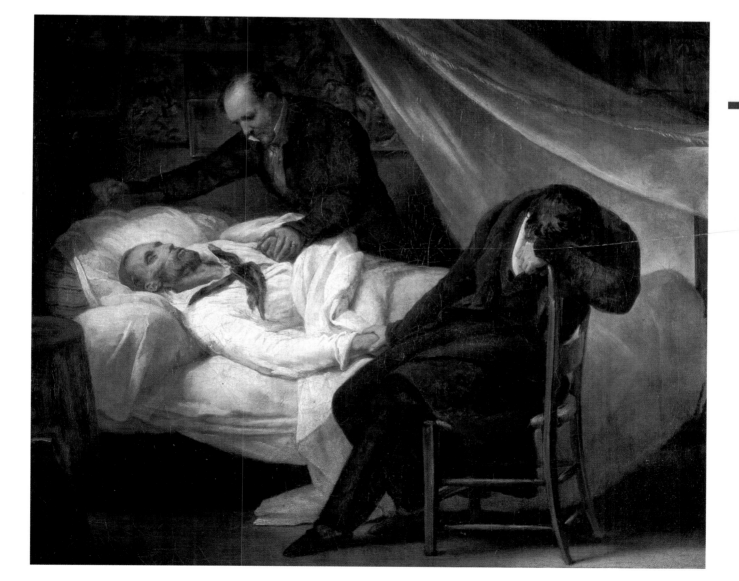

as models for his portraits, such as in *Portrait of Clara Bianca von Quandt*, a work that uses flat colors, as well precision of outlines and strong lines. This is a a style that became more accentuated after his stay in Rome, which in 1817. He joined the Nazarene group of the Brotherhood of St. Luke, founded by **Overbeck** and **Pforr**, and participated in the fresco decoration of the Casino Massimo, where he was in charge of the compositions in the Ariosto Room. His strong style was now accompanied by pale, vague coloring in works that reflected Quattrocento models, as can be seen in his painting *The Wedding Feast at Cana* from 1819. In 1827, he returned to Germany to teach at the Munich Academy. In that same year, Ludwig I of Bavaria commissioned him to decorate the Residenz in that city with typical subjects from Germany's legendary history, such as scenes of the Nibelungs. He was appointed director of the Painting Gallery and the Academy in Dresden in 1846. His landscape drawings are also outstanding, as they are designs that, like much of his work, are indicative of the influence Ferdinand Olivier had on him. Among his landscape drawings, *Wetlass Castle in Lower Austria*, an early work from 1815, is of special interest.

SCHWIND, MORITZ VON

(Vienna, 1804–Munich, 1871)

An Austrian painter, belonging to late **Romanticism** in the German school, and classified as a praction-

The Symphony.
MORITZ VON SCHWIND.

er of the Biedermeier style. He studied in Munich with **Schnorr von Carolsfeld** and **Cornelius**, soon specializing in small-format paintings, whose subjects were usually taken from legends, stories, ballads, and popular songs. They were executed with skilled draftsmanship, with great pictorial and expressive strength, and are graceful, imaginative, and lyrical. They depict villages, castles, and incredible characters that do not exist in real life and that are taken from the world of fantasy, from popular culture, or from dreams, and are closely related to the medieval world, for which he displayed a great affinity. The paintings transmit a lightheartedness that distances them from the sobriety of the earliest Romantics. He also did large murals, although the results were uneven due the use certain conventionalisms as well as poor colors. This latter trait is a fairly general characteristic in all of his painting, in which color is secondary to his strong, expressive, and graceful draftsmanship. Thus, his best works are his drawings and engravings, as well as his watercolors, which allowed him greater freedom of expression. In 1853, he decorated Wartburg castle and in his old age, the newly-built Vienna State Opera (1865–1867), creating murals in which Mozart was the central subjectand drawing on his great love of music. He also did illustrations for poems and stories, using a healthy dose of fantasy and ingenuousness. Among his extensive production artworks, the following should be mentioned: *The Prisoner's Dream* (1836), *Mr. Winter* (1847), *Monk Watering Horses, King Alder* (ca. 1850), *Dawn* (1858), *Krobus and the Wood Nymph,*

The Knight of Falkenstein, On the Danube Bridge (ca. 1860), *The Honeymoon* (1862) and *The Fairy Melusina* (1868–1869).

SCOTT, DAVID

(Edinburgh, 1806–1849)

Scottish painter and engraver. The son of an engraver, he got started in painting as a result of a long trip he made through Italy from 1832 to 1834, during which time he encountered the great masters of Italian painting, who be an inspiration in his artistic training. The subjects he chose for his works were historical and allegorical, and he executed them with a fairly loose style, reminiscent of **Delacroix**. He also did some etch-

Chapel in the Woods.
MORITZ VON SCHWIND.

ings, as well as the illustrations for one of Coleridge's works. In 1830, he became a member of the Scottish Academy. Among his most

Monk Watering Horses.
MORITZ VON SCHWIND.

Amor at the Fountain of Life.
GIOVANNI SEGANTINI.

S

important works are *Paracelsus Lecturing on the Elixir Vitae, Achilles Evoking Patrocles next to Hector's Body, Wallace, Defender of Scotland* (1844), and *The Grape Picker.*

SEGANTINI, GIOVANNI

(Arco, 1858–Schafberg, 1899)

Italian painter. He was interested in rustic life and alpine landscapes, working at first in the Realist style but gradually moving toward Symbolism. He developed a very personal technique consisting of a light palette and dissociated brushstrokes, juxtaposing colors to achieve light effects that contrast with heavily accentuated shadows. He started with realist painting and achieved his first notable success in Milan in 1885. Noteworthy among his paintings of rural subjects and alpine scenes are *At the Watering Place, Return to the Native Country, Dairy Farm in the Engadine*

(1887), *The Potato Harvest* (1890), and *Hay Harvest* (1899). In the last years of his life, he dedicated himself to symbolic investigations and mystical visions, often inspired by the work of the Pre-Raphaelites, such as *Angel of Life* (1894), or by **Böcklin**'s compositions. *The Evil Mothers* and *Amor at the Fountain of Life* are works that can be considered significant and important examples of European Symbolism and Modernism. He died in Switzerland at the age of forty, while he was working on a large allegorical triptych for the Universal Exposition of 1900, *Life, Nature, and Death.*

SEQUEIRA, DOMINGO ANTONIO DE

(Belem, 1768–Rome, 1837)

Portuguese painter and designer. Initially within the **Neoclassical** movement, although later influenced by the Romantics, as can be seen in his painting *Ascension* (1832). He is considered one of the

most important Portuguese painters. His training began in Lisbon and in 1788, he gained a scholarship and traveled to Rome with an allowance from Queen Maria I of Portugal. There he was a pupil of Antonio Cavallucci and Domenico Corvi. He is considered, along with Francisco Vieira Portuense, a forerunner of the Romantic movement in Portugal, and as did his compatriot, painted religious, genre, and historical pictures, although his most outstanding works were portraits, many of which are in the Lisbon Museum. In this latter genre, in which he showed that he was an innovator, his elegance and closeness to **Romanticism** should be mentioned, as well as the original chiaroscuro effects and certain similarities to **Goya**. Some characteristics of later movements can also be seen, as is clearly evident in *The Artist's Daughters*, a painting with some elements that make certain scholars

Angelus on Board.
GIOVANNI SEGANTINI.

Girl with Peaches.
VALENTIN ALEXANDROVICH SEROV.

consider him to be a forerunner of **Manet**. In the early 1790s, he entered the Academy of St. Luke in Rome, due to the wide acceptance of his work, *The Beheading of St. Luke*. After traveling around Italy and studying the great Italian masters, he returned to Portugal where, due to his fame which had spread across international borders, he received numerous commissions, such as one to direct the decorative work at the Ajuda Palace. In 1802, he was appointed court painter to João IV, after having spent seven years at the Carthusian monastery at Laveiras, where he painted to serve the order and employed the religious subject matter of the old tenebrist style (*Life of St. Bruno*). From 1805 to 1808, he was the head of the Design School in Oporto, succeeding the late Francisco Vieira Portuense. After the French invasion, while he was in Lisbon he had some problems with his countrymen because of his political ambiguity, which led him to paint a picture entitled *Allegory of Junot Protecting Lisbon*, which was interpreted as clearly supporting the invaders. He tried to make amends for this incident and improve his reputation by creating other paintings expressing support for his country, such as *Lisbon Protecting the Victims of the French Invasion* and *The Spirit of the People Defending Religion, Throne, and Country*. During the revolutionary events of 1820, he was appointed president in perpetuity of the Academy and later received a commission to paint an allegory on the 1822 Constitution. However, the advent of the Restoration

forced him to go into exile, and he traveled to London, Paris, and Rome. His mastery of draftsmanship is very noticeable in his work, which shows many different styles of uneven quality, with a tendency towards soft colors, although always within the spirit fo Romanticism. However, because of the high level of quality he achieved in some of his large compositions, many critics consider him "the Portuguese Goya." Of his European work, which is his most outstanding because of its quality, some noteworthy examples are

Death of Camoens, Flight into Egypt, The Descent, and *Epiphany.*

SEROV, VALENTIN ALEXANDROVICH

(St. Petersburg, 1865–Moscow, 1911)

A Russian painter, working as a **Realist**. He was educated in an artistic environment and studied at the St. Petersburg Academy under Ilya Riepin, who especially influenced him in his early work. In this first stage, his work was Im-

He primarily painted portraits and was outstanding in this genre. From the 1890s onward, he mostly painted personalities from cultural circles. He was also an excellent landscape painter, with a style in between Realism and Impressionism. As an illustrator, he did miniatures showing genre scenes related to hunting, for which the royal family felt great fondness. Some of his noteworthy works are *Portrait of Francesco Tamagno* (1891–1893), *Portrait of the Artist Korovin* (1891), *October, Domptkanovo* (1895), *Leviathan, Portrait of S. M. Botkina* (1899), *Peter the Great* (1907), *Autumn Evening*, and *Portrait of the Countess of Yusopova*.

Man Leaning on a Parapet.
GEORGES SEURAT.

Young Man, Seated.
GEORGES SEURAT.

SEURAT, GEORGES

(Paris, 1859–1891)

pressionistic and even showed some glimpses of **Post-Impressionism** (*Girl with Peaches*, 1887). Later, he continued his training in Paris, where he took part in the Universal Exposition of 1900, exhibiting some of his works and winning an award. As a result of his exposure to Europe, his style became more intimate—showing a more pronounced tendency towards Vuillard's style—and approached the aesthetics that dominated in Western Europe at the time. Although considered a Realist, his art is closer to the elegant and refined style of Modernism.

A French painter, he was the initiator and chief representative of the Neo-Impressionist movement. Seurat received his first artistic training at the Fine Arts School in Paris under the guidance of a pupil of **Ingres**, and

while he was studying, he began to take an interest in scientific literature, specifically in the theories of Rood, Helmholz, and especially Chevreul, an author who set forth his knowledge about the effects of light in *An Education in the Spirit of Forms* and *An Education in the Spirit of Colors*. From 1882 onward, he applied these theories to his painting, and in 1884, he composed *Bathers at Asnières*, a grandiose Sunday scene set in the en-

Young Woman Holding a Powder Puff.
GEORGES SEURAT.

The Channel at Gravelines.
GEORGES SEURAT.

virons of Paris. It was a manifesto of divisionist, Pointillist, or Neo-Impressionist painting, a technique that consists of breaking colors down into their primary elements and applying them with tiny brushstrokes, almost dots, following a slow, systematic, and reflective method. This work, however, was rejected at the official Salon, and Seurat showed it at the Salon of Independent Artists. The composition was the focus of all attention, and **Signac**, among other artists, immediately joined the new art movement. In 1886, he settled in Honfleur, and finished what is considered

Grand-Camp, Dusk.
GEORGES SEURAT.

The Painter at Work.
GEORGES SEURAT.

his masterpiece, *Sunday Afternoon on the Island of La Grande Jatte*, a composition in which he applied chromatic Pointillism, resulting in cold perfection. Another work that is outstanding is *The Models*, completed in 1888. However, for many historians his most significant works are *The Parade* (1887–1888) and *The Circus*, a painting that remained unfinished at the time of his death

SHARAKU, TOSHUSAI

(Tokyo, ca. 1770–ca. 1825)

A Japanese painter and woodblock engraver, of whose life very little is known. From 1794 onward, he dedicated himself to engraving. Along with **Hiroshige** and Korusai, among others, he belonged to the ukiyo-e school of colored printmaking, which produced innovations in landscapes, portraits, and genre scenes. He was known for his portraits of Kabuki actors, costumed and made up for their performances. He made numerous drawings for these paintings, which employed great realism and expressivity. He made one hundred and thirty-six highly original prints, characterized by the use of brilliant colors and the purity of their lines, as well as his great ability to capture the psychological traits of the people he portrayed.

SHEE, SIR MARTIN ARCHER

(Dublin, 1769–Brighton, 1850)

Irish painter, writer, and art critic. He studied painting at the drawing school in his native city and later, with Reynolds as his teacher, at the Royal Academy in London, where he settled in 1788. There he dedicated himself to painting portraits of people from the well-to-do classes in the city, becoming the most important portrait painter after Thomas Lawrence, with a style reminiscent of both Lawrence's and **West**'s, because of its precision. For many years, he was also the court

Kabuki Theater Actor.
TOSHUSAI SHARAKU.

\int

Bathers at Dieppe.
WALTER RICHARD SICKERT.

riors of cafés, music halls, and theaters; as well as portraits. Whistler's influence led him to methods that were closer to **Post-Impressionism**. His constant use of dark colors and somber tones produced paintings that had a pessimistic feeling. In 1911, he founded the Camden Town group, from which an avant-garde independent art association was born. During the First World War, he settled in Bath and focused on studying light and atmospheric effects, as seen in the landscapes and views of Bath and Brighton that he painted. In the 1920s, he was a member and teacher at the Royal Academy in London, where he lived until his death. Among his works, the numerous *Views of Dieppe*, such as *Bathers at Dieppe*, and of Venice are worthy of note, as are *Café Concert* and *Young Girl*.

SIGNAC, PAUL

(Paris, 1863–1935)

A French painter, he formed part of the Neo-Impressionist group and was known for his Pointillist or divisionist technique. He began to paint at the age of nineteen, but did not fully dedicate himself to painting until 1882, through the influence of **Monet** and **Guillaumin**. In 1884, along with **Redon** and **Seurat**, he founded the Society of Independent Artists, a group joined by numerous painters of the era, who exhibited their works outside of academic and official circles, thus reviving the defunct Salon des Refusés. Upon Seurat's death (1891), he became the head of the Society for more than twenty years. At the exhibition organized in 1884, he was astounded when he viewed Seu-

portraitist. In 1800, he was elected to the Royal Academy and elected its President in 1836. Noteworthy works are the portraits of *Anthony Gilbert Storer, Queen Adelaide, Queen Victoria, William IV, Charles Keppel*, and his *Self-Portrait*.

SICKERT, WALTER RICHARD

(Munich, 1860–Bathampton, 1942)

A landscape painter, born in Germany, the son of a Danish painter residing in England. He is considered an outstanding representative of English **Impressionism**, although his artistic evolution tended to depart from this movement. His father started him out in painting, and in 1881, a scholarship enabled him to study in London, where **Whistler** encouraged him to learn engraving techniques and recommended him to **Degas**, whose work noticeably influenced him. After a trip to Munich, Vienna, and Milan, during which he devoted himself to painting in the open air, he began painting in a style very close to Impressionism, with which he had become familiar on successive trips to Paris. His favorite subjects were urban scenes of Vienna, Dieppe, and Venice; female figures; and the inte-

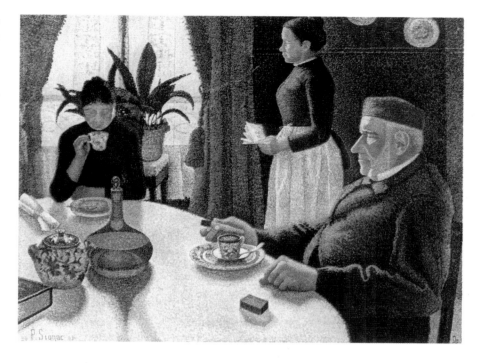

Breakfast.
PAUL SIGNAC.

rat's technique in the painting *Sunday Afternoon on the Island of La Grand Jatte*, a manifesto of divisionism, a slow and laborious process in which the painter, by means of countless dots and tiny brushstrokes in pure, juxtaposed colors, achieves their blending in the eye of the viewer. From that time onward, he applied this technique to all of his compositions, and became the group's theorist, writing a well-known text that was published in 1899: *From Delacroix to Neo-Impressionism*. The series showing the docks of Paris, the port

of La Rochelle, and the views of Saint-Raphael and Antibes, natural and urban landscapes that he en-

countered on his numerous and constant trips, are quite exceptional. For some years, he settled in

Leaving the Port of Marseilles.
PAUL SIGNAC.

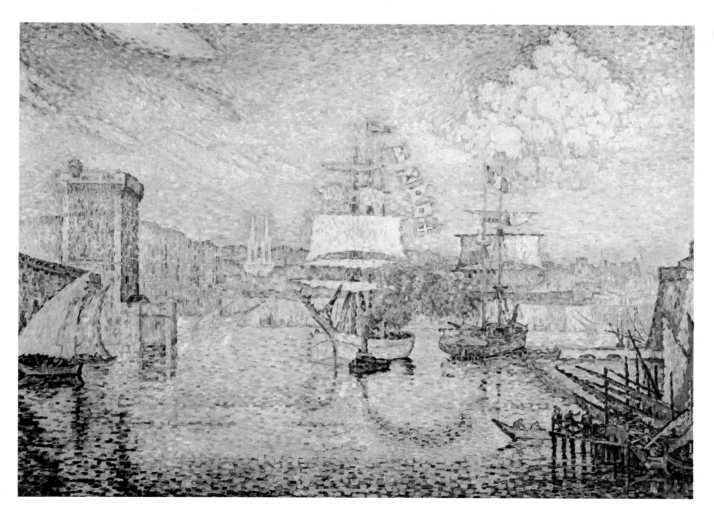

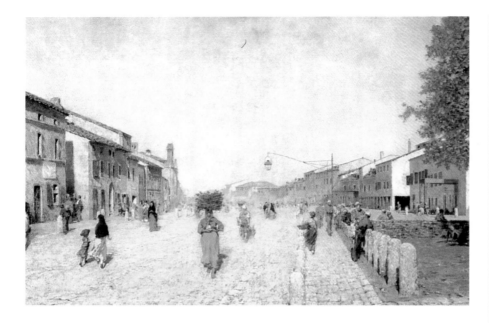

The Porta Adriana Suburb in Ravenna.
TELÉMACO SIGNORINI.

S

Saint-Tropez (from 1892 to 1911). His paintings are very lyrical; a sampling of the many he created would include *Notre-Dame de Paris, The Papal Bridge* (1912), *Le Pont Neuf, Le Pont des Arts* (1914), and *Antibes in the Afternoon* (1914).

Wheat Fields.
ALFRED SISLEY.

SIGNORINI, TELÉMACO

(Florence, 1835–1901)

An Italian painter, engraver, and writer, he was one of the main artists in the **Macchiaioli** group, apart from being the theorist and memorialist for that school of painting. He was an active politician in the Italian Risorgimento and a prominent supporter of Garibaldi, with a brilliant, restless temperament. He painted in the open air from the time he was very young, both landscapes and scenes showing marked realism, in thickly applied hues that contrast with certain somber motifs. In his genre scenes, he bordered on social criticism and established his position as a committed painter. His paintings *Old Market, Ravenna Gateway, The Ghetto, Riomaggiore* (1890), and *Sleeping Children*

∫

Landscape.
ALFRED SISLEY.

(1896) are of special interest, but his best-known work is *The Madwomen's Ward at San Bonifacio in Florence*, from 1865. His trips to Paris and London, and his encounters with Impressionist painters, caused his work to evolve towards a style closer to **Manet**'s.

SISLEY, ALFRED

(Paris, 1839–Moret-sur-Loing, 1899)

An Anglo-French painter, he is considered one of the artists with the purist style within the Impressionist art movement. He was born in Paris to English parents, and until 1870, painted only as a hobby. His friendship with **Monet** influenced his style, and he soon joined the Impressionists, showing his work at the group's first exhibition, which was organized in 1874 at the studio of the photographer Nadar. His works are simple compositions, usually landscapes, which show scenes from the

S

Saint-Martin Canal, Paris.
ALFRED SISLEY.

environs of Paris. All of the Île-de-France region is represented in his oil paintings, with delicate colors and pale light. His interest was focused on seeking atmospheric effects and studying the reflection of the sun on water or the brilliance and luminosity of snow. In this sense, his works *The Floods at Port-Marly* (1876), *Orchard with Trees in Bloom* (1877) and *Snow at Louveciennes* (1878) are significant. Other works are *The Seine at Saint-Mames, Bridge at Moret-sur-Loing,* and *Road During Snow Season.* In 1879, he settled in the small French town of Moret-sur-Loing,

until the end of his days. There he continued painting with a style that became affected, and acquired certain melancholy traits.

SOROLLA Y BASTIDA, JOAQUÍN

(Valencia, 1863–Cercedilla, 1923)

A Spanish painter linked to **Impressionism** and a representative of *plein air* ("open air") painting. He was from a family of craftsman, and his artistic training began in Valencia, where he attended the classes of the sculptor Cayetano Capuz. In 1878, he went on to study at the Fine Arts School of San Carlos. In

1881, he traveled to Madrid and became interested in the great Golden Age painters in the Prado Museum. A scholarship enabled him to go to the Fine Arts Academy in Rome in 1884 to continue his studies. One year later, he made his first trip to Paris and met the painters who worked in the open air, a practice that he took back with him to Spain, and that he assimilated during his stay in Biarritz, where he painted with **Beruete**. His early Academicism was, as a result, displaced by his growing interest in the effects of light. Among his first works, some with subjects that have a strong social content are of interest, such as *They Still Say That Fish is Expensive!* (1894), a painting that

Girl Coming out of the Bath.
JOAQUÍN SOROLLA.

brought him significant prestige in Madrid and Paris. While related to Impressionism, he gave this movement a personal interpretation, based on light as the absolute focal point, on color, and on depicting movement in his figures, captured in works such as *Girl Coming out of the Bath and Selling Fish. Children at the Beach* and *A Walk by the Sea*, painted in the first decade of the twentieth century, are clear examples of his preference for beaches and seascapes, especially of the Spanish Mediterranean coast, showing a skilled use of light, intense colors and very free brushstrokes. He left a profound imprint on Valencian

Selling Fish.
JOAQUÍN SOROLLA.

Postman in Rosenthal.
CARL SPITZWEG.

painters, even to the point where a "Sorollism" movement spontaneously sprang up. Among the honors he received, some important ones are his election to the French Academy of Fine Arts, as well as to the Academy of San Fernando in Madrid. In 1911, he was given a commission to decorate the building housing the Hispanic Society of America in New York with large mural paintings. To this end, he dedicated more than ten years to composing a large frieze showing the customs and festivals of the different regions of Spain. There are also numerous portraits in his abundant body of work. Without a doubt, the most important achievement of his career was the influence he had on Spanish painting through his innovative spirit, as well as the strong presence of light he brought to the gloomy atmosphere of the nineteenth century. In 1920, an illness definitively put an end to his creative work.

SPITZWEG, CARL

(Munich, 1808–1885)

A German painter, designer, engraver, and illustrator, he was the most prominent representative of Biedermeier **Romanticism**. He began his painting career quite late, and taught himself by viewing and copying the seventeenth-century Dutch masters. In his native city, he contributed illustrations and drawings, especially caricatures, to different periodical publications from 1830 to 1840. He also did small-format narrative paintings, in which he captured the everyday life of his

Beach at Boulogne.
PHILIP WILSON STEER.

city—especially among the bourgeoisie—in streets and squares, with a wealth of anecdotal details that demonstrated his excellent powers of observation. In these paintings, he portrayed the most typical people with a sense of humor, cheerfulness, and keen psychological insight, treating them kindly and gently, in simple compositions with nuances of light, harking back to the works of the seventeenth-century Dutch painters. He would later paint landscapes with a Romantic feeling, with pleasant colors and bold compositions, in which the influence of the **Barbizon School** can be seen, as well as **Díaz de la Peña** and **Delacroix**, and **Constable**, whose works he studied on trips to London and Paris. His achieved perfect atmospheric sensations in these paintings. Noteworthy works are *The Poor Poet* (1839), *Serenade* (from The Barber of Seville), *Postman in Rosenthal*, *The Cactus Friend* (ca. 1845), *The Love Letter* (1845–1846), *The Bookworm* (1852), *The Farewell* (1855), *Spanish Serenade* (1864), and *Rest at Dusk*.

STEER, PHILIP WILSON

(Birkenhead, 1860–London, 1942)

An English painter, trained in Paris at the Fine Arts School and the Julian Academy. His painting style was linked to the typical aesthetics of the years around 1900, with a clear influence from the eclectic, **Post-Impressionist** painter **Whistler**. He painted landscapes

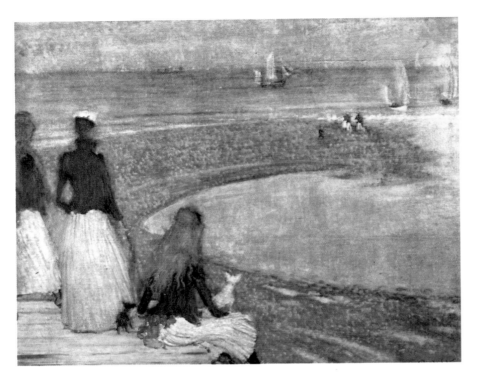

Beach at Walberswick.
PHILIP WILSON STEER.

George Washington.
GILBERT STUART.

and His Mother and *Mary Ann, Wife of Leonard Collman*, **Watts**' influence can clearly be seen.

STEVENS, ALFRED ÉMILE

(Brussels, 1823–Paris, 1906)

Belgian painter. Raised in a family of artists, he first received training in Brussels and in 1844, he settled in Paris, where he studied painting with **Navez**, and apparently with **Ingres**, and where he did nearly all of his artistic work. His paintings,

S

and portraits with luminosity and a decorative rhythm rich in color.

STEVENS, ALFRED

(Blandford, 1817–London, 1875)

English sculptor, painter, and designer. From 1832 to 1842, he studied in Italy, and there he met Thorvaldsen and worked with him at sculpting. He also observed and studied the work of the great masters of the Renaissance, especially Raphael. When he returned to London, he worked as a drawing and design teacher and from 1856 onward, he devoted himself to producing industrial designs, which would have a great impact. In painting, he primarily worked with portraits, in some of which, such as *King Alfred*

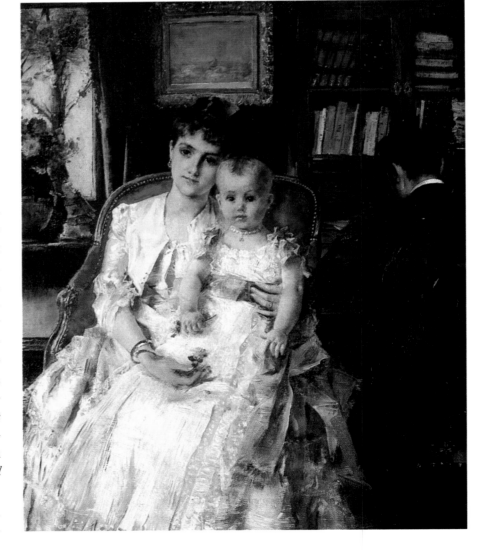

Family Scene.
ALFRED STEVENS.

Mother and Son.
THOMAS SULLY.

in which **Courbet**'s influence, so noticeable in his first paintings, is barely evident, despite the fact that **Realism** is maintained, especially in the careful and perfect treatment given to fabrics. He received many commissions and held some exhibitions of his work, such as the one in 1900 at the Fine Arts School. His painting was influenced by Japanese art, which was in fashion in his day, and he was one of the greatest enthusiasts, along with **Whistler**, of this country's art in its most decorative facet, the colored prints of the ukiyo-e school. His last works were coastal landscapes and seascapes, done in a freer, looser style, close to **Impressionism**. He influenced **Tissot** and **Sargent**. Especially interesting works are *Autumn Flowers* (1867), *Panorama of the Century* (1879–1889), which no longer exists, and *Entering the Dance*.

STUART, GILBERT

(North Kingston, Rhode Island, 1755–Boston, 1828)

An American painter and a prominent portraitist. From 1775 to 1792, he lived in London, where he had gone to study with **Benjamin West** and to paint portraits in the European tradition, which he later made popular among his American colleagues. In his portraits, he accurately reflected the image of the society of the times. His style, characterized by his meticulousness of detail, the exquisite treatment of drapery, and by his fondness for brilliant colors and loose, thick brushstrokes applied directly onto

which depict the court and bourgeois environment of French society, were within the Realist style that was in vogue at the time, the glory days of the Second Empire. They were very popular from 1860 onward, especially those showing interiors with young bourgeois women,

the canvas, caused him to be in great demand as a portrait painter, along with Thomas Gainsborough and Sir Joshua Reynolds. He was strongly influenced by both men in his art, as he was by the English school of the eighteenth century in general. In his work, he sometimes succeeded in creating surroundings that supported a certain psychological vision of the sitter. The fame he achieved during his stay in London followed him when he returned to America in 1793, where he worked in Philadelphia, Washington, and Boston. He was immediately welcomed as the portraitist for high society. Among his works, the portraits he made of *Mrs. Richard Yates, Reynolds*, his *Self-Portrait, Benjamin West, Mrs. Perez Morton, John Henderson, John P. Remble, W. Woollett, Robert Shaw*, and *Burton Conyngham* are among his finest, as is the series of likenesses he did of *George Washington* beginning in 1795.

Spring Dance.
FRANZ VON STUCK.

the last years of the nineteenth century.

STUCK, Franz von

(Tettenweis, 1863–Munich, 1928)

A German painter and sculptor, he was one of the artists who formed part of the Viennese *sezession* ("secession") group founded by **Klimt**. Trained at the Munich Academy (1882–1884), he followed the style of this Viennese creator by painting pictures with obvious symbolic and allegorical content, such as *Sin, War*, and *Expulsion from Paradise*, as well as mythological compositions reminiscent of the pictorial style of the Symbolists (*The Amazon, Medusa*, and *Orestes*), within the decadent spirit that characterized

SULLY, Thomas

(Horncastle, 1783–1872)

A painter of English origin. At an early age he moved with his family to the United States, where he began his artistic training in New York City, working with **John Trumbull** and **Gilbert Stuart**, as well as other American painters. He later completed his training in London in 1809, under the guidance of **Benjamin West** and the portraitist **Thomas Lawrence**, from whom he inherited his delicate coloring and loose brushstrokes. In 1811, he settled in the city of Philadelphia, where he painted a good many personalities, among

them Presidents Thomas Jefferson, James Madison, and Andrew Jackson, Because of these, he was revealed as the most brilliant American portraitist from among those who had been influenced by Gilbert Stuart in the first half of the nineteenth century. In his portraits, in which the **Realism** used in the portrayal of his sitters is noteworthy, there is already a Romantic tone in his use of color, with which he suggests feelings of melancholy and a certain dreamy air. Notable examples are the portraits of *George Frederick Cooke, Thomas Jefferson, Queen Victoria, General Lafayette* and *The Student*. He also painted pictures on historical subjects. The main work of this type is *Washington Crossing the Delaware*.

Portrait of Ángela Tejeo.
RAFAEL TEJEO

TEJEO, RAFAEL

(Carava, 1798– Madrid, 1856)

A Neoclassical Spanish painter, trained at the Fine Arts Academy of San Fernando with **Aparicio**. In 1822, he moved to Rome, where he lived until 1827. His first compositions were on religious subjects, although he also painted works using mythological and historical themes. Paintings such as *Last Communion of St. Jerome* and *Hercules and Antheus* reveal his style, which employs strong draftsmanship but is cold and academic. From 1846 until his death, he dedicated himself com-pletely to portraits; this work is clearly Romantic and was very successful among the bourgeoisie of Madrid.

THOMA, HANS

(Bernau, 1839–Karlsruhe, 1924)

A German painter, lithographer, and engraver. He studied at the Art School in Karlsruhe and was a pupil of Johann Wilhelm Schirmer, among other teachers. Later, he worked in Düsseldorf, before leaving for Paris in 1867, where he met the great masters of the times, **Courbet** among them. Courbet's work attracted and influenced him, especially in his youth, as did the landscape painters of the **Barbizon School**, although ultimately Thoma's style became more lyrical and romantic than theirs. Later, around 1870, he established residence in Munich and began one of the most productive periods of his artistic life. In this city, he met the landscape artist William J. Müller, who had a significant effect on his later landscapes, as well as **Friedrich, Richter**, and **Schwind**. He became fully caught up in the nationalistic spirit of German **Romanticism**, developing a taste for legendary subjects. In addition, he painted landscapes combining **Realism** and Idealism, with a poetic and romantic touch, and in which fantastic beings sometimes appeared beside real ones (*Black Forest Landscape with Goats*, 1872; *The Waterfall*, 1875). In his treatment of peasants especially, he shows an original type of Naturalism which is very austere while depicting the simplest and most primitive feelings with great skill, as can be seen in *The Corral* (1870), *Grandmother's Lesson* (1878), and *Village Violinist*. This made him one of the most important representatives of this movement in his country. In Munich, he also met **Böcklin** and **Leibl** and, influenced by them, painted allegories, such as *Children Dancing in a Ring* (1872). In 1874, he traveled to Italy, where he studied the work of the great masters of the Renaissance, whose influence was added to those he had already received, producing a style in which the figures are too static but filled with poetry and mysticism. In 1876, he moved to Frankfurt, where he continued working with mythological themes, so popular at the time, as well as with religious subjects, to which his style lent it-

self so well (*Christ in the Garden of Gethsemane*, 1889). In 1899, he was appointed teacher at the Fine Arts Academy in Karlsruhe, and later, director of the museum in that city. Within his extensive output, which covered all genres, there are even excellent illustrations and murals. His work bordered on Modernism and Symbolism, a movement which had great impact in Germany. He reproduced most of his paintings in lithographs and etchings to make them more accessible to people of more modest means. Among his numerous works, some outstanding ones are *The Artist with His Mother and His Sister* (1866), *In the Sunshine* (1867), *The Poet Martin Greif, Young Man at the Railing, At Lake Garda*

View of the Rhine at Laufenbour.
HANS THOMA.

(1866), *View of the Rhine at Laufenbour* (1870), *Spring Idyll* (1882), *Cupid on a Bird* (1885), *Self-Portrait, Solitude* (1898), *Birth of Christ, Temptation of Christ*, and *Flight into Egypt.*

TISCHBEIN, FRIEDRICH AUGUST

(Maastricht, 1750–Heidelberg, 1812)

A German painter, a portraitist in various Central European courts, his final works can be classified as **Neoclassical**. He belonged to a large family of painters from Essen. His

Goethe in the Roman Campagna.
JOHANN HEINRICH WILHEILM
TISCHBEIN.

Portrait of James Tissot.
EDGAR DEGAS.

first teachers were his father, Johann Valentin Tischbein and his uncle, Johann Heinrich **Wilhelm Tischbein**, the court portraitist. His trips and stays abroad exposed him to Classicism, especially in Rome, where he met Mengs and **David**, as well as English portraitists living there who would influence him throughout his career. Upon his return, he worked in Kassel, Dessau, and Leipzig as an innovative portraitist to the family of the crown prince of Weimar. Among his portraits, those of *Christiane Amalie of Anhalt-Dessau, Duke Karl August of Saxony-Weimar*, and *Countess Theresia Fries* are considered excellent. In

1800, he was appointed director of the Academy in Leipzig.

TISCHBEIN, JOHANN HEINRICH WILHELM

(Haina, 1751–Eutin, 1829)

A German painter and engraver and the nephew of Johann Heinrich Tischbein, a painter of court portraits, his work encompassed portraits, landscapes, and historical paintings. His best-known work is *Goethe in the Roman Campagna*, a portrait of the writer in a natural setting, in an attitude typical of ancient times, wearing very theatrical clothing. It was painted in 1786–1787 in Naples, where he was appointed director of the Academy. In 1800, he settled in Hamburg, and in 1808, in Eutin, went to work in the service of the Duke of Oldenburg. His engravings and drawings are of interest and were inspired by the ancient classics.

TISSOT, JAMES

(Nantes, 1836–Bouillon, 1902)

French painter and graphic artist. He was a pupil of **Flandrin** and Louis Lamothe. His first works, most with historical subjects that he romanticized and medievalized, were exhibited at the 1859 Salon. Later, from 1864 until the end of the 1870s, his favorite subjects would be delicate scenes showing the everyday life of the high society of the times, with women playing an important role and dressed in the latest fashions. These works, such as *Ball on Shipboard* (1874), were in great demand by the public. In

The Artists and Their Wives.
JAMES TISSOT.

1871, he was forced to exile himself to London, where he also achieved great fame through his worldly paintings, in which he portrayed the upper classes of society with a realist and elegant style and without any intent to criticize or reform. Of special interest is the treatment he gave to the rich fabrics of his subjects' gowns. Beginning in 1880 he also achieved great renown as a portraitist and as a humorous caricaturist, contributing to the magazine

Vanity Fair. In 1882, he returned to France and and executed and exhibited a series of paintings in Paris, *Women in Paris*, whose theme was Parisian women and their different lifestyles. However, in 1888 he underwent a type of conversion, after which he dedicated himself to religious painting, especially subjects from the Bible, both in oils and in

Annie Hall.
JAN TOOROP.

gouaches, whose fame reached over to the other side of the Atlantic.

TOOROP, JAN

(Poerworedjo, 1859–The Hague, 1928)

A Dutch painter and engraver, trained at the Fine Arts Academy in The Hague. He traveled around France, England, Italy. Holland, and Belgium, where he met the painters **Khnopff** and **Ensor**. At first, his work corresponded to the Impressionist movement—a phase in which he produced *Strolling Musicians in the Streets of London* — but later, his subject matter was

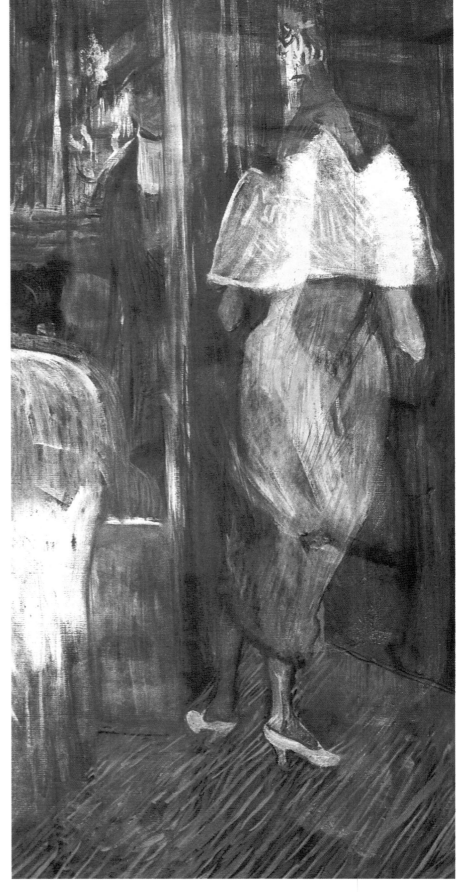

Woman Wearing an Evening Gown.
HENRI DE TOULOUSE-LAUTREC.

mainly religious and related to the Symbolist and Modernist movements. *Venus in the Sea* and *The Garden of Pain* are representative of this time in the artist's career. Toorop was awarded a gold medal at the Universal Exposition of 1900. He was also a good portraitist and painted *Madame van Zuylen, Madame van Nyevelt*, and *The Artist G. Vogels.*

TOULOUSE-LAUTREC, HENRI-MARIE-RAYMOND DE

(Albi, 1864–Malromé, 1901)

A French painter, draftsman, and illustrator. He is celebrated for his skill at painting subjects showing the worldly and bohemian life of Paris. In addition, his original creativity in the area of advertising posters—he was a true master in this genre— made him a revolutionary artist, a model and source of inspiration for Art Nouveau and the painters of the first third of the twentieth century, among them the Expressionists and, especially, Pablo Picasso. Coming from an aristocratic family, he spent his childhood

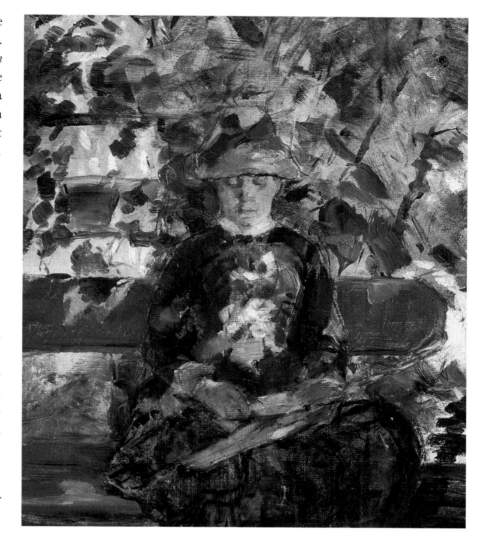

at Viaur castle and studied with a private tutor and in a Parisian secondary

Countess Adèle de Toulouse-Lautrec.
HENRI DE TOULOUSE-LAUTREC.

school. Apart from being sickly by nature, he suffered two falls from horses during adolescence that caused various fractures in his legs. As a result, they atrophied and as he grew, his anatomical development was irregular, causing him to be deformed, almost a dwarf. A great draftsman, he was interested in painting and had a psychological perspective of isolation and loneliness. He went to Paris in 1881 to briefly train in several ateliers, apparently always helped finan-

Left: *The Passenger in Cabin 54.*
Right: *Nouveau Cirque.*
HENRI DE TOULOUSE-LAUTREC.

Moulin Rouge: La Goulue.
HENRI DE TOULOUSE-LAUTREC.

a resident of the popular entertainment district of Montmartre in Paris and an assiduous habitué of cafés, cabarets, brothels, and theaters. Here he captured the amusing and frivolous life of society with his very lively pencil and pen, expressing the weaknesses, poetry, and irony of many people in that bohemian milieu, filled as it was with artists, singers, and people living on the fringe, as well as wealthy clients and comrades. His pictorial activity was vast and varied, as far as the media he used were concerned, using canvas, paper, cardboard, and even boards as surfaces, with either oils, pastels, charcoal, or even pencil that was sometimes finished with areas of color. Among his works, which were always executed with precise and agile draftsmanship, *Messalina* and *Monsieur Boileau at the Café* (1893) are outstanding. However, it was in color lithography, which had recently been discovered, where his true innovation was felt. When

La Grosse Maria.
HENRI DE TOULOUSE-LAUTREC.

cially by his mother, his great protector at some of the most dramatic times of his life. He saw **Cézanne**'s work and met **Degas** and **Van Gogh**—whose paintings filled him with enthusiasm—and was fascinated by the recently discovered Japanese prints, which had a decisive impact on his work. In the decade of the 1880s, he exhibited with the Belgian group The Twenty and made drawings and lithographs for the *Revue Blanche*. From 1885 onward, he was

The Two Girlfriends.
HENRI DE TOULOUSE-LAUTREC.

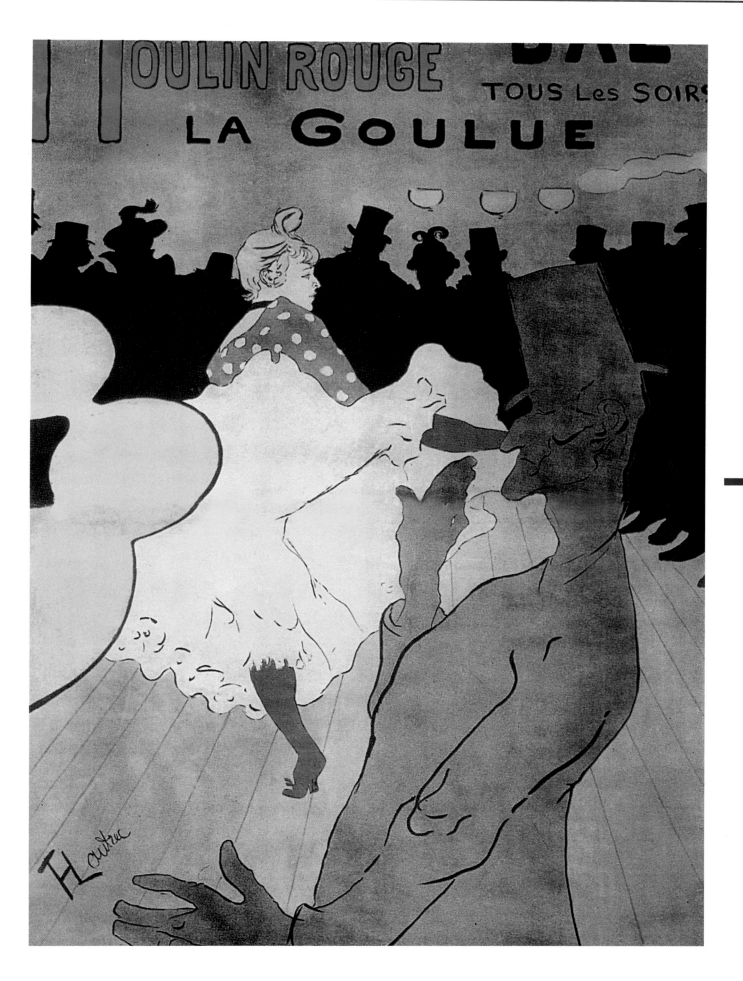

T

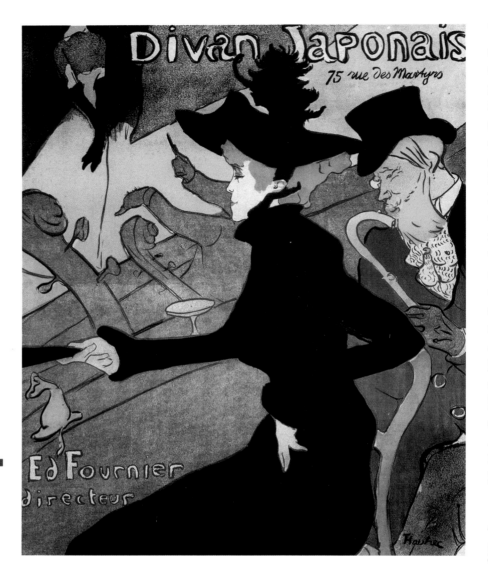

Le Divan Japonais.
HENRI DE TOULOUSE-LAUTREC.

the famous Moulin Rouge café was opened, his famous poster *Equestrienne at the Circus Fernando* (1885) was at the entrance. It was done at a time when he was interested in races, even bicycle races. *Moulin Rouge: La Goulue* was one of his masterpieces. From 1890 onward, he established his residence in a luxurious brothel, and there he studied his favorite subject: women. From these years, his works on canvas and cardboard *Le Divan Japonais, The Medical Inspection,*

A la Bastille (Jeanne Wenz).
HENRI DE TOULOUSE-LAUTREC.

Woman Pulling up Her Stockings, Marcelle, and *The Two Girlfriends* are exceptional images. His advertising posters are testimonials to his genius for capturing the motion in a dance step or an acrobatic exercise, the essence of the "affiche" pieces that today are coveted by collectors. Among his trips, those he made to Lisbon, Madrid, and Toledo should be mentioned. He began to sell his paintings in 1899, the year when his excesses with drink caused some serious medical crises that required his admittance to a clinic in Neuilly. He took advantage of a two-month convalescence period to compose a series of drawings, with colored pencils, that he called *At the Circus.* He left the clinic apparently restored to health, but still ill, and created *Examination at the Paris Faculty of Medicine.* In August 1901, he suffered another health crisis. After a period of agony, he died at the age of thirty-seven.

TRESGUERRAS, FRANCISCO EDUARDO

(Celaya, Guanajuato, 1759–1833)

Mexican architect, engraver, and painter. Before dedicating himself primarily to architecture after becoming familar with the work of Reanaissance architect Giacomo da Vignola, Tresguerras acquired basic knowledge in painting from Mexican masters. His work as a painter, within the Neoclassical style, was well received by the public at a very early date, allowing him to enjoy great popularity in his day. He did portraits, landscapes, and religious subjects, both in paintings, such as *St. Anne and the Virgin as a Child,* and in frescoes, such as those in the chapel of the Brothers of Celaya.

TROPININ, VASILI

(1776–1857)

A Russian painter, of Ukrainian origin. Very little is known about the education and life of this artist except the important role he played in pictorial art in Russia in the nineteenth century. He was a serf of Count I. I. Morkov, but because of his aptitude as a painter, he was allowed to freely attend the Fine Arts Academy in St. Petersburg. This, along with his study of the works of Jean-Baptiste Greuze—of which he made multiple copies—and other European painters, perfected his style, allowing him to attain high levels of quality in his work. In 1823, the count set him free and because his work was held in high esteem, he was made an academician and settled in Moscow. His work shows marked Classicism, and the naturalness and objectivity with which he treated portraits and, above all, popular scenes (*Girl with a Pot of Roses*) are remarkable. It is, furthermore, interesting to note his avoidance of artificiality and his classicist and traditional tone, even though chronologically he was working squarely in the Romantic period. He was an important portraitist who captured his subjects in a serene state. They are perfectly finished with benevolent gentleness showing in their features, and the verism of their likenesses allows their social position, more than their own qualities as individuals, to be glimpsed (*General Nechliond-off; Bulakov*, 1823). From 1820 on-ward, certain Romantic traits can be seen, such as in *A. S. Pushkin* (1827). Other pictorial works are *Old Man's Head, Girl with a Doll, The Lace Maker, A Hunter, L. S. Borodska*, and his son *Gal*.

Self-Portrait in the Window.
VASILI TROPININ.

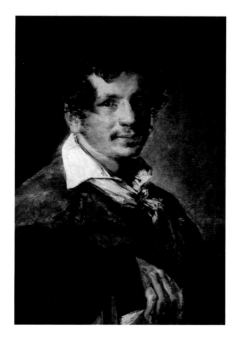

Portrait of Bulakov.
VASILI TROPININ.

TROYON, CONSTANT

(Sevres, 1810–Paris, 1865)

A French painter, he was the first painter of animals of his era. He

learned to draw at the Sèvres porcelain factory and later studied with Victor Bertin, a historical painter. In around 1830, he began painting landscapes, depicting the environs of Paris, Normandy, and Tourain. His fondness for studies of nature led him to make contact with the landscape painters of the **Barbizon School**, of which he was soon considered one of its most notable members. Later on, he decided to insert enormous domestic animals, especially cattle, into his landscapes, inspired by the Dutch animal painters Aelbert Cuyp and Paulus Potter, whose works he saw on a trip to Holland in 1847 (*Return to the Farm*, 1859). His last works were seascapes, painted very freely, which had an influence on **Manet** and **Boudin**. His style was naturalistic, with confident execution and wonderful color, enabling him to produce an abundance of paintings, due to the skill with which he worked.

TRUMBULL, JOHN

(Lebanon, Connecticut 1756–New York City, 1843)

An American historical painter. A pupil of **Benjamin West**, he was perhaps the man who was most responsible for introducing new art movements from Europe to his country. Born into an affluent family, he found it easy to obtain meticulous training in the field of painting, to which he had been attracted from a very early age, and for which he showed great talent. He even

Major William Lithgow.
JOHN TRUMBULL.

painted a picture while he was at school, *The Battle of Cannas*, in which his artistic abilities can already be seen. In 1773, he finished his studies and later was involved in the Revolutionary War (1775–1783), serving for four years as George Washington's assistant. The result of this experience were the

paintings in which he immortalized the figures who had taken part in that war. He exalted and glorified them in a manner that was typical of the nineteenth century in the United States, in which the Revolutionary War and those who fought in it held a privileged position. In 1780, before the American Revolution was over, he traveled to London, where his previous involvement in the war caused him to be viewed with suspicion and accused of espionage against Great Britain, who was fighting to retain her colonies. There, he studied in the atelier of West, from whom he acquired his vision of historical painting which he would practice throughout his career. Through his family, he was appointed director of the Fine Arts Academy of Pennsylvania when he returned to his own country. He painted his first great historical work in Paris, *Declaration of Independence*, and after that produced a large

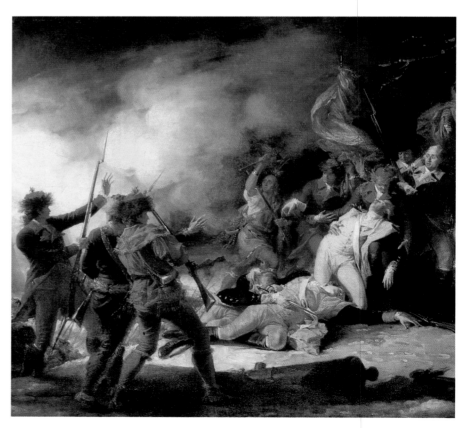

Death of General Montgomery at Quebec.
JOHN TRUMBULL.

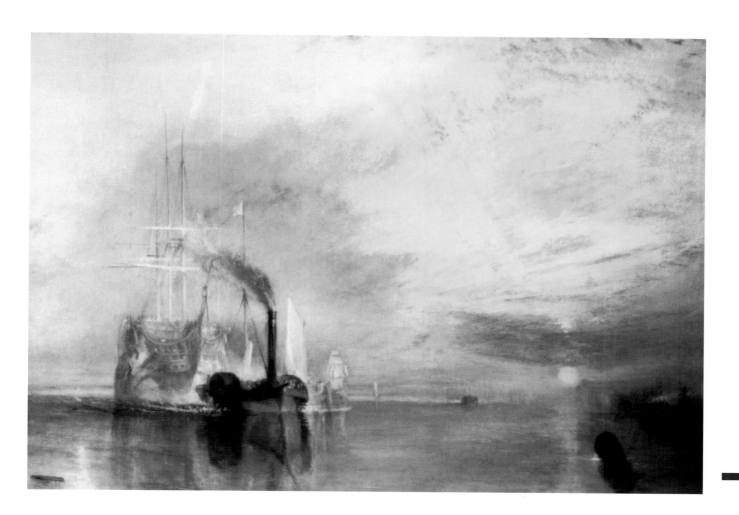

number of paintings, of which *George Washington Resigning His Commission to Congress; Annapolis, Maryland; Surrender of General Burgoyne;* and *The Battle of Bunker Hill* are outstanding and well-known examples. In these paintings, the main characteristics of his work are evident: excellent composition and color and accentuated Realism. In around 1786, he did a series of studies for murals, characterized both by the complexity of their composition, in which the influence of Rubens can be seen, and by his treatment of light, inherited from West, as well as the marked Realism taken from John Singleton Copley. Like most of the contemporary painters in his country, he also did some portraits, examples of which are the ones of *George Washington, The Duke of Wellington*, and *Jonathan Trumbull.*

TURNER, JOSEPH MALLORD WILLIAM

(London, 1775–Chelsea, 1851)

An English painter, he is considered one of the greatest landscape artists of all time. His pictorial power had a great impact on later artists, especially the Impressionists. The son of a barber in London's Covent Garden area, his vocation came to light very early, for by the age of nine, he had already begun to exhibit drawings and paintings in his father's barbershop. His interest in landscapes and nature was also evident early on, possibly due to the countryside around the rural the town of Brentsford, where he spent time for reasons of health. At the age of fourteen, he became an apprentice at the studio of a topog-

The Fighting 'Temeraire' Tugged to Her Last Berth to be Broken Up.
JOSEPH WILLIAM TURNER.

rapher, a famous watercolorist with whom he stayed for a year, learning to love nature by studying the land and landscapes. He enrolled in the Royal Academy in 1789 and was a student of **Ruskin**. However, academic training did not leave a lasting mark on him. He was self-taught for the rest of his life, and his learning was based on observation and sketches from life, studies that he transferred into his paintings with very little prior drawing. On the contrary, he emphasized the validity of color as the main element in art. These were characteristics that were absolutely unheard of in those days, the last decade of the eighteenth century, when he

Rain, Steam and Speed.
JOSEPH WILLIAM TURNER.

painted his first work, *Moonlight on the Thames*, and later, *Buttermere Lake*. In both paintings, the characteristics typical of his work can be seen: an imaginative approach to the use of space; and his study of light, of the phenomenon of light, both natural and artificial. At the advice of the English painter Joshua Reynolds, he began to study classical landscapes and painters such as Claude Lorrain and Nicolas

Tours: Sunset.
JOSEPH WILLIAM TURNER.

Keelmen Heaving in Coals by Moonlight.
JOSEPH WILLIAM TURNER.

Poussin, artists he discovered when he made his first trip to the continent in 1802, a trip he repeated in the second and third decades of the century. France, Holland, Belgium, the Rhine Valley, and Italy provided him with a series of museums to study, and new scenery to capture, such as the snowy mountains of the Alps, the mists and rain of the French coasts and the Low Countries, or the luminous tranquility of the South. Most of his mountainous landscapes were a result of these travels, such as *Snow Storm: Hannibal and His Army Crossing the Alps*, exhibited in 1812 and painted with a heroic vision of nature, nature that man cannot dominate because of its overwhelming pow-

Venice.
JOSEPH WILLIAM TURNER.

er. This painting summarizes the two components that are integrated into his work: on the one hand, a direct depiction of nature, studied through his sketches and observations; and on the other, his interest in historical and poetic subject matter, as in his compositions *Ae-*

neas and the Sibyl, The Fifth Plague of Egypt, Dido Building Carthage, and *Ulysses Deriding Polyphemus*, works that should be included within the category of heroic landscape. Swirling snow or rain storms and lightning, thick fog pierced by sunlight, or raging seas are his fa-

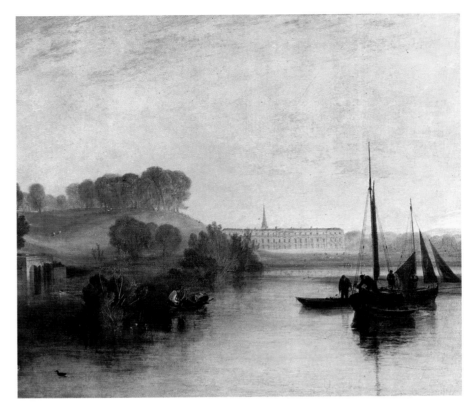

Petworth: Dewy Morning.
JOSEPH WILLIAM TURNER.

The Dort Packet-Boat from Rotterdam Becalmed.
JOSEPH WILLIAM TURNER.

vorite atmospheric and natural events, which he captures in compositions with elaborate chromatic effects. He painted a series of pictures dedicated to tempests, at the same time as his attraction continued for mountainous landscapes. *The Battle of Fort Roch in the Val d'Aosta* (1815) is an expressive example of Turner's contribution to Romantic landscapes. The knowledge of color acquired from the Venetian school, as well as the light of Rome and Naples, lightened his palette and caused him to abandon his taste for dark and gray tones. This is evident in his Italian creations, such as *View of Orvieto* (1828), *The Grand Canal: Venice* (1835), and *The Environs of Venice* (1835). An oil painting done to-

ward the end of his career, known as *Rain, Steam and Speed* (1844), may offer even more interest, as it was one of the first landscapes of the industrial age and achieves a fusion of nature and machines, as it captures fog to perfection, a natur-

al element that blends with the dynamic movement of the train and its man-made steam. Although his work favorably impressed his contemporaries, he remained aloof from opinion, and critical comments never mattered to him. He clung to his style, with a tenacity recognized by Ruskin, who dedicated significant praise to him in his work *Modern Painters* (1843). Other noteworthy examples of his work are *Slavers Throwing Overboard the Dead and Dying* (1842) and *Heidelberg* (1846). He lived the last years of his life afflicted with gout, secluded in the town of Chelsea on the banks of the Thames, painting the landscapes he saw around him, which he put through the sieve of his own personal vision. **Pissarro** and **Monet**, like many other artists, felt they had found the true language of modern painting when they discovered his work.

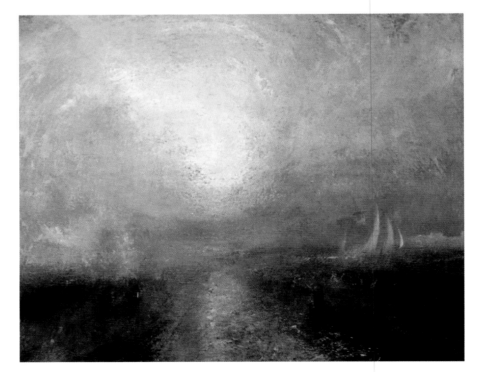

Yacht Approaching the Coast.
JOSEPH WILLIAM TURNER.

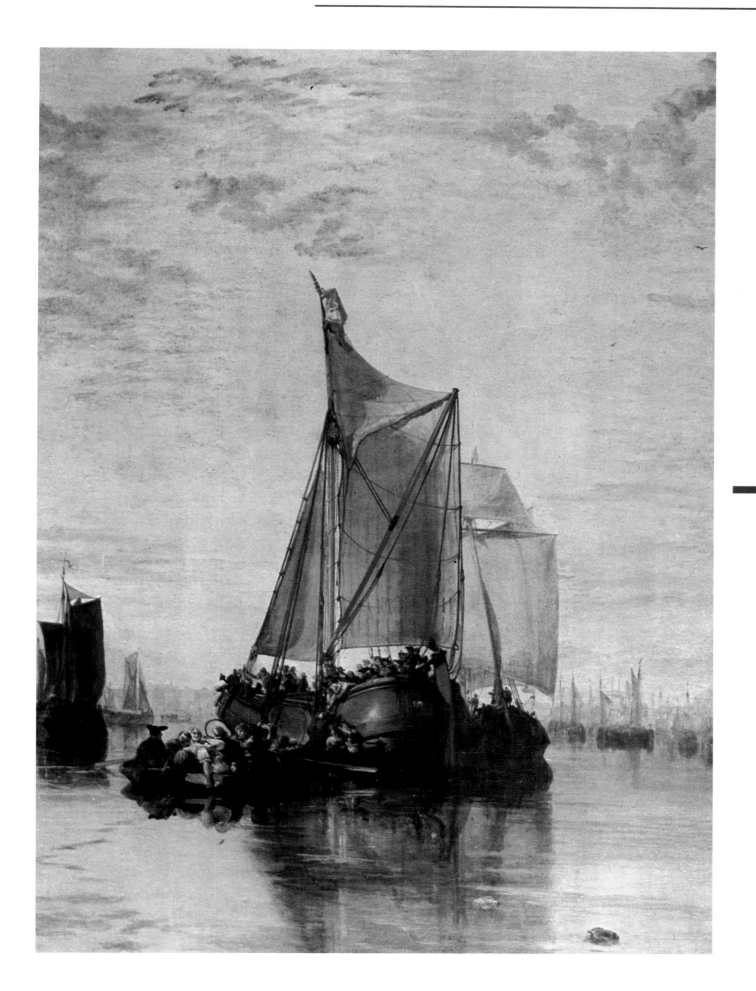

Woman Peeling Potatoes.
Fritz von Uhde.

UHDE, Fritz von

(Wolkenburg, 1848–Berlin, 1911)

A German **Impressionist** painter. In 1866, he began his studies at the Fine Arts Academy in Dresden, but he really did not begin painting until the age of twenty-three, when he did historical paintings, influenced by **Makart**. In 1880, he settled in Munich, where he joined the *sezession* ("secession") group in that city, headed by the painter **Stuck**, which was against the academic historicism of the times and sought the perfect synthesis of all arts. He met **Liebermann**, whose way of painting in the open air he imitated, practicing it with enthusiasm until the end of his life. At this point, he could be considered an Impressionist. He painted genre, historical, and religious pictures, treating the latter in the manner of scenes of customs and manners, with a great sense of Realism and with rather loose brushstrokes; they were very well received by the public. Noteworthy works of his are *Noli Me Tangere, Supper at Emmaus, St. Joseph and the Virgin, Suffer the Little Children to Come Unto Me, Young Tobias*, and *Landscape at Nightfall*.

VALLOTTON, Félix-Édouard

(Lausanne, 1865–Paris, 1920)

French painter and engraver, of Swiss origin. In 1882, he went to Paris and studied with Lefebvre at the Julian Academy, where he met **Bonnard**, Édouard Vouillard, **Denis**, and Charles Maurin, who was a Symbolist. He exhibited for the first time at the age of twenty, at the 1885 Salon; these first works showed the influence of **Manet** and **Courbet**. However, his style later moved towards **Pointillism**, and later in 1892 he joined the **Nabis**, taking on that group's characteristics, which he would retain, with small modifications, until the end of his life. His style was then characterized by simplification, which at times became schematism, of both the composition and the elements of the painting, as well as by the uniformity of light and by a bold Neo-Primitivism in his landscapes. From 1894 onward, he began to work as an engraver and illustrator of books and magazines. Starting in 1900, by now internationally known, he exhibited work at all the salons. In these pieces, whose primary subject matter was everyday life, he experimented with a new form of expression, in accordance with highly realist formulas, producing an almost Hyper-realism. This was very close to Objectivism and many times fully with-

Madame Vallotton's Toilette.
FÉLIX VALLOTTON.

in a caricaturesque style. Beginning in 1911, he spent two years traveling around Germany, Italy, and Russia; in the latter country, he painted numerous pictures of its cities (*Ansicht des Kremlin Moskau*, 1913). Apart from his paintings, which were symbolic in nature as well as decorative, and at times steeped in mystery, his woodcuts must also be mentioned, some of which are very sarcastic. In these, he critized the hypocrisy of the bourgeois class and in a series about the Great War, he harshly attacked Germany's bellicose position. Among his limited work, *Interior, Self-Portrait, The Honfleur Estuary, It's War!, Madame Vallotton's Toilette*, and *Summer Afternoon Bath* are worthy of mention.

VAN GOGH, VINCENT

(Groot–Zundert, 1853–Auvers-sur-Oise, 1890)

A Dutch painter, he was one of the four most significant painters of the Post-Impressionist generation, along with **Seurat, Gauguin**, and **Cézanne**. His highly personal and anguished works had a definitive influence on French Fauvism and on the development of the European **Expressionist** movement. He was born into a very religious family; his father was a Protestant minister, and his first vocation was to become a missionary. He began to work for an art gallery, with locations in The Hague and Paris, where he stayed

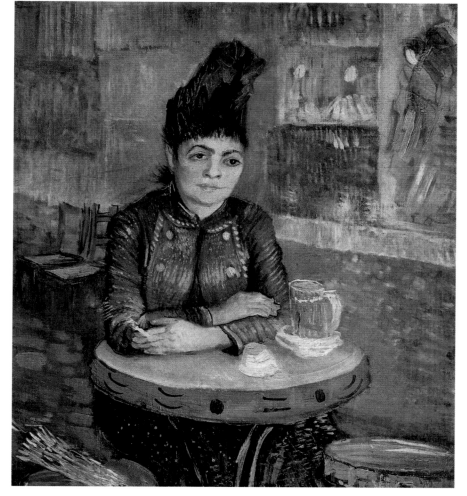

Agostina Segatori in the Café du Tambourin.
VINCENT VAN GOGH.

V

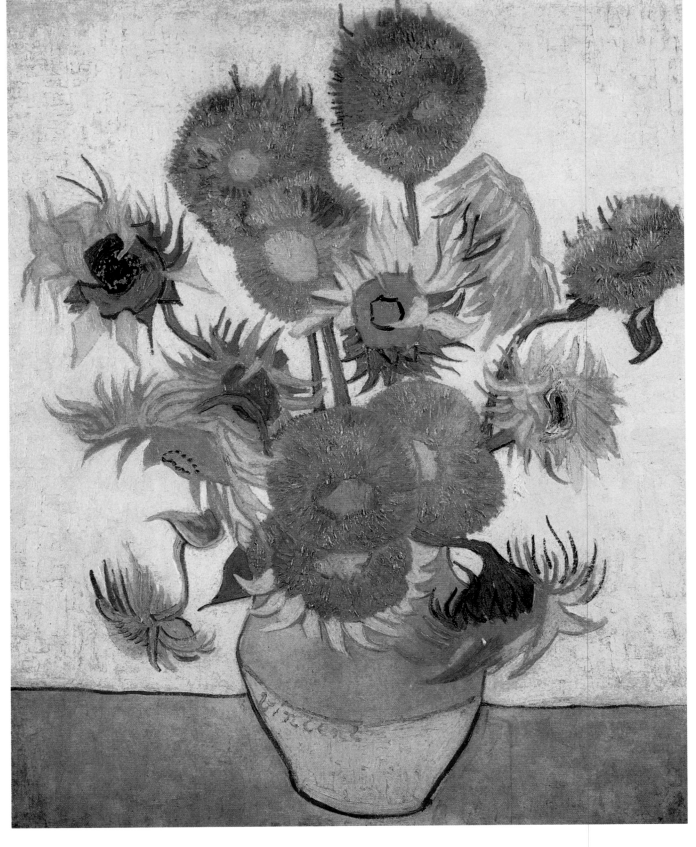

Above: *Fourteen Sunflowers in a Vase.*
Right: *The Café Terrace on the Place du Forum, Arles at Night.*
VINCENT VAN GOGH.

for seven years. In 1878, he began studying theology, but he did not graduate, due to his overly mystical determination to follow in "Christ's footsteps." However, his desire to save souls and help the poor led him

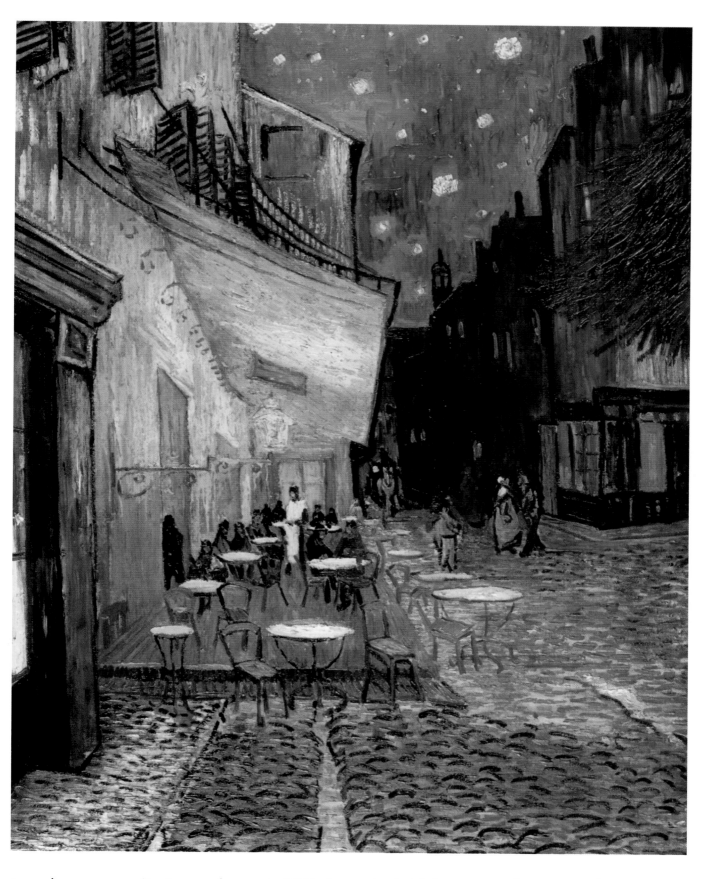

V

to work as an evangelist in one of the poorest mining areas in Belgium, from which he was driven out in 1880, the year he decided to become a painter. He began his artistic career with the moral and financial support of his brother, Theo, with whom he maintained continuous correspondence

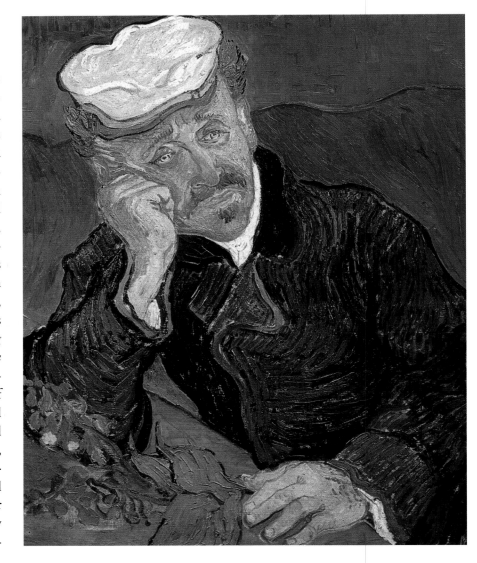

Portrait of Dr. Gachet.
VINCENT VAN GOGH.

V

throughout his life. These hundreds of letters have become an instrument for first-hand research and a detailed manifesto of the painter's ideas and artistic goals. He spent a few months in 1880 living in Brussels with his parents. Later, between 1881 and 1885, he lived in Holland and painted and the year after that, he studied at the Antwerp Academy. His first drawings are from this period and show impeccable skill in delineating images of peasants, weavers, and humble folk. His drawing of *Peasant Woman Gleaning* (1885) and his paintings *Head of a Peasant Woman* (1885) and *The Potato Eaters* (1885) are examples of Rembrandt's influence on him and his interest in chiaroscuro and monochromatic, somber tones, traits that are also found in the **Barbizon School**. In 1886, he moved to Paris to live with his brother Theo, whose profession as a gallery owner enabled him to meet the Im-

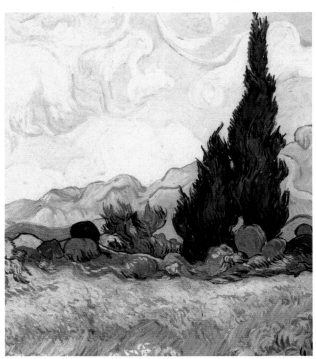

Wheat Field with Cypresses.
VINCENT VAN GOGH.

pressionists and Post-Impressionists. He struck up a friendship with Gauguin and lightened his palette with more vivid and luminous colors. Examples of some works from his time in Paris are *The Restaurant de la Sirène* and *Gardens on Montmartre Hill*. He had an extraordinary passion for color which led him to look for light and sun in the south of France. He moved to Arlés, in Provence, in 1888, and there he found his true style, a reflection of his anguished and depressive nature, but also of his revolutionary interpretation of color. That same

year, he was visited in Arles by Gauguin, but they began to argue, quarreling about their different visions of painting. He suffered his first bout of insanity, cut off his ear, and voluntarily committed himself to an asylum for a few months. Van Gogh tried to express his state of mind through color, and he did so through thick paint, with agitated brush strokes and sinuous, light draftsmanship that at times became swirling and twisted, giving his compositions a hallucinatory vision of landscapes and figures. *The Night Café in the Place Lamartine in Arles*

Girl in White.
VINCENT VAN GOGH.

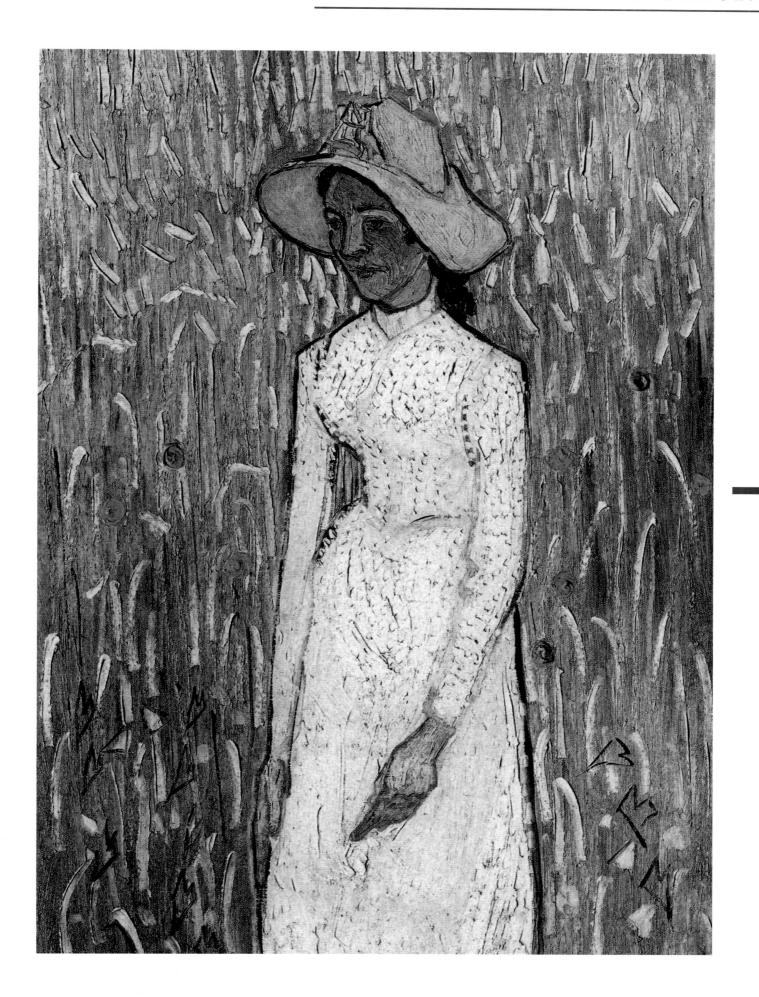

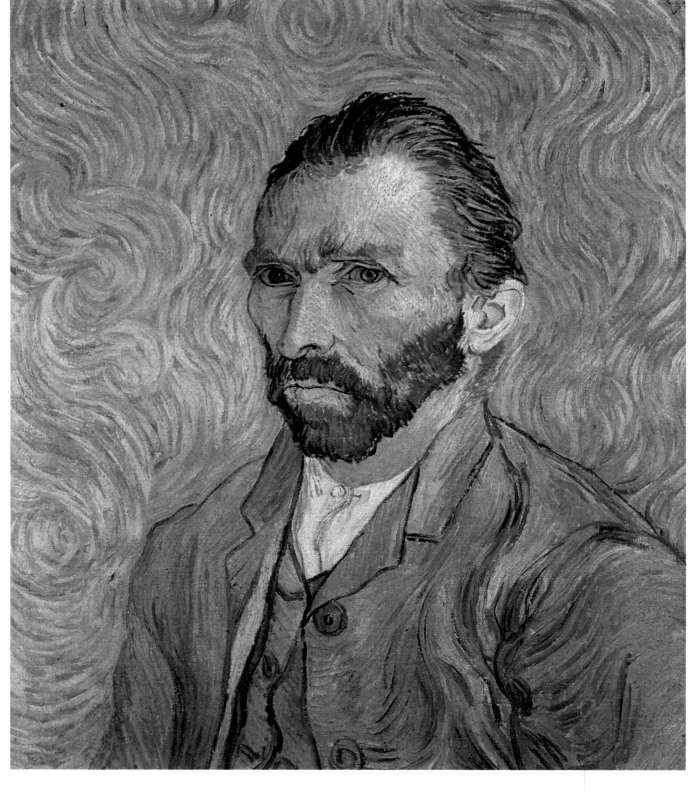

Self-Portrait.
VINCENT VAN GOGH.

(1888), *Portrait of the Postman Joseph Roulin, The Sower, Self-Portrait* (1889), *Olive Trees* (1889), *The Lan-* *glois Bridge at Arles, Road with Cypress and Star* (1890) and *Wheat Field with Crows* (1890) are examples from among the hundreds of paintings that he did in the last two years of his life, and of which he sold only one, *The Red Vineyard*, exhibited at the Salon of The Twenty in Brussels in 1890. After another breakdown, he was hospitalized in the Saint-Remy hospital, and although he continued to paint nu-

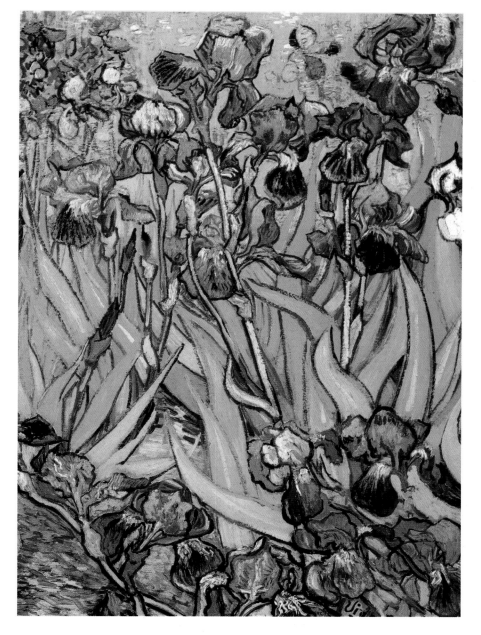

Irises.
VINCENT VAN GOGH.

death, a great many of his works were exhibited at the Salon of Independent Artists, and the paintings began their unstoppable rise in value in auctions and galleries throughout the entire twentieth century.

VAN RYSSELBERGHE, Theo

(Ghent, 1862–Saint-Clair, 1926)

A Belgian engraver and painter, his work is included in the **Post-Impressionist** movement. The son of an architect, he began his artistic studies in Ghent and completed them in Brussels. His artistic progression started with his admiration of the Symbolist painter **Puvis de Chavannes**, and very soon after that, he was exposed to **Seurat**'s divisionist and Pointillist technique. However, his interest in light and color made his final work more closely associated with the Fauves. He was a member of the Belgian group The Twenty from 1884 onward. Noteworthy among his por-

merous pictures (*Starry Night, Reapers in the Field,* and *Portrait of Dr. Gachet*, his doctor), his desperation led him to commit suicide. He shot himself in the chest on July 27, 1890 and lay dying until the morning of the twenty-ninth, when his brother arrived at his side. Almost all of his paintings passed into Theo's possession, and upon his death, were donated to the city of Amsterdam. Ten years after his

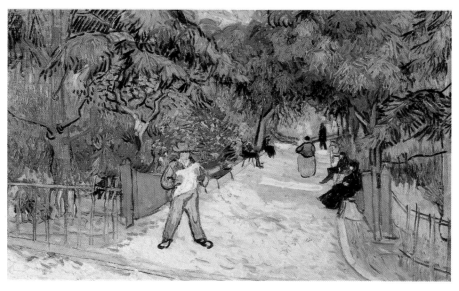

Entrance to the Public Park in Arlés.
VINCENT VAN GOGH.

V

The Bogatyrs.
VIKTOR M. VASNETSOV.

traits is the one he did of the Spanish painter **Regoyos**. His favorite motifs were scenes of tranquil landscapes and female figures. Notable works are *The Walk, The Reading, At the Beach*, and *Everyone into the Bath*.

VASNETSOV, VIKTOR M.

(1848–1926)

A Russian Modernist painter. He entered the Academy in 1868 and later, in the 1880s, formed part of a community of restless and creative avant-garde artists, under the patronage of S. I. Mamontov; also in this group were Vrubel, **Serov**, and Korovin. He painted a large number of works of great quality which brought him international fame, and which were mostly produced in an intensive effort beginning in 1874. His work showed, in accordance with the new era in painting, a great variety of subjects, in which there are numerous religious paintings and others depicting Russian customs. However, he also painted portraits and worked in the historical-legendary genre, in which he was inspired by legends and by Russia's epic history. His religious work was inspired by the fact that he was the son of an Orthodox pope and had studied in the seminary at Viatca. In these pictures, he combined the characteristics of the ancient, traditional Russian painting form—the icon—with the style of modern European movements, as can be seen in the frescoes he painted to decorate the church of St. Vladimir in Kiev between 1885 and 1895. This work was highly praised and constitutes a grandiose encomium to religion. In it, he humanizes icons, although still using a Byzantine style, eliminating their solemn rigidity and treating them with a certain amount of Realism. He did the Novgorod frescoes in the same manner. Examples of the historicism of the nineteenth century, and more noteworthy than the previous ones, are his historical paintings, which primarily illustrate

Russian legends, which are treated with a poetic tone and an abundance of decorative motifs and traditional popular forms. Outstanding among these are *After Prince Igor's Battle with the Polovtsy* (1880), *The Bogatyrs, Alionushka, Three Princesses of the Underground Kingdom* (1884), and *Heroes*. He also worked as an architect, in addition to creating theatrical scenery and restoring religious paintings. Other important works are *Military Telegram, The Emperor Arriving in Moscow by Night, Ivan Tsarevich Riding the Gray Wolf,* and *The Last Judgment.*

VAYREDA VILA, JOAQUÍN

(Gerona, 1843–Olot, 1894)

Spanish painter. His work holds a prominent place in nineteenth-century Catalan landscape painting. He studied drawing in his native city and at the Fine Arts School in Olot.

Figure in the Garden.
JOAQUÍN VAYREDA VILA.

He continued his training in Barcelona, where he met **Martí Alsina** and collaborated in his atelier. After an initial phase of religious and genre painting, Vayreda became

interested in landscapes. In 1868, he settled in Olot, and one year later, he founded the Artistic Center, later called the Olot School, which was dedicated to landscapes. With the coming of the Third Carlist War, he exiled himself to France, where he remained from 1871 to 1874. There he met the painters of the **Barbizon School**, whose advances with chromatic and atmospheric values would cause his painting to move towards more modern principles. When he returned to Olot, he achieved a certain amount of success with his work and combined painting with a position as provincial deputy in Gerona. Of interest are paintings such as *The Harvest* and *Spring*, works that show a timid assimilation of the innovations of Impressionism and a stronger tie to pictorial Realism. He also depicted figures and left an extensive collection of pencil draw-

Procession of Schoolgirls.
JOAQUÍN VAYREDA VILA.

ings, aquatints, and etchings. Nearly 250 of his paintings are on display in different museums. Other renowned works are *The First Trousers* (1871), *The Baptism and Summer* (1877), and *April Flowers* (1881).

VAYREDA VILA, Mariano

(Olot, 1853–Barcelona, 1903)

A Spanish painter and writer, the brother of **Joaquín Vayreda**. He was a pupil of **Gerôme** in Paris and painted subjects that were similar to his brother's but placing more emphasis on figures, such as in *Washerwomen* (1881; Museum of Modern Art, Barcelona), a work for which Joaquín painted the landscape background. He also painted historical subjects. Noteworthy paintings are *Figure* and *The Viaticum on the Mountain*.

VEIT, Philipp

(Berlin, 1793–Mainz, 1877)

A German artist, he was one of the representatives of the **Nazarene** movement who most effectively spread its aesthetic ideas. Trained between 1809 and 1811 in Dresden, where he met the painter **Koch**, he went to Rome in 1815. One year later, he joined the Nazarene Brotherhood of St. Luke, founded by **Pforr** and **Overbeck**. Like many of the German artists residing in Rome, he specialized in painting frescoes, a technique he applied to decorating Casa Bartholdy in Rome from 1816–1817. The following year, he collaborated on the paintings to decorate the Casino Massimo, with compositions dedicated to

The Morning of a Landlady.
ALEXIS VENETSIANOV.

the poet Dante. However, his best-known work is the series of frescoes he did for the Municipal Art Museum in Frankfurt-am-Main, after being named its director in 1830. This is one of the most beautiful sets of pictorial works from late German **Romanticism**, made up of historical and allegorical compositions such as *Christianity Bringing the Fine Arts into Germany* (1833). *Germania* (1848), a work showing patriotic characteristics, typical of Nazarene

ideals, was painted for the National Assembly in Frankfurt and later moved to the National Museum of Germany in Nuremberg. In 1854, he took on the role of director of the Municipal Gallery in Mainz, where he lived until his death.

VENETSIANOV, Alexis

(Moscow, 1780–Tver, 1847)

Russian painter. He owes his name to the fact that he was the son of a Greek immigrant named Venetian.

He studied at the Moscow Academy with Borovikovsky and completed his training by analysing and copying the seventeenth-century Dutch masters at the Hermitage in St. Petersburg. The French painter **Granet**'s influence on his artistic development is also obvious, specifically in the way he created genre paintings. His style, in which the sharpness of his outlines and delicate modeling of forms predominate, is Classical, although he has also been considered a clear forerunner of the Russian Realist school of 1860, in the paintings he did at his estate in Safonkovo in Tver, in which he portrays his serfs in different situations of peasant life. These works constitute true genre scenes, with great technical perfection and delicateness of color, taking inspiration from nature and often using it as the background for his pictures, which he painted from life. Some examples of this are his works from this period: *The Threshing Floor* (1821–1823), *Boy Putting on His Shoes* (1823), *Peasant Woman Feeding a Calf* (1829), and *Summer* (ca. 1830). He was an innovator due to the **Realism** seen in some of his painting but also an innovator in his own country because he painted nudes in the open air, such as *Bathers*, a painting that was a complete departure from academic

Harvesting: Summer.
ALEXIS VENETSIANOV.

Sleeping Shepherd.
ALEXIS VENETSIANOV.

aesthetics. In the first phase of his career, he did portraits, among which his *Self-Portrait* (1811) is worthy of note.

VERKADE, JAN

(Zaandan, 1868–Amsterdam, 1946)

Dutch painter, sculptor, and writer. Much of his work was related to his status as a Benedictine monk, and he is noted for the decoration of many churches and abbeys in Switzerland and Czechoslovakia. A tireless traveler and a great reader, he spent the decade of the 1880s in Paris, living among the most prominent artists and literati of the times. In 1898, he decided to dedicate himself to monastic life, and within those silent and mystical walls, to art. His paintings, exhibited in Vienna, Munich, and Copenhagen, are a blend of styles learned during his travels, although with hints of the Symbolism movement.

VERNET, EMILE-JEAN-HORACE

(1789–1863)

French Neoclassical painter of the First and Second Empire. He belonged to a family of painters and trained with his father. From the time he was a small child, he endlessly painted soldiers, so that when he grew up, his favorite subject was battles, almost exclusively Napoleonic battles. He was the most prolific French military painter, although he also did seascapes and mythological subjects, as well as animals (basically equestrian paintings), and oriental genre scenes, which, because of their exoticism, are reminiscent of **Fortuny**'s (*Taking of the Amalah of Abd-el-Kader*, 1845). He was so precocious that at the age of thirteen, he received numerous commissions and was the main draftsman for the *Journal des Modes* to which he also contributed caricatures. In his paintings, the first of which was *Taking of an Entrenched Field*, which brought him great success, their scenographic structure has a key

The Defense of Paris.
ÉMILE-JEAN-HORACE VERNET.

Madame Vigée-Lebrun and Her Daughter.
ELISABETH VIGÉE-LEBRUN.

role, and there is a tendency towards "the sublime," because of his service to and admiration for Napoleon. They show the different influences that his style gradually assimilated throughout his life, such as that of his father, especially in equestrian paintings, and **Delacroix**, in his battles (*The Battles of Jemappes*) and seascapes, which have a great sense of movement and of observation. He is considered the official painter of the Second Empire. He worked for Louis-Philippe, and in 1827, he was appointed director of the French Academy in Rome. Other important works are *Taking of Malakoff* (1855), *Mazeppa, Brigades and Carabineers, Equestrian Portrait of Napoleon III, Jérôme Bonaparte*, and *Soldier from Waterloo*.

VIGÉE-LEBRUN, ELISABETH

(Paris, 1755–1842)

A French Neoclassical painter. After the death of her father, who was a pastel portraitist, with whom she

Portrait of Queen Marie Antoinette.
ELISABETH VIGÉE-LEBRUN.

learned the basics of painting, she continued her studies, first with Gabriel Briard and then with **Vernet** and **Greuze**. In addition, she visited museums to study the great masters and observed nature. Her precociousness soon became evident

in an unconventional, although Neoclassical, style, which made her famous as a portraitist by the age of fifteen. She primarily dedicated herself to this genre, for which she was in great demand by high society in Paris, so much so that at times she had to resort to assistants to complete her commissions. She painted the highest quality works after

Mystical Apparition.
JOSÉ VILLEGAS CORDERO.

1776, and in 1779 was appointed official painter to Queen Marie Antoinette, of whom she painted her best portraits. In 1782, she traveled to Flanders, where she studied Rubens' paintings. Fleeing the French Revolution, she traveled through several European cities, while continuing her work as a portraitist and reaping success. She painted an especially large number of women, producing works of great elegance. In 1783, due to her deserved fame, she was elected to the Academy. Outstanding examples of her numerous portraits are *Comtesse de Brionne, Duchess d'Orleans, Marie Antoinette, Prince of Wales, Lord Byron, Lady Hamilton, A Boy, Self-Portrait with Her Daughter*, which are

probably her masterpieces, and *Madame de Staël.*

VILLEGAS CORDERO, JOSÉ

(Seville, 1844–Madrid, 1921)

A Spanish painter, the creator of a very versatile body of work, covering historical subjects, scenes of customs and manners, and anecdotal scenes. At a very early age, he moved to Madrid to study the great masters in the Prado Museum, where he became an enthusiast of Velázquez's work and adopted his loose, spontaneous brushstrokes. He trained in Rome and was influenced by **Fortuny**, and to a lesser degree,

Moroccan Smoking.
JOSÉ VILLEGAS CORDERO.

by **Madrazo** and **Rosales**. His work was very personal and held in high esteem in his day. Of interest among his works are *The Death of the Master* (1882) and *Bulerías Dance* (1884). In 1901, he was appointed director of the Prado Museum, a post he held until 1918.

VRUBEL, MIKHAIL ALEXANDROVITCH

(Omsk, Siberia, 1856–St. Petersburg, 1910)

A Russian painter of Polish origin, as well as a maker of ceramics and a decorator. He also did some work in architecture and followed the model of a typical modernist artist whose work encompasses different disciplines, although his primary activity was focused on painting. From 1880 to 1884, he studied at the Fine Arts Academy in St. Petersburg and later found a great patron in Mamontov. He showed great technical and compositional

The Swan Princess.
MIKHAIL A. VRUBEL.

ability as a decorator and ceramist, and this skill carried over into his large-format paintings, which were characterized by their great abundance of forms and his choice of colors in which he sought beauty, contrary to the idea of the Russian realists, who sought truth in what they depicted, with aesthetic considerations only secondary. In 1889, he settled in Moscow, where he witnessed the profound innovation that Modernism meant for painting. The subject matter of his

The Fortune Teller.
MIKHAIL A. VRUBEL.

work reflected the fascination and interest he felt for medieval legends and for mythology. Around 1902, the first symptoms of the mental illness that would continue to afflict him became evident. The frescoes he did for the church of St. Cyril and the cathedral of St. Vladimir, in Kiev, are of interest, as is his expressive *The Demon Seated* (1890).

W

very long. This would be due to a series of problems he had with the authorities and above all, his hostility towards Academicism, from which his painting would depart in search of **Realism**, especially in landscapes. His numerous and very noteworthy portraits, still bearing a Classical stamp, have great psychological depth and brought him fame. Examples of these are his *Self-Portrait* from 1828 and the portrait considered his masterpiece, *Count Razumowski*. However, he mainly painted excellent landscapes, both of the city of Vienna and of its environs, which demonstrate his sense of detail and light in which he specialized, often depicting full sunlight, which along with his strong colors, sometimes gives his paintings a certain harshness. He felt the only model for painting was nature, which he captured with a naturalistic and detailed style. He often included merry groups of children and young people in his landscapes. In around 1830, the light and colors in his paintings evolved towards an

The Forced Sale.
FERDINAND WALDMÜLLER.

The Birthday Table.
FERDINAND WALDMÜLLER.

WALDMÜLLER, FERDINAND GEORG

(Vienna, 1793–1865)

Austrian painter. After studying at the Viennese Academy, he began his artistic career as a painter of miniatures and theater sets in Brün and Prague. He traveled around Germany and Italy and in 1830, was appointed professor at the Academy in Vienna, a post he would not hold for

W

Spring in the Vienna Woods.
FERDINAND WALDMÜLLER.

Impressionistic style, and he painted many works in the open air, such as *Early Spring in the Woods*. He also painted still lifes, following the line of the classical Baroque painters, and genre scenes, reminiscent of **Boilly**'s, with which he sought to highlight lower-middle-class morality. He is considered one of the most important representatives of the Viennese Biedermeier style, partly due to his naturalistic and detailed manner, with its precise lines (*The Family of J. August Eltzen Isch*, 1835; *The Family of Councilor Ritter von Neuhaus*, 1827). In his last works, his technique became freer and looser (*View of Cobenzl*). Other works of his are *Prater Landscape, Vienna* (1830), *Vienna Woods before Spring, The Birthday Table, Woodsman in the Vienna Woods* (1855), *First Communion*, and *The Artist's Wife*.

WAPPERS, GUSTAVE

(Antwerp, 1803–Paris, 1874)

Belgian historical painter. He first trained with Bree at the Painting Academy in his native city and later, in Paris, primarily studying the masters of the Venetian school and the Flemish painters, Peter Paul Rubens and Jacob Jordaens, who noticeably influenced him. In his historical paintings, he depicted dramatic scenes with numerous figures—reminiscent of both **Delaroche** and Rubens—in his elaborate historical reconstructions in the Baroque manner, using a naturalistic and highly detailed style. Many of his subjects are patriotic, so they were very pop-

ular since the country's independence was so recent. An example of this type is *Episode During the Belgian Revolution of 1830* (1834), He also painted scenes of customs and manners, as well as portraits. Other works that are worthy of note are *Charles I Taking Leave of His Children, The Selflessness of the Burgomasters of Leiden* (1830), and *Taking of Rhodes by the Turks.*

WARD, JAMES

(London, 1769–Cheshunt, 1858)

An English painter and engraver, who studied at the Royal Academy. Until the age of nearly thirty, he painted genre scenes that were anecdotal by nature, with a loose style using Rubens-like colors and broad brushstrokes, in the manner of George Morland. Later at the Academy around 1790, he began to create

Goredale Scar.
JAMES WARD.

Circe Offering the Cup to Ulysses.
JOHN WILLIAM WATERHOUSE.

landscapes that were settings for animals—cows, horses, and especially bulls—which would make him popular and in which he revealed himself as a great animal painter. He also painted historical subjects, but without much success, such as *The Genius*

of Wellington *(Allegorical Painting of the Triumph of Waterloo)*, as well as religious themes which included a large number of animals (*Star of Bethlehem* and *Pool of Bethseda*). In 1800, he was named official painter to the Prince of Wales, and in 1811, academician. His work was much admired, and among his faithful adherents were **Delacroix** and **Géricault**. However, he died in poverty, after having gone into retirement in 1830 to live in Cheshunt and after receiving titles and honors. Other notable works are *Gordale Scar* (1811–1815), *Cattle, View of Harlech Castle, Bulls Fighting* (ca. 1804), *The Cowshed, Landscape with Rams*, and *View of the Coast, Storm.*

WATERHOUSE, JOHN WILLIAM

(Rome, 1849–London, 1917)

An English painter, his work varied between the historical genre and religious subjects. The son of an English painter living in Rome, who

The Wounded Heron.
GEORGE FREDERICK WATTS.

WATTS, GEORGE FREDERICK

(London, 1817–1904)

The Three Goddesses.
GEORGE FREDERICK WATTS.

oration of the new Parliament building in London and enabled him to finance a trip to Italy, where he lived in Florence and learned fresco techniques. Upon his return in 1846, he once again received an award for *Alfred Inciting the Saxons to Encounter the Danes at Sea* (1847). He was responsible for decorating the Hall of Poets and painted a series of frescoes revolving around the theme of *St. George and the Dragon*. The recognition he received both in his own country and on the European continent in general guaranteed his appointment as an academician of the Royal Academy. He also won the medal of honor at the

copied the great masters of Classicism, he trained with his father, acquired his knowledge and also copied the masterpieces at the National Gallery and other great collections. An associate and later full member of the Royal Academy, where he received some awards, he made a name for himself at the Universal Exposition in Paris in 1889. Worthy of note are his paintings *The Annunciation, Echo and Narcissus, Ulysses and the Sirens*, and *Diogenes*.

An English painter and sculptor, part of his work harks back to Greek Classicism within poetic and symbolic aesthetics. He left his studies at the Royal Academy to learn on his own. He practiced all genres, and among his early works, mythological and historical themes were prominent, such as *Vertumnus and Pomona* and *Caractacus Led in Triumph through the Streets of Rome* (1842). The latter work won an award in the competition for the dec-

1900 Universal Exposition in Paris. Among his numerous portraits, the most interesting are those of famous people of his time, such as Gladstone, Lord Salisbury, Swinburne, and Garibaldi; and among his freer compositions, *Love and Life* (1885), *Love and Death* (1877–1896), *Love Triumphant* (1898), and the *Trilogy of Eve*. His sculptural work is characterized by great boldness, and his most noteworthy work in this area is *Bishop Consdale*.

ENCYCLOPEDIA OF ARTISTS

WEST, BENJAMIN

(Springfield, Pennsylvania, 1738–London, 1820)

An internationally known American painter and draftsman, who is considered the creator and head of modern historical painting. He began his painting studies in New York, first painting portraits with great success. In 1760, he went to Rome, although he also traveled through Venice, Florence, and Bologna. He was the first American painter who was able to do this, primarily through the generous contribution of his patrons. This trip enabled him to be exposed to Classicism through the work of Anton R. Mengs, Gavin Hamilton, Johann Joachim Winckelmann, and other artists present in Rome at that time. In 1763, he went to London, where he was warmly received by society. This made him decide to settle in that city, where he became a renowned portraitist and one of those most in demand at the time, along

The Golden Age.
BENJAMIN WEST.

with Thomas Gainsborough and Sir Joshua Reynolds. He and the latter were among the founders of the Royal Academy in London (1769), of which he was appointed president in 1792. His fame brought him the patronage of King George III, who named him court historical painter and commissioned numerous projects, including a series of historical and religious compositions for Windsor Palace. The magnitude of his popularity earned him certain titles of nobility, which he rejected because of the beliefs inherent to the Quaker faith he professed. Upon his death in 1820, he was interred in St. Paul's Cathedral. His style was between **Neoclassicism** and **Romanticism**. Elements from the former are his preference for precise draftsmanship and purity of color, and from the latter, his sense of theatricality in his use of light, the aura of mystery that usually enshrouds his scenes, and the dramatic composition of his paint-

Colonel Guy Johnson.
BENJAMIN WEST.

ings. His style was an eclectic mixture, the result of a series of influences: the old Italian masters on the one hand, and on the other, Rubens and Van Dyck, but these almost always imbued with a feeling of solemnity. He depicted religious and secular subjects in his paintings, as well as scenes from both ancient and contemporary history. Among his works representing religious subjects and ancient history—the most conventional and academic ones—the series of paintings and stained glass windows for Windsor Palace, commissioned by George III, are important: *Pylades and Orestes Brought as Victims to Iphigenia,* and *Agrippina Landing at Brundisium with the Ashes of Germanicus.* Much more important are his paintings of contemporary history, which blend portraitrature and landscape painting and in which a variation that is widespread in English art is introduced. This consisted of depicting personalities of the times in

compositions and attitudes more characteristic of the classical world, while wearing contemporary clothing. Among these is *The Death of General Wolfe*, the first great painting depicting a scene of contemporary

Self-Portrait.
BENJAMIN WEST.

American history, *The Death of Admiral Nelson*, and *The Battle of the Boyne*. Among his more mature works, in which the Classicism/Romanticism dichotomy in his style became more evident, his different versions of *Death on a Pale Horse* (1796–1817) are noteworthy. He was quite prolific in his work, and the greatest

American painters were trained in his atelier. However, they primarily learned his technical knowledge, since his style did not inspire an art movement. Nevertheless, he exercised great influence on modern historical painters in France and contributed to the triumph of Realism in painting.

W

365

Rose and Silver: The Princess from the Land of Porcelain.
JAMES ABBOT MCNEILL WHISTLER.

Symphony in White No. 2: The Little White Girl.
JAMES ABBOT MCNEILL WHISTLER.

WHISTLER, JAMES ABBOTT MCNEILL

(Boston, 1834–London, 1903)

An American painter, engraver, and illustrator, whose work is closely similar to **Impressionism**, although it gradually became linked to other trends as well. Whistler left his native country in 1855 to move to Europe and take up residence in England. That same year, he exhibited his paintings at the

Royal Academy in London, but the ones he sent to the Salon in Paris two years later were not accepted. This rejection continued until 1863, when, because of his friendship with **Fantin-Latour** and his own painting *The White Girl*, he was allowed to form part of the group of independent painters who exhibited at the so-called Salon des Refusés ("Salon of the Rejected"). He traveled to France, and in the city of Trouville, met **Manet,**

Boudin and one of the painters he most admired, **Courbet**. He joined the Impressionists, although his work differed from the group's guiding principles. His landscapes usually depicted a nocturnal world, colored with very flat surfaces, while his figures were created with a very refined brush-

stroke. The graphics of his compositions, which became increasingly decorative, were influenced by Japanese prints. As his style evolved, the influence of **Rossetti**, with whom Whistler struck up a friendship in about 1867, had a special impact. Whistler decided to settle in London once again, where he met the artists who formed the **Pre-Raphaelite** group. However, his works have some peculiarities that prevent them from being associated

Arrangement in Gray and Black: Portrait of the Painter's Mother.
JAMES ABBOT MCNEILL WHISTLER.

with any specific movement or school. *Nocturne in Blue and Silver* (1870), *Miss Cecily Alexander* (1872), and *Thomas Carlyle* (1874) are examples of the landscapes and portraits he did at that time. One of his best oils, *Portrait of the Painter's Mother*, was exhibited at the Royal Academy in 1872, and twelve years later, at the Salon in Paris, where it was awarded the gold medal. He was also interested in the relationship between painting and music, so many of his works—such as *Symphony in White, Scherzo*, and *Variations*—are exercises in associating musical compositions with color. A significant

episode in his biography was the public dispute he had with **John Ruskin**, the Pre-Raphaelites' ideologist, who criticized one of his showings in London at the Grosvenor Gallery in 1877. This gave rise to the pamphlet *Whistler versus Ruskin*, written by Whistler himself. The disagreement, however, did not prevent him from painting pictures whose parallels with Pre-Raphaelism are evident, such as the decorative work known as *The Peacock Room*, which is very much along the lines of **William Morris**' work. From 1892 onward, he lived in France, where he exhibited innovative

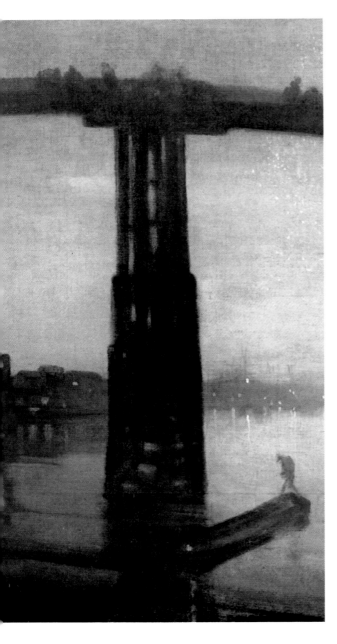

Nocturne in Blue and Gold.
JAMES ABBOT MCNEILL WHISTLER.

lithographs and etchings of views of
Venice. He taught at the Carmen
Academy in Paris, which he himself
founded and directed in 1898. His last
works were related to the aesthetic
principles of the Symbolists. In 1901,
he returned to London, where he died
two years later.

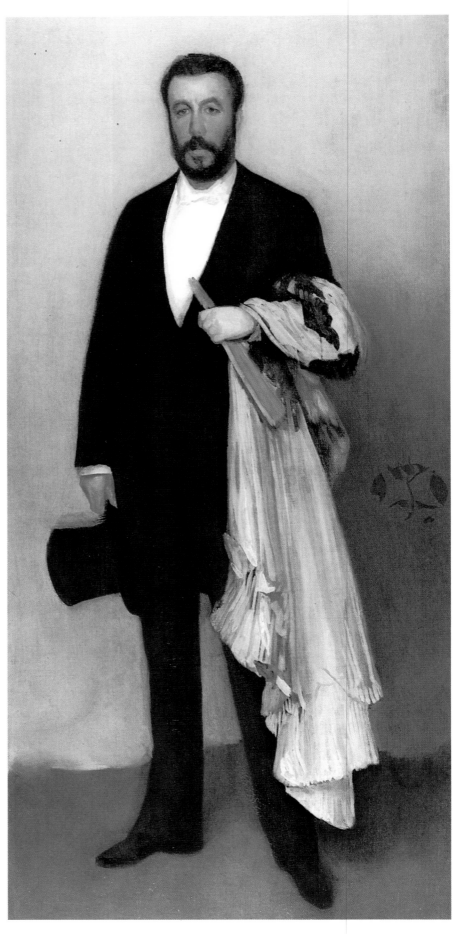

Arrangement in Flesh Color and Black:
Portrait of Théodore Duret.
JAMES ABBOT MCNEILL WHISTLER.

Harmony in Gray and Green: Miss Cecily Alexander.
JAMES ABBOT MCNEILL WHISTLER.

WIERTZ, ANTOINE

(Dinart, 1806–Brussels, 1865)

Belgian painter. He began his training in Antwerp and continued it in Paris and Rome, where he received a scholarship in 1832. There he studied the painting of Michelangelo, who along with Peter Paul Rubens, would be an influence in shaping his style. He painted enormous pictures with historical, mythological, allegorical, and religious subjects in a **Romantic** style that was pompous, melodramatic, and highly Baroque, as can be seen in *Greeks and Trojans Contesting the Body of Patroclus* (1836) and *Rebellion of Hell Against Heaven* (ca. 1840), in which the influence of Michelangelo and Rubens can easily be detected. Most of his works are compositions showing great movement, and many depict fantastic, symbolic, and at times erotic or horrorific scenes. Because of these strange works, he is considered a forerunner of the Symbolists and Surrealists, although certain analogies to modern **Expressionism** can also be seen. This provocative and shocking artist painted portraits in order to earn a living and enable him to keep on producing his peculiar pictures. Some noteworthy works of his are *The Beautiful Rosine* (1847), *One Second after Death* (1847), *Revolt of the Rebel Angels* (1842), *Christ's Triumph and its Consequences for the Culture of Mankind, Girl in Flames, Madness and Crime*, and *The Reader of Novels*.

The Beautiful Rosine.
ANTOINE WIERTZ.

WILKIE, DAVID

(Cults, 1785–near Gibraltar, 1841)

A Scottish painter, one of the masters of British **Romanticism**. He first studied in Edinburgh, and in 1805 went to London, where he entered the Royal Academy. He took long trips around several Eu-

The Blind Fiddler.
DAVID WILKIE.

W

ropean countries—France, Germany, Switzerland, and Spain (where he was especially influenced by Murillo and Velázquez)—studying the painting of the great masters, which helped to form his style. He was highly regarded as a painter in English society, and he

The Empress Eugenie and Her Maids of Honor.
FRANZ WINTERHALTER.

received numerous commissions and was named court painter, succeeding Sir Thomas Lawrence in that post. He painted scenes of customs and manners, in which the influence of the seventeenth-century Flemish and Dutch painters can be seen, especially that of Teniers and Ostende, and which brought him great success (*The Blind Craftsman, The Card Players*, etc.). He also did historical painting in vivid and brilliant colors, with which he began his painting career, but which did not bring him as much fame as his genre painting. Despite this fact, he dedicated himself almost exclusively to this genre from 1825 onward, when his style was partially influenced by Spanish painting. He also painted portraits; the early ones showed the clear influence of Henry Raeburn which later faded or disappeared when Wilkie's style matured. He

The Letter of Introduction.
DAVID WILKIE.

also painted some landscapes. Noteworthy works are *The Blind Fiddler* (1806), *Chelsea Pensioners Reading the Gazette of the Battle of Waterloo* (1818–1822), *Portrait of*

Woman in a Meadow.
FEDERICO ZANDOMENEGUI.

William IV (1832–1833), and *Maid of Saragossa*.

WINTERHALTER, FRANZ XAVER

(Menzens-Chwand, 1805–Frankfurt-am-Main, 1873)

A German painter, he was the best-known court portraitist of his time. He was also at the service of other European royalty, such as Empress Eugenie de Montijo and the court of Napoleon III. From 1834 until the start of the Franco-Prussian War in 1870, he lived in Paris, where he was the most highly regarded portraitist, and Queen Maria Amelia was his patroness. In Karlsruhe, he was named official painter to Duke Leopold and was so popular that all the royal families asked him for portraits. These were objective portraits, painted with a masterful technique. He also painted genre scenes, such as *Family of Fisherfolk* and *Dolce Farniente*, in the Romantic style. He was a good

lithographer as well. Special mention should be made of his works *Duke Leopold of Baden, Bocaccio's*

Decameron, The Empress Eugenia and Her Maids of Honor, Madame Barbe de Rimsky-Korsakov, Louis-Philippe, and *Napoleon III.*

ZANDOMENEGHI, FEDERICO

(Venice, 1841–Paris, 1917)

An Italian painter, the son of a modest sculptor, his work can be classified as **Impressionistic**. He trained in Florence, then left Italy and settled in Paris in 1874, joining the

Fishing in the Seine.
FEDERICO ZANDOMENEGUI.

Z

371

Z

Left: *Portrait of a Young Girl.*
Above: *Games in Monceau Park.*
FEDERICO ZANDOMENEGUI.

new trends and the Impressionist movement. He exhibited his paintings at the Salon of Independent Artists. These works showed sensitive colors and a technique approaching **Renoir**'s, with influence from **Degas**. Noteworthy examples of his work are *Reading, Morning Music Session, La Roussotte* and, from 1872, *The Poor on the Steps of the Ara Coeli Convent in Rome.*

ZORN, ANDERS

(Mora, Sweden, 1860–1920)

Swedish painter, sculptor, and engraver. He studied in Stockholm, and made numerous study trips to Spain, America, Hungary, and Turkey. In

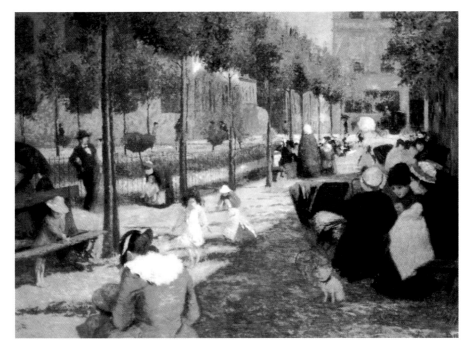

La Place d'Anvers.
FEDERICO ZANDOMENEGUI.

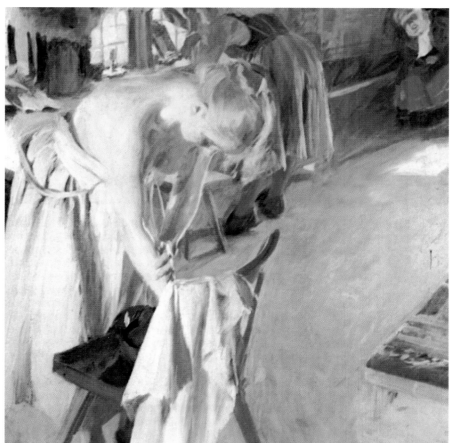

Z

Spain, a country he visited in 1881, he was exposed to Velázquez's painting and created many watercolors and portraits. From 1888 on, he lived in Paris, where he received first prize at the Exposition in 1900, and in 1896, he returned to his country. In addition to portraits, which make up the largest part of his work, and to which he would especially dedicate himself between 1880 and 1890 with great success, he also did genre scenes showing everyday life, in which he depicted ordinary people of Sweden, such as peasants and laborers; nudes in nature; as well as etchings of sea-related themes. His work is perceived as Realist, at times Naturalist, although the technique he used was very loose, especially in his later paintings, in which he used broad brushstrokes, similar to Sorolla's, and in which he depicted open-air settings, seeking light effects to represent the dazzling light of southern Europe, without becoming **Impressionistic**. The best of his works are the female nudes and the engravings, which show greater spon-

taneity in capturing the different motifs than his oils. Noteworthy examples are *The Cousins, Maja, Beer Factory, Maternal Pleasures, King Oscar II of Sweden, Summer Dance* (1892), and *Madame Gadner in Venice* (1894).

Above: *Sunday Morning.*
Below: *In the Bottling Plant.*
ANDERS ZORN.

Following Page: *Summer Night's Dance.*
ANDERS ZORN.